LONELY PLANET'S GUIDE TO

TRAVEL
PHOTOGRAPHY

Richard I'Anson

CONTENTS

TRAVEL PHOTOGRAPHY

4th edition – August 2012
ISBN 978-1-74321-139-7

PUBLISHED BY
Lonely Planet Publications Pty Ltd
ABN 36 005 607 983

LONELY PLANET OFFICES
90 Maribyrnong St, Footscray, Victoria 3011, Australia
150 Linden Street, Oakland, CA 94607, USA
Media Centre, 201 Wood Lane, London W12 7TQ, UK

10 9 8 7 6 5 4 3 2

Printed in China

PHOTOGRAPHS
Cover Image: Eiffel Tower at dusk, Paris, France
Cover Design: Mark Adams & Mik Ruff
Title Page Images:
Giant Sky Wheel, Melbourne, Australia p18
Gellert Baths, Budapest, Hungary p126
Woman in sea, Puri, India p 204
Hot-air balloon, Amber, India p322
Images in this guide are available for licensing from Getty Images (www.gettyimages.com) or National Geographic Stock (www.nationalgeographicstock.com).

THE AUTHOR

Richard I'Anson is a freelance photographer who has built a career on his twin passions for travel and photography. Over the past 30 years he has travelled the world amassing a substantial and compelling collection of images of people and places in more than 90 countries on all seven continents.

Richard received his first camera as a gift from his parents when he was 16 and has been infatuated with photography ever since. After studying photography, film and television for two years at Rusden State College in Melbourne, he worked in a camera store and minilab before going freelance in 1982.

His work is published worldwide in books, magazines, newspapers, brochures, calendars, posters, cards and websites. He has published numerous books: *Chasing Rickshaws* (1998) and *Rice Trails* (2004), both collaborations with Lonely Planet co-founder Tony Wheeler; *Travel Photography* (2000, 2004 and 2009 editions) and *Urban Travel Photography* (2006); and the large-format pictorials *Australia: 42 Great Landscape Experiences* (2006); *Nepal: Kathmandu Valley, Chitwan, Annapurna, Mustang, Everest* (2007) and *India: Essential Encounters* (2010).

Richard is a double Master of Photography with the Australian Institute of Professional Photography (AIPP) and was judged top travel photographer in *Capture Magazine*'s 2007 Australia's Top Photographers Awards.

Lonely Planet has been using Richard's photographs for 21 years and his work has been featured in over 500 editions of Lonely Planet titles. When he's not on the road Richard lives in Melbourne, Australia. To see more of Richard's images log onto www.richardianson.com and www.facebook.com/richardiansonphotography.

FROM THE AUTHOR

It's a pleasure to be able to share what I've learned and seen in more than 30 years of shooting travel photographs. Thanks to the rapidly evolving developments in the world of digital photography, it's a serious challenge for all of us involved in the imaging industry to keep up to date with equipment and software offerings. Writing this book gives me the opportunity to gather, assess and present a relevant snapshot of this information alongside the more creative and timeless elements of the art, subjects and practicalities of travel photography.

It's also a great opportunity to thank again the people who have played a significant part in my journey and contributed in various ways to my body of work from which I draw the contents of this book. Thanks then to Tony and Maureen Wheeler, Lonely Planet founders, Nick Kostos and Sue Badyari at World Expeditions, Peter Cocklin at Kodak Australia, Lothar Huber and Doug Porter at Bond Imaging, Rick Slowgrove at Canon Professional Services and Rik Evans-Deane at Camera Action Camera House in Melbourne.

At Lonely Planet, Ben Handicott and Ryan Evans made significant contributions to this edition.

THIS BOOK

USING THIS BOOK

Travel is an exciting experience and your photography should reflect that. *Travel Photography* introduces you to every aspect of the picture-taking process and the wide range of subject matter that you'll encounter on your travels, to help you produce vibrant and meaningful images. It aims to increase the percentage of good photographs you take and to lift your travel photography to the next level of creativity. No matter where you're going or what camera you use, you'll find the information you need to make the most of the picture-taking situations that come your way. It will help you create photographic opportunities and to make your travel experience more photo friendly, with practical advice, tried-and-tested tips and inspirational images sure to get you thinking about both your photography and your next trip.

With film cameras no longer being manufactured, every new camera these days is a digital model. Although film still has a loyal following, the book assumes readers will be travelling with a digital camera. And although there is a substantial amount of technical information, the heart of the book lies in the images. The advice and suggestions are just as applicable whether you capture your experiences on the pixels of a sensor or the silver halides of a film emulsion.

Although the focus of the book is on capturing great still images on digital cameras, digital technology has opened up other possibilities for recording images. In the (not so) old days, you needed a camera for taking photos, a phone for making phone calls, an MP3 player for listening to music and a video camera for taking videos. Now you can do all of these things on one device. This is called technology convergence and it is leading to some truly exciting innovations. The most relevant examples to image-making are the camera phone, allowing both still and video images to be captured on a device made for making phone calls; video-capture mode on digital still cameras; and still-capture mode on video cameras. The introduction of video mode on digital cameras and mobile phones has introduced many people to the world of video-making for the first time. This book follows the convergence trend and offers advice about making photographs and videos with camera phones, digital cameras and video equipment.

Part 1 will bring you up to speed with digital photography, discussing all your gear options and the many features and functions you need to know about to buy the right camera and get the most out of your gear (note that prices are given in US dollars throughout the book). It shows how research, planning and practice will enhance the experience of travelling with your camera. Part 2 looks at the art of photography and will give you the tools to create images that reflect your own vision of the world. Part 3 is an in-depth look at the subjects you'll encounter, providing all the information you'll need to successfully capture them, and is packed with inspirational images from around the world. Part 4 deals with photography post-trip, including digital workflow, image editing, sharing and selling your pictures, as well as an insight into the business of travel photography.

This 4th edition of *Travel Photography* is also full of new images and insights from the road. Since the 3rd edition was published in 2009 I've been to India (10 times), China, Hong Kong, Taiwan, Bosnia, Montenegro, Hungary, Italy, Iceland, England, Ireland, France, Malaysia and Myanmar, as well as to every Australian state.

Even though this book is about travel photography, it could be said that all photography (outside the studio) is travel photography. One person's backyard is another's dream destination. Although this book is packed with images taken all over the world, you don't have to have immediate plans for the ideas and techniques to be useful. You can put into practice much of what's discussed here next time you photograph your family, your pets, go on a day trip and certainly on a holiday in your own country. In fact, I highly recommend that you do just that. Study the resulting photographs, and then go back out and take some more. You'll learn a lot from your own successes and failures and reap the rewards in better photographs on your next trip to someone else's backyard.

THE AUTHOR'S APPROACH

I've had the privilege of photographing all over the world and, most importantly from a creative perspective, had many opportunities to return to some countries three, four, 10 (China) and even more than 20 times (India and Nepal). And even after all these years, the thrill of arriving at my destination, dropping the bags at the hotel, grabbing the cameras and getting out there hasn't waned. In fact, I enjoy it more now because I'm confident I'll be able to capture the pictures I've come to take.

Photographing travel for a living is an intense, exciting, tiring and thoroughly rewarding endeavour. I often walk 5km to 10km a day, shoot between 300 and 400 images and get very little sleep. But by the end of my trip I'll have a comprehensive collection of images that capture a good cross-section of the places to see, things to do and people who live there. You can read more about my own travel photography practices on p350.

The way I go about taking travel photographs has developed over the years and I am constantly assessing my methods and images in an attempt to make the results of each trip better than the last. I capture all my images digitally and now wonder how I ever lived without some of digital imaging's most useful features: at the capture stage, the flexibility of changing the ISO from frame to frame, and the ability to instantly review the shots. Seeing the pictures immediately is helpful when shooting but, just as importantly, it allows me to make accurate decisions regarding completion of a subject shoot. At the post-capture stage, it is easy and quick to label large quantities of images and find them again when you need them, thanks to workflow software. Finally, although the digital workflow has pushed a lot of work back onto the photographer that was previously performed by photo labs and photo libraries, the gain in control over the entire imaging process, from capture to output, means the pictures will always be seen how they are intended to look.

But that's just the technical stuff. What hasn't changed is my aim to capture the reality of a place (as I see it) through strong individual images that build on each other to create a comprehensive coverage of a destination or topic, so that viewers get a sense of what it's like to be there. My own interpretation – my style – is expressed through choice of camera format, lens, aperture and shutter-speed combinations, what I choose to photograph, the composition I settle on, the light I photograph in and, finally, the images I choose to show.

I take the same gear on every trip and it consists of the following items:

- Two Canon EOS 5D MkIII DSLR camera bodies
- Canon EF 24–70mm f2.8 L USM zoom lens
- Canon EF 70–200mm f2.8 L USM image stabiliser lens
- Canon 300mm f4 L USM image stabiliser lens

- Canon 1.4x teleconverter
- Canon Speedlite 430EX II
- Hoya multicoated skylight 1B filters (permanently attached to all lenses for protection)
- Hoya circular polarising filter
- Gitzo G1228 carbon-fibre tripod with Induro ball head. (I photograph landscapes, cityscapes and interiors, where possible, on the tripod; everything else is hand-held.)
- Assorted 8 GB, 4 GB and 2 GB Compact Flash II memory cards totalling 24 GB capacity
- Laptop computer with 15-inch screen loaded with Adobe Lightroom, an image-processing and management program
- Two 750 GB portable hard disks
- Memory card reader
- Crumpler 7 Million Dollar Home soft shoulder bag – holds everything bar the tripod and 300mm lens
- Crumpler Whickey and Cox backpack for carrying gear onto planes and when trekking.

Day to day, I keep my gear as simple as possible but, to cover the range of subjects I know I'll encounter and to work as fast and as efficiently as possible, I always carry the two DSLR cameras, one with a

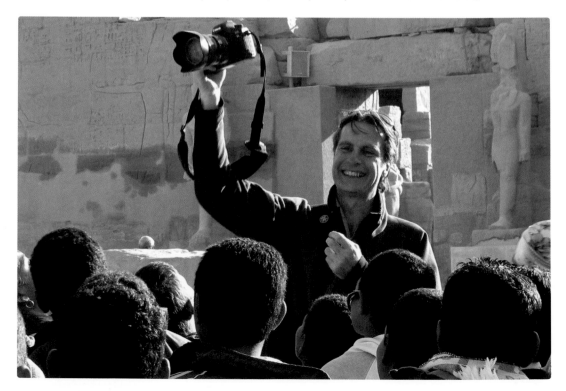

24–70mm lens and the other with a 70–200mm lens. I only carry the tripod, 300mm lens and flash unit when I know I'll need them for specific shots. All images are captured in the raw file format. My default sensor sensitivity setting is ISO 100.

PHOTO CAPTIONS

This book contains images taken with the equipment listed above, and also images shot on various other cameras I've owned or loaned over the years, including both digital and film cameras.

The photographs in *Travel Photography* are accompanied by both informative and technical captions that will help you learn about taking photographs in a variety of circumstances and give you an insight into many of the issues encountered when shooting on the road. Captions include the following information:

o Image title, location and country

o Camera type and lens

o File or film format

o Exposure (shutter speed, aperture and ISO)

o Any accessories used (tripod, filters and flash).

Note that all focal lengths are given as 35mm equivalents (see p52).

Author at Temples of Karnak, Luxor, Egypt

Photo by Alice l'Anson

FOREWORD

Plenty of my photographs have appeared in Lonely Planet guides over the years. Some of them have been good enough to find their place in photo library collections; I can even claim to be a Getty photographer. Not because I've pulled any strings. Just being, for many years, Lonely Planet employee number one – number two if my wife, Maureen, pulls rank on me – didn't get me any favours. (I've even written a whole book on travelling across the Pacific, only to have it rejected by Lonely Planet's travel literature publisher – 'not exciting enough', she announced.)

No, my travel photographs appeared because they were good enough to make the cut. Of course, the fact that I manage to get to some pretty unusual places helps. There's less competition for photographs from, say, Saudi Arabia, Haiti or North Korea than from Italy, France or the USA. But, at the end of the day, they're still going to have to be very good photographs.

What's in front of your lens may help things along, and high-quality camera equipment is a given, but it's your skill – the quality of your photography – that is going to make all the difference. I reckon there are three secrets to getting those 'wow factor' photographs. First of all, take lots of photographs; there's no substitute for experience and that means point your lens and exercise that finger on the shutter release. Secondly, there's education, which can mean taking a photography course or reading a good book on photography, like the one in your hands right now. Thirdly, there's no better way to find how to do it than to watch and study a real expert.

I've been lucky enough to have several intensive experiences of that third element of a photographic education. I've travelled with Richard I'Anson to work on our books *Chasing Rickshaws* and *Rice Trails* and I've travelled with both incarnations of Richard: the film and the digital photographer. The history of this book has tracked the shift from film to digital photography and this latest edition reflects the current situation: it's an almost-total change; film is an endangered species.

Of course, many aspects of photography are just as relevant to the digital world as they were to the old film one. Composition, focus and exposure are all important skills which this book will help you master, but while digital photography has brought new conveniences and opportunities, it also presents unexpected new challenges.

Sometimes travelling with Richard simply confirms that the very oldest photographic clichés are still true: the light really is better at dawn, otherwise why would I have suffered so many predawn wake-up calls when I've been in Richard's company?

I've also been horrified by how much camera equipment Richard seems to carry around, and moving into the digital world hasn't made that load any lighter. Photographers no longer have to carry all that film and worry about keeping it cool, out of the sun and away from X-ray machines, but the bag is going to be weighed

down by a laptop or some other digital storage medium, and calculating the remaining gigabytes of storage capacity can be just as big a worry as how many frames of film remain.

My first digital trip with Richard, a little coast-to-coast two-week trek across England from the Irish Sea to the North Sea, brought those changes home, along with the necessity of always heading out, waiting for that unexpected opportunity to pop up. The longest and dullest day of the walk also happened to be the day with the worst weather. Yorkshire weather. Our fellow walkers all decided this was the day to take the bus; Richard and I walked on, through a thunderstorm. Richard because there always might be a photograph out there. And me? Because I'm crazy, I guess.

No matter how good your equipment and how skilled the practitioner, successful travel photography can come down to sheer luck. Or sheer perseverance. Sometimes you simply have to tough it out in search of the perfect photo. On one trip to Nepal our search for rice terraces with snow-capped mountains in the background had been thwarted by day after day of nonstop rain. Finally the sun broke through just hours before our departure. We diverted our airport-bound taxi to the edge of the Kathmandu Valley and sprinted up a hill to find, on the other side, the perfect view – rice fields being harvested, picturesque houses in the foreground, soaring Himalayan peaks as a backdrop. And a river separating us from the picture. We tore off our shoes, rolled up our trousers, waded across the river, got the photographs, spoke to the farmers, and still made it to the airport in time for our flight – a little damp and rather muddy, but with the images we needed.

On another Nepal visit I staggered to the top of Kala Pattar, the Everest viewpoint overlooking Everest Base Camp. Richard was already there, wedged against a rock, hanging on in a wind fierce enough to strip the Gore-Tex off your back and the camera out of your hand. I soon decided to head back down to my tent, leaving Richard to look for that perfect sunset shot of the world's highest peak. Perseverance won out; he got it.

Equipment, expertise, luck and straightforward hard work are all only parts of the photographic story. It's travel that takes us out there and puts those amazing images, whether of people, places, nature or scenery, in front of our cameras.

TONY WHEELER
FOUNDER, LONELY PLANET

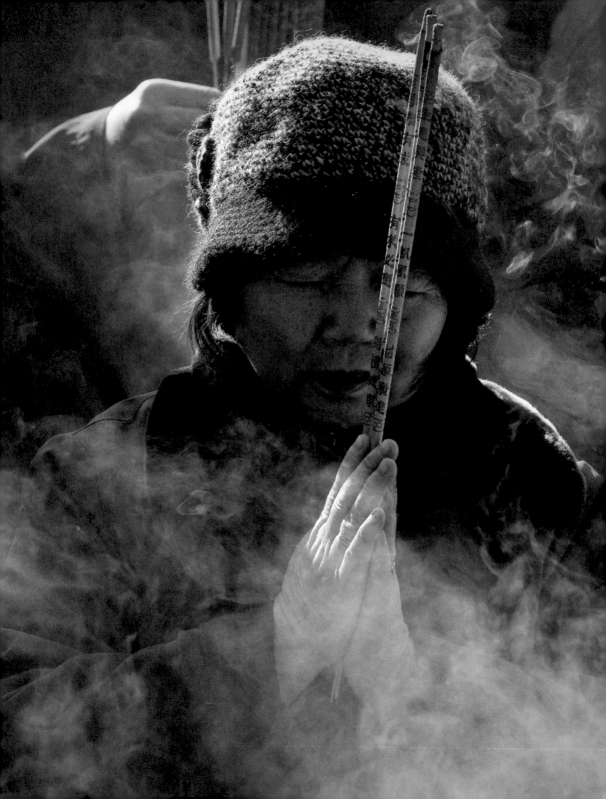

INTRODUCTION

I started travelling to take pictures over 30 years ago, but the adventure that is travel photography continues to stimulate and challenge me. The range of subject matter encountered on the road is truly diverse: it can see me standing alone beside a glacial lake at dawn one day and negotiating the crowds in a Chinese temple at festival time on another. The mix of travel experience and photographic endeavour that culminates in new images in such different settings, cultures, time zones and climates is exciting to say the least.

Although I'm shooting photographs commercially, I love that every picture has a personal story: about the subject or the journey or how the photograph was taken. Often it's all three, and I get to relive my experiences time and time again as I work with the images. The one constant that unites my photography and travels and connects all my images is the desire to be in the right place at the right time, giving me the opportunity to match my subject to the best possible light. That can mean rising before dawn or simply deciding on which side of the road to stand as a procession passes by. The ability of light to transform a subject or scene from the ordinary to the extraordinary cannot be over emphasised. It is the light a photographer shoots in that sets images apart. My photography took a quantum leap when this message sank in and I've been obsessed with the colour, direction and quality of the light ever since.

I'm often asked what came first, travel or photography? It's hard to say: the first photograph I ever took was a travel photo. I was in the Canary Isles, I'd ridden from the port to the town in a horse-drawn cart, and when the driver had been paid I took a shot of him and his cart and my family – I was 10 and on my first big overseas trip, sailing from England to Australia. I remember the moment as though it were yesterday: the foreign sounds, language and smells; the click of the shutter. It must have made a deep impression. Six years later I got my first camera. My first thought was where can I go to take pictures? Ninety-odd countries, seven continents, hundreds of thousands, maybe millions of pictures later, and the list of places to see is still longer than the places I've been. Travel is like that; it's addictive. So is photography. Combine the two and you have a lifetime of restlessness where the next trip is planned before the one you're on is finished, time and money permitting. I solved the financial problem by turning my passions into my work, but I'm certainly not alone in wanting to capture and share what I see when I travel.

In over 30 years of travelling I can count on one hand the number of people I've met who deliberately left home without a camera. Travelling provides a natural stimulus to picture-taking and even those who aren't 'into' photography display a strong, instinctive urge to record new places, new faces and new experiences.

For some, travel photography is simply a record of a trip. For others, it's a chance to release their creative side. Photo enthusiasts revel in the never-ending opportunities to take pictures that normally have to be planned and fit into regular life back home. For the professional travel photographer, it's work. But for everyone, travel photography is about memories, experiences, engaging with new people and places, and sharing the journey with others.

At its most basic, travel photography provides a visual record of the places visited. At its best it gives an insight into the world at large in all its diversity, adding something new to our understanding of a place and the people who live there. It portrays familiar places in unique ways, reveals lesser-known places with equal import, captures the spirit of the people with dignity and encapsulates unique moments in time that surprise,

Woman praying at Lama Temple, Beijing, China
DSLR, 70-200mm lens at 200mm, 1/200 f13, raw, ISO 200

inform and intrigue viewers. It's the counter to the incessant reporting and news footage that focuses on the negatives of people and places. Ultimately, it inspires in others a desire to see the world for themselves, and to take their own photographs along the way.

Thanks to the ease in which digital images can be captured and shared via the internet, more pictures are being taken by more people than ever before. (That's *more* pictures, not *better* pictures!) The idea that creating good photographs is simply a numbers game is as misguided as the camera manufacturers' claims that by using their latest camera anyone can instantly produce professional-quality images. Without doubt, digital photographic technology has captured the public's imagination and rejuvenated many people's interest in photography, but it certainly hasn't made people better photographers.

Digital capture is now the norm, but there is plenty to learn about the technology. Consequently, and quite understandably, a lot of emphasis is still being placed on the equipment, rather than the image. Modern cameras certainly give the impression that taking pictures is easier than ever before with the emphasis on automatic features that take care of everything, but people can still be left disappointed with their photos.

If you want to avoid disappointment and elevate your pictures from simple snaps of your travels to the next level of quality and individuality, you need to understand the elements that go into creating good photographs. Then you can begin to take control of the picture-taking process.

Automatic features are brilliant *if* you know what they are doing and the impact they are having on the image, so that you can decide if that is really how you want your photo to look. Exposure, for example, is often seen as a technical problem that the camera can solve automatically. And yes it can, in terms of exposing the sensor to the right amount of light. However, the variables that go into attaining 'correct' exposure (ISO, shutter speed and aperture settings) should actually be regarded as creative elements, as the combination selected can dramatically affect the look of the image; this is why professional photographers decide these things for themselves. In fact, every decision you make should be thought of as a creative decision, including your choice of camera and lens, exposure settings, whether or not you use a flash or tripod, the position from where you take the photo and the time of day you release the shutter.

I hope that when you hit the road, *Travel Photography* inspires you to see and think creatively and to bring back images that best reflect your personal response to the people and places you visit.

Enjoy the journey.

RICHARD I'ANSON
MELBOURNE, AUSTRALIA

Icebergs carved from Fjallsjokull glacier in Broidarlon glacial lagoon,
Breidamerkursandur, Iceland
DSLR, 70-200mm lens at 130mm, 1/60 f18, raw, ISO 100, tripod

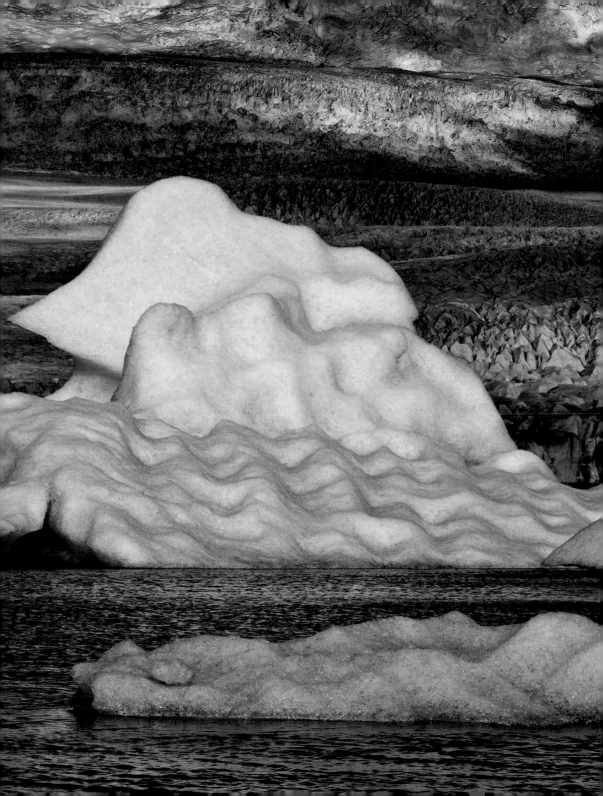

A SHORT HISTORY OF TRAVEL PHOTOGRAPHY

The connection between photography and travel runs deep. The oldest surviving image produced by a camera was made around 1826 when Joseph Nicephore Niepce photographed a street scene at Saint Loup de Varennes, in France. Arguably, this is also the oldest surviving travel photo. The photograph, taken in daylight, required an eight-hour exposure.

In Paris in 1839, Louis Jacques Mande Daguerre introduced the photographic process now known as the daguerreotype. The process was complicated, requiring lots of equipment and handling of chemicals, but was embraced quickly. Each daguerreotype was unique and recorded scenes with excellent detail. It also allowed people to travel with cameras. The first owners photographed their local area: Notre Dame Cathedral, the River Seine and the Pont Neuf; subjects that are considered a 'must take' by today's tourists. The appeal of photography was as obvious to travellers in the middle of the 19th century as it is today. Daguerre himself suggested that his camera could easily be taken along on a journey. He was right, but it wasn't quite that simple. The travelling photographer also had to carry a portable darkroom tent and enough chemicals to stock a small laboratory.

Around the same time, William Henry Fox Talbot, Daguerre's English contemporary, invented the calotype (better known today as a negative). This made multiple copies of an image possible, but without the detail achieved in a daguerreotype. Talbot too imagined the appeal his invention would have to travellers:

...THE TRAVELLER IN FOREIGN LANDS, WHO LIKE MOST OF HIS BREED, CANNOT DRAW, WOULD BENEFIT IMMENSELY FROM THE DISCOVERY OF SUCH A MATERIAL. ALL HE HAS TO DO IS TO SET UP A NUMBER OF SMALL CAMERAS IN DIFFERENT LOCATIONS AND A HOST OF INTERESTING IMPRESSIONS ARE HIS, WHICH HE DID NOT HAVE TO DRAW OR WRITE DOWN.

MASTERS OF EARLY TRAVEL PHOTOGRAPHY, R FABIAN & H ADAM, 1983

In 1851, Frederick Scott Archer invented the wet collodion plate, which became the standard photographic process until 1880. This new process, which reduced exposure times to a mere two seconds, matched the detail possible with a daguerreotype and the calotype's ability to be reproduced, and overcame the long exposure times required by both. It didn't, however, ease the burden for the travel photographer. Each glass plate had to be prepared in the field and processed immediately while still damp. A standard outfit in the 1850s included a camera (on the large size), tripod, glass plates and plate holders; a tent-like portable darkroom; chemicals for coating, sensitising, developing and fixing the plates; and dishes, tanks and water containers. Even so, photographers carted their equipment around the world. The Great Wall, feluccas on the Nile, temples on the Ganges at Varanasi, high passes in the Himalaya and the Grand Canyon had all been photographed in great detail by 1860.

Many of the travel photographs taken in the mid-1800s were recorded during scientific and exploratory trips, but they also served to create public interest in distant lands. Although cumbersome in the field, the collodion process produced good-quality images that were easily reproduced.

As tourism increased, so did the demand for pictures as souvenirs, and photographers began shooting for commercial reasons. According to Fabian and Adam, the first postcard was introduced by the Austrian postal service in 1869. In 1910, France printed 123 million postcards and the world's mail systems processed around seven billion in the same year. The images, once painstakingly produced by hand, were now being churned out by printing presses, and the purists were bemoaning the loss of the craft. The insatiable desire for postcards led

critic Walter Benjamin to declare that photography had lost its 'aura'. Others suggested that the sheer quantity of photographs being printed and released onto the market was causing a loss of interest in the medium.

The bulk, weight and messiness of the photographic process restricted the gathering of images in the early years to a small group of people who were part adventurer, part scientist, part camera technician and part artist. Noting the needs of the travelling photographer, the Michelin guidebooks of the day included an icon to indicate that a hotel had a *chamber noir*, ie a darkroom, available for developing film.

But by the end of the 19th century tourists could take their own pictures. In 1888, George Eastman, the founder of Kodak, invented a camera using a roll of film. He launched the first point-and-shoot with the now-famous slogan: 'You press the button, we do the rest.' The camera came loaded with a 100-exposure film and a memorandum book that had to be filled in to keep count of the photos. When the film was finished the camera was posted back to the factory. The camera was returned with the prints and loaded with a fresh roll of film. In the first year Eastman sold 13,000 cameras. They proved instantly popular with tourists as this testimonial shows:

'IT IS THE GREATEST BOON ON EARTH TO THE TRAVELLING MAN, LIKE MYSELF, TO BE ABLE TO BRING HOME, AT SO SMALL AN OUTLAY OF TIME AND MONEY, A COMPLETE PHOTOGRAPHIC MEMORANDUM OF HIS TRAVELS.'

THE BIRTH OF PHOTOGRAPHY: THE STORY OF THE FORMATIVE YEARS, 1800–1900, B COE, 1977

Further refinements saw the introduction of the Kodak Brownie camera in 1900, which made the photographic process accessible to millions of people around the world. Photography had become a mass medium and tourists were travelling with small, easy-to-use cameras. According to some, by the start of the 20th century, the world had been photographed to death.

Mr Benjamin and friends will be spinning in their graves when they get wind of recent InfoTrends statistics that suggest over 500 billion digital photos will be taken in 2009. With the combination of affordable digital capture and the distribution powers of the internet, imagery is flooding the market like never before. It's also interesting to consider the demands of the changing technology on the travel photographer. In a way it feels as though we've come full circle. For years, between the days of hotels with darkrooms and the advent of digital photography, all travel photographers had to carry was camera equipment and film. We could concentrate on being adventurers and artists. The messy and cumbersome developing and printing process was left to technicians in photographic labs. Yes, we had to wait a day or two for our pictures, but when they came they were in neatly cut strips in filing sheets or in little boxes of 36 mounted slides. Now, just like the old days, we carry the digital equivalent of a darkroom everywhere we go and again do the processing ourselves; the wet plates, dishes and tanks replaced by memory cards, computers, storage devices, battery chargers, plugs and cables; the chemicals replaced by software. Once again we have to complement our adventurous and artistic natures with additional skills, replacing the scientist and camera technician abilities of our predecessors with computer literacy and sophisticated software skills. When choosing somewhere to stay we still look for a relevant icon – only now it indicates broadband internet or wi-fi access.

If the world had been photographed to death a hundred years ago, imagine how it must feel now! We all know what world-famous destinations look like even if we haven't been there ourselves. The content of our pictures rarely surprises the travel-savvy society we live in, yet images are published every year that cast new light on old subjects and push our visual awareness into new territory. And so what if everyone you know has photographed the Taj Mahal, the Pyramids and the Eiffel Tower? There's nothing quite like the thrill of seeing places yourself and making your own version of the 'classic shot'. When you do, you're making your own contribution to a genre of photography that has been around since the very first photograph.

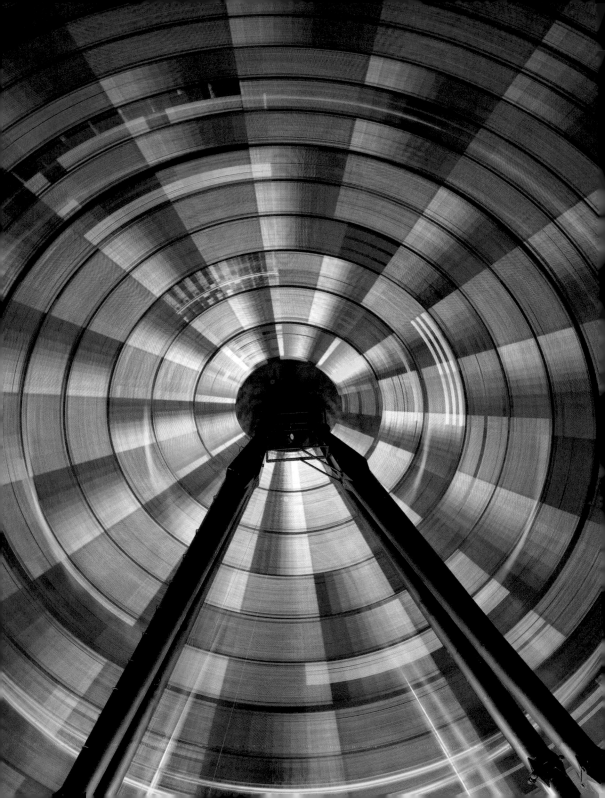

01: GETTING STARTED

There are plenty of things you can do, both at home and at your destination, to make your travel photography a fun and creative experience. It's as important as ever to select the right camera and lenses. Understanding digital technology and the myriad features and controls found on digital cameras will help you to decide which model is for you and how to get the most out of it. The right accessories will help you to get the image in any situation. Research, planning and practice will ensure that you not only make the most of your photo opportunities but create them as well, resulting in more and better pictures.

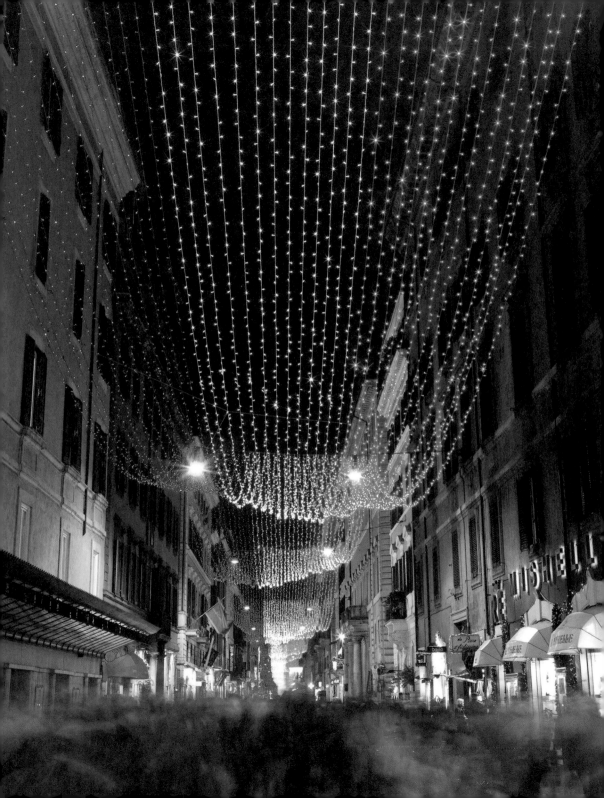

DIGITAL PHOTOGRAPHY

There is a lot to like about digital photography. From a capture point of view, being able to review images as they're taken and change the ISO setting from frame to frame are brilliant features. Post capture, the flexibility and control we have over how an image looks is unbelievable. Yes, you could scan a colour slide and enjoy the same image-editing options offered by programs such as Adobe Photoshop, but not having to scan each slide is a serious advantage in terms of cost, workflow and minimising computer time.

The world of digital imaging can seem a little daunting at first, but it needn't be. Here's a simple summary of what happens after you press the shutter on a digital camera.

o The lens focuses the light onto an image sensor made up of light-sensitive cells.

o The light is converted into electronic data and processed by in-built software to create an image file.

o The image file is saved to a removable and reusable memory card, sometimes called digital film.

o The image can be reviewed immediately on the camera's built-in screen. You can delete the image if you're not satisfied with it.

o When the memory card is full you can replace it with another card or transfer the images to a storage medium such as a computer hard drive or a CD/DVD.

o You then delete the images from the memory card.

o You reuse the memory card.

o Prints can be made directly from the memory card before deleting the files or from a computer or a CD/DVD.

Of course, you can't have all the wonders of digital capture without some downsides. It's worth understanding the good and the not-so-good features of this medium, as this will inform your choices in terms of equipment, computer and software needs, to help you make the most out of the technology and avoid the bits you don't like.

THE GOOD

o instant image review lets you check the shot, so you can reshoot if you're unhappy with the result

o no film or processing costs; you can save your best pictures to a computer hard drive or CD/DVD

o you can take thousands of photos before having to change cards

o unwanted images can be deleted and only selected pictures printed (no need to pay for the whole roll to be printed)

o the white-balance feature eliminates the need to carry filters to correct colour under artificial light

o you can adjust the ISO rating from frame to frame

(Opposite) Christmas lights on Via Corso, Rome, Italy

DSLR, 24-70mm lens at 43mm, 15 secs f14, raw, ISO 100, tripod

o film weight and bulk are eliminated

o no X-ray hassles at the airport or other security-screening points

o you can match the image file size to output requirements, eg print or email

o you can compose close-ups effectively with a Liquid Crystal Display (LCD) screen

o images can be downloaded directly to a computer, eliminating the need for scanning

o ideal for web use, emails and business presentations

o date, time and shooting data such as shutter speed, aperture and focal length are recorded automatically

o a sound annotation feature on some cameras allows spoken notes to be recorded against images

o you can shoot in colour, black and white (B&W) or sepia from frame to frame

o prints can be made within minutes of taking the photographs

o images can be emailed or posted to a website easily

o the cost of making digital prints is comparable to making prints from negatives

o immediacy makes it a great learning tool

o you can share the images with the people you've photographed

o it's a lot of fun.

THE NOT SO GOOD

o it's easy to delete files accidentally

o computer hardware, peripherals and software need to match the photographer's output in regard to quantity of images, file size and the intended end use of the images

o computer time is required to manage digital files

o many digital cameras take time, typically one to three seconds, to power up from the off setting

o battery power needs to be diligently managed and the batteries constantly recharged

o dust on the sensor of a Digital Single Lens Reflex (DSLR) camera affects every image, and is often not noticeable until images are viewed at 100% enlargement on a computer monitor

o a digital camera may require the purchase of new lenses; lens multiplier factor (see p52) requires a re-evaluation of the lenses SLR owners have

o print size is limited by the camera's resolution.

There is, of course, a lot more to know about digital image capture, especially if you're in the market for a new camera. You don't have to be a tech head to understand the technology. However, to ensure you get the right camera for your creative goals there are a few basic concepts and lots of jargon to get your head around. Understanding the different types of digital cameras and their host of features and functions will help you to make the right choice.

SENSORS, PIXELS & RESOLUTION

At the heart of a digital camera is the image sensor, which takes the place of film. The size and quality of the sensor are key variables that affect the price of the camera, the maximum print size possible and the underlying characteristics of the digital image file produced, in terms of colour and sharpness. The sensor converts light into numerical data so that it can be processed, stored and retrieved using computer language. Various sensors are manufactured, but the most common in digital cameras are the CCD (Charge Coupled Device) and the CMOS (Complementary Metal Oxide Semiconductor). Essentially, sensors are semiconductor chips made up of a grid of tiny light-sensitive cells called photodiodes. Because photodiodes are monochromatic devices, a coloured filter is placed over the sensor to enable colour to be recorded. When light hits the photodiode an electrical charge is generated. Each photodiode records the brightness and colour of the light and generates a corresponding pixel that is placed in a grid. The number of pixels in the grid determines the amount of information recorded. The degree to which this information displays detail, sharpness and colour accuracy is described as resolution. High-resolution images are made from millions of pixels that allow fine detail, sharpness and accurate colour to be recorded. Low-resolution images are made from fewer pixels and therefore cannot reproduce all of the data originally captured.

A camera's resolution is determined by multiplying the number of photodiodes on the vertical and horizontal axis of the sensor. This equation usually results in a total pixel count in the millions and is described in megapixels (MP). One million pixels equal a megapixel. For example, a camera with a sensor containing 3916 x 2634 pixels has a pixel count of 10,314,744 and is described as a 10.3 MP camera. This number is usually displayed on the camera body and is an initial indicator of price, as well as the image quality and maximum print size that the camera can be expected to produce. However, it's only an initial indicator. It's important to understand that cameras can't be compared on pixel count alone. The actual quality of the information recorded in the image file is affected by manufacturing variables including the build quality and physical size of the sensor; the quality, size and spacing of the actual pixels; the way the data is processed by the camera's image processor; and the quality of the lens and the image stabilisation technology (see p35). In other words, all equivalent megapixel cameras are not exactly the same.

SENSOR CHARACTERISTICS & SIZE

Unlike film – which can be changed to suit the lighting conditions, the subject and the photographer's creative intentions – the image sensor is built into the camera. Consequently, the inherent characteristics of the sensor will be

imparted onto the image files. The integral look of the file does vary from sensor to sensor, although varying degrees of customisation are possible with advanced cameras. This is particularly evident when comparing compact cameras with DSLRs because of the latter's much larger photodiodes. Manufacturers determine how they feel an image looks best through variations in colour balance, saturation levels, automatic white balance and sharpness. The sensor's inherent characteristics should be an important consideration when buying a camera – you will need to override the settings or adjust the image with editing software if you want to change them. Look for the differences when comparing cameras in a shop, especially if the salesperson is making prints for you. You can also check out technical reviews on websites that have tested sensor characteristics and provide information on colour rendition.

You'll notice a discrepancy in a camera's technical specifications between sensor resolution and image resolution, sometimes described as effective pixels. This is because part of the sensor is masked with black dye as a reference point for establishing an accurate black level. Part of the sensor may also be required for other functions such as recording time and date. It's the number of effective pixels that matters.

Sensor size is an important contributor to digital image quality and generally speaking, bigger is better. All other things being equal, larger sensors allow the use of larger pixels, which absorb more light and should result in the capture of sharper images with more detail, less noise, wider dynamic range and smoother tonal gradation.

The main benefit of the smaller sensor sizes is that camera manufacturers can make smaller camera bodies and lenses. However, smaller sensors are limited in the number of pixels they can use and the size of those pixels. As the total pixel counts go up at each size, the size of each pixel is reduced, which also reduces the surface area that's available to receive light. Compact cameras, from simple point-and-shoot through to high-quality advanced cameras, are built with sensors that range in size from 5mm to 11mm diagonally and are described using imperial fractions such as 1/2.5in or 1/1.7in.

Sensor size also determines a lens' angle of view and lens multiplier factor (see p52).

DSLR SENSOR FORMATS

There are currently four commonly used DSLR sensor sizes measuring between 22mm and 44mm diagonally, described using either imperial fractions such as 4/3in or metric such as 22.2 x 14.8mm. Just to confuse things even further, their size is also designated as either Four Thirds, APS-C, 35mm or 6 x 4.5cm.

FOUR THIRDS FORMAT

The Four Thirds format, originally created by Olympus and Kodak and since joined by Panasonic, Leica and Sigma, is an 'open' format for DSLRs that allows cameras and lenses from different manufacturers to be interchangeable. The sensor is 18 x 13.5mm (22.5mm diagonally), making it larger than those found in digital compact cameras but smaller than the APS-C sensor used in many DSLR cameras. Four Third format cameras have a lens multiplication factor of 2x, dou-

bling the focal length of lenses based on the 35mm film format (see p73).

APS-C FORMAT

Although Advanced Photo System (APS) film cameras were swept away with the proliferation of digital compact cameras, they have given their name to the most common DSLR sensor format, the APS-C, as the imaging area is around the same size as the APS films' Classic frame size of 25.1 x 16.7mm. To add yet more complexity to the sensor size issue, the APS-C format is not a uniform size. Nikon's 'DX' sensor measures 23.7 x 15.7mm, Sony's APS-C measures 21.5 x 14.4mm, and different Canon models come with different-sized APS-C sensors, including 22.2 x 14.8mm and 28.7 x 19.1mm. Pixel counts range from 8 MP to 15 MP.

35MM FORMAT

Commonly known as full-frame sensors, because they're the same size as a 35mm film frame (24 x 36mm), these sensors offer pixel counts between 12 MP and 25 MP but are only used in a small number of high-end cameras. As well as offering the highest-resolution files, the full-frame-sensor cameras allow photographers to avoid the lens multiplier factor, achieve slightly shallower depth of field (see p159) and enjoy larger, brighter viewfinders. On the other hand the camera bodies are more expensive, bulkier and heavier than APS-C cameras, and the large image files mean more or higher-capacity memory cards and more computer hard-drive space are required (see p93).

6 X 4.5CM FORMAT

Medium- or 6 x 4.5cm format sensors are loosely based on the film size of the popular medium-format camera that uses roll film known as 120. The most commonly used sensors are made by Kodak and are approximately 36 x 48mm and offer pixel counts of 22 MP, 39 MP and 50 MP.

ISO SENSITIVITY

Image sensors, like film, are light sensitive. Unlike film, which has its sensitivity predetermined and requires the entire roll to be exposed at the same ISO setting, a sensor's ISO sensitivity can be electronically varied from shot to shot to suit the lighting situation or the creative intent of the photographer. As the ISO setting is increased the sensor becomes more sensitive to light. The settings are described as ISO equivalents, allowing the photographer to understand the sensor's sensitivity by relating it to the familiar ISO rating of film (see p76).

OTHER FORMATS

There have been some interesting developments that extended the range of sensor formats, including Leica's 30 x 45mm sensor, which is 56% larger than the full-frame 35mm sensor and has a pixel count of 37.5 MP, and sits nicely between the full-frame and medium-format sensors.

Most compact cameras offer a small range of ISO-equivalent options or automatically alter the setting to suit the conditions, typically offering 100, 200, 400 and 800 ISO equivalents. More advanced compact and DSLR cameras extend the range to offer lower (25, 50, 64 and 80) and higher (800, 1600, 3200 and 6400) ISO

equivalents. Some cameras restrict the file size or image quality to small or lower resolution images with 800 or higher ISO settings. The best-quality images are made at the lowest ISO equivalent setting, and ISO 100 or 200 is a good standard setting for general travel photography.

NOISE

Noise is the digital equivalent of film grain but not as attractive. It appears in two forms, colour and luminance. You'll rarely see noise in quality cameras when the sensor's ISO rating is set at the standard, or lowest, setting, typically ISO 100. Noise becomes more apparent as the sensor's ISO setting increases, with longer exposures and as the temperature of the sensor increases. It is commonly seen when high ISO settings are used in low-light conditions because the sensor can't record the available light. This results in interference during the conversion of data to pixels, and gaps will appear, which the

processor fills with white or coloured pixels (error pixels) and termed 'colour noise'. Luminance noise is an electronic grain that appears as a speckled pattern in very noisy images.

Larger sensors produce less noise across the ISO range and allow higher ISO settings to be used before noise becomes visible. It is often most noticeable in shadow areas. You can use this fact to test the quality of the sensor when buying a camera: take pictures with your preferred cameras at their highest ISO setting in low light levels using exposures of at least five seconds, and compare the results.

COMPRESSION

The creation of high-quality digital images requires the capture and storage of a lot of information, often resulting in large image files that use up a lot of space on storage devices. In order to maximise memory-card storage capacity, image files are reduced in size through a mathematical process known as compression. Images can be compressed using lossless or lossy compression routines. Both systems reduce image files by discarding some of the data. Lossless compression doesn't reduce the file size as much as lossy compression, so less space is saved, but, as the name suggests, there is no loss of image quality. When the file is restored back to its original size in image-editing software, all of the information captured in the image is visible. Lossy compression allows the files to be reduced in varying degrees, discarding more and more data as compression is increased. When the file is decom-

Band performing at Wanch, Wan Chai, Hong Kong, China
In this tiny bar I preferred to use what little light there was rather than fire my flash at the band from such close range. The high ISO setting has resulted in quite noticeable noise, but like film grain it adds to the atmosphere in this kind of shot.
DRangefinder, 21mm lens, 1/20 f2.8, raw, ISO 640

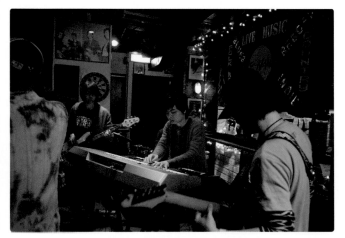

pressed the discarded data is added back in to the file through a process known as interpolation. This can cause image quality to deteriorate, especially when high levels of compression have been applied. It's also important to understand that each time an image is compressed using a lossy compression process, more data is lost.

FILE FORMATS

The data captured by a camera to create a digital image is stored in a file format that can be retrieved and processed using photo-editing software. There are many file-format options but the most com-monly used in digital image capture are JPEG (Joint Photographic Experts Group), TIFF (Tagged Image File Format), raw and Adobe DNG (Digital Negative format).

JPEG

Most digital cameras use the industry standard JPEG file format and compression routine. JPEG files are compressed using lossy compression that offers quick in-camera processing and allows large numbers of images to be stored on memory cards. Most entry-level compacts only provide one 'resolution' or 'quality' setting. Better-quality models provide separate 'resolution' and 'quality' settings; 'resolution' adjusts the size

You can reduce the effects of noise using tools provided in image-editing applications, or use dedicated anti-noise programs such as Picture-Code's Noise Ninja or Imagenomic's Noiseware.

RAW OR JPEG OR BOTH?

If your camera gives you the choice of shooting in JPEG or raw, consider how you intend to use your photos. Shoot JPEG if:
- you don't want to spend time enhancing your images in image-editing software
- the pictures are for personal use in photo albums and to share on websites
- you want to get as many photos on the memory card as possible.

Shoot raw if:
- you want the best possible results from your camera
- you're willing to spend considerable time working with your files on the computer
- you have any ambition to exhibit, sell, publish or place your images with a photo library
- you intend to print images larger than 20.3cm x 25.4cm (8in x 10in).

Shoot both
Some cameras offer the option to capture raw and JPEG files simultaneously. As camera processing software becomes faster and memory cards cheaper, this option is becoming quite viable. It allows you to organise and edit your images quickly and easily in any image-editing software using the JPEG files, as well as keeping open the option to process in raw your best images or those that could use some serious postcapture help to look their best.

of the pixel array, while 'quality' sets the level of JPEG compression. The degree of compression can be varied through a camera control or menu option usually labelled 'Image Quality'. This option allows images to be stored in a range of file sizes or compression levels usually described as Low, Medium and High. The highest-resolution files are compressed the least. The smallest files are heavily compressed. The greater the compression the lower the quality of the image file (see p26).

TIFF

TIFF is an industry-standard file format commonly used for storing images intended for print publishing. Some advanced compacts and DSLR cameras offer TIFF storage as the highest-quality option. TIFF files are usually uncompressed and are subjected to extensive postcapture processing. Consequently,

they quickly use up space on a memory card and take longer to save, increasing the delay between shots.

RAW

If you want to get the absolute best results from your digital camera, capture your images using the raw file format, an option available on advanced compacts and DSLR cameras. Often described as a digital negative, it's the format preferred by professional photographers. Raw files are not processed by the camera's software, which compresses the data and makes adjustments that are embedded irremovably in the image file. Instead, raw files are compressed using a lossless process, so they retain all the information originally captured but are saved to the memory card quickly. Adjustments such as white balance, exposure, contrast, saturation and sharpness are made by the photographer after the image has been

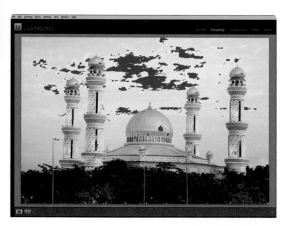 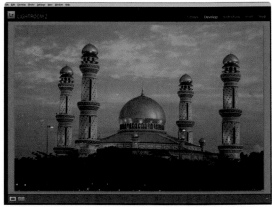

This example illustrates the extra tonal information available when you capture raw data. The JPEG on the left displays the clipping warning (see p151), the red pixels in part of the sky, and indicates that nothing can be done to increase the amount of detail in the highlights. The in-camera image processing has fixed the tonal range in the image. The right-hand image shows the same shot captured in raw and then adjusted using the tonal controls in image-editing software to reveal the highlight detail in the clouds that is lost in the JPEG. See p328 for information on image-editing techniques.

downloaded to a computer. Creative decisions can then be tailored to each image using the much greater functionality of image-editing software.

Shooting raw files requires a considerable amount of postcapture computer time and more than a basic understanding of image-editing software. Raw files must be processed or converted before they can be opened in photo-editing programs. Cameras with raw file capture are sold with proprietary software for that purpose. Alternatively, you can use a third-party specialist raw-conversion program or one that is included in your image-editing software (see p97). Your investment in time and equipment will be rewarded with digital files and prints that maximise the capabilities of your camera.

DNG

Just about every camera capable of capturing raw files uses a different proprietary format. The differences aren't just between different manufacturers: nearly every Canon and Nikon camera uses a different format to the others in their range. Consequently, third-party software providers have to figure out how all new software works and then release updates for their own raw-file converters. The Digital Negative file format is a raw image format designed by Adobe Systems (the makers of Photoshop) in an attempt to create an 'open' standard raw file format that would be adopted by camera and software manufacturers in their products, either as the main raw file format or offered as an alternative to the propriety

THE DNG DEBATE

There is considerable debate around the DNG concept on internet forums, so check them out and form your own opinion. If you think it's a good idea you can even sign a petition in support at www.petitiononline.com/dng01/petition.html.

file. DNG is supported by many image-editing programs and is being offered by some camera manufacturers including Hasselblad, Leica, Samsung and Ricoh.

The main argument for the DNG standard is one of image security. The propriety raw-file converters are specific to hardware manufacturers, which may or may not support the software in years to come, with the risk that files will become unreadable. DNG aims to guard against obsolescence by offering future support, as much as that can be guaranteed.

Even if you can't or don't capture raw files in the DNG format, it is possible to archive your raw files to the format. For maximum future flexibility (and protection) you can also embed a copy of the original raw data into the DNG file. The Adobe DNG Converter, which converts raw files from any camera that is supported by Adobe's Camera Raw image converter (see p98), is available for free at www.adobe.co.uk. Of course this adds another step to the process involving more time at the computer, and the resulting files demand considerable storage capacity.

IMAGE QUALITY & FILE SIZE

Even if you intend to set your digital camera on Auto-everything, you should still take the time to understand and control the Image Quality or File Size setting. Selecting the correct image-quality setting at the point of capture is critical to what you can do with the image file post-capture and is particularly important in relation to printing options. Additionally, your choice will determine how many photographs can be stored on your memory card.

On all cameras, small or low-resolution files allow the maximum number of images to be stored and are ideal for emailing and web use. However, they are unsuitable for printing. Fewer high-resolution images or large files can be stored on a memory card, but these allow the largest photo-quality prints to be made. The maximum size of the print is primarily determined by

> If you are intending primarily to make postcard-sized prints of your digital image files, it makes a lot of sense to consider the camera's aspect ratio as one of the important factors in deciding which camera to buy.

the number of pixels captured by the camera. For example, bigger prints can generally be made from the biggest file size on a 10 MP camera than from the biggest file size on a 6 MP camera. Remember also that variables other than pixel count determine image quality (see p23). General photo techniques, including the ISO, aperture and shutter speed combination, play their usual role in attaining a quality image.

Knowing exactly how the images are to be used means you can select the 'quality' setting with confidence. This decision can be made image by image. However, it is highly recommended that you shoot at the highest-quality setting your camera allows. Large files can always be made smaller for email or web use through image-editing software, but enlarging small files creates unsatisfactory results. See the print-size table on p340.

ASPECT RATIO

Aspect ratio is the relationship of the width of an image to its height. Digital cameras produce images in one of two common aspect ratios: 3:2 and 4:3. The first number represents the width of the image, the second the height, in inches. Most compact cameras, Four Third cameras and micro Four Third cameras have sensors with an aspect ratio of 4:3. The APS-C type sensors used in most DSLRs have an aspect ratio of 3:2. Some digital cameras offer multiple aspect ratios as a

creative option via the camera's menu. Apart from the fact that you may prefer the look of a more rectangular image (3:2) over the squarer image (4:3) it's important to understand the impact aspect ratio has on printing images.

Printing paper comes in fixed sizes with their own aspect ratios. If the aspect ratio of your image doesn't match that of the paper then the image will have to be cropped or printed within the dimensions of the paper, which will give you an odd-sized border

around the photo. If you're doing your own printing you'll be able to make that decision to suit the image or your personal preference. If you're leaving it in the hands of someone else or letting the desktop printer decide automatically, you may lose important subject matter. (See p339 for more information on printing your images.)

In practice, this means that photos taken on a camera with a 3:2 sensor will not be cropped when printed as 10cm x 15cm (4in x 6in) prints. However, if you want to make standard 13cm x 18cm (5in x 7in) or 20cm x 25cm (8in x 10in) enlargements you will have to crop your image. In fact, you'll lose 5cm of your original image when you make an 20cm x 25cm print. If you use a camera with a 4:3 sensor all your images will be cropped when you make 10cm x 15cm prints, but you'll be able to make 13cm x 18cm and 20cm x 25cm prints with very little loss of your original composition.

MEMORY CARDS

Digital cameras store images on removable, reusable flash memory cards. Sometimes referred to as digital film, flash memory cards are available in various formats, storage capacities, qualities and prices. Even though things can go wrong (see p107), they are reassuringly robust. According to the CompactFlash Association, a properly manufactured and adequately cared for CompactFlash card will perform for over 100 years of normal use with no loss of data. Leaving images on the cards is also considered very safe, with no known deterioration. Equally comforting is the knowledge that flash memory is not affected by walk-through metal detectors, hand-held metal detector wands or X-ray scanners, including the powerful CT scanners used for check-in baggage.

FORMATS

The memory-card format that a camera uses is determined at the manufacturing stage. Most cameras have a single memory-card slot built into the camera body, but there are models that have slots for two different cards. The memory-card slot is compatible with one type of memory-card format. The most common formats are Secure Digital (SD), Secure Digital High Capacity (SDHC), Secure Digital Extra High Capacity (SDXC), Memory Stick (MS) and CompactFlash (CF). The newest format on the block is XQD, developed for high-end cameras and camcorders. The cards offer the fastest write-speed performance to complement the increasing number of high-resolution frames that the latest cameras can capture per second and in ex-

If you want to use high-capacity cards over 8 GB, check your camera manual to confirm that your camera is compatible, particularly if it was made before 2011.

FAKE MEMORY CARDS

There is quite an industry in counterfeit or fake memory cards. These cards are inferior in quality, offer less capacity than the labelling suggests and lack warranties. Many are sold on eBay, where the relabelling and repacking is hard to detect until it's too late. Risking your images to save a few extra dollars, or even a couple of hundred dollars, is just not worth it. Buy from a reputable dealer and allow time to test and rectify any problems you encounter.

tended bursts. The format is not backward compatible, so can only be used in cameras designed to support the format.

STORAGE CAPACITY

The storage capacity of memory cards is described in gigabytes (GB). Cards are available in a range of capacities including 2, 4, 8, 16, 32, 64 and 128 GB. Not all formats are available in every size. The actual number of images that can be stored on a memory card varies depending on the image quality (compression level) or file size selected, the content and complexity of the image, and specification differences from camera to camera. Greater storage capacity equals higher price.

QUALITY & PRICE

Memory cards are manufactured with varying component quality and technical specifications to suit different user budgets and needs. The more expensive cards in each brand range are made from higher-quality components backed by a lifetime guarantee. They also offer faster read and write speeds (write speed determines how fast the image is recorded onto the card; read speed determines how quickly the image can be reviewed on the LCD screen). These are important factors in ensuring that the camera is ready as quickly as possible to capture the next image. However, the speed at which data is transferred is mainly determined by a

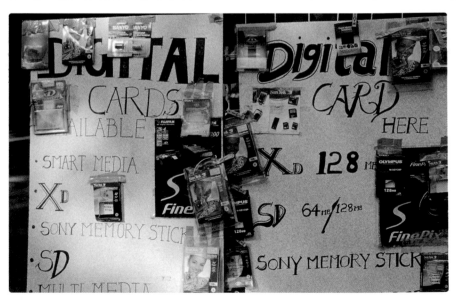

Memory cards for sale, Pinnewala, Sri Lanka
Although memory cards are readily available at most tourist destinations, it's recommended that you buy and test what you think you'll need before you leave home. Although cards are a very robust media it's best to avoid having to buy products that may not have been stored properly, like those on this board displayed outside a shop on a dusty road in full sun.
DSLR, 24-70mm lens at 70mm, 1/125 f8, raw, ISO 100

camera's internal processing system and software, so make sure that your camera is able to take advantage of the technology before you spend extra money. If your camera can keep up, fast write speeds are particularly useful for shooting action and for video capture. Additionally, the highest-priced cards are guaranteed to work in extreme low and high temperatures and to withstand the rigours that professional camera equipment is often put through.

FIRMWARE

There is a lot of sophisticated technology in a digital camera and it's all run by micro-processors, which are controlled by a computer program known as firmware. Like computer software, the firmware in many cameras can be upgraded in order to add new features and improve performance (which includes correcting problems discovered after the camera was released).

To update, download the installer from the camera manufacturer's website to a computer hard drive and then connect the computer to the camera via a USB cable, or transfer the installer to a memory card and run it from inside the camera.

Firmware upgrades are specific to each camera model, so take extra care to ensure you are downloading the correct version for your camera. A camera made for the European market may not be able to work with a firmware update for the same model made for the US or Asian markets.

DIGITAL CAMERA FEATURES

Users of film cameras will recognise many of the features built into digital cameras, such as different exposure modes, spot metering, flash options, subject modes, exposure compensation, auto bracketing and depth-of-field preview. However, there are a whole load of features that are unique to digital image capture.

AC POWER CONNECTOR

Cameras with an AC socket can be connected to the mains electricity. This allows batteries to be recharged in the camera, and for domestic power to be used when the camera is connected to the computer, minimising the possibility of disruption during image transfer or firmware updates.

BUFFER MEMORY

Digital cameras have built-in, or buffer, memory, where the raw data is processed into the final image file, after which it is written to the memory card. The amount of memory determines how many shots can be taken in burst mode before the images have to be processed.

33

The EXIF camera data and histogram are displayed alongside the image in most imaging applications. These provide all the information you need to see what you did right or wrong at the moment you took the photo.

BURST MODE

To help overcome the delay between shots as the camera processes the image file, most cameras have a Burst mode or Continuous Shooting mode, which allows the camera to take several pictures continuously. It varies from camera to camera, but on advanced compacts a typical burst produces two to three shots per second, with a maximum of six or seven shots in one burst. To achieve this, images are either captured at a lower resolution or, preferably, high-res images are stored in the camera's buffer memory and processed at the end of the burst. The mode is useful for action shots and any moving subject. It's also handy for portraits, where facial expressions change quickly. Remember, the camera has to process the files at some point – plan ahead so that it's not writing to the memory card at the high point of the action.

EXIF METADATA

Many cameras use the Exchangeable Image Format (EXIF) to record and store information about each photo as it's taken. Shooting data such as date, time, shutter speed, aperture, focal length (even when using zoom lenses), image-quality setting, image size and file format is recorded automatically. This metadata is attached to the image file and can usually be reviewed on the LCD screen alongside the image. The data is also visible in most image-editing programs, browser programs and workflow programs. Being able to see this information alongside of the image is a great learning tool and beats taking notes.

FACE RECOGNITION

Face Detection AF (Auto Focus), recognises the presence of human faces in a composition and adjusts the focus accordingly. Smile detection works with face detection to make sure your subjects are always smiling!

HISTOGRAMS

A histogram is a graphic representation of the distribution of pixels in an image, showing their relative weighting in the shadow, midtone and highlight areas. The histogram can be viewed on the LCD screen after the picture has been taken, or in the viewfind-

er of a bridge camera. It is also displayed when the image is opened in most image-editing programs, browser programs and workflow programs. See p151 for information on understanding histograms.

IMAGE REVIEW

Image review, or playback, is available in various formats. Images can be viewed individually; as a series of tiny images, usually called thumbnails or index display; or as a slide show, where the pictures are displayed one after the other for a few seconds each. Images can also be magnified for a closer look at details such as facial expressions and to confirm sharpness, using a feature called playback zoom. The degree of magnification varies from model to model but all cameras let you move about the display to view different areas of the image using a four-way controller.

When reviewing images to decide which ones to delete, always use the magnification or playback zoom function to confirm that the image is in focus. Assessing how well focused, or how sharp, an image is on an LCD screen takes time and practice. Even with powerful magnification review tools, it's impossible on a 3in screen to be absolutely positive of critical sharpness. If in doubt, don't delete. Wait until you can analyse the image properly on a computer monitor.

IMAGE STABILISATION

Most compacts offer image stabilisation technology, which reduces the impact of camera shake by the photographer, thus improving the sharpness of the image. This result is achieved through either op-

tical stabilisation, which uses a floating lens element connected to a tiny gyroscope, or a system that moves the camera's sensor to compensate for the movement. Optical stabilisation is considered to produce the best results (see p51).

LIQUID CRYSTAL DISPLAY (LCD) SCREEN

Digital cameras have an LCD screen on the back of the body for reviewing the images. On many compact cameras it replaces the optical viewfinder as the means of composing images. The LCD also gives access to control menus and camera settings. LCD screen size varies from camera to camera: most are between 2.7in and 3in, measured diagonally. Generally, larger screens make viewing more comfortable. Some screens are more viewable in bright light than others – check the performance of an LCD screen in different lighting conditions. Some cameras also offer a brightness control for the LCD. The brighter the setting, the more battery power is used. If your compact camera has an optical viewfinder it's much better to get into the habit of composing images through this rather than with the LCD screen. The screen can be hard to see in bright sunlight. More importantly, it's a major drain on battery power. However, most viewfinders typically show between 80% and 90% of the field of view, so there are occasions when composing with the screen is recommended, as the screen displays the same view as the lens. Use it for accurate framing generally and especially when your subject is less than 1m away. It's also necessary to use the screen when taking pictures with

The absolute sharpness of raw files cannot be judged on the camera's LCD screen because you're looking at a JPEG version of the image produced for instant review only. It's worth going into the camera's menu and adding some sharpening to the JPEG image so that you can at least get a sense of whether the image is in or out of focus.

CHIMPING

If you check (or admire) every photo you take on the camera's LCD screen immediately after capture, then you're 'chimping'. This is not a criticism, but it's a habit that's best avoided. Concentrate on shooting and review later. Most cameras take one or two seconds for the image to appear on the screen – while you're waiting and then looking at the photo you just took, you may miss an even better shot.

SENSOR CLEANING

Some DSLR cameras have built-in sensor-cleaning systems that vibrate the sensor to dislodge dust. The best systems are a 'must have' feature – they save the time (and drama) of having to clean the sensor yourself, the cost of having it professionally cleaned, and hours of retouching time in front of the computer that are needed for images taken with a dirty sensor.

SOUND ANNOTATION

Some cameras have built-in microphones to allow sound to be captured with video clips or to add brief spoken annotations to still images. Sound clips are usually limited to between five and 20 seconds. Important information can be recorded at the time of shooting, which can be useful for identifying subjects and makes captioning easier. It also means still photographers can now stand around talking to themselves, just like people with video cameras!

VIDEO MODE

A feature available on most DSLRs and all but the most basic compact cameras, Video mode allows the capture of moving images. The available clip length depends on the model; it can vary from around 15 seconds to continuous recording (limited only by the capacity of the memory card). The functionality of Video mode in digital cameras has improved continually since 2008 when Nikon and Canon released the first DSLRs capable of capturing high-definition video. This was an exciting development, not only from a practical point of view, but creatively as well. Video cameras and compact digital cameras use

a digital zoom because the effect can't be seen through an optical viewfinder.

Some LCD screens are hinged and can be flipped out and rotated. This is a very useful feature as it allows you to adjust the screen to provide the best view when shooting in bright outdoor light where a fixed screen can be hard to view. It's also an excellent tool for quick variation of viewpoints. You can easily compose pictures using a very low angle (you only have to get on your knees, not your stomach) and in crowded situations you can hold the camera up over people's heads, just like the press photographers do.

Standard on compact cameras, the option of viewing and composing images on the LCD screen is becoming available on more and more DSLRs.

small sensors that produce images with a very deep depth of field; that is, most elements of the scene appear sharp. The scene modes (see p147) on compact digital attempt to address this for capturing still images, but there is little you can do in Video mode or with a video camera. As discussed later, controlling depth of field (see p159) to achieve selective focus is one of the most powerful creative tools at the photographer's disposal, and this is retained when shooting video with a DSLR with a full-frame sensor.

If you want to shoot some serious video on your compact digital camera, look for the following specifications and features of the Video mode when choosing a camera:

o A video graphics array (VGA) with a resolution of 640 x 480 or higher.

o A frame rate over 20 frames per second (fps). Anything below 15 fps offers borderline quality and will be visibly jerky. You need about 20 fps for the clip to look as smooth as standard video footage. The smoothest, most detailed results will come from 30 fps capture.

o Continuous recording. The length of continuous recording varies from camera to camera so select a model that matches your requirements.

o Sound. Some cameras capture only video not audio. Choose a camera that captures both.

o A zoom lens that functions in video mode. This isn't the case on all cameras.

o The ability to accept high-capacity memory cards of at least 4 GB. Video recording fills memory cards fast.

With these specifications and features in your camera, follow some basic video shooting techniques (see p200) and you'll be able to produce technically excellent and watchable videos without sacrificing the quality of your still images.

VIDEO OUT

Cameras with a 'video out' socket can be connected directly to a TV. Images can then be viewed on a large screen using the camera's review mode.

COLOUR & CREATIVE CONTROLS

Most digital cameras suitable for serious photography have a range of colour and creative controls that can be applied to suit the photographer's preferences. Less-sophisticated cameras often offer a choice of three presets, while higher-end cameras offer sliding scales for precise adjustment. If you're going to print straight from the memory card you may want to experiment with these controls. If you're going to upload the images to a computer it's advisable to leave most of the options in the auto or off position. With the exception of capturing images in raw (see p28), the results of the settings you choose can't be altered once they are recorded in the

image file. Additionally, image-editing software offers more options and finer tuning than is possible in the camera. Requiring the camera to perform additional processing tasks also adds to the delay between shots and uses battery power.

Standard compact digital cameras allow basic colour selection options such as colour, B&W or sepia. Advanced cameras may also offer control over colour space, contrast, sharpness and colour saturation. All cameras have white balance control, but in entry level models no adjustments can be made.

Unless you are taking images solely for display on a computer monitor or the web, capture your image files in the Adobe RGB colour space.

COLOUR GAMUT

A colour gamut is a range of colours. There can be wide gamuts with lots of colours, or narrow gamuts with fewer colours. Gamuts can also favour warm colours, cool colours or be neutral. Each digital camera produces a slightly different colour gamut, depending on the design of the sensor and the processing algorithms. Digital cameras (and inkjet printers) cannot reproduce all the colours humans can see. They only produce a smaller subset of colours, but fortunately these subsets can still result in great-looking photos: your camera makes an exposure taking all the colours it sees, and maps them into a smaller colour gamut. If you capture raw files you retain the widest gamut of colours that your camera can record. If you save your images as JPEG or TIFF files, the camera will apply a colour space, usually sRGB or Adobe RGB, when it processes the files. During this process any colours outside the destination colour space are changed to similar colours that are inside the colour space.

COLOUR SPACE

Colour space refers to the spectrum of colours that are available to create the image. Most digital cameras use the Red Green Blue colour space, known as RGB. This is predetermined by the manufacturer and is of little interest to compact-camera users. All DSLRs offer alternative colour spaces including Adobe RGB (1998) and sRGB. Although these don't cover as large a visible spectrum as the eye can see, they offer a broader colour range for the photographer to work with.

COLOUR TEMPERATURE & WHITE BALANCE

The colour of light changes throughout the day as the sun follows its course. On a clear day early morning and late afternoon light is warm. As the sun gets higher the colour of daylight becomes cooler and more neutral. If heavy cloud blocks the sun, the light will be even cooler and photographs can have a bluish cast. These changes in colour are recorded as colour temperature, which is measured in degrees Kelvin. (The colour temperature of direct sunlight is around 5000 degrees Kelvin.) Just as our eyes and brain adjust to compensate for the changing colour temperatures so does the digital camera, using the automatic white-balance function to ensure that white is recorded as white under all lighting conditions.

The auto function works well in most situations, but to ensure optimum colour many cameras also have a range of presets for shooting under a range of conditions that typically include tungsten, fluorescent,

cloudy and shady. Advanced cameras may have several settings for balancing the different types of fluorescent light and 'sunset' and 'flash' presets. Many of the more expensive models include a 'custom' or 'one-touch' setting that lets the photographer measure the colour of the ambient light and apply a suitable correction.

There will be times when you want to take control of the white balance. The impact of shooting early or late in the day to capture subjects transformed by a yellow-orange glow, or just after dusk when the world can be bathed in a soft pink light, will be lost if the camera neutralises the colour temperature. To capture the actual colours in such situations select the 'daylight' or 'neutral' white balance preset.

If you're saving your images as JPEGs it's important to get the white balance right in-camera because it's harder to change satisfactorily in the computer. The more inaccurate the setting the more difficult it is to change. If you're capturing images as raw files you can leave the white-balance setting on auto and set it with great precision when you open the file in the raw conversion software on your computer. (See p150 for more details on shooting raw files.)

CONTRAST CONTROL

Contrast refers to the difference between the lightest and darkest parts of the image. The contrast control allows the photographer to change the number of intermediate tones between the darkest shadows and brightest highlights recorded. A high-contrast image has a greater number of black and white pixels than an image

with normal contrast. One problem with compact cameras is their limited dynamic range, or range of light levels that the sensor is able to record. This can result in blown-out, or overexposed, highlights and blocked-up, or underexposed, shadows in photographs taken in bright outdoor light. The dynamic range can be extended slightly by reducing the contrast setting. Varying the contrast in the camera is only recommended if images are to be viewed on a monitor or printed directly from the memory card; otherwise, it's better to adjust the contrast using image-editing software.

SATURATION CONTROL

Colour can be set to look natural or with varying degrees of saturation. Selecting the saturated setting on a standard compact camera increases the strength of colour in the image. Many compact digital cameras have inherently high saturation settings, which can be brought back to a more normal level by lowering the Saturation Control. More advanced cameras allow more precise variation in saturation.

SHARPENING CONTROL

Images can be made to appear sharper or softer through the use of a filter that increases or decreases the contrast between objects in the image. If used to excess, the sharpening control can produce white or black lines along edges of high contrast. This degrades picture quality. Its use is only recommended if images are to be viewed on a monitor or printed directly from the memory card.

THE GEAR

Choice of equipment is important. It's the first building block in a series of creative decisions that will lead to you capturing images that reflect your personal photographic vision. A good photographer can take good pictures of any subject on any camera with any lens; however, matching your gear to the kinds of shots you want to take and the kind of travel you prefer makes photography more enjoyable and productive. You can expect to be out and about for many hours at a time, sightseeing, walking, climbing steps, getting in and out of vehicles...all the time watching and waiting for that great shot, so unless you have very specific aims that demand a truckload of specialist equipment, keep your gear to a minimum. A bag with a couple of camera bodies and three lenses might not feel particularly heavy when you pick it up at home to put it in the car, but after a couple of hours on your shoulder it can become so burdensome that it acts as a real disincentive to walk an extra kilometre or climb those extra steps. Your gear shouldn't be a reason for not going to places and getting the shots you bought it for in the first place.

Hornbill festival, Kisama, India

DSLR, 70-200mm lens at 200mm, 1/250 f2.8, raw, ISO 125

When you're out taking photos, aim to fit everything you need comfortably into a small to medium-sized shoulder or sling bag that allows quick access and doesn't cause you to walk around with an obvious lean. Other gear can be taken on the journey for specific shots but left in the hotel room until required. A tripod, for example, is useful for capturing some images, but there is no need to carry it around with you all day.

Until you've made several trips and are confident anticipating your needs, what you actually take will have to be a compromise between what you think you need, what you can afford, and how much weight you're prepared to carry. Finding the balance is the trick. Aim to keep things simple, accessible and manageable. You don't need tons of expensive gear to take great photos; you just need to know how to get the best out of the equipment you have and to use it within its limitations.

CAMERAS

Flip through the pages of camera magazines and websites and it's easy to be overwhelmed by the choice of cameras. The digital age means that models are updated or replaced at an alarming rate, with every new wave being spruiked as significantly better than the last. You just have to accept that the camera you buy will be superseded sooner rather than later. However, it's not as bad as it sounds. Technology has reached a point where the changes are no longer as regularly dramatic as they once were, and the camera you buy today will only need to be upgraded if your interest level or requirements change. Although you'll be confronted by a staggering array of cameras in all sorts of shapes, sizes, colours and prices, first you'll need to decide between the three types of digital camera that are of most interest to travellers: compact, bridge and digital single lens reflex (DSLR). Consider their advantages and disadvantages in relation to your photographic goals and travel style. Within these categories cameras are made to suit every budget and requirement level and can be broken down into entry level, midrange, advanced and professional.

COMPACT DIGITAL CAMERAS

Compact digital cameras, also known as digicams or point-and-shoot, are ideal for taking photos with a minimum of fuss – perfect if you want to travel light. It is this category that is especially mind-boggling and sees the most new camera releases. The small sensors and fixed lenses mean that manufacturers can be more creative with their designs, so there are very small and thin cameras in the range. If all you require is a record of your trip to be viewed on a computer or printed as postcard-sized (10cm x 15cm; 4in x 6in) prints for an album, a fully automatic, 12 MP compact digital camera will easily do the job. Compact camera sensor sizes range from 10 MP to 16 MP.

ADVANTAGES

o ease of use

o models are available to suit all budgets

o no accessories are required

o image sensors range: 10 MP to 16 MP

o the majority of cameras have a fully automatic mode, a built-in flash and a zoom lens

o most cameras accept a removable and reusable memory card

o most models have at least three image-quality settings

o small, light and easily carried in a pocket or a small bag

o underwater housing is available for many models

o weatherproof and waterproof models are available

The prices given in this section should be regarded as a guide only and are not a substitute for your own careful, up-to-date research. A year is a long time in the digital photography business, and prices, features and performance of all products are changing rapidly. You should get opinions, quotes and advice from a number of places before you part with your hard-earned cash.

o wide range of sizes and styles

o quiet shutter

o video mode

o retractable lens models are compact

o fixed lens eliminates the problem of sensor dust

o useful as a second or backup camera for DSLR users.

DISADVANTAGES

o lower battery capacity; battery power must be managed and batteries regularly charged to ensure the camera is always ready to go

o lenses cannot be changed

o cheaper models have low-quality lenses

o some cameras restrict file size when high ISO settings are selected

o lenses produce much greater depth of field compared to a DSLR camera, which means selective focusing (throwing the background out of focus) is very difficult to achieve

o accurate framing is limited when subjects are composed through an optical viewfinder (not the lens)

o battery power is consumed when subjects are viewed via an electronic viewfinder or LCD screen

o many models don't have optical viewfinders, only LCD screens

o delay between pressing the shutter and the picture being taken, known as shutter lag

o if offered, raw file format is slow

o noticeable noise at higher ISO settings

o restricted dynamic range

o not good for fast-moving subjects

o not good for low-light photography.

ENTRY-LEVEL COMPACT DIGITAL CAMERAS

The compact digital range starts with point-and-shoot cameras that are small, light and very easy to use. They are aimed at beginners and people who want to keep picture-taking as simple as possible, so the default position on all controls and features is automatic. Sensor sizes range from 10 MP to 14 MP, which is quite sufficient to make prints up to 15cm x 20cm (6in x 8in). They often have limited zoom range and perform best in bright lighting conditions. They are prone to noise in low-light situations. Cameras in this category range between US$100 to US$200.

Common features:

o 4x optical zoom lens

o autofocus lens

o built-in flash with optional settings for red-eye reduction, fill flash, night flash and flash off

o 2.7in LCD

o preset shooting modes for portrait, landscape, action and close-up pictures

o 'quick delete' button

o 'quick review' button

o slot for removable memory card

o three image-quality settings

o scene modes

o face recognition

o image stabilisation

o video mode.

MIDRANGE COMPACT DIGITAL CAMERAS

More highly recommended is the next level of compacts with 8 MP to 16 MP sensors, and the ideal choice for holiday and family photography. They offer similar results to what was expected of film as long as the print size is restricted to less than 20cm x 25cm (8in x 10in). This category includes the ultracompact cameras that continue to push the boundaries of style and substance in the smallest package possible. Prices range from US$200 to US$500. In Automatic mode they're point-and-shoot cameras, but they have a number of features that give some control over composition and exposure.

Common features:

o 4x to 6x optical zoom lens

o autofocus lens, often with manual focus presets and macro capability to 10cm or less

o built-in flash with optional settings for red-eye reduction, fill flash, night flash and flash off

o adjustable settings for white balance, ISO and exposure compensation

o controls to adjust colour, contrast and sharpness

o focus lock

o large 3in LCD

o scene modes for portrait, landscape, action and close-up pictures

o orientation sensor to rotate vertical shots

o 'quick delete' button

o 'quick review' button

o slot for removable memory card

o three image-quality settings

o various review options

o varying levels of manual control

o face recognition

o image stabilisation

o full HD video recording.

ADVANCED COMPACT DIGITAL CAMERAS

Advanced compact digital cameras offer another step up again in terms of functionality, features, performance and image quality. If you're prepared to sacrifice the advantages of a DSLR to minimise weight and bulk, an advanced compact digital camera is the next best option. Available with 10 MP to 14 MP sensors, the best of these cameras are well built and packed with features, including high-quality fixed prime or zoom lenses; large, bright LCD screens; fast file processing; manual exposure modes; and multipoint autofocus sensors to handle off-centre subjects. Excellent print quality can be expected up to 40cm x 50cm (16in x 20in), with some manufacturers claiming that film-quality 50cm x 76cm (20in x 30in) prints are possible. Some models offer powerful 6x, 8x, 10x or 12x optical zoom lenses. If you want to capture your travels digitally and don't want to use a DSLR camera, an advanced compact is highly recommended. Advanced compacts range in price from US$500 to US$1500.

Common features:

o 4x to 7x optical zoom

o optical viewfinder with adjustable viewfinder diopter

o JPEG, TIFF and raw file capture

o accept high-capacity memory cards

o burst mode

o controls to adjust colour, contrast and sharpness

o large 3in LCD

o excellent build and component quality

o excellent-quality lens

o focus and exposure lock for accurate focusing and exposure of the subject

o hot shoe for external flash

o image-file data display

o increased ISO range

o increased white-balance options

o manual exposure modes

o multipoint autofocus sensors to handle off-centre subjects

o self-timer

o clip-on conversion lenses and filters

o sound annotation

o full HD video recording

o image stabilisation

o face recognition

o flash exposure adjustment.

BRIDGE CAMERAS

Looking like small DSLRs, bridge cameras, also known as Superzooms, Electronic Viewfinder (EVF) or 'all in one' cameras, sit between compact and DSLRs in terms of style and size. They feature an electronic viewfinder, which gives a live view of the scene (in the same way a video camera does) and is the same image seen on the LCD. They have a fixed but powerful zoom lens made possible by the use of a sensor the size of a compact camera's. After a photo is taken, the data display and the instant review image are shown in the viewfinder (as well as the LCD screen), so you don't need to take the camera from your eye to see the shot you've just taken. The best Superzooms have feature sets that rival mid-range DSLRs.

On the downside there is a slight lag between reality and the view in the finder or on screen. The EVF and LCD have low resolutions, so the images they display lack clarity and detail, particularly in highlight areas and in low light. When it's dark the viewfinder is also dark; focusing manually can be difficult; the cheaper models display poor-quality colour, which is distracting when composing; they can white-out or get filled with vertical white streaks when taking backlit shots; and they use a lot of power. The quality of the EVF and the LCD vary considerably between cameras, so check these out carefully. Cameras in this category have 12 MP to 16 MP sensors and range in price from US$200 to US$850. They may appeal to people who are considering a DSLR but like the more compact package and aren't interested in extending their kit with additional lenses.

Advantages

o advanced feature sets similar to mid-range DSLRs

o fixed lens eliminates the problem of sensor dust

o compact and light compared to DSLRs

o manual controls

o 12x to 30x optical zoom

o accurate framing of close-up subjects

o option of viewing and reviewing via the electronic viewfinder or the LCD screen

- live view
- digital preview shows 100% of the image as it will be captured
- full HD video recording.

Disadvantages

- same sensor size as used in digital compacts, so susceptible to more noise and offering less control of depth of field than DSLR sensors
- no interchangeable lenses
- small ISO range
- no optical viewfinder
- limited system expansion options
- EVF and LCD screens are low resolution
- difficult to focus manually
- high drain on batteries
- risk of increased digital noise due to heating of sensor through continuous use of the LCD screen and the EVF.

COMPACT SYSTEM CAMERAS

Compact System Cameras or Mirrorless Interchangeable Lens Cameras (MILC) is a new camera category that has grown rapidly since the launch in 2008 of the Micro Four Third camera range developed jointly by Olympus and Panasonic. Interest inw this category really took off in 2011–12 as new camera systems from Nikon, Olympus, Pentax, Fujifilm, Ricoh, Sony and Samsung were released. These camera systems have filled the gap between compact cameras and DSLRs by combining the best features of both categories, namely APS-C sensors (found in the majority of DSLRs) and interchangeable lens systems, to produce excellent image quality in two compact design styles reminiscent of the traditional rangefinder camera or small DSLRs. Unlike the DSLRs they are styled after, compact system cameras don't have an optical viewfinder; they have an electronic viewfinder as found in the Superzoom bridge cameras. Those styled on the rangefinder design use the rear LCD screen for composing images as is common with compact cameras. These cameras will appeal to people who always wanted the flexibility to choose different lenses, but were put off by the size and weight of DSLR systems. Cameras in this category have 10 MP to 24 MP sensors and range in price from US$500 to US$2400.

St Basil's Cathedral on Red Square, Moscow, Russia

Compact digital cameras can produce excellent results. Technically the image file is inferior to the 21 MP file I get from my professional DSLR, but the composition and light is identical to the DSLR version of the picture I took at the same time.

Digital compact, 140mm lens, 1/60 f8, JPEG, ISO 100

ADVANTAGES

- smallest and lightest camera system with interchangeable lenses
- models available with APS-C or Four Third sensor sizes
- APS-C sensor is around 12 times the size of most compact camera sensors, allowing more depth-of-field control and producing higher-quality files in low light than is possible with compact cameras
- APS-C sensor, when combined with quality lenses, produces image files comparable to those of a DSLR
- JPEG and raw file capture
- manual controls
- fast lenses
- built-in flash and hot shoe for external flash
- DSLR and Four Thirds system owners can use their existing lenses on the smaller camera body via an adaptor
- sensor dust removal systems on most cameras.

DISADVANTAGES

- larger and heavier than compact cameras
- small lens range for most cameras compared to extensive ranges available for DSLRs
- prone to sensor dust
- cameras can have difficulty focusing in low light
- smaller batteries means less capacity and more recharging required

DIGITAL SINGLE LENS REFLEX CAMERAS

If you're serious about travel photography and aiming for success across the widest range of subjects in all situations, you can't go past a DSLR, which is based on the familiar 35mm film single lens reflex (SLR) camera format. The subject is viewed through the lens, allowing quick assessment and adjustment of focus and framing decisions. Its versatility, the sheer number of useful features and the ability to take interchangeable lenses to suit all subjects makes this the ideal travel camera. Switch it to Auto mode to avoid worrying about the technical stuff or use the manual override to take control of the technical side of photography.

DSLRs are available in a wide price range with varying sensor sizes and build quality. The main drawback of the better-quality models and the accompanying lens range is that they are heavy and bulky when compared to compact and bridge cameras. But that's a small price to pay if you're intent on getting great pictures.

Apart from the features, assess the weight, size and feel of the camera. If it's too heavy you may be inclined to leave it in the hotel room. Don't compromise lens quality for camera features. The lens determines image sharpness, contrast and colour rendition. Buy the fastest lens you can afford for superior optics, strong construction and maximum flexibility in low-light situations. Many cameras are sold as a package with a zoom lens at the bottom end of the quality scale to keep the price down. Inquire about what other options are available.

ADVANTAGES

o all DSLRs have a fully automatic set-
ting, making them easy to use even for
the digitally challenged

o interchangeable lenses and accesso-
ries to suit every application

o large buffer memory to minimise delay
between frames

o most models have built-in flash units

o most models have sophisticated light
meters and autofocus lens systems as
standard features

o subject is viewed through the lens

o typically based on existing film camera
systems, allowing the same lenses to
be used

o shoot raw file format

o wide ISO range

o expandable systems

o body and lenses can be purchased
separately, allowing the body only to be
upgraded

o good performance in low light com-
pared to compacts

o models include entry level, prosumer
(or semi pro) and pro.

DISADVANTAGES

o heavier and bulkier than compacts

o investment in or upgrade of computer
equipment and software may be re-
quired due to large file sizes

o lens multiplier factor may require the
purchase of additional lenses

o more expensive than compact cameras
with equivalent MP sensors

o limited models with video mode

o prone to sensor dust

o entry-level cameras don't show 100%
of the image to be captured.

ENTRY LEVEL DSLRS

The entry level DSLR category provides
cameras aimed at the first-time SLR user.
They're compact, light and are usually
sold as a kit with inexpensive, but slow,
zoom lenses to allow attractive pricing.
Typically, the kit will include a wide-angle
zoom lens with a focal length of around
18mm to 55mm f3.5 to f5.6. This is OK
for outdoor conditions but is far too slow
for the wide range of general subject mat-
ter and conditions you'll be photographing
on your travels. Fortunately, most camer-
as are available as body-only purchases to
allow consumers to buy a DSLR body to
match their existing film SLR lenses, or to
simply buy a better lens. Most cameras
have 12 MP to 14 MP APS-sized sensors,
capable of producing excellent quality

NEW PRODUCTS

We can expect new digital products to keep on coming, so
keep an eye out for devices that interest you personally. For
example, at the end of 2011 Polaroid released the Z340, a
camera that allows you to capture, view, and immediately print
your pictures. Using ink-free printing technology, the camera
spits out 7.6cm x 10.2cm (3in x 4in) prints, the same size as the
classic Polaroid print. Printing costs can be kept under control
with the built-in editing feature that allows you to review, crop
and choose from various border options before you print. It's
not exactly a compact camera but if you're an old Polaroid fan
or are inclined to hand out pictures to the people you photo-
graph, this could be just what you're looking for.

prints up to 33cm x 48cm (13in x 19in). Prices range from US$600 to US$800 for a camera body and a zoom lens.

Common features:

o adjustable viewfinder diopter

o built-in flash

o hot shoe for external flash

o burst mode

o slot for a removable memory card

o controls to adjust colour, contrast and sharpness

o focus and exposure lock

o histogram

o scene modes for portrait, landscape, action and close-up pictures

o large 3in LCD

o live view LCD

o image file data display

o multipoint autofocus sensors with selectable focus points

o orientation sensor to rotate vertical images

o image stabilisation

o self-timer

o range of file size and compression settings.

MIDRANGE DSLRS

Midrange or prosumer DSLRs are feature-packed cameras aimed at enthusiasts. They're slightly larger and heavier than entry-level cameras and are available as kits with zoom lenses or body only. They're well built and should withstand the rigours of travel and perform reliably in most conditions. Models are available with APS and full-frame sensors capturing 16 MP to 25 MP, capable of producing

excellent-quality prints up to 40cm x 50cm (16in x 20in). Prices range from US$800 to US$3000 for a camera body only. The cameras at the top of this range h ave sensors, processors and features that deliver image quality close to that of professional cameras. The list of features you can expect is long and includes everything available in an entry-level camera, plus:

o image capture at three frames per second or more

o large buffer memory

o CompactFlash slots that accept high-speed cards

o second slot for SD memory card

o semiautomatic and full manual exposure control

o depth-of-field preview button

o program modes

o colour space options

o wide range of file size and compression settings

o integrated sensor-cleaning system

o full HD video recording.

PROFESSIONAL DSLRS

Aimed at the professional photographer, cameras in this category have 16 MP or higher sensors to suit the varying applications required by working photographers. The high-end cameras in this range offer the ultimate in digital SLR capture with full-frame sensors capable of producing the most data-rich files and high-quality prints up to 75cm x 100cm (20in x 30in). Prices range from US$3000 to US$8000 for the camera body only. More robust than their consumer-oriented cousins, professional DSLRs are built strong us-

ing alloys for both the body shell and the chassis, and are sealed against moisture, water, dust and sand. They have long-lasting batteries, the most extensive feature lists, plus expanded functionality options and very sophisticated image-processing controls. You won't get scene modes or a built-in flash, but you will get the following:

o advanced light-metering systems

o camera specifications tailored to suit specific professional applications

o image capture at 10 frames per second or more

o exceptional build quality

o extended ISO range

o extended white-balance options

o dual memory-card slots

o fast autofocus

o fine adjustment controls for sharpness, contrast, saturation and colour tone

o high burst rates of at least 10 frames per second

o large memory buffer

o more file-size and compression options

o increased working-temperature range for reliability in extreme temperatures

o manual override of automatic functions

o integrated sensor-cleaning system

o full HD video recording.

RANGEFINDER CAMERAS

The rangefinder is another camera type worth considering for travel photography, even though there's currently only one to choose from, made by Leica, and it's not cheap. Rangefinder refers to the focusing system, which splits or doubles the image on the focusing point. Correct focus is achieved by manually superimposing the double image. Aimed at the professional and keen enthusiast, it's popular with photojournalists and street photographers because it's compact and virtually silent, so it's much easier to work discreetly than with a DSLR. However, the rangefinder camera doesn't have a huge following as it lacks the advanced features, sophisticated metering and lens range of DSLR cameras. DSLR users will find it takes some time to learn to focus the manual system quickly. Still, check it out if you intend to specialise in candid people photography and want professional DSLR results with minimum weight and bulk. The 18 MP rangefinder costs around US$7000.

ADVANTAGES

o accepts interchangeable lenses

o smallest professional camera on market

o high-end camera offering DSLR quality in lighter and more compact package than the DSLR

o compact and extremely well built

o high-quality lenses

o very quiet operation

o viewing of the subject is uninterrupted by the shutter because it is seen through a viewfinder, not the lens.

DISADVANTAGES

o expensive

o limited features for the price compared to DSLRs

o limited range of lenses.

LENSES

The capacity to interchange lenses is one of the most persuasive factors for choosing a DSLR. While you can photograph almost any subject with any lens as long as you can get close enough or far enough away, this isn't always practical or safe. Having various lenses on hand increases your creative options and your ability to solve photographic problems. Don't compromise on lens quality – buy the best lenses you can afford, as lens quality determines image sharpness, colour and the light-gathering capacity of the lens, which can determine how you shoot in various lighting conditions.

FOCAL LENGTH AND LENS SPEED

All lenses have a designated focal length and maximum aperture, which are used to describe the lens. The focal length is the distance between the centre of the lens when it's focused at infinity and the focal plane, the flat surface on which a sharp image of the subject is formed. A normal, general-purpose camera lens is designed to have a focal length approximately equal to the diagonal of the sensor. A full-frame sensor has an image area of approximately 24 x 36mm, and the diagonal measures 45mm. Consequently, a 50mm lens is regarded as standard for cameras with full-frame sensors; it covers about the same field of view as the human eye looking straight ahead. Wide-angle lenses provide a wider field of view and closer focusing than a standard lens. Telephoto lenses have a narrower field of view and a greater minimum focusing distance than standard lenses.

The maximum aperture describes the widest opening available on the lens and is described as an f-number (see p145). The wider the maximum aperture the greater the light-gathering power of the lens. Lenses with wide maximum apertures (f1.2, f1.4, f1.8, f2, f2.8) are also referred to as fast lenses. The lower the maximum aperture the slower the lens because its light gathering ability is less. A lens with a focal length of 100mm and a maximum aperture of f2 is called a 100mm f2 lens. The wider the maximum aperture the bigger and heavier the lens is (and the more it costs).

Zoom lenses have variable focal lengths. At one end the lens may have a focal length of 28mm and at the other a focal length of 90mm. At its widest position (28mm) the lens is at its maximum light-gathering capability, say, f2.8, but this changes as it zooms in to its longest position (90mm) to, say, f4.5. This lens would be referred to as a 28–90mm f2.8–4.5 zoom. On very pricey professional zooms the maximum aperture does not change as the focal length varies.

IMAGE STABILISATION

A feature available on an increasing number of lenses is optical image stabilisation. This is well worth paying for, especially on telephoto and telephoto zoom lenses. The lens makers have all given the feature their own name including: image stabilisation (IS) from Canon, vibration reduction (VR) from Nikon, shake reduction (SR)

from Pentax and vibration compensation (VC) from Tamron. The technology uses a floating element that counteracts camera shake and allows the lens to be hand-held at shutter speeds two or three stops slower than required for nonstabilised lenses. For example, with a 200mm lens, image-stabilisation technology allows hand-held photography at 1/60 or even 1/30 of a second, rather than the recommended 1/250 of a second for non-IS lenses. This means images can be taken in lower light without a tripod or without switching to a faster ISO setting. See p35 for other stabilisation technology.

LENS MULTIPLIER OR CONVERSION FACTOR

There are some unique features and issues to understand about lenses for both digital compact and DSLR cameras. Most DSLR camera bodies are based on film systems and accept lenses from camera manufacturers' existing lens range. This is great news for photographers with a bag full of lenses, who can keep their investment in digital-camera gear down by only having to buy a digital body. However, there is a catch! Unless you buy one of the few cameras with a full-size image sensor, the area

Dockyards and city skyline, Melbourne, Australia
The advantage of carrying various focal-length lenses, either fixed prime lenses or zooms, is clear when you can take three different pictures without changing your position, in this case from the rooftop of Lonely Planet's head office in Melbourne.
(Top) DSLR, 24-70mm lens at 65mm, 1/160 f6.3, raw, ISO 100

(Middle) DSLR, 70-210mm lens at 95mm, 1/160 f7.1, raw, ISO 100

(Bottom) DSLR, 70-210mm lens at 170mm, 1/160 f5.6, raw, ISO 100

covered by all other sensors is somewhat smaller than the 24 x 36mm area covered by a frame of 35mm film. Consequently, when lenses made for 35mm film SLRs are attached to a digital body the effective focal length is increased. This is known as the lens multiplier factor (LMF), or focal-length conversion factor. The multiplier factor is determined by the sensor's size relative to a 35mm film frame or full-size sensor. For example, if the sensor is two-thirds the area of a frame of 35mm film the camera has an LMF of 1.5x. A 100mm lens becomes a 150mm lens on the digital body; a 24–70mm zoom lens becomes a 36–105mm zoom. This can be a real bonus at the telephoto end of your zoom because an 80–200mm becomes a 120–300mm lens. However, if you take a lot of pictures with a 24mm wide-angle lens you'll be

Because many people already understand focal length (p50) and the relative angle of view (p163) based on experience with 35mm film cameras, manufacturers provide 35mm-equivalent focal lengths in their advertising and technical specifications for digital cameras and lenses.

disappointed – suddenly it will become a not-so-wide 36mm. Be prepared to buy at least one new lens when you buy your first DSLR. On the upside, the maximum aperture is not affected. Also, the smaller coverage required means that manufacturers have the opportunity to make lenses specifically for digital cameras that are smaller, lighter and, in the consumer range, cheaper than lenses made for film SLRs. Be aware

though that these purpose-designed lenses for sub-full-frame DSLR cameras can't be used on full-frame-sensor camera bodies (or film SLRs) as they have a smaller imaging circle and will vignette, or darken the corners of, the image.

Lenses can be grouped by focal length into seven main categories: superwide, wide, standard, telephoto, super telephoto, zoom and special-purpose lenses (which include macro, shift, mirror and fisheye lenses). Every lens or lens group is particularly suited to certain subject matter (these are listed under individual lens descriptions).

Note that the following references to focal length are based on full-frame digital sensors and 35mm film. For other digital cameras seek out the equivalent focal lengths to suit the size of your sensor.

SUPERWIDE-ANGLE LENSES

Superwide -angle lenses include 17mm, 21mm and 24mm focal lengths. With their very wide angle of view, these lenses lend themselves to landscape, interiors and working in confined spaces. The 17mm and 21mm are a bit too wide for general photography. Unless these lenses are used well, it's easy to include unwanted elements in the composition and for subjects to appear too small. The 24mm produces images that have a distinct wide-angle perspective, but can be used in many situations. Particularly suited to taking environmental portraits, they allow you to get close to your subject to create a sense of involvement in the picture while including the location as well.

WIDE-ANGLE LENSES

Photographers often use 28mm and 35mm wide-angle lenses as a standard lens. They produce pictures with a natural perspective, but take in a considerably wider angle of view than standard lenses. Fixed-focal-length compact cameras commonly use a 35mm lens, as it's considered suitable for a wide range of subject matter.

STANDARD LENSES

Standard lenses have focal lengths of 50mm or 55mm, which have an angle of view that is close to what the eye sees. They still have an important place in the photographer's kit because they're compact, light and the fastest lenses available, making them ideal for low-light photography.

TELEPHOTO LENSES

Telephotos range from 65mm to 250mm. Their most common characteristics are increased magnification of the subject and a foreshortening of perspective. Medium telephotos range from 85mm to 105mm and make excellent portrait lenses. They give a pleasing perspective to the face and let you fill the frame with a head-and-shoulder composition without being uncomfortably close to your subject. The long telephotos, from 135mm to 250mm, are ideal for picking faces out of a crowd and showing details on buildings and in landscapes. They also allow the frame to be filled when moving closer is not possible, such as at sporting events or when you're on the edge of a canyon. They clearly compress distances, making distant objects look closer to each other than they actually are.

If you're shooting a lot in low light, consider complementing your zooms with a fast standard lens, such as a 50mm f1.4. More compact than a zoom, it's also easier to slip into a bag for those times when you want to take your camera but are put off by its weight and bulk, and you'll have maximum flexibility for selecting your desired depth of field.

Monastery, Bodhgaya, India
The wide field of view of a 24mm lens was perfect for revealing the colour and detail of the monastery ceiling and placing the main Buddha statue in its very colourful context.
35mm SLR, 24-70mm lens, 1/2 f16, Ektachrome E100VS, tripod

SUPER TELEPHOTO LENSES

Ranging from 300mm to 1000mm, these lenses display significant foreshortening and have a very narrow angle of view. Apart from the 300mm, the super tele-photos are specialist lenses. If the weight doesn't bother you then the price probably will. A 300mm lens magnifies the subject six times more than a standard lens, and is commonly used by wildlife and sports photographers. For serious bird photography (that is, if you want to take pictures where you can actually see the bird) a 500mm lens, at the very least, is required.

ZOOM LENSES

Zoom lenses offer convenience and flexibility by giving an unlimited choice of focal lengths within the given range of the lens. The many and varied focal-length options have made zooms extremely popular and the ideal choice for the traveller. A standard fixed-focal-length outfit would typically include a 28mm wide-angle lens, a 50mm standard lens and a 135mm telephoto lens. Use a 28–150mm zoom and you can carry one lens instead of three, and you have the added bonus of all the focal lengths in between. This allows various framing possibilities from a fixed position, including the ability to hold a subject moving towards or away from you in frame without having to move with it, so that it appears the same size. This is very useful for action and wildlife photography. Many zooms also have a 'macro' setting, which allows close focusing.

The ability to make smaller and lighter lenses thanks to the lens multiplier factor (see p52) has encouraged manufacturers to produce extreme focal-length ranges, such as 28–388mm and 320–800mm,

Hong Kong Island skyline, Hong Kong, China
One fun effect that you can create with zoom lenses is achieved by zooming during the exposure. Choose a point of interest at the centre of the composition and, if you're hand holding the camera, select a shutter speed between 1/2 and 1/30. Start zooming before you press the shutter. In this case, shooting at night I needed a much longer exposure so I mounted the camera on a tripod and began to zoom out slowly about 4 seconds after the shutter was released.
DSLR, 24-70mm lens at 70mm, 8 secs f9, raw, ISO 100, tripod

which aim to be all-in-one lens solutions. Even so, they are generally heavier, larger and have greater minimum focusing distances to the more moderate zooms. Two zooms, such as a 24–90mm and a 70–210mm, will cover most subjects. If that's one lens too many, and the 28–200mm doesn't suit you either, a wide-to-medium zoom such as a 35–105mm or a 28–80mm is the best single-lens option.

The main drawback with zoom lenses is that they're slower than comparable fixed focal lengths, which has a couple of consequences. Firstly, unsharp pictures as a result of camera shake are common – especially at the telephoto end of the zoom range and when using the close-focusing feature. Image-stabilisation technology and the ability to easily increase the ISO sensitivity of the sensor have certainly made this less of a drawback than it once was. However, you need to be alert as you zoom to the telephoto end of your lens that the shutter speed is not dropping to a point where camera shake is likely. Secondly, your control over depth of field is limited by the lens' maximum aperture (see p145).

PERSPECTIVE-CORRECTION LENSES

Perspective-correction (PC), or tilt and shift, lenses are used by architectural photographers to eliminate the linear distortion that occurs when you tilt a camera up to photograph a building. These specialist and very expensive wide-angle lenses allow control of the angle of the plane of focus through tilt and shift movements, so that you can keep the image plane parallel to the building. These will only be of interest

Jamid Masjid, Old Delhi, India
The minarets aren't about to fall over backwards, but that's the impression you'll get when you point your lens up at a building. Perspective-correction (PC) lenses are the professional way to photograph buildings without having to find a vantage point that allows you to keep your film or sensor plane parallel with the subject (see p254).
(Top) 35mm SLR, 24mm lens, 1/60 f8, Ektachrome E100SW

(Bottom) 35mm SLR, 24mm lens, 1/60 f8, Ektachrome E100SW, corrected in Photoshop

to travellers with a special interest in architecture or those of you who just can't stand the look of buildings that appear to be falling backwards. Keep in mind that converging verticals can now be corrected in image-editing software such as Photoshop.

MACRO LENSES

If you have a special interest in photographing very small things, such as insects or individual flowers, consider equipment made for macro photography: macro lenses, extension tubes or close-up filters. Macro lenses are described by the degree of magnification possible. A macro lens with 1x magnification is capable of 1:1 reproduction (ie, it reproduces objects at life size). A lens capable of 0.5x magnification reproduces objects at half life size. Macro lenses are available in various focal lengths, including 50mm, which can be used as a standard lens for 'normal' photography. Extension tubes go between the camera body and the prime lens, which determines the magnification. With a 35–80mm zoom, magnification of 0.3x to 0.5x is possible. The least expensive, but optically inferior, option is close-up filters, which screw on to the front of a prime lens. Available individually, or as a set of three with magnifications of 0.1x, 0.2x and 0.4x, these can be used in any combination for a magnification up to 0.7x.

TELECONVERTERS

Teleconverters are optical accessories that fit between the camera body and the lens to increase the focal length of the lens. They're available to increase magnification by 1.4x or 2x. Used with a 200mm lens, a 1.4x teleconveter turns your lens into a 280mm, and a 2x converter increases its focal length to 400mm. Used with a 70–210mm zoom lens, a 2x teleconverter will change the focal length to 140–420mm. They provide an ideal solution for people who need access to focal lengths in the super-telephoto range for a one-off event such as an African safari. Teleconverters will save you a lot of money, packing space and weight – but you can't have all that without giving up something. It's inadvisable to buy a cheap teleconverter because the inferior optics will have a noticeable effect on the sharpness of your pictures. And why put a cheap piece of glass between your good

Lemur, Brisbane, Australia

Teleconvertors are really useful when you only occasionally need that extra focal length, in this case taking my 300mm lens to a much more effective 420mm.

35mm SLR, 300mm lens + 1.4 teleconverter, 1/250 f8, Ektachrome E100VS

lens and your sensor? Best results will be gained by using a teleconverter made by the manufacturer of the lens you intend to use it with.

As with zooms, the main drawback, even with high-quality teleconverters, is loss of lens speed or light-gathering power. With a 2x converter your 70–210mm f3.5/5.6 suddenly becomes a painfully slow f7–f11. It's fine in bright, sunny conditions, but it won't take much variation in the sun's brightness for you to be cranking up the ISO sensitivity on your camera's sensor or reaching for a tripod.

OPTICAL & DIGITAL ZOOM LENSES FOR COMPACT CAMERAS

Zoom lenses are standard on most compact digital cameras and are available with either an optical or digital zoom, or both. The focal-length range of zooms varies from camera to camera, and manufacturers make the range a major selling point. It's also common to differentiate between the optical and digital zoom capability. The range, or power, of the zoom is expressed as a number followed by an 'x'. A lens with a focal length range of 6.3–63.2 is described as a 10x zoom. If the camera also features a 3x digital zoom it would be described as having a 10x optical zoom with a 3x digital zoom and a 30x total zoom. Optical zooms are far superior, so be sure to clarify the type and respective range on every camera you consider.

Optical zoom works by physically moving the lens in and out of the camera body to vary the focal length and magnify the subject accordingly. Digital zoom uses the camera's image processor to enlarge a portion of the image by creating and adding pixels to the image using a process called interpolation, which gives the illusion of zooming in. It's similar to cropping an image and then enlarging it to the same size as the original. Digital zooms offer what may appear to be extreme zooming capability, but the results are often disappointing because extra pixels have to be generated to maintain the set file sizes, resulting in loss of image sharpness and a fall-off in image contrast. Camera shake (p144) may also be a problem. The same effect can by achieved in a computer much more satisfactorily due to better and more controllable interpolation processing, and you'll be working with the superior file captured by the optical zoom lens.

If your camera has both optical and digital zoom capabilities you may have to activate the digital zoom function through the menu. Otherwise, it moves through the optical range first, then switches to digital for continuous zoom. Better cameras let you know that you've exceeded the optical zoom range and are composing with the digital zoom, usually via a line graph on the display. Be aware that the effect of digital zoom can't be seen through an optical viewfinder; you must compose with the LCD screen unless your camera has an electronic viewfinder.

CONVERSION LENSES FOR COMPACT DIGITAL CAMERAS

Compact cameras do not have interchangeable lenses. However, some

advanced compacts accept conversion, or auxiliary, lenses that clip or screw onto the front of the prime lens. These lenses are optical accessories. Wide-angle conversion lenses increase the viewable area; telephoto conversion lenses magnify the subject; and close-up conversion lenses allow macro photography. These accessories may provide an economical solution for people who want to increase their compositional options without the expense of a DSLR outfit. As with traditional optical accessories, it's inadvisable to buy cheap conversion lenses. Inferior optics will degrade the image file. One major problem with wide conversion lenses is the very obvious distortion that is introduced to the image. Note also that lens speed, or light-gathering power, is reduced by up to two stops. These lenses are also very heavy and can unbalance the camera. Additionally, they can only be used with the LCD screen or an electronic viewfinder and therefore demand greater battery power. Cameras with electronic viewfinders have special settings in the menu that must be activated when using conversion lenses.

ACCESSORIES

Once you've got your camera and lenses organised, there are a few other pieces of equipment and a range of accessories that will enhance your photography experience and ensure things go smoothly on the road. Plus, you'll need a convenient and practical way of carrying it all.

FLASH UNITS

Available light is the primary source of illumination for travel photographs, but it still pays to carry a compact flash unit (also called a flashgun or speedlight) if there isn't one built in to your camera or if you'd like to be a bit more creative with flash light. There will be times when it's inconvenient, impractical, prohibited or simply too dark (even for quality sensors) to set up a tripod.

All flash units have a guide number (GN) that indicates their power with the sensor set to 100 ISO. Guide numbers range from 10 to 50. The higher the guide number the more powerful (and expensive) the unit. The majority of new cameras have built-in flash units and these provide a convenient light source, ideal for candid photos such as in restaurants, bars, nightclubs and at parties, but they have limited value for creative photography (see p178). Remember to always work within the limitations of the flash. Most have a GN of 10 to 15 and illuminate subjects between 1m and 5m from the flash.

There are many accessory flash units to choose from, which are either mounted onto the camera via a hot shoe or mounted off-camera on a flash bracket, connected to the camera with a flash lead. Manual flash units are available, but far more popular are automatic and TTL (through the lens) units.

MANUAL FLASH UNITS

Manual flash units deliver a constant amount of light and require a simple calculation to determine the aperture setting to achieve correct exposure. The shutter speed is irrelevant (except for the synchronisation speed – see p179) because the flash duration is very fast, typically 1/10,000 of a second or faster. With a sensor setting of 100 ISO, divide the GN of the flash unit by the subject's distance from the camera. For example, if the GN is 32 and the subject is 8m away, then the aperture will be f4. The intensity of flashlight falls off rapidly as it travels away from the unit, so the further away the subject is the wider the required aperture. Most manual flashes have a scale on the back of the unit that shows the aperture required based on the sensor's ISO setting and subject distance. This saves adjusting the GN if you're using a setting other than 100 ISO.

AUTOMATIC FLASH UNITS

Automatic flash units, which can be used on any DSLR, have sensors that read the amount of light reflected from the subject and quench the flash as soon as the correct amount of light has reached the subject. Most units offer a selection of f-stop settings and indicators that confirm correct exposure, or alert you to over- or underexposure.

TTL FLASH UNITS

TTL flash is a more sophisticated form of automatic flash. The sensor that determines the exposure is in the camera body, which means that the light that hits the sensor is measured automatically, taking into account the aperture setting

and the filters on the lens. Any aperture can be used (restricted only by the unit's capacity and the distance from the subject), and the need for ISO and aperture settings on the flash unit is eliminated.

Camera manufacturers make dedicated flash units with TTL functions for use with their cameras, and sometimes only for a specific model. Independent flash manufacturers produce units that can be dedicated to most cameras via an adaptor. To simplify flash work, TTL flash units are recommended (if your camera has TTL

Halloween Party Parade float, West Hollywood, USA
It's not every day you come across a guy with a noose around his neck, peering out from a picture frame hanging above a brick fireplace on wheels, moving quickly down Santa Monica Blvd in the middle of the night. When you do, you'll be glad you're carrying a flash unit, even if the light it produces isn't the most flattering. It's more important to be able to capture the moment.
35mm SLR, 50mm lens, 1/60 f5.6, Ektachrome E100VS, flash

flash capabilities). Look for a unit with a manual mode that will let you experiment further with the possibilities of flash.

TRIPODS

You'll be able to photograph most subjects without the aid of a tripod or other camera support, but you won't necessarily be able to take the best photographs. There's no question that a good tripod is an extremely important piece of equipment for the serious travel photographer. Whether or not you actually take one comes down to the kind of pictures you hope to take and whether these will be worth the hassle of packing and carrying the extra weight. You can take the majority of travel pictures without a tripod. During most of the day there's plenty of light, and hand-holding the camera will present few problems. In low-light conditions indoors or on city streets, increasing the sensor's ISO setting will let you continue hand-holding the camera. But if you want to achieve images with minimum noise in low light indoors or out, maximise depth of field and use slow shutter speeds for creative effects, a tripod is necessary.

The most common travel subjects that call for a tripod are landscapes and cityscapes. Many of the most successful pictures of these subjects are taken early or late in the day, when light levels are low and maximum depth of field is required to render the whole scene sharp. If you have a special interest in landscape photography you'll need a tripod. Look for one that you're happy to carry – they're useless if you keep leaving them behind. Anything too flimsy will let you down by not keeping the camera steady. Check them out at full extension and with your camera and your longest lens attached. Make sure you can splay the legs for ease of use on unlevel ground. If your budget allows, a carbon-fibre tripod will take a load off your back.

TRIPOD HEADS

Tripod heads attach to the camera base and allow movement of the camera in any direction. Buy a reasonably good tripod and you'll have a choice of heads. It's worth checking out the options to find one that you feel comfortable with.

Bundi Palace reflected in Nawal Lake, Bundi, India

Carrying a tripod can be a real hassle, but when the light is low, the colours saturated and you want the finest detail in your pictures, they're an essential piece of gear.
DSLR, 24-70mm lens at 70mm, 1/6 f16, raw, ISO 100, tripod

You'll have a choice between a ball head and a pan-and-tilt head. The ball head is ideal for travel photography because it's more streamlined and easier to pack. Make sure that switching between horizontal and vertical positions is smooth, that it locks into position easily, and that it is strong enough to support your biggest lens in both positions.

Another feature worth its weight in gold is the quick-release plate. The release plate is attached to the base of the camera, and slides into the tripod head and is locked in position. This saves a lot of time attaching and removing the camera from the tripod. They really come into their own if you're working with multiple cameras and long lenses with their own dedicated tripod attachments.

OTHER CAMERA-SUPPORT OPTIONS

If you don't want to take even a small tripod there are several options worth considering. Table-top tripods support the camera around 15cm above the surface. These tiny tripods are suitable for compact cameras that have auto exposures running to several seconds, and for the smaller DSLRs with wide-angle or standard lenses. They need to be used in conjunction with a wall or table...unless you want to take all your low-light pictures lying on the ground looking up.

Monopods are a single-leg camera support. They're well suited for street and action photography and are often used by sport photographers. They can provide support in crowded places where setting up a tripod would be impractical.

Alternatively, you can improvise a camera support. Your camera bag will always be at hand, and can be easily manipulated to cradle the camera. Jackets or sleeping bags can be bundled up and the camera nestled into the folds. A pile of stones will do a similar job. These suggestions will work better using DSLRs with zoom or telephoto lenses, so that the front of the lens can be positioned clear of the support. When you've finished getting organised, just hope that the elements of the scene that attracted you haven't disappeared. You can also try bracing yourself against trees, buildings, fences or anything else that is solid and in the right place. It's worth practicing some handheld low-light photography, shooting at speeds of 1/15 of a second and slower, to find out how steady your hand is – and just how far you can push your luck (see p144). These compromises may or may not work for you, but don't expect the consistent sharpness, speed and ease that the use of a tripod provides.

FILTERS

Filters are optical accessories that are attached to the front of the lens, either via a filter holder or screwed directly onto the lens. Every lens has a filter size and it's ideal if your different lenses have the same filter size, as it reduces the number of filters you need to carry. Filters are available for a wide range of technical and creative applications, but those discussed here are favoured by professional travel and landscape photographers. If you want to keep your gear simple, only two – the skylight and the polariser – are really necessary for general, colour travel photography. The white-balance function on

digital cameras also alleviates the need to carry colour-correction filters (film users may consider carrying these, particularly for those taking a lot of photos indoors).

If you do carry four or more filters, consider carrying them in a filter pouch. Although filters are neatly packaged in individual cases, a pouch is much more practical because it takes up less room and gives quicker access.

The use of filters should be handled carefully; they don't automatically improve pictures, and often they do the opposite. Good filtration should not be noticed. It's good practice not to stack, or to use more than one filter at a time – making the light pass through more layers of glass than necessary will result in a loss of image quality. Also, stacking screw-in filters on wide-angle lenses may cause you to photograph the filter mount itself, which will show up in the photograph as a vignetting or darkening of the corners.

SKYLIGHT (1B) & ULTRAVIOLET (UV) FILTERS

Technically, skylight filters reduce the excessive bluishness that often occurs in colour photography outdoors, especially in open shade. UV filters absorb ultraviolet rays, which can contribute to hazy and indistinct outdoor photographs. Filters also protect your lenses from dirt, dust, water and fingerprints. Lenses are expensive, filters aren't. It's much better to clean a dirty big fingerprint off a filter than off a lens.

POLARISING (PL) FILTERS

A polarising filter is an essential item in any camera bag. Polarisers eliminate unwanted reflections by cutting down the light reflected from the subject. This increases the colour saturation and the contrast in the picture, intensifying colours and increasing contrast between different elements. The level of polarisation is variable and is controlled by rotating the front of the filter and

A skylight or UV filter should be on every lens you own simply to protect the expensive optical glass from dust, dirt, water and fingerprints.

Shop window, Hong Kong, China
(Left) Taken without a polarising filter, this is an ineffective photo. The reflection from the window reduces colour and contrast.
35mm SLR, 24mm lens, 1/30 f5.6, Kodachrome 200

(Right) Add a polarising filter and there's still a little reflection, but it's been minimised and moved away from the main subject area.
35mm SLR, 24mm lens, 1/30 f2.8, Kodachrome 200, polarising filter

the camera lens in relation to the position of the sun. As you view your subject through the lens you can see exactly what effect the filter will have at different points in the rotation. A polariser has its most marked effect when the sun is shining and the filter is at 90 degrees off axis with the sun. It has its minimum effect when the sun is directly behind or in front of the camera.

Although the effect produced by polarisers can be very seductive in the viewfinder, they shouldn't be treated as standard filters. Don't leave them on your lens. They don't enhance every photo, and should be used only as a creative tool. Additionally, they reduce the amount of light reaching the sensor by two stops. On lenses wider than 28mm it's important to note the position of the filter, particularly in clear areas of the picture such as the sky. If it's not positioned properly one part of the sky may appear darker than another, which translates to very unsatisfactory

image files and more time at the computer correcting the problem. Also, when the contrast of a scene is already high, such as white snow against a deep blue sky, overpolarisation can result in the sky recording as an unnatural-looking black.

There are two types of polarising filters, the standard PL and the circular polariser (PL-CIR). The PL-CIR is designed to avoid problems with through the lens (TTL) autofocusing. Check your camera manual, but if in doubt, use a circular polariser.

NEUTRAL DENSITY FILTERS

Neutral density (ND) filters reduce the light reaching the sensor. They are available in one-, two- or three-stop densities and are typically used in bright conditions to achieve shallow depth of field, or to allow slower shutter speeds to express movement. Some advanced compacts have built-in digital ND filters that you access through the camera's menu.

Reflection, Gordon River, Australia

(Left) By exposing for the trees, good colour and detail were ensured, but the reflection in the water can hardly be seen.
35mm SLR, 24-70mm lens, 1/250 sec f4, Ektachrome E100VS

(Middle) Exposing for the water records the reflection correctly but the colour and detail in the rainforest are lost.
35mm SLR, 24-70mm lens, 1/30 sec f8, Ektachrome E100VS

(Right) A graduated neutral density filter solves the problem by evening out the light levels between the light and dark areas, ensuring good colour and detail in both the forested hillside and its reflection.
35mm SLR, 24-70mm lens, 1/30 sec f8, Ektachrome E100VS, graduated ND filter

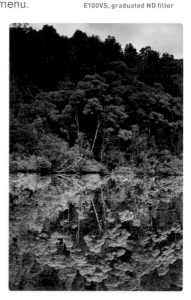

GRADUATED FILTERS

Graduated filters are clear in one half and coloured in the other. The density of the colour decreases towards the centre of the filter to prevent the boundary between the two halves showing up in your photograph. Available in many colours, they are special-effect filters that have to be used very carefully or the result will be unnatural. For example, if you put a sunset coloured filter on to change the colour of the sky to orange, but the shadows in the picture are short, the use of the filter will be obvious and the effect amateurish.

The most useful graduated filter is the grey, or neutral density (ND grad) filter. ND grads don't add colour to the image, but reduce the light reaching the sensor in half the scene. It's used by landscape photographers to even out exposure differences where the contrast between two areas of a scene is too high for the sensor to record detail in both areas (see p150).

When using graduated filters it's important not to stop down too much, especially with wide-angle lenses, as this can result in a sharp line across the picture. If your camera has a depth-of-field preview button, use it to ensure the line isn't visible.

Graduated filters are much more useful and easier to control in the square, slip-in holder style than the screw-in style. It allows you to move the filter up and down for more accurate placement of the line between the coloured and clear areas.

80 SERIES FILTERS

The 80A, 80B and 80C filters are blue, colour-conversion filters used to reduce the yellow/orange cast that occurs when using daylight film with incandescent light. If you're going to take a lot of interiors using the available light (rather than flash) and don't like the colour cast, the mid-strength 80B is a good option. It reduces the light reaching the film by one stop.

81 SERIES FILTERS

The 81A, 81B and 81C filters are amber-coloured, light-balancing filters referred to as warming filters. Essentially strong skylight filters, they're commonly used to reduce the bluish cast from shadows under a clear sky, for portraits in open shade and in snow scenes. The 81C is the strongest of the three and is the one to carry as a good general warming filter. It reduces the light reaching the film by two-thirds of a stop.

82 SERIES FILTERS

The 82A, 82B and 82C filters are blue-coloured, light-balancing filters referred to as cooling filters. They reduce the warm tones of early-morning or late-afternoon light to give a more natural look to portraits.

Half Dome detail, Yosemite National Park, USA
An 81C filter warmed up the colours of Half Dome's sheer rock wall rising above Mirror Lake. For film cameras, until you're really sure what effect a filter will have, try shooting frames with and without so you can see the difference when you have the film developed. These filters are not worth carrying if you're shooting digitally as the same effect is easily achieved by adjusting the colour temperature in image editing software.

(Left) 35mm SLR, 100mm lens, 1/30 f16, Ektachrome E100SW, tripod

(Right) 35mm SLR, 100mm lens, 1/30 f11, Ektachrome E100SW, tripod, 81C filter

BATTERIES, CHARGERS, ADAPTORS AND CABLES

One of the most noticeable differences between shooting film and digital is the number of batteries, chargers, adaptors and cables that have to be packed and then untangled every time you get to a hotel.

Digital cameras use a lot of power. Unlike film cameras, you can't put a new battery in at the start of a month-long trip and expect it to last. It won't. Battery power is consumed at every step of the way, including turning the camera on and off, using the LCD screen, zooming and focusing, using an electronic viewfinder, reviewing and deleting images, firing the flash, using image-stabilisation lenses, writing images to the memory card, and transferring files from the camera. In other words – everything!

Always carry spare batteries for each piece of equipment. Ideally, you'll begin each day with two fully charged batteries. This becomes more important the further off the beaten track you go, especially if your camera uses lithium batteries (they last longer but aren't readily available in smaller places).

The latest models from quality manufacturers include power-saving facilities that have led to lower battery consumption in most cameras. Even so, managing battery power is a serious business when you're on the road and should be considered when you're shopping for a camera. Buy a camera that comes with a rechargeable battery – most do, but check. Definitely avoid cameras that only use common AA or AAA alkaline batteries because they're only good for around 20 shots. You're likely to come across three types of rechargeable battery; each has its strengths and weaknesses:

o The common AA nickel cadmium (NiCd) rechargeable batteries suffer from what's known as 'memory effect'. This results in reduced power levels if they're not fully discharged before recharging, which can be a bit inconvenient. However, they can be recharged up to 1000 times.

o Nickel metal hydride (NiMH) batteries have much greater capacity on each charge than NiCds, and they can be recharged at any time. They're only a bit more expensive than NiCds when you consider the total lifetime of the battery and are much cheaper to run than alkalines. The only downside is that they can only be recharged approximately 500 times.

o Many cameras use lithium-ion (Lion) batteries. They're the most expensive but offer the greatest capacity per charge. Be aware that many cameras are supplied with a camera-specific Lion battery. This makes it especially important to carry spares – availability on the road can't be guaranteed.

Once you have got your camera with rechargeable battery, do not leave home without:

o at least one spare rechargeable camera battery

o at least one set of nonrechargeable batteries if your camera or other gear accepts AA or AAA cells (in case recharging is not possible)

You can maximise the number of shots you get from your camera battery by turning off the LCD screen and using the optical viewfinder to compose images; resisting the temptation to review and delete images; only using image-stabilisation functions when necessary; and switching to Manual focus mode.

o at least one set of spare batteries for your portable flash unit

o power-conversion adaptor plugs for all your destinations

o the battery recharger and cables.

If you're carrying multiple chargers and other power-hungry gear, such as a laptop, a video camera, a phone and an MP3 player, it's worth taking a double adaptor or better still a four-point power board so you can charge several items at once.

If you are going to be away from a power supply for any length of time, you'll need to investigate charging your gear using compact, foldable solar panels and battery chargers.

CABLE RELEASES

Cable releases, also known as remote switches, are accessories that are connected to the camera body and let you fire the shutter without physically touching the camera, reducing the risk of camera shake. If you have your camera on a tripod (or a pile of stones), you should use a cable release. DSLR users will need to use the dedicated electronic cable release made for their camera by their camera's manufacturer. These are not compatible with other camera makes or even with other cameras by the same manufacturer. Compact cameras do not generally accept cable releases, but some advanced compact cameras have wireless or infrared devices that perform the same function, as well as letting you fire the shutter at some distance from the camera.

LENS HOODS & EYECUPS

Lens hoods are essential and should be fitted to every lens if one is not built in. Their function is to prevent stray light entering the lens, which can cause flare, reduce sharpness and affect exposure settings. They also protect the front of the lens.

If your DSLR doesn't have a built in eyecup around the eyepiece, buy one as an accessory. It will prevent light entering the eyepiece so that the viewfinder remains at its optimum brightness for accurate focusing.

LCD HOODS

An LCD hood provides shade for the screen to make it easier to compose pictures in bright conditions.

CLEANING KITS

Lens tissues and a blower brush are sufficient for most cleaning requirements. For really stubborn marks on lenses, a lens-cleaning fluid may be required. Generally, though, it's not worth carrying on the road. To keep your camera's image sensor clean you'll need a dedicated antistatic brush and/or a natural air blower, depending on your preference. See p105 for advice on cleaning sensors.

PORTABLE STORAGE DEVICES

Portable storage devices are compact, light, easy to use and run on rechargeable batteries. They accept most memory cards either directly or via an adaptor. Capacity ranges from 5 GB to 60 GB, allowing thousands of high-resolution images

to be stored, ready to be transferred to a computer at a later date. The higher-priced units have LCD screens, so images can be reviewed anytime and, just as importantly, allowing visual verification of successful transfer. Portable CD readers and CD-RW units let you store images on a hard drive and make backup copies on CD, making you totally self-reliant (ie you don't need access to a shop, internet café or computer to transfer and back-up pictures).

CARD READERS

Card readers are compact devices that connect to a computer via a USB port. Cards are inserted into the card reader and images are transferred at the touch of a button. Available in single- or multiformat versions, they can be left attached to a computer, which means less fiddling around with cables every time you want to transfer images. Multiformat card readers are particularly useful if you're using two or more cameras that use different memory cards.

CAMERA DOCKS

Camera docks, also known as cradles, power bases or docking stations, are particularly useful accessories made for specific camera models. They make transferring images to a computer simple, and simultaneously charge the battery. The dock is connected to the computer via a USB cable and can be left permanently attached.

UNDERWATER HOUSINGS

If you'd like to explore the marine world with your nonunderwater camera, you'll need to protect it with an underwater housing. Compact-camera manufacturers offer underwater housings as an accessory for many of their models. DSLR users have the choice of selecting from various models at varying prices made by specialist companies; these housings are capable of going down as far as you're willing to go yourself.

OTHER ITEMS

You'll also find a few other items are particularly useful:

o an alarm clock, so you don't miss a single sunrise (or the train)

o a head torch for early-morning and late-evening walks, as well as changing settings on your camera in the dark

o a compass, so you can predict where the sun will rise and set

o gaffa tape, for running repairs (easy to carry if you wrap a couple of metres around the legs of your tripod).

Couple photographing themselves with a compact digital camera, Melbourne, Australia

DSLR, 24-70mm lens at 35mm, 1/100 f2.8, raw, ISO 500

BAGS

If you've got anything more than a simple DSLR outfit, your choice of bag is important for comfort, security and ease of access. When buying one, take all the equipment you intend carrying on your travels and try out the options in the shop. Aim to fit all your gear into one bag, but ensure that it's easily accessible. It can then be carried onto planes as hand luggage, and you only have one bag to worry about. Try not to select a bag that looks so good it's worth stealing. Look for bags with wide straps and shoulder pads – they make carrying a weighty bag much more comfortable.

It's important to have a trial run with your bag of choice loaded up with everything you intend to take. Don't just wander around the lounge room for five minutes. Carry it and use the equipment to see how comfortable and easy it is.

Many travellers prefer to carry their camera and lenses in their regular day-pack. Avoid this unless you're prepared to carry your camera on your shoulder whenever you're out; having to remove the camera from the day-pack every time you want to take a photo is slow and inefficient.

Lots of bags look good but are not necessarily functional or comfortable. The following are the main styles available.

DAY-PACKS & BACKPACKS

Ideal for carrying lots of equipment, but access is slow because the bag has to be removed from your back. Popular for hiking and trekking.

SOFT SHOULDER BAGS

These offer quick access and are generally comfortable to carry. They conform to the body and adapt easily as the gear in the bag changes. However, they offer the least amount of protection from knocks.

SLING BAGS

A hybrid of the day-pack and shoulder-bag options, these let you keep your bag on your shoulder but provide easy and quick access to your gear.

HARD-SIDED CASES

These offer the greatest protection for equipment, but are very uncomfortable to carry around. Access is slow and all your gear is displayed when you open them up. Ideal if you're carrying a lot of equipment and need to check it in on planes, but carry a soft bag for use at your destination.

POUCHES

If you have one camera and a zoom lens, consider carrying it in a pouch worn on a belt. Pouches provide quick access and take the place of the camera-maker's case. There's usually enough room for essential items like filters, a notepad and a pen.

STRAPS

Camera straps should be wide. Those provided by the camera-makers are not always comfortable, especially for cameras with heavy telephoto and long zoom lenses.

On plane trips, travel with all your gear in a day-pack-style bag, and then transfer it to a shoulder bag for use at your destination. You can get much more gear into the day-pack, but the speed of access afforded by a shoulder bag is preferable when shooting. Plus, you can revert to the day-pack for particularly long walks, for which the shoulder bag isn't so comfortable.

JACKETS & VESTS

Photographers' jackets and vests have numerous pockets, which distribute the weight of the gear evenly over the shoulders. Quick access is assured…that is, if you can remember in which of the 400 pockets you've put what you need. They're useful in crowded situations and permit greater agility in more adventurous environments than a bag swinging from the shoulder or bulging from your back. Plus, you can always carry a bit more gear onto the plane by loading up the pockets and wearing it.

BUYING GUIDE FOR DIGITAL CAMERAS

When you've read the preceding section, browsing the internet, thumbing through catalogues and visiting camera shops won't be quite so overwhelming as they might otherwise be. The range of cameras and accessories is simply staggering, and at first glance can be confusing. What appear to be very similar cameras in terms of size, megapixels and lens can be more than US$1000 apart in price. Some cameras come with one lens, others with two, and others are advertised 'body only'. The quickest way to make sense of this is to remember the adage, 'you get what you pay for'. It can certainly be applied to camera equipment. Higher prices should buy a camera with more features and better-quality components, construction and optics. In the digital world it also means more pixels, larger pixels, larger sensors, more in-camera computer memory and increasingly sophisticated and faster in-camera image-processing software. The key things to keep in mind are:

- How much you want to spend
- What kind of pictures you want to take – holiday snaps or considered images
- What you want to do with the pictures. Will you view them on a personal computer or sell them to the world?
- How much involvement you want in the capture process (fully auto or lots of personal input?)
- What priority you're going to give to photography on your travels. Will you shoot as you go or plan in advance?
- How involved you want to be in the postcapture digital process. Do you want to be an image-editing master, or would you rather have no involvement?

The quickest way to get a sense of what's out there and how much you'll need to spend is to go online. The internet is a great resource, especially once you're comfortable with the technology and the terminology. There's a heap of information on every aspect of digital imaging, including test reports, camera comparisons, technical specifications, price guides, personal opinions, sample images, manufacturers' propaganda and lots of valuable and up-to-date information on buying and using digital cameras.

Some handy websites to start researching equipment online: www.allmemory cards.com, www .camerastore. com.au, www .cnet.com, www. dcviews.com, www.digicamhelp .com, www.digital camerainfo.com, www.dpreview .com, www.fred miranda.com, www.steves -digicams.com and www.photo graphy.about.com

Take your own flash memory card when you're shopping around and use it in the cameras you're interested in. You can then view and compare the files on your computer, which is always much more revealing than a 3in LCD screen.

It's also a good idea to visit a large retailer. A good salesperson will quickly match your needs and budget and come up with a short list of possibilities. Spend time handling these cameras and take photos with them in and around the shop. It's the only way you'll discover which cameras fit comfortably in your hand, feel balanced, are easy to use, are too heavy or too light, or too big or too small. You'll also be able to determine if the controls and menus are easy for you to access and operate, and if it feels comfortable to take, review and delete images. You should be able to access all key controls with fewer than three clicks of a button, or toggles of a switch.

It's also worth considering if this purchase may be a stepping stone to a future upgrade because of the lens-factor issue.

Shop around because retail prices can vary considerably, especially when a model is about to be superseded. Always check the warranty. This is particularly important if buying on the internet or outside your own country. Make sure it covers your home country and those you intend visiting, in case you require repairs while travelling. No matter where you buy your camera, leave yourself time before you travel to use it intensively for a couple of days so that any problems are detected immediately and can be sorted out.

DSLR SYSTEMS

Outlined below are three suggested camera outfits for travel photography. The gear should fit into a single camera bag (except the tripod) when the equipment is removed from its individual cases. There are numerous other camera-and-lens combinations, so use this as a guide as you consider your own budget, needs, photographic goals and travel plans. Note that the focal lengths are based on full-frame sensors.

BASIC SYSTEM

This is a popular system with many travellers who want to keep it simple, and is the recommended minimum outfit:

- DSLR camera body
- 18–200mm f3.5–5.6 zoom lens bundled lens
- 12 MP sensor

- built-in flash
- skylight or UV filter
- polarising filter
- three or four 4 GB memory cards.

STANDARD SYSTEM

The addition of a portable flash and a tripod adds flexibility in low light and greater control over depth of field.

- DSLR camera body
- 12 MP to 18 MP sensor
- 17–85mm f4–5.6 zoom lens
- 70–200mm f4 zoom lens or 70–300mm f4–5.6 zoom lens (if wildlife or sport is a priority subject)
- portable flash
- compact tripod

- skylight or UV filter for each lens
- polarising filter to fit all lenses
- four 4 GB memory cards
- card reader
- portable storage device for storing and viewing images.

ADVANCED SYSTEM

A versatile outfit for the traveller who places a high priority on picture-taking and is more concerned with capturing images than the weight and bulk of their camera bag. The extra body is a great backup in case of loss or damage to one of your cameras, but also increases speed and flexibility while shooting. The fixed-aperture fast lenses offer a significant step up in terms of image quality and, along with the tripod, will increase picture opportunities and give you greater control over depth of field in

the majority of low-light situations. The bounce-flash kit provides natural-looking flash pictures.

- two DSLR camera bodies
- 18 MP to 22 MP sensor
- 24–70mm f2.8 zoom lens
- 70–200mm f2.8 zoom lens
- 300mm f4 lens
- portable flash
- bounce-flash reflector kit
- skylight or UV filter for each lens
- polarising filter to fit all lenses
- compact carbon-fibre tripod
- four 8 GB memory cards
- card reader
- laptop for viewing and storing images
- external hard drive for backing up your images

It's possible to buy a camera, take it out of the box, set it on Auto and get good pictures. But to ensure minimal problems and maximum success, buy the camera far enough in advance to give yourself time to become totally familiar with all its functions and creative possibilities, especially if it's your first digital camera.

Photographing the Dragon Boat races, Stanley, Hong Kong, China
35mm SLR, 70-200mm lens, 1/250 f11, Ektachrome E100VS

FILM CAMERAS

Apart from plastic cameras such as the Holga, new film cameras are no longer being sold, but there are plenty of bargains to be had on the secondhand market. Film still has a loyal following, particularly in the fine-art (colour and B&W) tradition and among users of medium- and large-format cameras. The range of film types to choose from is diminishing due to the transition to digital capture by the majority of photographers, although Kodak did release two new films in 2011. If you're interested in the film-camera option or intend travelling with one, the following section covers the camera choices and the most critical film-only aspects of travelling with a film camera.

CAMERA FORMATS

Camera formats are based on the size of the film frame.

Advanced Photo System (APS) The smallest and final film format to be developed, launched in 1996. APS has a film-frame size of 17 x 30mm.

35mm The most popular format and the film size upon which the majority of camera systems are based. Produces 24 x 36mm negatives and slides.

Medium formats There is a range of medium-format cameras that use roll film known as 120. The most popular formats are 6 x 4.5cm (known as 645), 6 x 6cm (2¼in square) and 6 x 7cm. Depending on the camera, you get a different number of frames per roll, ranging from 10 to 15. Medium-format cameras offer a considerably larger negative or transparency than 35mm – an important consideration if very large prints are required.

Panoramic Available in 35mm and medium format. A true panoramic camera has a format ratio of at least 1:3 (ie, the film is three times as wide as it is high). The panoramic format is very popular with landscape photographers. Two 35mm frames side by side would be panoramic. In medium format a 6 x 12cm panoramic camera gives six frames per roll of 120 film. A 6 x 17cm panoramic camera produces only four frames per roll of 120 film, which are almost three times as wide as they are high.

Hemis Festival, Ladakh, India
35mm SLR cameras, with their vast range of interchangeable lenses, let you get close to the action even when you're forced to sit in the crowd.
35mm SLR, 70-200mm lens, 1/250 f8, Ektachrome E100VS

CAMERA TYPES

ADVANCED PHOTO SYSTEM CAMERAS (APS)

Kodak stopped manufacturing APS cameras in 2006 as digital compact cameras gained market dominance. They are only of interest here as a reference point, as they gave their name to the sensor size most commonly used in digital cameras, based on the APS film dimension of 17 x 30mm.

COMPACT 35MM CAMERAS

No one is manufacturing 35mm compact cameras anymore. Digital compacts have completely taken over this segment of the market. If you're still using one, you'll know that they're ideal for taking photos with a minimum of fuss. Perfect if you want to travel light, only require colour prints of your travels and want a photo lab to do all the work of developing and printing your shots.

35MM RANGEFINDERS

These cameras are aimed at the professional and keen enthusiast, just as their digital equivalent is. In fact, it's owners of 35mm rangefinders that are most likely to buy digital rangefinders. They lack the advanced features, sophisticated metering and lens range of the SLR. But, for the photographic traditionalists out there who want to follow in the footsteps of Cartier Bresson, this is the camera for you. See p49 for more information on rangefinder cameras.

Monk photographing ceremony with a compact film camera, Kopan, Nepal

35mm SLR, 70-200mm lens, 1/250 f8, Ektachrome E100VS

35MM SINGLE LENS REFLEX (SLR) CAMERAS

No one is manufacturing 35mm SLRs either, although there are still plenty of loyal users out there. Now is an excellent time to pick up a second-hand bargain. If you're serious about travel photography and you still prefer to shoot film, then a 35mm SLR, preferably one that allows you to manually override all of its automatic features, is the camera of choice. This will let you take complete control of the technical side of photography if you choose. SLR film cameras are available in 35mm and medium formats. All the lenses and accessories described earlier (pp50–67) are as suitable for SLRs as they are for DSLRs, with the exception of lenses that have been purpose-designed for sub-full-frame DSLR cameras (see p52).

FILM

The film you choose will have a dramatic impact on how your images look. It will determine the kinds of pictures you can take successfully, when and where you can take them, and what other equipment you may need, such as flashguns and tripods. The choice of film type – colour-transparency (slide) film, and colour or B&W negative film for prints – is a personal one and depends very much on your photographic vision and how you want to work with, store, distribute and present your images.

In some cases one film might be more suited to a particular application or subject than another. Fujichrome Velvia is regarded as an excellent film for landscapes and Kodak Portra is made specifically to accurately reproduce skin tones. Additionally, film is manufactured with a particular colour balance. The majority of films are balanced for daylight and electronic flashlight. When daylight film is used in situations where incandescent light is the dominant light source, the print or slide will have a yellowish or warm cast. This can be overcome with flash, filtration, or by using a film balanced for tungsten lighting.

For the traveller, it's impractical to carry different films to cover the range of subjects and lighting conditions you'll want to record. It's recommended that you use film with an ISO rating of 100 as your standard film. It's suitable for the majority of picture-taking situations and subjects, and the resulting fine-grained slides or negatives ensure you'll have no trouble making very large prints or quality scans. For low-light situations colour-transparency users should carry either 200 or 400 ISO film, which can be exposed at its nominated speed or push processed two or three stops. Colour- and B&W-negative users should carry 400 ISO film for low-light situations. Try a few different films to see for yourself how they react to different subject matter and under different lighting conditions, and you'll discover which film type and speed suits your photography and gives you the most pleasing results.

Carrying enough film from home is especially important for colour-transparency users travelling to less-developed countries (see p79). No matter where you're travelling, beware that with the domination of digital cameras fewer places are stocking the range and quantity of films that they used to.

PRINTS OR SLIDES?

The first decision to make is whether you want prints or slides, colour or B&W, or a combination. It's obviously a personal choice and depends a lot on what you want to do with your pictures and how you want to show them when you get home. Shooting two types of film at once, eg for colour prints and slides, won't be easy unless you have two cameras. The time spent swapping film will lead to a lack of continuity in your final presentation. But even if you have two cameras, why take everything twice? You can always make prints (colour and B&W) from slides or slides from negatives.

Film choice will be easier if you're clear about your main priority for taking pictures. If you're simply recording your trip for yourself, then colour negative film, from which colour prints are made, is the most suitable choice. If you intend to submit your work to a photo library or hope to publish your work, then colour slide film (transparency film) is the way to go.

COLOUR PRINTS

Colour prints, displayed in an album, are easy to show others and, because they're so accessible, they get looked at a lot more often than slides after the initial burst of interest wears off. Reprints, to send to people you've photographed and travelled with, and enlargements of your favourite photos, are inexpensive. Minilabs now exist in most cities and towns, allowing you to develop and print film quickly and cheaply. You can enjoy your photos and get feedback immediately, and learn from your successes and failures as you travel.

On the technical side, exposing negative film is much easier than slide film, as it has wide exposure latitude and exposure mistakes can often be corrected in the printing. If you're using a fully automatic compact point-and-shoot camera, colour negative film is clearly the best choice.

The main disadvantage of colour negative film is the limited control you have over the finished print. Unless you go to the extra expense of using a professional lab to print to your directions or you print your own negatives, you may be disappointed that the intensity of colour you remembered photographing is missing. Minilabs generally print everything as close to average as possible, so most prints have a sameness about them.

B&W PRINTS

The emphasis in this section is on the use of colour films, but B&W films are still widely available and popular. Processing B&W is not as convenient as colour negative films (few minilabs offer a B&W service, instead sending the film off to a professional laboratory). The convenience of minilab processing is available if you use one of the B&W chromogenic films that can be developed and printed with the same chemicals and paper used for colour negative films. The prints often have a colour cast, which can result in them looking slightly blue or sepia brown. Good B&W prints are possible off chromogenic negatives when they're printed onto B&W paper.

COLOUR TRANSPARENCIES

A colour transparency or slide (aka a trannie or chrome), when properly exposed and projected onto a white screen in a very dark room, is the closest you can get to reliving the depth of colour and range of tones that you saw when you took the photo. Before digital photography, most professional photographers shot transparency film because it allows total flexibility in end use (and it was also the standard requirement of most publishers and photo libraries). Also, the final look of the image is determined by the type of film used and through exposure choices made by the photographer. The slide is a final product and therefore an expression of the photographer's vision and intentions. It doesn't need to be

interpreted by a printer, as a negative does, before it can be viewed.

It's important to understand that different films record colour differently, and that this characteristic is especially relevant to colour transparency film. The variations between films can be quite dramatic and aren't just apparent from one manufacturer to another. A particular Kodak 100 ISO colour slide film will not only record colours quite differently from a Fujifilm or Agfa 100 ISO film, but differently from another Kodak 100 ISO film.

When you choose one slide film over another you're actually making a creative decision that can greatly affect how your pictures look. The film type determines the way colour is recorded, and the film speed determines the overall quality and sharpness of the image.

Colour prints can be made from slides but are more expensive than prints from negatives, and as contrast is increased in the process they're often disappointing and look too dark. Good-quality prints from slides can be made at a considerable increase in cost by a professional laboratory, but are well worth it if you intend to display a framed print of your favourite photograph.

Transparency film is not recommended for travellers using automatic point-and-shoot cameras. To ensure consistent results an SLR with a reasonably sophisticated built-in exposure meter is required.

Colour slides need to be projected if you wish others to see them, and that requires extra equipment and preparation. (Not to mention the fear you'll put into your friends when they're invited over to see the slides

of your latest trip!) But nothing beats a projected slide for brilliance and colour.

FILM SPEED

All film has an International Organization for Standardization (ISO) rating that designates the speed of the film. Film is light sensitive and the more sensitive it is to light, the higher the film speed or ISO. Film speed is recorded numerically. For example, there are 64 ISO, 100 ISO and 400 ISO films. Doubling of the number shows the doubling of film speed: 100 ISO film is twice as fast and twice as sensitive to light as 50 ISO. The 50 ISO film requires twice as much light to achieve the same exposure as the 100 ISO film.

Film is also classified more informally into slow, medium and fast. Slow films have ratings of 25 or 50 ISO. Medium- (or standard) speed films are rated at 64, 100, 160 and 200 ISO, and fast films include 400, 800, 1000, 1600 and 3200 ISO films.

Film speed is a good indication of the potential overall image quality. Slow films have a finer grain than fast films and result in much sharper images with excellent detail and colour rendition. This is particularly noticeable in prints larger than 20cm x 25cm. As the image is enlarged the grain is magnified and, unless the effect has been sought for artistic reasons, the print will acquire an unsatisfactory soft, textured effect.

The choice of film speed comes down to the conditions you expect to be shooting in, personal preference, and the expected or desired end use of your photographs.

The extra sensitivity to light of faster films means you can hand-hold your camera in most situations, and the effective range of

Even if you're shooting digitally, it's worth understanding the concept of film speed as this is what sensor sensitivity is based on.

the built-in flash is extended. But different situations call for different speed films. If you have an interest in landscape photography and will be carrying a tripod, then a fine grain 50 ISO would be best. If your interest is in photographing sport or theatre, you'll need greater quantities of faster film. Carry a few rolls of 400 ISO for low-light situations or explore push processing.

PUSHING & PULLING FILM

Pushing and pulling film is a technique that allows you to vary the ISO of colour slide and B&W film, at the time of exposure, for practical and creative reasons.

The most common technique is to 'push' film one or two stops by exposing it at a higher ISO setting than its actual film speed. For example, with 100 ISO film, set the ISO on 200 for a 'one-stop push', or on 400 for a 'two-stop push'. The camera meter is tricked into thinking that you're using faster film and that less light is required for correct exposure. The entire roll must be exposed at the new setting and the film lab must be informed so that the developing time is extended. If you don't inform the lab you'll end up with transparencies that are underexposed, or too dark. If you 'push' your standard films, carry stickers to identify the pushed film.

Pushing film creates opportunities to take pictures in low levels of available light, instead of resorting to flash, using a tripod or having to hand-hold your camera at shutter speeds that risk camera shake (see p144). It also allows you to carry only one film stock and push the film as necessary in low-light situations, rather than having to estimate in advance how much

Umbrella workshop, Pathein, Myanmar

(Top) Working in a covered but open-sided building, this young boy was facing the light. There was enough light to use 100 ISO film with my fastest lens – always my first choice. 35mm SLR, 50mm lens, 1/60 f1.4, hand-held, Ektachrome E100VS

(Bottom) The workshop owner was working in a dimly lit area, which required an 1/8 sec exposure with the 100 ISO film. Flash would have eliminated the ambience of the location, and although a tripod could have been used I find it limits the spontaneity possible when working with people. Switching to my camera body loaded with 200 ISO film, but rated at 800 ISO, I was able to hand-hold the camera and move around my subject as he worked. Workshops like this one are often dark, but in low-light situations the grain of the film enhances the mood and sense of place. 35mm SLR, 24mm lens, 1/30 f2, hand-held, Kodak E200 rated at 800 ISO (a two-stop push)

fast film you should carry on a trip.

Be aware that when film is pushed, contrast and grain are both increased, which is why pushing film is not recommended in good lighting conditions. It's an ideal technique when working indoors and in low light. The increase in grain often adds to the mood of the shot.

'Pulling film', rating film below its actual ISO, isn't a technique commonly used, but it can be useful if film is accidentally exposed incorrectly. If you change from 100 ISO film to 400 ISO film but forget to change the setting on your camera, your pictures will be overexposed. Inform the lab and in the processing they'll compensate for the error.

Rating film incorrectly has become less of a problem since DX coding, which reads the speed of the film and sets it automatically when it's loaded into the camera, became standard.

X-RAYS

Ideally, film should not be X-rayed. Unprocessed film is light and heat sensitive, and exposure to X-rays can fog the film. The amount of damage results from a combination of the ISO rating, the strength of the X-rays and the number of times the film is scanned. The good news is that Kodak has done extensive tests and found that slow and medium-speed films can handle up to 16 passes through the X-ray machines used to check hand luggage at modern Western airports. The more light-sensitive, faster films, from 400 ISO, are much more susceptible to X-ray damage. Limit their exposure to four or five passes.

Be aware that in many developing countries airports are still using old technology and the dose of the X-ray may be set at higher than acceptable levels. The danger for medium and slow ISO films is the cumulative effect of X-rays. One or two passes through the scanner may not matter, but five or six may take the levels over the acceptable threshold and fog the film. It's very easy to clock up half a dozen security checks even on a short trip.

Never pack film in your check-in luggage. High-dose CT (computerised tomography) scanners are now widely used for check-in luggage at airports around the world and have been proven to fog film with just one pass. Carry all unprocessed film in your hand luggage. If your travels will take you through many security checks, or you're confronted with a machine that you're not confident is 'film safe', ask for a hand inspection.

Hand inspections are not usually a problem, even with the increasing focus on airport security, but there are ways of making the request less painful for the security staff. Take all film out of the boxes and plastic containers and carry it in a clear plastic bag or box. Before you get to the security check remove your film and put your camera bag through the machine, making sure there's no film in your cameras. This indicates that you're doing your best to comply with security requirements, and packaging the film in clear containers makes the security staff's job easier. It's also worth getting to the security check with plenty of time to spare so you have time to wait if the security staff claim to be too busy to hand-check bags. Remember, they're only doing their

job, and after all it's for your protection, so be patient and courteous.

Lead-lined bags may give you some peace of mind if a hand-check is refused. The lead lining stops the X-ray penetrating the bag, but may cause the inspector to increase the dosage. If you're lucky, the presence of a solid black package in your bag will simply lead to a hand-check after the X-ray.

HOW MUCH FILM TO TAKE

The cost of film adds up when you use lots of it, but it's better to take too much than too little. Run out of film and you'll never forgive yourself. Compared with the other costs of travel, film and processing are relatively cheap, especially given the years of pleasure you'll get from the photographic memories. It's best to take as much as you can with you,

particularly if you're travelling to out-of-the-way places. Even if the more remote locations have the exact film you want, when you want it, it may not be fresh or it may not have been handled properly, and it will often be very expensive. Excess film can always be used when you get home or stored in the freezer for your next trip.

It's almost impossible to recommend how much film to take. You'll need more if you're rushing around from sight to sight than if you intend to sit on the same beach for days. A quick survey of regular travellers suggests that two to three rolls of 36 exposures per week is adequate to record a trip, but five to six rolls a week would suit someone with a keen interest in photography. You could easily double these numbers if you're going on a wildlife safari or attending big festivals.

Film and beer seller, Pinnewala, Sri Lanka
Do you really want to buy your film from the front of a bike? This young man is providing an excellent service to badly prepared travellers – make sure you're not one of them.
35mm SLR, 24-70mm lens, 1/125 f5.6, Ektachrome E100VS

OTHER IMAGING OPTIONS

Traditionally, the realms of still and moving imagery were regarded as two quite different disciplines with their own specialist equipment and visual language. You were either a photographer or a movie-maker. Creatively, the disciplines have much in common, but with each requiring unique equipment and skill sets there wasn't a lot of crossover. However, converging technologies that bring together various functionalities into one device, such as still cameras with Video mode, telephones with built-in cameras and video cameras with still-picture capability, are challenging these conventions, at least at the equipment level.

With Video mode a standard feature on most digital compact cameras, DSLRs and camera phones, many people who never would have considered travelling with a video camera are experimenting and enjoying the opportunity to capture moving images of their trip. The camera's bundled software or any number of third-party options let you view, edit and combine both your still and moving images into slide-show and movie presentations.

The most obvious benefits of converging technologies are the reduced number of devices you need to own and the opportunity to experiment with another medium without the investment and extra luggage. Not that long ago, if you wanted to make phone calls, take still pictures and shoot movies you needed three different devices, a couple of bags and four arms. Now you can do it all with one pocket-sized device and one hand! However, in most cases multifunction devices will do one thing better than the other (although this will be constantly challenged with each new generation of technological advancement). For now, you will still need to prioritise your requirements based on your personal needs, and be prepared to give up some quality in one medium. If you're OK with this, choose a digital camera with Video mode if photo quality is most important, or a video camera with photo mode if the highest-quality video is your goal.

CAMERA PHONES

The camera is an integral feature of the mobile (cell) phone. Sensor size, lens type and photo-taking features are prominent in the sales pitch of every new product. The appeal is obvious: you can capture, view and distribute your images with ease, from a device that slips easily into a pocket or purse and is always with you. Not only that, you can even make phone calls!

Although the image quality is pretty ordinary on the majority of camera phones, their potential as a creative tool is being explored by photographers, artists and film makers.

The technology is, of course, moving fast. Image quality and the experience of photography with a mobile phone are improving rapidly. Camera phones have reached the 16 MP sensor size and include better lenses made by well-known lens makers such as Carl Zeiss, increased storage capacity and features once exclusive to digital cameras, such as adjustable white balance, scene selection, optical zoom lenses, flash, macro focus, autofocus, choice of ISO setting, face detection and shake-reduction technology.. Most also let you shoot video.

As the quality of the image file improves, the high-end camera phones are becoming much closer to compact digital cameras. There is no doubt that the best camera phones offer a serious alternative to the lower-end compact cameras for people who just want to point and shoot and enjoy their images on a computer screen or as postcard-sized prints. But if you want more than that from a camera, keep using the phone for making phone calls.

If you do want to make sure that the pictures you take with a camera phone are the best they can be, and especially if you intend to use it as your primary image-capture device on your travels, consider the following features.

CAMERA RESOLUTION

With sensors ranging from 4 MP to 16 MP, there is no shortage of choice. Choose a camera with a 5 MP sensor or higher if you want to be able to make postcard-sized prints. The higher the MP count the more detailed the images. If you think you'll want enlargements of your images up to 20cm x 25cm (8in x 10in), buy a device with the highest-resolution camera phone available. Don't forget, you can't simply compare megapixel for megapixel when evaluating

Artificial flowers for sale, Hong Kong, China

Camera Phone, 5 MP, 4mm lens, 1/1117 f2.8, JPEG, ISO 80

digital cameras and camera phones. Except for the very high-end camera phones, most are inferior to even entry-level compact digital cameras. They have smaller sensors, which means the megapixels are smaller and squashed closer together than in an equivalent digital compact, and the on-board software compresses the images heavily to maximise the small storage capacity.

Tourists with DSLRs photographing Victoria Harbour and skyline, Hong Kong, China

35mm SLR, 24-70mm lens, 1/125 f5.6, Ektachrome E100VS

LENS

One of the main reasons that many camera-phone pictures look decidedly poor is that many camera phones have very cheap plastic lenses. To compound the problem, the lens is unprotected and is covered with fingerprints and dirt picked up from pockets and bags. Phones with the best lenses usually have a protective sliding cover, and the marketing blurb will be quick to point out that the lens is made by a well-known camera lens maker. An optical zoom also suggests the phone has a better-quality lens. As with compact cameras, avoid digital zoom lenses (see p57).

BUTTONS AND MENUS

Make sure you actually handle the phone in its picture-taking mode before purchase. How easy is it to get to the camera mode, access the picture-taking menus and make changes? Press the release and make sure you're comfortable with the position of the button.

MEMORY CARD

The internal memory of most camera phones is not sufficient to store many photos, so choose a phone that accepts removable flash memory cards (see p31). A 1 GB card in a 4 MP camera set to capture images at the highest quality will store approximately 1000 images. Make sure it's easy to access the card for easy removal.

PRINTING OPTIONS

Check the options for printing your images – at least one of these options should be offered:

o PictBridge allows camera phones to be connected directly to a printer via a USB cable (this custom cable is typically supplied with your camera phone, but if not can be purchased separately).

o Bluetooth lets you print wireless if you have a Bluetooth-capable printer. Not all Bluetooth-capable phones support printing. Those that do will have a 'Print' or 'Send' feature that can transmit photos to a printer via Bluetooth.

o Memory Card allows the image to be transferred to the phone's removable memory card for printing at home, a kiosk or online.

FLASH

Some phones come with a tiny built-in flash but are only useful for subjects within a range of 1m to 2m.

VIDEO-RECORDING CAPABILITY

If video quality is important, look for a phone with a Video mode that captures 30 frames per second.

CARRIER CHARGES

Find out the charges for sharing your images with other phone users. Wireless carriers generally charge a fee to send photos to another phone as a Multimedia Service (MMS) message, to email it to an internet address or to upload it to an online storage site. Fees for sharing pictures are often in addition to your base plan charges. Depending on the carrier, the fee might be a few dollars per month or it might be charged on a per-image basis, which could add up quickly if you're a shutterbug. Look for a wireless provider that charges a flat fee for unlimited picture sharing. You can avoid fees altogether if the phone has Bluetooth and the person you want to share with is sitting next to you with their Bluetooth-capable phone. Alternatively, transfer your photos to a computer and share them via email (p345) or a blog (p348), but this eliminates the spontaneity of instant picture messaging.

VIDEO CAMERAS

To explore the world of moving images beyond the Video mode on your camera phone or digital camera, you'll need a video camera, or camcorder. The following introduction to video-camera technology will get you started on the road to understanding the language, options and features that you'll encounter.

There is a mind-boggling range of digital-video (DV) camcorders, available in all sorts of shapes, sizes and prices. Choosing a camcorder is a lot like choosing a digital camera: the clearer you are about what you want to achieve and how much you've got to spend, the quicker you'll narrow down your choice. The first decision to make is whether to go for a standard-definition or a high-definition camcorder. Next you need to decide which of the four recording formats you prefer, as video can be recorded onto tape, flash memory card, mini-DVD/Blu-ray disk or hard disk. But before you can make these decisions there are a few basic facts and some jargon that's worth getting to know, because you'll encounter it as soon as you start looking for a camcorder. Don't forget, it's not just about the tech specs. Once you've worked up a short list, get down to a shop and check out the cameras. Consider weight, size and the layout of the controls. Pay particular attention to how comfortable each camera feels in your

hand and how easy it is for you to access and operate the controls.

THE BASICS

There are three broadcast television and video standards:

o NTSC (National Television Standards Committee): USA, Canada, Mexico, Japan, Taiwan, Korea and the Philippines.

o PAL (Phase Alternating Line): Western Europe, Australia, Southeast Asia, India, China, Africa, the Middle East and South America.

o Secam (Sequential Couleur Avec Memoire): France, Russia, Eastern Europe, Central Asia and some parts of the Middle East.

Tourist capturing video on a zodiac cruise, Isla Isabela, Galápagos, Ecuador

35mm SLR, 24mm lens, 1/500 f5.6, Ektachrome E100VS

As standards vary around the world, it's important to understand this when you're buying video equipment and planning to

edit and share your efforts. Camcorders, TVs and DVD players usually conform to one broadcast standard determined by the location in which they are sold and expected to be operated. A DVD recorded in the PAL format in Australia will generally not play on NTSC DVD players sold in North America, and vice versa.

VIDEO FORMATS

Camcorders record video in either standard or high definition, which is defined by the vertical resolution or number of horizontal lines of pixels displayed on a TV screen or captured by a camcorder. Standard definition (standard-def) is the format used for analogue TV and video. Picture resolution with an NTSC signal is 480 lines with 4:3 aspect ratio, which produces images with a resolution of 640 x 480. A PAL signal is 576 lines with a 4:3 aspect ratio (768 x 576). Standard-definition video has enough resolution to be used in broadcast video programs.

High definition (high-def) offers approximately twice the vertical and horizontal picture resolution of standard-definition TV and video. There are three high-definition standard resolution formats for high-definition recording and display devices: 720p, which produces images that have 1280 x 720 of overall resolution and is known as high definition; and 1080i and 1080p, which create images with 1920 x 1080 of overall resolution and are known as full high definition. All three high-def formats have an aspect ratio of 16:9. The 'i' and 'p' after the number stand for Interlaced and Progressive scan respectively.

PROGRESSIVE AND INTERLACED SCAN

A television or recorded video image is made up of single horizontal lines displayed in rapid succession. Standard-definition television and video images are created by interlaced scanning. A single frame of video is split into two fields, one containing the odd-numbered lines, the other containing the even-numbered lines. These two fields are then displayed in alternate passes to create a complete image. A progressive scan displays the lines sequentially, reproducing an entire frame in a single pass, resulting in less screen flicker, better contrast and an improved picture, especially when displaying fast-moving action or sport. LCD computer monitors and the 720p and 1080p high-definition TV and video formats all display progressive scans.

RECORDING FORMATS

To get data-rich video and audio signals into manageable files, you must compress them using a codec. A codec is a program or component that can encode and/or decode or compress and/or decompress video and audio data for transfer between devices via cables and internet connections. Common codecs include AVCHD, HDV, MPEG-4, MPEG-2, DiVX and DV25 (MiniDV). Most high-definition camcorders use either AVCHD or HDV recording formats:

o AVCHD (Advanced Video Codec High Definition) is a high-definition video-recording format that compresses video files using MPEG-4 compression algorithm without compromising quality. This format allows video to be recorded onto DVDs, hard disk drives or flash memory cards.

o HDV (High Definition Video) is a high-definition tape-based recording format used for recording video to MiniDV (Miniature Digital Video) cassette tapes using MPEG-2 compression.

ASPECT RATIOS

Aspect ratio refers to the shape of a screen and the relationship of width and height. When an image is displayed on different screens, the aspect ratio must be kept the same to avoid either vertical or horizontal stretching. You'll probably be familiar with several common screen aspect ratios:

o 4:3: The picture aspect ratio of traditional TV screens and computer monitors

o 16:9: The picture aspect ratio used for plasma and LCD TVs and LCD computer monitors. Commonly known as widescreen, this format approximates that of 35mm film and full-frame digital-camera sensors as well as cinematic movie screens.

Most camcorders let you choose between filming in either the 4:3 or the 16:9 aspect ratio.

CAMCORDER FORMATS

Once you've decided on video format, you should consider which recording medium best suits your needs. All four camcorder formats are available in standard and high definition and have strengths and weaknesses.

MiniDV/HDV Tape

MiniDV/HDV (Miniature Digital Video/ Miniature High Definition Video) has been the industry standard for years, but is quickly being overtaken in popularity by the newer tapeless media camcorders. Interestingly, you'll now find these cameras at either the entry level or the high end of the market. Video is recorded onto 60 and 80 minute cassette tapes. The same tape is used in both standard-definition and high-definition camcorders and delivers the same number of minutes in each format, thanks to sophisticated compression technology in the HD cameras.

These camcorders are easy to use and produce high-quality recordings, the tapes are inexpensive and widely available, and all models are supported by the majority of computer editing programs. On the downside, finding sequences is often a slow process as you have to play and rewind the tape as you search for the beginning of a scene. Transferring the video to a computer is done in real time, so one hour of footage takes one hour to transfer. Connection to the computer is via a FireWire cable, which is not offered as a standard port on most computers. Some cameras also use the more common USB2.0 cable. Check your computer for compatibility before buying. The price range for standard definition is US$400 to US$500; for high definition expect to pay between US$700 and US$850.

Flash Memory

Flash memory camcorders record video to both built-in and removable media cards, and are quickly becoming the most popular recording format. Built-in flash memory is generally 16 GB or 32 GB but is effectively unlimited with the additional removable flash memory slot. Apart from Sony camcorders, which use proprietary Memory Stick Pro Duo cards, most camcorders accept SD and SDHC memory cards, which will be familiar to many digital-still-camera users. Cards optimised specifically for HD video are available and display minutes of recording time as well as capacity. An 8 GB memory card can hold between 60 and 80 minutes of HD video. Being solid-state devices without moving parts, they use less power and have a proven reputation for reliability and handling the rigours of the road. Flash memory camcorders are generally very compact and light, which make them a great choice for the traveller, but make sure the camera is comfortable in your hand when held in its shooting position. Finding scenes and simple in-camera editing, such as scene deletion, is easy as the footage is recorded in file clips with a similar appearance to thumbnail views in still cameras.

Transferring video to a computer follows the same procedures as still photography. The camera is either connected directly to the computer or the card is removed from the camcorder and inserted into a card reader (see p67) or directly into a media slot in a computer. After you've verified the transfer, the card can be reused. You can also watch your video direct from the card if you have a TV with built-in memory card slots.

Unless you're able to shoot and transfer your data from the memory card immediately you'll need quite a few

OTHER IMAGING OPTIONS VIDEO CAMERAS

cards, particularly if you're shooting high-definition footage. Compared to hard-disk, flash memory is the more expensive option. Standard-definition units cost from US$300 to US$800, while the high def price range is US$600 to US$1100.

Mini-DVD/Blu-ray Discs

Mini-DVD and Blu-ray Disc (BD) camcorders record video to 8cm (3in) DVD or Blu-ray discs (standard DVD/BD discs are 12cm or 4¾in in diameter). These cameras are easy to use and offer instant playback in the familiar home DVD player or the DVD drive in a computer.

A serious disadvantage of this format is the limited recording times, which are considerably shorter than all the other formats. The mini-DVD holds only 1.4 GB of data, which is around 20 minutes of standard-definition footage or just 10 minutes of high-def footage. The higher-capacity single-sided BD can record around one hour of high-definition footage. Consequently, you will need to carry additional discs and plan ahead to change them so as not to miss important shots. On a long trip the number of discs you have to manage could add up. This isn't the best choice of camcorder for the traveller. If you like the idea of being able to burn your video to DVD in-camera, consider a hybrid camcorder (p88). You should also check compatibility with your DVD player as discs written by the camcorder can't always be played back on every model. The price range for standard-definition models is US$200 to US$300, and US$550 to US$750 for high definition.

Blu-ray disc is an optical disc format developed specifically to enable recording, copying, playback and storing of full high-definition video (1920 x 1080). A standard size Blu-ray disc can hold up to 25 GB of data, compared to 4.7 GB on a standard DVD. The choice of Blu-ray camcorders is limited but they are worth checking out if you intend to watch your videos on a large screen HDTV, to which you can connect the camcorder directly. Otherwise you'll need a Blue-ray disc player or disc drive in your computer to view your recordings. The high-definition price range is US$400 to US$500.

Hard-Disk Drive

Camcorders with built-in hard-disk drives (HDD) are the latest recording format to hit the market. They offer the convenience of long recording times without the need to buy or carry additional media. Standard-def camcorders have storage capacities between 30 GB and 60 GB, or you'll be able to film 430 or 860 minutes respectively. High-def cameras are available that can hold between 40 GB and 120 GB of the highest-quality footage. This translates to about 290 and 900 minutes (that's 15 hours!) respectively.

Also in their favour is easy access to footage for review and simple in-camera editing tasks, and easy and quick transfer to computer as the footage appears as a single file that you can drag and drop. One hour of footage takes around five minutes to transfer.

Given the finite capacity of a hard disk, you have to make sure you have enough space for the shoot or are able to transfer

the video from the hard disk to computer or DVD. There is some concern that the hard disk may be susceptible to damage if the camera is mishandled, but the manufacturers are building in plenty of protection. It's also sobering to contemplate that being a hard disk it will probably crash one day. Take the same precaution you do with your photos and important documents: back up regularly.

Hybrid Camcorders

Hybrid camcorders offer dual recording systems that allow the user to record and transfer video between two different media formats in the same camera. There are three combinations of hybrid available: hard-disk drive and SD flash memory card (HDD + SD); mini-DVD and SD flash memory card (Mini-DVD + SD); and hard-disk drive and Blu-ray disc (HDD + BD).

CAMCORDER FEATURES

There's a lot of information in the spec sheets and brochures of digital camcorders, so focus on these key features to quickly make sense of it all.

IMAGE SENSORS

You'll find camcorders with either CCD (Charge-Coupled Device) or CMOS (Complementary Metal-Oxide) sensors, which convert optical images from the lens into electrical signals. Both sensors offer excellent picture quality. Most camcorders have a single sensor, either $\frac{1}{3}$ in or $\frac{1}{6}$ in. Larger sensors will generally outperform smaller sensors. Higher-end camcorders use three sensors with one chip dedicated to each of the red, green and blue colour channels. These sensors are designated as 3CCD. For the extra money you can expect better image quality.

LENSES

As with all imaging devices, the quality of the lens is crucial in determining the sharpness, contrast and colour that is recorded. It goes without saying that all other features being equal, choose the camcorder with the best-quality lens.

OPTICAL ZOOM

All camcorders have an optical zoom lens that determines the number of times the camera can magnify an image through its lens. Optically zoomed images enlarge the picture without sacrificing quality. Look for an optical zoom in the 10–45x range. Most cameras also have digital zoom, with incredibly large zoom power being claimed. Don't be impressed by these numbers, as using digital zoom is not recommended. Image quality is quickly sacrificed as the zoom effect is achieved by cropping the image and enlarging it (see p57).

LCD MONITORS

All camcorders are equipped with a fold-out LCD monitor or screen for composing shots and reviewing footage. The screens are generally between 2.5in and 3in, measured diagonally. The best screens allow easy viewing even in bright conditions. Take the camera outdoors when you're shopping around to test the screen's ability in a variety of lighting conditions.

ELECTRONIC VIEWFINDERS

Higher-end camcorders complement the LCD with an electronic viewfinder. This can be very handy when shooting in bright conditions and the LCD is hard to see.

IMAGE STABILISATION

Though it is now common in digital still cameras, image-stabilisation technology was actually first pioneered in video cameras. All camcorders have image stabilisation, either optical or electronic, as a standard feature. The best system is optical stabilisation, which varies the optical path by moving the actual lens assembly to keep the image centred on the CCD, and is effective even in low light and while the lens is zooming. Electronic stabilisation is performed within the camera by comparing each frame of the image projected onto the CCD and shifting frames that don't match. Electronic stabilisation does not work well in low light or when zooming.

EXTERNAL MICROPHONE CONNECTORS

All camcorders have built-in microphones, which do a remarkably good job. But if you're serious about sound quality, ensure the camera has provision for connecting an external microphone. Most have a standard minijack connector, while the high-end camcorders will have a three-pin XLR connector.

MANUAL CONTROLS

As with still photography, if you're serious about producing great video you're going to want the option to override the automatic settings to gain technical and creative control. Check out the layout of the controls, as some are easier and quicker to use than others.

BATTERIES

Lithium-ion or NiMH are the batteries of choice for maximum recording time and reliability. Find out how many minutes of video a fully charged battery will record and how much spare batteries cost.

ACCESSORIES

There are plenty of video accessories to spend your money on but the following will add quality and versatility to your video productions.

FILTERS

If the lens of your camcorder accepts screw-in filters, a clear skylight or ultraviolet filter should be put on the lens the moment you buy the camera to protect it from dust, rain and fingerprints. You can also use the same filter types that you use for still photography when shooting video to achieve the same effects (see p61). You'll need to buy a separate set for your camcorder because the screw-thread size will be different.

CONVERSION LENSES

Wide-angle and telephoto conversion lenses that screw onto the camcorder lens allow you to add variety to your shots by increasing or narrowing the field of view respectively.

EXTERNAL MICROPHONES

Built-in camcorder microphones can work well in a controlled environment, but if there are people around or you're

STILL CAPTURE WITH VIDEO CAMERAS

Many camcorders now have a photo mode that allows users to record a still image over several seconds of videotape, or a built-in digital camera that stores images on a flash memory card. Neither option is recommended for capturing still images of any importance. Both options produce images that are really only suitable for viewing on a computer screen or sharing via email. Camcorders use inferior-quality lenses that perform well for video capture but do not compare to even quite basic compact cameras. Plus, there are other practical difficulties.

In photo mode, if you take a picture while recording video the sequence will be interrupted by a four- or five-second freeze frame. You can achieve exactly the same thing in video-editing software once you've transferred the tape to a computer. Either way you'll end up with a low-resolution image.

Camcorders with a built-in digital camera are a better option. Images on memory cards are much easier to access and transfer to a computer (see p326). Photo resolutions are still low by digital camera standards, ranging from 0.3 MP to 2 MP. If you do decide to shoot stills this way, you can improve your chances of success by choosing a camera with a photo resolution of at least 2 MP, a built-in flash and other still-camera features such as scene-selection modes and exposure-compensation settings. Also, check that you can take a still while recording without interrupting the sequence.

Aswan, Egypt
Digital HD video camera, 1/220
f4, JPEG

shooting outdoors they tend to pick up a lot of unwanted sound, including handling noise, wind noise and out-of-shot chatter. A directional microphone, mounted on the camera in the accessory shoe and covered with a foam windshield, will produce a clearer sound from subjects directly in front of the camera and eliminate some, but not all, extraneous noise. Putting on a pair of headphones will not only make you look like you know what you're doing, you'll be able to clearly hear what the microphone is recording and position it accordingly for the best possible sound.

TRIPODS AND TRIPOD HEADS

It is really hard to keep a camcorder perfectly still, even with image-stabilisation technology, especially when shooting longer sequences. If you're serious about getting as much watchable footage as possible, use a tripod whenever you can. If you've got a tripod to support a DSLR with a zoom lens, this will also be fine for a camcorder. However, you'll need to swap the ball or pan-and-tilt head for a fluid head in order to ensure the smoothest of movements on either axis when panning or tilting.

You can gain some stability for hand-held shots, especially for sequences taken while you are walking, by attaching a mini- or table-top tripod to the video camera. In crowded situations you'll find a monopod much more practical than a tripod, and it is also great for shooting from a high angle, such as over the top of people's heads.

VIDEO LIGHTS

An inexpensive, battery-operated video light that can be mounted on the camera via the accessory shoe is a handy accessory to have in the bag to illuminate your subject if you don't have quite enough available light.

COMPUTER REQUIREMENTS

The specifications recommended for working with video files are similar to those for still photography, but if you're shooting a lot of high-definition video you'll soon find yourself adding more hard-disk capacity. Video files demand a lot of hard-disk space: five minutes of high-definition video will take up around 4 GB. Unlike digital image files, it is not recommended to work with video stored on external hard disks. Disk speed is crucial when importing or exporting video files, and internal drives will deliver faster speed than external disks connected with FireWire or USB2.0 cables.

A recommended minimum set up for video only is listed below, but double the hard-disk capacity if you're also shooting high-resolution still images and storing them on your computer.

o 3 GHz processor

o 2 GB of RAM

o 200 GB hard disk

o video (or graphics) card with 64 MB video RAM

o LCD monitor with minimum pixel resolution of 1024 x 768

o CD/DVD-ROM drive.

VIDEO-EDITING SOFTWARE

As you will have already noted, you can connect your camcorder directly to a TV set,

The Windows Movie Maker program offers an easily accessible and straightforward introduction to the world of video editing. This screen shows the clips that have been transferred from the camera to the computer in the main pane, with the preview monitor to the right and selected clips placed in the storyboard at the bottom of the screen.

or pop the flash memory card or mini-DVD into the appropriate slot in the appropriate machine and watch your handiwork immediately. Unless you've been quite disciplined and are reasonably talented, this footage will probably not appeal to anyone except those who were there or, more importantly, actually appear in the film.

The good news is you can launch right into video-editing without even buying software, as both Windows and Apple include video-editing programs with their operating systems. Windows Movie Maker comes with Windows 7, XP and Vista; Apple iMovie is included with Apple Mac computers as part of the iLife program package. If you've never edited video before, these are perfectly fine programs to get started with. Once the film has been transferred, or 'captured' as it is correctly called, to your computer you'll be able to cut poor sequences; reduce the length of those contemplative shots that seemed so interesting at the time; change scene order; add titles; add fancy transitions between scenes; add a soundtrack that's way more interesting than your voiceover describing the scene as you filmed it; add sound effects; and generally put together a video package that will be worth watching again. And when it's 'in the can', you can share it directly from the program by sending it to the world in an email or publishing it on a website.

If video isn't your main game, these packages might even offer you all that you'll ever need. If your ambitions are higher and your talent outgrows these basic programs, step up to Apple Final Cut Express for Mac or Corel Ulead VideoStudio or Sony Vegas Pro for Windows, or the cross-platform Adobe Premier Elements. If these aren't complex enough for you, check out the programs the pros use: Apple Final Cut Pro for Mac; Corel Ulead Media Studio Pro, Pinnacle Liquid Edition and Sony Foundry Vegas for Windows; or the cross-platform Avid XPress DV and Adobe Premier Pro.

COMPUTERS & SOFTWARE

Computers and software are an integral part of the equipment requirements for photographers and anyone else who wants to view, store, edit and generally manage an image collection. They have replaced the darkroom, the light box and loupe (magnifier), and the filing sheets and filing cabinets of the traditional photographic world.

DIGITAL PHOTOGRAPHY WITHOUT A COMPUTER

A computer isn't necessary to take or print digital pictures. The absolute simplest method is to buy enough memory-card capacity to cover your entire trip and wait until you get home to have them printed. With an 8 GB memory card in a 10 MP compact camera you could take around 80 high-resolution JPEGs a day on a two-week holiday. The following workflow is as close as you can get to the predigital experience of dropping off film at the photo lab to be developed and printed, with the added benefits of not paying for the printing of pictures you don't want and not having to buy more film:

o select a memory card to suit your expected needs

o review images on the camera's built-in LCD screen as you take them

o delete images you're not satisfied with

o at the end of your trip take the memory card to a photo lab and order a print of every image, and request the files be transferred to a CD (this gives you the digital equivalent of negatives)

o delete the images from the memory card

o file the CD for future reference.

However, if you want to enjoy all the possibilities that the digital medium has to offer, a computer and imaging software are integral to the digital photographer's set-up.

COMPUTER SPECIFICATIONS

Digital images contain a lot more information than text files and require a considerable amount of computer memory or RAM to process them quickly. A decent hard-disk drive capacity is also important to handle image storage and image-editing software. The processors in today's computers are sufficiently fast for handling

Most laptops store
data on a hard disk
drive (HDD), an
electromechani-
cal device that
contains spinning
disks and other
movable parts,
making them sus-
ceptible to data
loss from knocks
and vibrations.
For frequent
flyers they are
also vulnerable
to extreme shock,
typically caused
by turbulence
and air pressure
differentiation. If
you are travelling
regularly, con-
sider purchasing
a computer with a
solid-state drive
(SSD) that stores
data on micro-
chips and contains
no moving parts,
thereby minimis-
ing these risks.
SSDs are more
expensive than
HDDs but also of-
fer longer battery
life and faster
performance.

most image-processing requirements. Exactly what computer specifications you need depends on how many pictures you take, their file size, the software you use and the degree of involvement you want to have with the process.

Photographers generally have two computer systems: a laptop or notebook (see p109) for the road, and a desktop with the biggest monitor they can afford back at the office.

If you capture your images as JPEGs on a 12 MP or higher compact or DSLR, the following is a recommended minimum computer set-up:

o 2 GB RAM

o 160 GB hard disk drive

o video (or graphics) card with 64 MB video RAM

o LCD monitor with a minimum pixel resolution of 1024 x 768

o CD/DVD-ROM drive.

If you're capturing raw files, the following is the recommended minimum computer set-up for both desktop and laptops:

o 4 GB RAM

o 320 GB hard disk drive

o video card with 128 MB video RAM

o LCD monitor with a minimum pixel resolution of 1024 x 768

o CD/DVD-ROM drive.

MONITORS

If you're serious about shooting digital images, investment in a good-quality, decent-sized (at least 43cm or 17in) monitor is money well spent, especially if you intend to use image-editing software to work creatively with your photographs. Displaying an image so that it fills the screen of a large monitor will soon reveal how good it is, or if it has to be sent to the recycle bin. It needs to be able to correctly display the colours, contrast and sharpness you've gone to the trouble of capturing, so that you can make proper judgements about the image and not spend time unnecessarily editing the image. Delve into the equipment manuals to ensure that your monitor is displaying the right number of colours and that the screen resolution setting is correct.

ENVIRONMENT

The monitor should be placed in a room with neutral-coloured walls and soft, in-direct lighting. It should be positioned so that stray light and reflections don't hit the screen and degrade the colour and brightness of the image. A screen shade will help to minimise reflections. Strong backlighting and even brightly painted walls are to be avoided: these affect your perception of colour on the screen.

CALIBRATION

A monitor cannot be guaranteed to display accurate colours as this is dependent on a variety of factors, including manufacturing variables, make, model, age and the user's viewing position. To overcome these problems and ensure that what you see on your monitor is as close as possible to what others will see when they view your images on theirs, monitors need to be calibrated. The aim is that they display neutral colours, without colour bias. The simplest, and free, method to calibrate your monitor is to use the Adobe Gamma tool, supplied with most imaging software. After setting the brightness, contrast and colour balance, the program saves the results as a Profile, which becomes the default settings for the monitor display.

More sophisticated tools such as the ColorVision Spyder are used by photographers, photo labs and pre-press bureaus. The device is physically placed on the screen and reads the characteristics of the monitor, then makes the required adjustments using dedicated software. Screens should be calibrated regularly if they are in constant use for image work.

COMPUTER ACCESSORIES

Storage is really the main issue of a growing image collection, and there are a couple of solutions other than buying a computer with the biggest hard disk you can get.

EXTERNAL HARD DISKS

An external hard disk drive is just that: a computer component that is exactly the same as the hard drive built in to your computer, only supplied as a peripheral device that connects to the computer with a USB cable. There are two reasons to invest in external hard disk drives. Firstly, as your collection grows you'll probably find that the images are taking up all the space on your computer's hard drive, affecting its performance and limiting your ability to add new software to your computer. Secondly, and more importantly, your images should be backed up to an external hard disk drive. Hard-disk drives are constantly growing in capacity and dropping in price. A 500 GB hard drive can store around 100,000 12 MP JPEG files or 30,000 raw images. They're a much better backup solution than that offered by optical media as you can keep your entire collection in one place, making it easy to browse, to move from one computer to another and to transfer to a larger hard disk when your collection gets even bigger. External disks, both desktop, which plug directly into the power supply, and portables, which draw their power from the computer via the USB connection, are available with multiple terabytes (TB) of storage capacity.

OPTICAL MEDIA

Optical storage media such as CDs, DVDs and Blu-ray discs are a common means to store digital photos. CDs are available in 650 MB and 700 MB capacity. DVDs come in single and dual layer. Single-layer DVDs have a capacity of 4.7 GB, about six times that of a CD. Dual-layer DVDs have a capacity of 8.5 GB.

There is some debate as to the life expectancy of optical media, and they should certainly be handled with care and stored appropriately. The useful life of a standard CD-R can be as short as two years if the reflective layer is tarnished through exposure to light, heat, humidity and mishandling. A better, but more expensive, alternative are gold CDs and DVDs – so called because the reflective layer is made with 100% 24-karat gold. Manufacturers claim a lifespan of 100 years for gold CDs and 300 years for gold DVDs. You can extend the life of all discs by:

o never touching the surface: handle discs by the outer edge or the centre hole

o using a non-solvent-based felt-tip permanent marker pen made for writing on the label side of discs

o never using adhesive labels

o storing discs upright in plastic cases, book-style

o keeping discs in cases when not in use

o storing discs in a cool, dry, dark place.

If you have a disc that your computer won't read, you should try it in one or two other machines. If it still doesn't work, clean the surface carefully with a disc-cleaning detergent, isopropyl alcohol or methanol by wiping gently in a circular motion.

SOFTWARE

All digital cameras come with software programs for the easy transfer of images from the camera. For those who want to explore the opportunities and possibilities of the digital-imaging world, investment in more advanced image-editing software is necessary. Additionally, if you're shooting large numbers of images, serious consideration should be given to a cataloguing program right from the start. Alternatively, there are workflow applications that handle your images each step of the way, and also online solutions.

CAMERA-BUNDLED SOFTWARE

All digital cameras come with a disc loaded with software that provides drivers to support the downloading of image files to a computer, plus tools for enhancing photos. The bundled software varies in functionality from simple to sophisticated, often related to the price of the camera.

Even the most basic programs enable images to be viewed as thumbnails, enlarged through a zoom or magnification function, resized for sending via email, and printed easily on a desktop printer. Simple editing tools enable retouching, cropping, red-eye reduction and image rotation. Some cameras are bundled with panorama stitching and basic video-editing software. Additionally, file-management functions allow images to be catalogued for quick access. Cameras that can capture images in the raw file format are supplied with proprietary software to process and convert the files (see p28). This bundled software is great for people who want to keep digital imaging simple.

IMAGE-EDITING SOFTWARE

That pictures can be altered on computer is commonly understood. It's one of the best-known things about digital photography, and altered images are often referred to as having been 'photoshopped', in reference to the industry-standard image-editing software Adobe Photoshop.

Specialist software is available for every aspect of the postcapture process of digital imaging, and ranges from highly sophisticated programs that offer powerful and sophisticated tools with customisable features to simple one-purpose applications. You can pay or consider the free options. Like all software, each product has pros and cons, and you'll need to assess them in terms of your personal needs and budget. Consider the following, aimed at the beginner and general consumer market: Adobe Photoshop Elements, Corel Paint Shop Pro, Ulead

PhotoImpact, Roxio PhotoSuite and Serif PhotoPlus. Mac users could also check out GraphicConverter.

FREE SOFTWARE

There are several free options, and if you're completely new to the image-editing side of digital it's not a bad idea to explore one of these first to see what's possible and gauge your level of interest in the process. You may find you enjoy this as much as taking pictures and so will want to purchase a sophisticated package, or you may find the free software offers enough for you. Download The Gimp, RawTherapee or VicMan Photo Editor to experience what you can get for free.

RAW FILE–CONVERSION SOFTWARE

Raw files must be processed or converted before they can be opened in photo-editing programs. Conversion software converts the file into a recognisable RGB picture, which is then processed into a standard file format, usually JPEG or TIFF. You have considerable creative control over how the data is processed, including being able to adjust exposure, colour, contrast, saturation, sharpness and white balance. These are the same as those offered in the menu of nearly all digital cameras but they are considerably more powerful and sophisticated, plus they offer more controls.

If your camera can capture raw files, the bundled software will include proprietary raw conversion software made by the camera manufacturer. This is dif-

ferent from maker to maker and often different between camera models made by the same company. Many image-editing and workflow applications include raw file conversion software that can handle the files from many different cameras. Adobe Photoshop's Camera Raw software, which ships with Photoshop, Photoshop Elements and Adobe Lightroom, supports more cameras than any other program. If you're going to use a third-party raw conversion program, check that it supports your camera. As new cameras are released the software vendors release updates to support them, but there may be a lag.

IMAGE BROWSERS

Image browser programs such as Adobe Bridge, which is bundled with Adobe Photoshop and Photoshop Elements, and PhotoMechanic by CameraBits allow you to browse a folder of images. You can view your images as a set of thumbnails in varying sizes, or individually in the preview window; add metadata such as your name, the image location and a caption; assign ratings to images and then sort by rating; move or copy images into different folders on the hard disk or an external hard disk; and view the EXIF metadata recorded by the camera at the moment of capture. You can also process and convert raw files ready for editing in image-editing software.

IMAGE CATALOGUING PROGRAMS

As your image collection grows – and for digital shooters it can grow very quickly –

there is a real need for you to be able manage it so you can find files quickly and efficiently. Cataloguing programs such as Extensis Portfolio, Phase One Media Pro and Canto Cumulus make it possible. These programs allow you to create thumbnails of your images, add metadata and keywords and then find them in any folder on the computer's hard disk, external hard disk or optical media.

WORKFLOW PROGRAMS

Dedicated workflow software, such as Apple's Aperture and iPhoto (which is bundled with all Macs) and cross-platform Adobe Lightroom, Corel After-Shot Pro, CyberLink PhotoDirector and ACDSee Pro, are single applications that have been developed to provide all-in-one solutions to image management by performing every step of the workflow from importing images to output, allowing users to manage files as they move from camera to editing, to storing, to output.

Computer users will be familiar with managing text and image files via a folder system using the file manager in the computer's operating system (OS). Image-workflow software takes the place of the computer's OS file manager, and images are imported into its library system instead. It's then possible to browse, compare, sort, add metadata, add ratings, process raw files, edit, resize (for web galleries, photo sharing sites and email) and export files to a printer. Most importantly you can search your entire image collection at once, not just one folder at a time.

PREPARATION

Once you've got your gear sorted, there are plenty of other things you can do at home to make your trip photo-friendly. If taking photos is an important part of your trip, it's worth planning your travels with your photographic goals in mind. Time spent researching your destinations, preparing for the conditions and creating shot lists will be rewarded with increased photo opportunities and more pictures. Simply shooting as you go along will rarely provide enough opportunities to be in the right place at the right time. You might be lucky and stumble across a weekly market or an annual festival, but a little research can guarantee your presence at such events, which is much better than turning up the day after and being told how wonderful it was.

Often, even with thorough research, you'll still find yourself having to stand around in one spot for ages, or going away and returning. As most people travel with friends, family or partners the priority given to photography often has to be compromised, but with a little planning you can increase the amount of quality time available for taking pictures and still accommodate the needs of your travelling companions. If you're on a set schedule, on say a group tour, your options may be very limited, but that's even more reason to do some preplanning with photography in mind. Likewise, the shorter your trip or time in each place, the more thorough your research and planning should be. If time is of the essence, you really do not want to miss the best sights. Nor do you want to spend valuable time walking to a place to discover that it would have been better to visit at another time of day.

You also need to allow time to become thoroughly familiar with your equipment, practise your shooting techniques and come up with a plan for managing and protecting your images.

Chinese New Year Festival, Beijing, China
When the idea for a trip or offer of an assignment comes up, I check the dates of festivals and the days of the week that markets are held. This forms the basis of my itinerary. In this case, a two-week trip was built around Chinese New Year celebrations in Hong Kong and Beijing.
DSLR, 24-70mm lens at 24mm, 1/160 f9, raw, ISO 200

RESEARCH

You can learn a lot about a place that will help you make photo-friendly decisions in the planning stage and begin your familiarisation process well before you arrive. Complement the obvious questions about how to get there, what the exchange rate is and what the weather is like with research into potential subjects, such as market days and festivals, the best viewpoints, and sunrise and sunset times. Then add information gained by viewing images on websites, in brochures, magazines and books, and you'll be in a much better position to determine when to go, where to stay, what to see, the order of your itinerary and how long you may need in each place to achieve your photographic ambitions. One day at a monastery festival featuring lama dancing may be enough for the sightseer, but someone keen to take photographs could happily spend three days watching the event.

If you know people who have been to your destination, ask them what they did and look at their photos. You'll soon discover a great deal about the place.

GET INSPIRED

You can learn a lot about the photographic possibilities and be inspired by some of the best images taken at the destinations you're going to visit by searching the image collections of the big photo libraries like Getty Images (www.gettyimages.com) and Corbis (www.corbis.com), and specialist travel-image libraries like National Geographic Stock (www.nationalgeographicstock.com) and Robert Harding (www.robertharding.co.uk). You'll find thousands of images shot by professional photographers over several years in all sorts of conditions, as well as themed travel-related galleries that are sure to whet your appetite.

WHEN TO GO

Assuming you're free to go any time, don't book your flights until you've checked out two key factors: the dates of special events and festivals, and the weather.

Festivals provide so many great photo opportunities that it is well worth planning your trip around them. Also check the dates of public holidays, as there are often special events associated with them.

No matter how well you plan you can't control the weather, but you can increase your chances of getting the conditions you want by understanding the climate of the region you intend to visit. Day after day of blue skies isn't necessarily the aim; it might be great for sightseeing but it's not so good for creative photography, unless you're specifically shooting for holiday brochures. Inclement weather can provide the atmosphere and light that will make your images different. Ideally, you'll be in a place long enough to experience a variety of conditions, which will add interest to your image collection.

TRAVELLING WITH OTHERS

Trying to combine serious photography with a family holiday, or while on a group tour, can be a challenge. Group itineraries are rarely sympathetic to the needs of a keen photographer. The one exception to this is dedicated photo tours, often led by experienced travel photographers. These trips are intended to put you in the right place at the right time, and to give photography priority.

However, if you're not on a photo tour, with a little thought you can do many things within the normal parameters of a holiday with others and still maximise your time photographically. For example, many cities have observation decks at the top of buildings, or lookouts from nearby hills. A map will tell you if the direction of the sun will be best in the morning or afternoon. With this information you can suggest visiting the place at the best time for photos. Others won't care when they visit as long as they visit, so take control of the timing. You can apply this tactic to the entire itinerary.

It's best to pick one or two themes to photograph comprehensively, and work on them within the framework of recording your trip. You could prioritise markets, allowing extra time for them and shooting the rest of your trip as it happens.

One of the easiest ways to fit in with others but still give photography some priority is to get up and shoot before breakfast. The light is often at its best, the activity in towns and markets is at its most intense and interesting, and you won't inconvenience anyone. You'll also be rewarded with experiences and images that most people miss. The more thought you give to this possibility in the planning stage, the more chance you have of making it happen.

Use a guidebook to complement your group tour. There'll often be other attractions in the area that the tour won't visit, which you might be able to find time to get to alone.

On safari in Ranthambhore National Park, India
Sometimes, especially when the chance of spotting a tiger is imminent, you just have to fit in with the group, or in this case several groups.
35mm SLR, 24-70mm lens, 1/125 f5.6, Ektachrome E100VS

101

TIME

It goes without saying that the more time you have, the more opportunities you give yourself to photograph subjects in the best light. Photographers demand more time in a place than the average camera-toting tourist – sometimes just a few extra minutes can make all the difference. The sun may come out or go in, the right person may stop and stand in just the right place, the rubbish-collection truck that's parked in front of the city's most beautiful building may move on, the person buying fruit may hand over their money. If you have days rather than minutes, you can look for new angles and viewpoints of well-known subjects, visit places at different times of the day, wait for the best light, and get better coverage.

Although it's possible to cover a lot of ground in a day and work quickly through a shot list, the light is at its absolute best only twice a day. It's not easy photographing more than one or two subjects in that hour or so at the beginning and end of each day.

As a really rough guide, assuming your intention is to photograph as many subjects as possible, four nights and three full days will allow you to cover most cities and towns reasonably well, although you'll need to set a cracking pace in the larger cities. Importantly, you'll be able to plan at least six sessions of photography in the best light.

Three more days will allow you to go beyond the expected and delve deeper into the life of the city and its inhabitants. You'll be able to explore lesser-known places and encounter people who don't see a lot of tourists. You'll benefit from being able to shoot at a more comfortable pace, increase your chances of getting great light at dawn and dusk, and decrease the impact of bad-weather days. The extra time will also allow you to experience the destination on working days and over a weekend, when the atmosphere, activity and photo opportunities can vary considerably. You'll also be able to get to take one or two day trips to surrounding places of interest.

Don't forget to take into account the time of year and the season that you'll be visiting. European summer days are very long and winter days short, whereas on the equator the sun rises and sets at about the same time every day.

SHOT LISTS

As you make discoveries about the places you're going, create a shot list: a list of the subjects and places that you want to photograph. Group the subjects by location and make notes such as opening times and the best time of day to visit.

Circle each place on your map. This will show you how much walking you can expect to do, and will also give you an idea of the best time of day to shoot each subject, simply by determining the position of the subject in relation to the rising and setting sun.

Gradually you'll build up a picture of everything you want to see and when to see it. In turn this will inform your decision of the best area to stay and how many days you'll need to cover everything. If your time available is fixed, it will help you prioritise to ensure you can photograph the main subjects in the number of days you have.

A well-researched shot list will make you the most informed person in town, but don't be afraid to stray from it. There will be plenty of interesting things to photograph that you haven't read about or seen pictures of, particularly the everyday activities of the local people.

PERFECTING YOUR TECHNIQUE

There's no better way to prepare for shooting your trip than getting out there and doing it. You can photograph most of the subject themes discussed throughout this book in any town or city in the world, including your own.

Planning and executing a shoot of your own city is a great way to practise your research skills, test your camera equipment, perfect your technique, develop your eye and get a feel for changing light. Buy a guidebook, check out the postcards and souvenir books, and draw up a shot list. Treat the exercise exactly as you would if you were away from home. You'll quickly get an insight into just how much walking you can expect to do, how many locations and subjects you can expect to photograph in a day, and how manageable your equipment is. You can then use this knowledge to plan your trips away from home a little more accurately to meet your own goals.

As a bonus, you'll be rewarded with a fresh insight into your home town. You're sure to see it in a different light and to discover subjects and places you didn't know about.

EQUIPMENT

Don't travel with equipment you've never used before; organise it in plenty of time and use it for a while before you set off. If you don't have time to become familiar with the gear, at least take the camera manual with you. Check and clean gear at least six weeks before you travel. Allow plenty of time to have cameras serviced and repaired if necessary, or to buy new equipment and familiarise yourself with it.

An advanced compact camera or, better still, a second DSLR camera body is great insurance against loss, damage and breakdown. But don't forget: it's no use having a second DSLR body in your pack if all your lenses are stolen.

Pack your camera battery charger, leads and adaptor plugs in your carry-on luggage with your camera so that if your luggage is lost or delayed for more than a day you'll still be able to take photos.

CHECKING DSLRS

Thanks to the instant playback of images you at least know immediately if there is a problem with your digital camera. Even so, it's still worth putting a DSLR through its paces to double-check every component is functioning properly. This is also good practice immediately after your gear is serviced or repaired. Particular attention has to be paid to keeping the sensor clean. The following steps will confirm all is well:

o Take several images on all the memory cards you intend to travel with.

o Take shots at various combinations of shutter speed and aperture.

o Take a series of shots using the continuous or burst mode.

o Repeat the above steps with each lens you use.

o Test the self-timer and the flash, and use any other accessories you intend to take.

o Clean all lenses and filters with a blower brush and/or a natural air blower. If there's dirt or fingerprints that won't blow off, breathe on the lens or filter and then wipe the lens gently in a circular motion with lens tissue or a lens cloth. If the marks are really stubborn you will need lens-cleaning fluid. By always having skylight filters on your lenses you should rarely have to touch the lens.

o Use a blower brush and/or a natural air blower to remove dust from the rear lens element.

o Use lens tissue or lens cloth to clean the eyepiece.

o Check that all screws on the camera and lenses are tight.

KEEPING THE SENSOR CLEAN

Keeping the image sensor of a DSLR free from dirt and dust is critical. Sensors are electrically charged components and consequently attract dust. This is only an issue for DSLR cameras when the sensor is exposed while lenses are being changed. The main problem is that any dust or dirt on the sensor will appear in every image. It can be removed with image-editing software, but imagine how much time that could take after a trip. Note also that you're not going to see the result of dust on the sensor when viewing your pictures on the camera's LCD screen. It's not until you view a variety of images at 100% magnification in image-editing software that the problem will be revealed. Some of the latest DSLR cameras have built-in sensor-cleaning systems that vibrate the sensor to dislodge dust; these vary in their efficiency, which experience with your own camera will reveal. You may want to consider having the sensor professionally cleaned before a trip, but you also need to know how to do it yourself so that you can deal with problems on the road.

CHECKING FOR SENSOR DUST

Checking for sensor dust is best done when you are able to transfer images to a computer. Follow these steps to see if you need to take action:

o Set the focus mode to Manual and set the focus at infinity.

o Fill the frame with a piece of evenly lit, blank white paper and set the exposure at one or two stops over the meter reading to ensure the paper records as white.

o Take a photograph and transfer the image to your computer.

o View every inch of the file at 100%.

o If you see any kind of mark you'll need to clean the sensor.

If you don't have access to a computer you can follow the same procedure, but you'll have to inspect the file on the camera's LCD screen.

CLEANING THE SENSOR

Removing dust from the image sensor is a delicate operation and extreme care needs to be exercised, as damage to the sensor can render the camera unworkable and leave you with a costly repair bill. Only clean it when you know you have a dust problem. Ideally, you'll be able to remove dust with a blower brush or natural air blower without touching the surface. More-stubborn particles may require sensor swabs and cleaning fluid made specifically for cleaning sensors, at which point most photographers will use a professional service – this is the recommended course of action for everyone. However,

if you do have to clean the sensor this is how to do it:

o Set up in a closed environment, such as a room or a tent.

o Ensure the camera battery is fully charged.

o Use a purpose-made statically charged brush (such as one from Visible Dust) and/or a natural air blower (such as a Giotto RocketAir). Never use a compressed air blower, as it can blow moisture droplets onto the sensor.

o Remove the lens and choose the 'Clean Sensor' option from the camera's menu. If your camera doesn't have this feature set the shutter speed to the 'B' setting.

o Press the shutter to lock the mirror up and reveal the sensor. (This is why the battery should be fully charged. You don't want the mirror resetting while you're in the middle of cleaning the sensor.)

o Hold the camera with the lens mount facing down so that any dust will fall out and new dust is less likely to fall in.

o Gently brush the sensor and/or release a couple of bursts of air.

o Turn the camera off to reset the mirror and replace the lens.

o Follow the procedure for checking for sensor dust to see if you've been successful in removing the dust.

Prevention is, of course, the best option. Avoid changing lenses in dusty environments and windy conditions. This is easier said than done, but travelling with a single body and one zoom or two camera

bodies and two zooms will eliminate or minimise the need to change lenses.

CHECKING SLRS

A basic check and clean for a film SLR is quick and easy, and you can do it yourself:

o Remove the lens and set the shutter speed on the 'B' setting.

o Hold the camera up against a plain, light background.

o Release the shutter and keep your finger down so that the shutter stays open. You can now look right through the camera.

o Look for hairs intruding into the open shutter area (these will leave an annoying black mark on every photo).

o Release the shutter.

o Hold the camera upside down and use a blower brush and/or natural air blower to clean dust off the mirror (don't touch the mirror with anything else) and out of the film-cassette space and the take-up spool (wind the film lever on a couple of times while you're doing this).

o Gently clean the pressure plate on the back of the camera. Be very careful when cleaning near the shutter curtain and ensure that hair from the blower brush doesn't get left in the camera.

o Put a lens on and, with the camera in manual mode, select the one-second shutter speed and the smallest aperture on the lens.

o Still with the back open, release the shutter. You will now see the shutter open and the aperture stop down. Repeat this at various shutter speeds and aperture combinations with each lens.

Confirm everything is OK by putting a roll of film through the camera. Take shots at various combinations of shutter speed and aperture. Test the self-timer and the flash, and use any other accessories you intend to take. Keep details of the shots so that if there's a problem you can easily identify which piece of equipment needs attention. This is also good practice immediately after your gear is serviced or repaired.

HOW MUCH MEMORY CAPACITY TO TAKE

How much memory-card capacity to take is no longer a difficult decision as prices have come down dramatically and you'll rarely find yourself too far from someone selling them. However, it's best to leave home with your own tried-and-tested cards and only resort to on-the-road purchases if you've underestimated your need. How much mem-

ory to leave home with depends on the length of your trip, how many pictures you anticipate taking, the file size you select and how you intend to manage the image files.

If you plan to rigorously review your pictures and delete the unwanted ones, you could probably select an appropriate memory card to cover your needs. In this

Even if you are familiar with your gear, it's worth taking the camera manual with you. Digital cameras have so many features there's a good chance that you're not actually using them all. A particular situation may raise questions that if you have access to the manual may lead you to discover another great feature you didn't realise you had.

case, remember that you're only counting the good pictures. Judicious editing will mean that the memory card only needs to store your good pictures, not the ones that usually end up in the rubbish bin. Make review and selection easier and more fun by carrying AV cables (these come with most digital cameras) to connect your camera to a TV set. Most cameras are PAL and NTSC compatible, so you'll be able to view your pictures anywhere you can access a TV set. If this plan works for you it's still strongly recommended that you carry a spare card.

However, you may prefer to review your pictures at the end of the trip in the comfort of your home. This will give you access to the benefits provided by a personal computer with its superior processing speed and large monitor. In this case, you may choose to carry enough memory-card capacity for the entire trip. More highly recommended is the use of a portable storage device (see p66).

You'll want enough capacity on your card to store at least 72 images per day. The decision can be made much easier if you have a clear plan on how to manage the files.

WHAT CAN GO WRONG?

One of the wonders of digital photography is that it's possible to capture an entire trip on a tiny bit of plastic as big as a postage stamp. Unfortunately, the digital advantage may be negated if any of the following happen:

o You accidentally delete some or all of your images.

Once you've transferred the photos from the memory card to the storage device, you can delete the images from the memory card and reuse it. Rather than use the 'Erase All' function in the camera's review mode you should format the card. This clears all image and indexing data off the card much more effectively and ensures the card continues to deliver optimum performance.

o The memory card is removed before the camera has finished writing to the card. Always wait until the image has been saved before turning off the camera.

o The memory card is removed while the camera is turned on.

o The CompactFlash memory card is inserted carelessly. This can result in damaging the connector pins in the camera body, preventing it from accepting cards and resulting in an expensive camera repair.

o The memory card is damaged by an electromagnetic field. Keep memory cards away from TVs, computer monitors, microwaves and mobile phones.

o The battery fails during writing.

People at an internet café, Canberra, Australia

If you don't want to carry a laptop but still want to manage and share your pictures while you're away, you can do a lot of imaging work at internet cafés.

DRangefinder, 21mm lens, 1/60 f4, raw, ISO 320

ON THE ROAD: PROFESSIONAL PRACTICE

All photographers need a system that lets them work efficiently. I travel with a memory card reader, two external hard disks and a laptop loaded with Adobe Lightroom. Image files I manage as follows:

o I start the day with two empty 8 GB CompactFlash memory cards.

o At the end of the day I put each memory card in the card reader and connect it to the computer.

o Adobe Lightroom opens automatically and brings up a dialogue box that allows me to select the destination for the images and add metadata to the image files during the transfer process.

o I create a folder for the day's work named after the place they were taken, eg Cairo. If pictures are taken at more than one place on the same day I move them into unique folders after transfer.

o I add information that is generic to all images, such as name, copyright assertion, city and country.

o I click the 'Import' button and the images are transferred to the computer and automatically backed up to one of the external hard disks.

o I can see the images being loaded onto the computer's hard disk and I verify that the backup was successful by viewing the folder on the external hard disk. I now have the recommended minimum two copies of my original raw files.

o I put the memory cards back in the camera and format them.

o I review the images and delete the obviously bad ones so that I never have to look at them again.

o I wait until I get home to make final image selections, process the raw files and perform image-editing on my large, calibrated monitor.

o The memory card is damaged. When the card is not in the camera, store it in a purpose-made dust- and moisture-free container, out of direct sunlight and away from heat sources.

o The memory card is lost. They're very small and easy to misplace.

o The device containing the memory card is stolen. Storage devices are expensive pieces of desirable hardware and need to be protected from theft.

o The memory card is rendered useless or corrupted through mishandling or by a computer virus.

FILE RECOVERY

The good news is that if the problem is technical, data-recovery software can recover deleted files from removable media as long as you haven't recorded new images on the card. Some image files on cards that have even been formatted are still not beyond recovery. Specialist software usually comes with the card or you can download software from the internet that is cheap and effective. Some photo retailers provide a data-recovery service, which you may prefer to use if you're not confident dealing with the problem yourself.

WORKFLOW ON THE ROAD

If you're going to be travelling for more than the average holiday period, are using a camera with a 12 MP sensor or higher to shoot large JPEGs or raw files, and know you'll be taking a lot of photos, then carrying enough memory cards for the entire trip may not be practical or cost effective. You may also have concerns about travelling around with your entire trip's worth of photos on one memory card. This will mean you'll need to consider how you're going to manage your pictures to ensure you have enough free memory every day. You can also take advantage of another of digital photography's strengths and create multiple copies of your images for additional security.

Although this section looks at managing your images on the road, you actually need to have a plan as to how you're going to do this before you leave home, so that you are adequately prepared from day one of your trip. For a full discussion on digital workflow and digital-asset management back at home see p323.

TRANSFERRING IMAGES

One of the great attractions of the digital medium is the elimination of film and processing costs. To achieve this saving, the images on the camera's memory card must be transferred to a storage device. They can then be erased from the card and it can be reused. This process also provides an alternative to buying and carrying enough memory cards to cover all of your expected requirements. Images can be transferred to various storage devices, typically computers, portable storage devices and optical media such as CDs or DVDs, as well as to online storage providers.

STORAGE DEVICES & SERVICES

Carrying a portable (laptop or notebook) computer gives you the ultimate flexibility for dealing with image files on the road. Assuming you've got access to power to recharge the battery, enough hard disk for

Photographer's portable workstation, Bangkok, Thailand

Laptop computers, card readers and external hard drives are now standard in the travel photographer's kit.
DSLR, 24-70mm lens at 40mm, 1/40 f2.8, raw, ISO 400

If your computer doesn't have a dedicated slot for the memory cards you use, transfer photos from camera to computer using a card reader that plugs in via a USB port (see p67). This is a compact accessory that doesn't require battery power, minimising the risk of losing images mid-download as you can from the camera if the batteries drain. It also means you won't be draining the camera's battery power between sessions when you need to download images but don't have time to recharge the battery. Plus, transfer rates are considerably faster if you are using memory cards of 8 GB or more and transferring raw files.

storage and enough RAM for fast processing, you can review your pictures any time. The large screen allows more accurate assessment of your images before your decide whether to delete them. You can also make copies, organise, caption, enhance, email and upload photographs to your social media accounts using your preferred software as you go. See p93 for recommended specifications. However, portable computers add weight to your luggage and they make you a target for theft so they may not suit all travellers, especially those visiting out-of-the-way places.

Remember, when transferring raw files you won't be able to see the actual images unless the camera's proprietary software or raw conversion software is loaded (see p97).

An attractive alternative, particularly if you're travelling for a while and intend shooting hundreds or thousands of images, is a portable storage device (p66).

A convenient option for the traveller shooting JPEG files who wants to keep equipment, cost, weight and bulk down is to use local CD/DVD transfer services, available in most cities (and more and more remote places). Always ask the operator to run the completed disc to verify the transfer has been successful before deleting the images from your memory card. It's highly recommended that you order two copies and post one of them home.

If you can access the internet, preferably via a broadband connection, you can upload your images to one of the many online storage providers (see p335). You'll want to have an account set up and be confident using the service before you leave home.

Walkers crossing stream on Loft Beck, England
You'll often find yourself a long way from a camera repair shop, so even with your equipment properly insured, the last thing you need is a breakdown or an accidental soaking. You can't do much about it if you fall in a small (but raging) stream, but a thorough check, clean and test of all your equipment before you leave home will help minimise the risk.
DSLR, 24-70mm lens at 24mm, 1/125 f6.3, raw, ISO 125

INSURANCE

Travel insurance is essential. Find a policy that includes coverage of your camera gear. If you're carrying anything more than a standard outfit it may be necessary to insure it separately. Write a list of all your equipment with serial numbers and value, and carry two copies of this list on your travels. Keep one with your money and the other in your main bag. It will be essential if your gear is stolen and you have to fill in a police report.

If you buy equipment on the road, make sure your policy covers it. Copy the receipts and send one set home to prove ownership if everything is lost or stolen.

AT YOUR DESTINATION

You've got the gear, done the research, refined your technique and taken a flight. Now the fun really begins, and new issues and challenges arise. The time has come to face the reality of capturing images in a new and unfamiliar environment, with limited time and in the weather you're given. It doesn't matter how much reading and looking at pictures you've done – it isn't until you land at your destination and start exploring that you'll get any real sense of its scale, geography, layout, where the light falls at the time of year you're there and most importantly, your response to the place. It can be quite daunting, but once you're out and about there are ways of making every opportunity count. Security and camera care also need to be considered.

AT CUSTOMS

Unless you have an unusual amount of equipment you should have no trouble clearing customs at your destination. Don't panic if you read that you're only allowed to take in one camera (and you've got two or three) – you'll rarely be questioned. If you are, three things can help: say you're carrying the gear for others in your group (the size of which can vary, depending on how much gear you have); tell them you're not carrying video (unless you have a video camera), as customs officers are much more interested in video cameras than still-camera equipment; finally, explain that you have so much camera gear because their country is so beautiful!

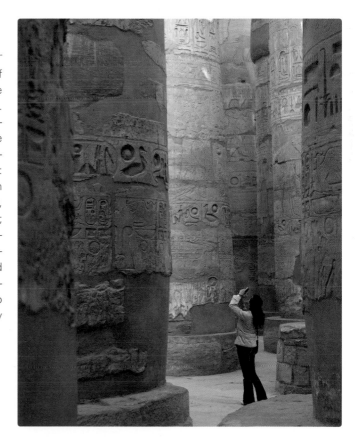

Tourist photographing in Great Hypostyle Hall in Amun Temple enclosure at Temples of Karnak, Luxor, Egypt
DSLR, 24-70mm lens at 47mm, 1/60 f4, raw, ISO 100

111

Hong Kong Island from Kowloon, Hong Kong, China
Some views are worth paying extra for. As the sun started to set, the light turned a most unusual pink colour, and I found myself sprinting back to my hotel room. It's great when you pay the money and actually get the shot as well.
35mm SLR, 24-70mm lens, 1/125 f11, Ektachrome E100VS, polarising filter

Always ask for a room on a high floor with a view, as you may be able to capture a great shot without even leaving your room.

WHERE TO STAY

Budget is often a factor in deciding where to stay, but to make your time most productive and enjoyable make sure you have an understanding of the size and layout of the city or town and the locations of the main sights before booking a room. Ideally, stay in as central a location as you can. Accommodation may be cheaper on the edge of town but you'll spend more money on taxis or have to walk further to get to the action. You'll also have to get up earlier, return home later and carry around extra bits of gear (such as your tripod) when you don't need them. It's a huge advantage to be able to pop back to your room to pick up and drop off gear as required, change and rest without losing valuable time travelling back and forth to your hotel.

FAMILIARISATION

For the photographer the aim is to get to know the destination as quickly as possible. Start on your way to the hotel from the airport, the train or bus station or from your car. Look for things of interest and ask the driver (language difficulties aside) what it is and then time how long it takes to get to the hotel, and ask for the names of the different neighbourhoods you drive through. Unless you arrive when the light is at its photographic best or when a festival is in full swing, take some time at the start of your visit to confirm key information from your pretrip research and start

to expand that research with local knowledge. Again, you can start by quizzing the taxi driver on the way to your hotel about the weather pattern, special events and vantage points. At the hotel you can ask a lot more questions of the reception staff and the concierge, and then ask again at the local tourist office. Always assume there is more on than you know about. There are far too many local festivals and events for guidebooks to list. If your own research revealed details about an event, don't be put off if the tourist office staff have no idea what you're talking about.

Some local festivals are so local that half the locals don't even know they're on.

The main point is not to assume that people will spontaneously inform you of what to see and what's on. In fact, it pays to get into the habit of seeking information from a variety of sources, including fellow travellers, throughout your stay, as you can never have enough new and useful information. The quality of answers will vary from an uninterested 'I know nothing,' to having someone drop everything and not rest until they've tracked down every last answer for you.

Try to undertake the following:

o Confirm event dates and times that your pretrip research uncovered, and establish the best places to be on the day.

o Confirm opening hours.

o Confirm sunrise and sunset times.

o Get local opinion on what to see, interesting locations and vantage points.

o Check that there are no access issues at the vantage points for your sunrise shoots (such as opening times for a gate in the 2m, barbed-wire fence), then work out how you're going to get there and how long it will take.

o Ask about cultural restrictions or local sensitivities to photography. Borders are often sensitive areas, as are airports, bridges and anything that resembles a military checkpoint or installation.

o Check out what tours are on offer and assess their usefulness.

o Check out postcards, tourist publications, local magazines and books – they provide a good overview of the places of interest, as well as a guide to potential vantage points. This is worth doing regularly during your stay, as the images will make much more sense as your familiarity with your destination grows.

But really, there's no better way to speed up your familiarity than to get out and walk. You'll quickly add first-hand knowledge to your research, and the map will soon make a lot more sense. Head for the main attraction: a city square, the main street, a market, the beachfront or the harbour. Study your map as you go, to get a feel for where things are and the direction of the light in relation to the main sights. You'll also quickly get a sense of the best ways to get around. On this first sojourn ensure you get to at least one vantage point that overlooks the area.

In larger cities consider joining an organised city tour. These have limited use for good photography as they're usually run in the middle of the day and give very little time at each destination, but are a useful and inexpensive way to get a quick overview of a new city and its main sights; particularly in very large cities, where walking everywhere isn't practical or even sensible. You can then decide where you'd like to spend more time and at what time of day. If your budget allows or time is of the essence, forget the bus and do the same thing in a taxi. You can start earlier, finish later and spend as little or as much time at each place as you wish. If you get the right taxi driver, you'll find yourself with a personal guide who will be full of useful information that you can put to good use in the days ahead.

Never, ever trust the weather. If the weather is fine on the morning you arrive it's very easy to assume that it will still be fine in the afternoon. This is a big mistake. If you're clear about your priorities, start at the top of the list if conditions are good. If you arrive in unfavourable conditions you can start with lesser priorities that are more suited to the conditions. And remember, it works both ways: bad weather can turn good just as quickly.

VANTAGE POINTS

Make your way to a high vantage point that overlooks your destination as soon as you can. Not only will it help you get your bearings and make the scale of the place clear, but you're pretty well guaranteed excellent photo opportunities.

Big cities often have official vantage points on nearby hills or at the top of tall buildings that provide great views of the city and beyond. Local postcards and tourist brochures will feature these views and often reveal the time of day they were taken. If not, use your map to determine if it's best to head up in the morning, afternoon or either. After taking in the well-known views, try to seek out different vantage points at various locations around the town so you can create distinctive photos.

Smaller places may not advertise a lookout, but most taxi drivers will know where you can look out over their town, or simply just follow the streets that are heading uphill. Hotels of all standards sometimes have rooftop bars, restaurants and swimming pools that can be easily accessed. Other views can be had from café balconies, shops windows and high-rise car parks. It's worth checking out a few of these possibilities during the day, noting where the sun will set and rise, and returning later to the best-placed viewpoints.

Skyline reflected in Main River at dusk, Frankfurt, Germany
Cities built beside rivers are a real bonus for the photographer. Many and various vantage points along the river bank and bridges are just about guaranteed. The reflections of the buildings in the river not only add a very photogenic element to the composition but their inclusion prevents linear distortion.
DSLR, 24-105mm lens at 28mm, 13 secs f6.3, raw, ISO 100, tripod

FINE-TUNING PLANS

As you're exploring your destination, consider what you're learning and start fine-tuning your shot list. You'll soon discover that a theoretical shot list drawn up thousands of kilometres away will not totally match the reality on the ground. You'll have to add and subtract subjects for lots of reasons. You may spend half a day photographing a festival that your pretrip research didn't reveal, or an event may be cancelled, leaving you with unexpected time on your hands. The weather may be playing havoc with your schedule. You may have to miss out on photographing a building because it's covered in scaffolding; a fountain may be dry; a landmark hotel shut for renovation. The list of variables is endless, and you need to adapt quickly to ensure you see and photograph everything that is important to you.

Plan what you intend to do each day, paying particular attention to what you're going to photograph in the late afternoons,

at dusk, at sunrise and in the early mornings. This will help you prioritise your schedule as reality takes over from pretrip research. This is an ongoing exercise that will keep you busy every time you sit down for a coffee or a meal.

Nanda Devi at sunset, Garwal Himal, India
I was about to start a 14-day trek; as the bus pulled up at the road head, the clouds cleared from the peak I'd come to see. I frantically put on my telephoto lens, mounted the camera on the tripod and got off four frames before the colour disappeared, and then the mountain itself. I didn't see Nanda Devi again for the entire trek. Always have your gear ready so you can set up fast. Never, ever assume you'll get a second chance.
35mm SLR, 180mm lens, 1/8 f11, Ektachrome E100VS, tripod

ROUTINE & HABITS

Potential images come and go in front of your eyes in a matter of seconds and are easily missed. A good routine plays a big part in helping you react quickly to photo opportunities. Let's start with the most obvious one: never leave your hotel room (or your house, if you're a home-bound traveller) without your camera. Even if you arrive in terrible weather conditions or there's only 10 minutes until sunset or you have a specific nonphotographic reason to be heading out, take your camera. Opportunities can occur at any time, even when you least expect it. It's almost guaranteed that these photo opportunities will be particularly interesting, unique and never to be repeated if you don't have your camera with you. Don't say you haven't been warned!

115

BEFORE YOU SET OFF

o Set the local time and date on your camera to ensure accurate data records. This is especially important if you're shooting with two cameras or intend to share photos with fellow travellers.

o Ensure you've got enough memory for the day, even if you intend to return to your hotel. Only you know how much you'll need based on your camera's maximum resolution and your shooting habits. But as a guide, start the day with at least 1 GB of free memory in 6 MP cameras, 2 GB in 8 MP to 10 MP cameras or 4 GB in cameras of 12 MP or higher.

o Pack a spare memory card.

o Keep everything in the same place in your bag so you're not constantly searching for things.

WHEN YOU'RE OUT & ABOUT

o Have your camera around your neck, switched on and with the lens cap off.

Sunburst over Sarankot Village, Nepal

The disappointment of waking to a cloudy, wet predawn sky can quickly turn to elation if you have the strength to stick to your plan (and not go back to bed) and head to your predetermined viewpoint regardless. You can't judge the weather from 10km away, and you can't assume there won't be great light for two minutes – even on the worst of days.

35mm SLR, 24-70mm lens, 1/60 f8, Ektachrome E100VS, tripod

You can't take pictures quickly if you have to get the camera out of a bag, remove the case, turn it on and remove the lens cap.

o Have the lens you're most likely to need on the camera. If you're on a crowded street looking for environmental portrait opportunities, a 24mm might be a good choice. If you're using zooms, set the lens at the most likely focal length for the subject you're anticipating.

o Be aware of existing light conditions and have your camera set accordingly. Change the settings as conditions change. If using manual settings, adjust the aperture and keep the shutter speed appropriate for the lens you're using. If your camera is set on auto, make sure the shutter speed doesn't drop too low for hand-held photography without you realising.

o Constantly check the ISO, especially if you're in and out of buildings and you're increasing the speed for low-light interiors. It's very easy to then shoot in bright outdoor conditions with an inappropriate ISO setting.

o Always change memory cards when they're full, or even before. It's often worth changing when you only have a couple of shots left, rather than only having a couple of frames available when the action starts. The same applies for film users.

o Store full memory cards in appropriately marked storage containers separately from empty memory cards so you don't grab a full one when you're in a hurry (and have to spend precious

time deleting images or finding another card before you can take photos).

o Have a notebook and a pen in your camera bag for recording important information quickly and accurately.

AT THE END OF THE DAY

o Prepare your gear each evening for the next morning's shoot so you're ready to go as soon as you wake up.

o If you're carrying a laptop or a portable storage device, download images, back them up and format memory cards (see p109 for details on digital workflow).

o Charge batteries.

o Clean lenses.

o Clean the sensor if necessary.

o Set the shutter speed and ISO for your intended first use. If you've been using your camera on a tripod and making long exposures, set the shutter speed back to your normal hand-held preference.

o If you've been using the self-timer for added stability on long exposures, turn it off. There's nothing more frustrating than hitting the shutter for the first shot of the day only for the camera to start beeping and fire 10 seconds later.

The LCD screen has been a great development in photographer/subject relations, allowing pictures to be shared on the spot and letting the subject enjoy the result of your photography, albeit briefly.

PHOTO ETIQUETTE

There are no rules for taking pictures, except those imposed by the law and local authorities. Mostly it's up to individuals to assess what is and what isn't appropriate.

You need to distinguish between activity put on for tourists where taking photos is expected and welcomed, and day-to-day activity. Just about anything can be photographed, including religious ceremonies, funerals, people on family outings or on the beach, if approached with sensitivity and respect. I really do believe it's possible to be respectful and still come away with not only great images but a rewarding experience to match.

People often ask you to send them a photo. If you take people's names and addresses with the promise of sending a photo, make sure you do. If you don't, it makes it harder for the next traveller,

Cremation, Pashupatinath, Nepal
There is no problem photographing the cremations that take place regularly on the burning ghats on the Bagmati River at Pashupatinath Temple in Kathmandu. But in these self-regulatory situations it is up to travellers with cameras to behave appropriately. This is what telephoto lenses are for. Photographing the same scene on the cremation ghats at Varanasi in India causes grievous offence and could cause you bodily harm if you choose to ignore local advice.
35mm SLR, 24-70mm lens, 1/125 f8, Ektachrome E100VS

and gives tourists (and photographers) a bad name. Just remember that when you get home, organising photos for a dozen strangers in distant lands is much more of a chore than it appears when you're having fun collecting names and addresses. Having said that, if your subject has an email address, it's a lot easier to email a file than to make prints and post them. You can also turn the request for a photo into an advantage if you hope to license the images, by getting your subject to fill in their details on a model release form (see p352).

People travelling in groups often unintentionally put local people in a difficult position by queuing up or crowding around someone who has agreed to be photographed but didn't realise they were giving permission to a whole busload of camera-carrying tourists. Unless the person is a professional model or someone who is posing for photos and receiving payment, this could make them feel quite uncomfortable. Try to find others to photograph. You can help prevent this zoolike atmosphere from happening if you're the one taking the initiative and approaching people just by wandering away from the group for a few minutes. You'll be rewarded for this behaviour with photos of the locals who aren't on everyone's memory card.

> If in any doubt at all about the appropriateness of taking pictures, just ask. It's always worth getting two or three opinions if the first one is negative.

RESTRICTIONS

You will come across few places that have restrictions on taking photographs for personal use, particularly outdoors, but make sure you're aware of any cultural restrictions or local sensitivities to photography. For example, bridges in India and beaches in France can be sensitive subjects, as are border posts, airports and anything that resembles a military checkpoint or installation. If a sign says 'no photos' it should be respected. It doesn't mean you can't seek permission: a courteous enquiry can often result in the stated rule being overturned.

Generally, you'll only need to seek permission when you want to take pictures (other than a couple of quick snaps) inside shops, cafés, restaurants, bars and nightclubs or other private businesses. These are difficult places to take decent pictures in quickly and without drawing attention to yourself, so it's wise and polite to seek permission before you pull out the camera.

Be aware, though, that seeking permission in some places can lead to a small-scale Spanish Inquisition, with numerous phone calls to off-site managers and the loss of a lot of time. Unless you're on assignment and have to get a shot in a particular establishment, it's easier to move on and ask elsewhere.

Setting up a tripod is the single quickest way to draw attention to yourself and can trigger security people into action. Large, modern shopping complexes and entertainment areas appear to be particularly sensitive. The logic seems to be that if you're using a tripod you must be a professional, so you should have permission.

TAKING NOTES

Take notes of what you've photographed and where you took it from. If you're shooting film also note the date and time of day. Digital users have the luxury of having date and time recorded automatically in the EXIF metadata (see p34). Not only is this information important for captioning your pictures later, but it's an effective way to learn from your own endeavours and very useful if you wish to return at a later date.

It can be just as important to make notes when you haven't taken a photo. When you find a location or subjects that will make a great image but you either don't have the time, the light isn't right or the elements you want to include aren't in place, note the place and its appeal. Use your compass to establish a north point; this will indicate where the sun will rise or set and allow you to determine the best time of day to return. Balance this with other factors, such as whether you want people in the shot.

Don't attempt to commit this knowledge to memory. It's easy to mix up the details of subjects, locations and times of day when you're taking a lot of photos in an unfamiliar place. It's also very easy to simply forget about potential shots, especially on a first visit, as you'll be overloaded with possibilities.

Note-taking is an important part of the overall package for successful travel photography. Good notes are needed for correct captioning of the images, and as a reference for returning to the same spot at another time.

SECURITY

You need to be alert and proactive to minimise the security risk to yourself, your equipment and your images. Cameras are, unfortunately, particularly attractive targets for thieves. For digital-camera users who are filling up memory cards rather than downloading images each night, it's even more imperative to protect your camera. With film, the most you could lose was 36 photographs. Now, you could lose an entire trip – hundreds, even thousands of photos, if your camera is stolen on the last day.

Most guidebooks will advise you to not walk alone at night on deserted city streets or through parks, but there may be other areas that are best avoided all the time. These no-go areas may be revealed in your

Lenin's Tomb in Red Square, Moscow, Russia
Lenin's Tomb is photographed day and night by hundreds of visitors who visit the Red Square. But to capture it illuminated against a darkening sky requires a tripod and long exposures. I didn't know it would lead to the threat of arrest (nothing a little cash didn't sort out). Experience, however, has taught me not to set up until the very last minute in the most discreet manner possible, then to work really fast to get my shots, just in case.
35mm SLR, 24-70mm lens, 5 secs f11, Ektachrome E100VS, tripod

pretrip research, but get local and updated opinion from your hotel staff on arrival. It's better to deliberately investigate these areas than accidentally wander into them.

This is a particular issue in some urban areas at vantage points overlooking the city, as these are often located in parkland and you'll either be there very early, when few people, if any, are about, or completing your photography after dark.

Things change: the guidebook author may have had a bad experience that coloured their advice; an area may have been revitalised as a result of commercial development; or security may have been increased to deal with the issue. However, if the area is considered risky and you still want to go there, hire a local guide or take a taxi and ask the driver to wait.

Being overly concerned about the security of your equipment doesn't only take the fun out of photography – it can prevent you from taking photos at all. A camera is no good at home, in the hotel, or at the bottom of your day-pack. By taking sensible precautions and remaining alert, you should be able to access your camera quickly and easily and still retain possession of it.

Here are some tips to minimise the risk of having your photographic gear and images stolen:

o Cameras, lenses, memory cards and the battery charger should be carried onto the plane as hand luggage on the way to your destination. Even if your clothes don't make it, at least you can take photos. You may choose to pack some equipment in your check-in luggage on the way home.

o Carry the camera bag across your body, not on your shoulder – it's harder to snatch.

o Carry your camera around your neck, not on your shoulder – it's harder to snatch.

o Don't put your gear in an expensive-looking bag with 'Canon' emblazoned on the side.

o If you have a top-opening bag, close it between shots.

o When you put your bag down, put your foot through the strap.

o Walk on the building side of footpaths rather than along the kerb so as to avoid motorbike thieves.

o Carry a portable storage device and transfer images each evening.

o Back-up images from the portable storage device to CD regularly. Ideally, transfer images to two CDs and post one or both home (on different days).

o Don't plan to shoot your entire trip on one high-capacity card. Although very attractive in terms of convenience (especially if you're shooting large JPEG

Outdoor market, Soweto, South Africa
Johannesburg and Soweto have troubled reputations that are hard to ignore on your first visit, especially as it's reinforced by the locals. Consequently, I thought it prudent to hire a driver/guide to show me around and generally watch out for me. It's not something I do often, but if time is limited or you're unsure of the security situation it can save a lot of time and worry.
35mm SLR, 24mm lens, 1/125 f11, Ektachrome E100VS

or raw files), if the card is damaged, lost or stolen you lose all your pictures. Several 2 GB or 4 GB cards offer more peace of mind. Be sure to store them carefully, since some of them are very small and can be easily mislaid.

o If you're not carrying a portable storage device, transfer images to CD regularly.

o Store memory cards, your laptop and portable-storage devices in the hotel room's safe or a safety deposit box at reception.

o If safes and safety deposit boxes don't exist and you're not confident in the security of your room, carry full memory cards with you in the same place as your money. Ideally, you'll have a backup of your images somewhere else as well.

o Never place your gear on overhead racks on trains, boats or buses. In other words, never let it out of your sight.

o If travelling overnight on trains or ferries, use the bag as a pillow, perhaps under a jacket.

o If you go out without your camera it's best locked in the in-room safe or in your main pack or suitcase, rather than left in a portable camera bag. If you have more than one camera, separate them.

o Never leave equipment, or exposed memory cards, in an unattended car.

DEVELOPING AND PRINTING FILM

Although not a lot of colour print film is being shot now, it can still be conveniently and cheaply developed and printed in most medium-sized towns. The labs haven't thrown out their very expensive processing equipment just yet. A good lab will be well patronised by locals (like a restaurant), so if it's busy it's probably doing a good job.

Most big cities have professional labs that process colour slide film. If you're in doubt about the lab doing a decent job, don't leave your film. Process one roll as a test before committing the film from your entire trip. Unless you're carrying a loupe, use a lens with the front element to your eye to magnify the slides for easier viewing. A 100mm lens is ideal.

SHIPPING DISCS, FILM & PRINTS

If you're travelling for an extended period (over three months), you may want to consider sending discs, film and prints home for security and practical reasons. If you've had your images printed along the way or shot slide film and processed it, you'll soon find that packets of prints and boxes of mounted slides take up a lot more space and are far heavier than a few memory cards or unprocessed film cassettes.

If you do ship discs and processed film, send the discs or negatives and the prints made from them separately, and post them a week apart from different post offices. If you've numbered your films sequentially, split them into odds and evens and ship them separately, again on separate days from separate places. If the worst happens, you won't lose a big chunk of images from one part of your trip.

Ship film with an air-courier service, rather than through the post. The expense is justified. Shipping unprocessed film raises the issue of X-rays again. Parcels may be X-rayed. Depending on the company, and the countries you're shipping between, you may be able to get an assurance from the agent that parcels won't be X-rayed, but there's some risk. Identify your parcels as having undeveloped film inside: not to be X-rayed.

Let someone know the film is on its way. They can take it to your lab of choice for processing or store it in a cool, dry and dark place. The refrigerator is a good place for this.

Balkumari Jatra Festival, Thimi, Nepal
When you're this close to red-powder-throwing revellers you and your camera are going to get covered in the stuff, unless you're prepared. The camera in-the-plastic-bag technique (p123) works well in instances such as this, and you'll be the envy of other travellers who can only photograph from a distance.
35mm SLR, 24mm lens, 1/125 f8, Ektachrome E100VS

CAMERA CARE

Things can go wrong. Problems are magnified in remote areas because camera-repair shops often don't exist. Equipment problems can occur in all sorts of ways: cameras can get lost, dropped, stolen or stop working. Regular checks and cleaning help prevent some problems, but others have to be dealt with along the way.

Do the basic check and clean described on p103 at least once a week while you're

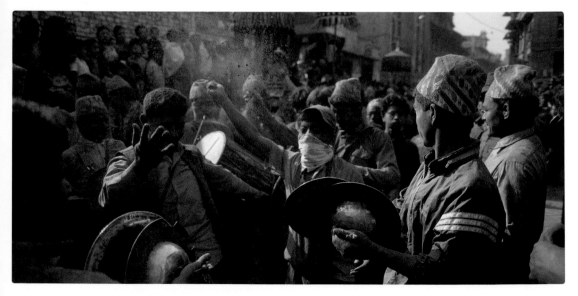

travelling. Check lenses and filters daily to prevent a build-up of dirt and fingerprints. These should be removed immediately, as they can cause flare and loss of definition, resulting in soft images. This is equally true for compact cameras as for DSLRs.

If your camera does break down while you're travelling, there really isn't much you can do about it except take it to the nearest camera shop and hope someone can perform some magic. If it's a new camera, trying to fix it yourself by opening it up will void the warranty.

THE PLASTIC-BAG TECHNIQUE

One quick and easy solution to protect your gear from most airborne problems is the old 'plastic bag and rubber band' trick. Cut a hole in the bottom of a plastic bag just big enough for the lens to fit through and use a rubber band to secure it in place on or just behind the lens hood. You then access the viewfinder and shutter release through the bag's original opening. The lens hood will help protect the filter on the front of the lens from rain, snow or dust, but keep checking it and wiping it as necessary.

PROTECTION FROM THE WEATHER

Weather conditions can change rapidly, so you have to be prepared. Just because it's a perfectly still, sunny day when you leave your hotel doesn't mean that a dust storm won't engulf you an hour later. Unsettled or unusual weather often brings with it moments of spectacular light and a change in the daily activity of the locals. Get out there and you can be rewarded with fantastic photographic opportunities. To take

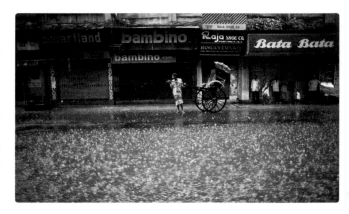

advantage of changing, unusual or difficult situations without putting your gear at risk, additional protection is needed.

WET WEATHER

Just because it's raining or snowing doesn't mean you have to put your camera away. Most cameras can take a fair bit of rain; just wipe it dry as soon as you get inside. Unless someone is on hand to hold an umbrella for you, shooting with one hand from under an umbrella isn't easy – especially as the light is probably low. It's much easier to keep your camera under your jacket between shots. The camera-in-the-plastic-bag technique (see left) works well if the downpour isn't too heavy. Some camera bags have an outer shell built in for protection against wet weather. If yours doesn't, a large plastic bag is easily carried and will do the job.

EXTREME COLD WEATHER

Most modern cameras will function properly down to 0°C. Professional DSLRs will operate adequately around –10°C to –15°C. The biggest problem in very cold temperatures is that batteries will fail.

Rickshaw wallah in rain, Kolkata, India
The weather really can test your patience. Usually it rains when you don't want it to but in this case I'd gone to Kolkata in August specifically to capture daily life during the monsoon, when streets can flood within minutes. After four days of sunshine, it finally rained on the morning I was leaving. I had to cram five days of photography into one. One of the reasons you pay more for professional cameras is to be able to work in conditions like this without having to worry too much about the camera getting wet, thanks to the comprehensive use of O-rings to seal them from the elements.
35mm SLR, 24mm lens, 1/60 f4, Ektachrome E200 rated at 400 ISO (one-stop push)

You can often solve this by removing the batteries from the camera and warming them in your hands. To minimise battery problems, keep your camera and its batteries warm until you start shooting. If you're not in a comfortable, warm hotel and intend going out at first light, sleep with your camera, ie keep it under the blankets or in your sleeping bag during the night. When you head out into the cold morning have the camera under your jacket until you need it; shoot quickly, then tuck it back into your jacket as soon as you've taken your shots.

In very cold weather film can become brittle and snap if not handled carefully. Turn off the film winder and advance and rewind the film slowly to prevent tearing it. Winding on and off too quickly can also result in static discharges that appear as clear blue specks or streaks on the film.

Condensation can also be a problem. When changing lenses outdoors don't breathe into the camera or onto the lens, and ensure snow doesn't get into the camera. Entering a warm room causes

the water vapour on the cold metal and glass surfaces to condense rapidly and mist up with tiny water droplets. When you go out again this water will freeze. To prevent this, wipe off as much moisture as possible, and don't change lenses until the camera has warmed up.

In extreme cold, don't touch the camera's metal parts with bare skin because it will stick. These problems don't usually arise above –10°C. Make sure you've got a large eyecup on and tape over the metal parts to help prevent your face coming into contact with them. Otherwise you could find your camera stuck to your face (which would be rather unpleasant, but could make a great shot for some other photographer).

HOT & HUMID WEATHER

Extreme heat can melt the glues holding the lens elements in place, but the biggest problem is the effect it can have on the recording media, both digital camera sensors and film, as both are not only light sensitive but heat sensitive. Cooking a sensor increases noise and cooking film results in very pink photos. Film can actually withstand much more heat than you might think, but it's still best to be on the cautious side and keep your equipment as cool as possible. It's recommended that you:

- Be aware that the floors of buses and cars can get very hot on long journeys, especially around the engine.
- Don't leave digital cameras or film in rooms in cheap hotels that become ovens around midday.
- Never leave cameras, memory cards or film in direct sunlight.

Gentoo penguin rookery, Petermann Island, Antarctica
If you're going to photograph the landscape at the best time of day in places like Antarctica, you're going to be cold. The camera will probably be fine, but you won't be if you don't come prepared. The last thing you need is to miss photo opportunities because of discomfort through lack of preparation.
DSLR, 24-70mm lens at 24mm, 1/250 f14, raw, ISO 125

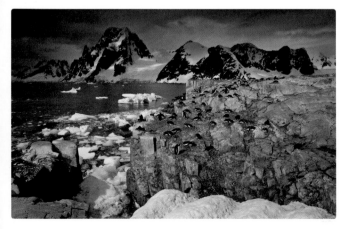

○ Never leave cameras, memory cards or film in a car, especially in the glove box. On a hot day, say 37°C, temperatures in cars can range from 64°C to 107°C.

High humidity also speeds up the natural deterioration of film, and can lead to fungus growth on equipment and film. Packets of silica gel (available from camera shops), which absorb moisture, should always be in your bag when travelling in humid climates.

Moving from an air-conditioned room to warm temperatures outdoors causes condensation on lenses and viewfinders, which can take up to 10 minutes to clear. As soon as you get outside, take your camera and each lens out of your bag and remove the front and rear lens caps so that the condensation can clear naturally. Don't wait until your first photo opportunity comes along or you'll spend precious minutes wiping the lens, including the rear lens element, which is best not touched.

SALT WATER

Salt water and sea spray can cause irreparable damage to your camera. When shooting by the sea, protect your camera with a plastic bag (see p123) and keep your gear bag closed. Cameras can also be protected against sea spray by wiping with a cloth lightly soaked in WD40 (or any substance that displaces moisture).

When travelling by boat, place equipment in strong, sealable plastic bags. If you drop a camera in the sea, the only thing you can do is wash it under fresh water as quickly as possible to remove the salt. The camera's chances of survival aren't good.

SAND & DUST

Sand and dust are deadly enemies of photographic equipment. If you find yourself in sandy or dusty conditions when the wind is blowing, be especially protective of your equipment. A single grain of sand in just the right (or wrong) place can cause a lens to seize up. Any foreign object on a digital camera's sensor is a potential nightmare, as it will leave a mark on every frame. In most cases it can be removed but you may find yourself spending countless hours at the computer dealing with the problem (see p104). If any sand gets caught in the film cassette's light seal it can scratch a straight line along the entire film. If you know you will be going to dusty or sandy environments take extra care (and spend more money if you have to) to get a camera bag that is fully sealable and comes with a protective outer shell.

To prevent damage from sand and dust:

○ Avoid changing lenses and memory cards if sand and dust are in the air.

○ Blow and wipe off dust and sand as soon as possible.

○ Don't put your camera bag down on the sand.

○ If conditions are really severe, put your camera bag inside a large plastic bag or place equipment in plastic bags inside your camera bag. Don't leave equipment in plastic bags for more than a couple of hours when the humidity levels are high.

○ Keep your camera bag well sealed.

○ Use the camera in the plastic bag technique for shooting (see p123).

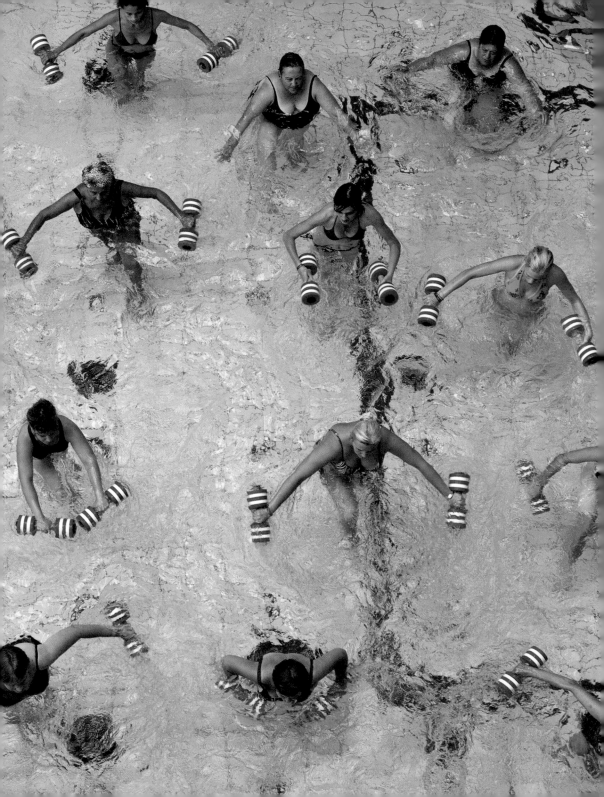

02: THE ART OF PHOTOGRAPHY

Great photos don't just happen in the split second it takes to release the shutter. They are hand-crafted moments in time created by photographers who can see, select and organise the elements before them into a visually cohesive and unique composition, and then translate that vision onto the sensor or film. To achieve this, no matter what camera you're using or what subject you're photographing, you need to work through a series of decisions regarding exposure, composition, light, and how to handle movement. You can also broaden your take on the specific subjects you'll encounter by seeking out iconic images, making the most of the time you have and looking for opportunities to tell stories through pictures.

MOMENTS IN TIME

So far the emphasis has been on the technical side of photography. This is obviously important but it's one thing taking technically good images, especially as camera technology prevents and image-editing software fixes a range of once-common mistakes; it's quite another to take consistently creative images. This is largely because the elements that go into the creative side of image-making defy automation, and they always will. The reality is that good pictures can be taken on any camera on any media. Many memorable images have been taken over the last hundred-and-eighty years using the equipment of the day. Even at famous tourist sights where there's a certain place to stand to take 'the' photo, the variation in the quality of images produced is amazing.

Great pictures are the result of matching an interesting subject with the best light, a pleasing placement of the elements and exposing the sensor or film to just the right amount of light using ISO, shutter speed and aperture settings that translate the way you see the scene – and retain all the detail and depth of colour – onto the sensor or film. It is how the photographer handles this combination of technical and creative skills at a particular moment in time that produces unique images and allows individuality to shine through

(Opposite) Gullfoss waterfall, Gullfoss, Iceland

For about two and half hours, from 4.45am, I had the spectacular Gullfoss waterfall to myself. Having already checked out the location the day before I knew the various viewpoints I wanted to shoot from. This meant I could concentrate on watching for the moment when the meeting of sun and spray resulted in the most distinctive and intensely coloured rainbows. No one else in the world saw this display of raw power and delicate beauty, let alone captured it. This is why photography is so special.

DSLR, 70–200mm lens at 90mm, 1/40 f9, raw, ISO 100, polarising filter, tripod

Centre Place, Melbourne, Australia

Coloured milk crates stacked up against laneway walls covered in even more colourful street art make for a great location. I've been here plenty of times, but the space took on a completely different look as a group of friends shifted the crates from one spot to another in a frenzied five minutes of fun. When this kind of moment unfolds before your eyes you need to act quickly. Very low light and moving subjects means hand holding the camera, so I cranked up the ISO to enable a shutter speed that prevented camera shake but was still slow enough to record the blur of the flying milk crates. It's a fine balance that makes understanding the exposure options available to you well worth the effort of learning (see pgs 143–146).

DSLR, 24–70mm lens at 24mm, 1/40 f3.2, raw, ISO 1600

PREVISUALISATION

You don't need a camera in your hand to 'see' images. How often have you heard someone say, 'If only I had my camera', or, worse still, said it yourself? At these moments we are responding to the fact that the elements that make a good photo, in our own opinion, are currently in play. It also implies that the moment is fleeting, which it usually is.

There's a common concept in photography called previsualisation. Essentially it means creating a photo in your mind's eye and then setting out to capture it. You can do this from anywhere. Images can be previsualised at home, maybe inspired by a television program or movie, from seeing published photographs or from your own memories of a place. The inspiration doesn't have to be visual. A travel writer may describe the scene from a café balcony which could inspire you to search it out. More commonly, previsualisation kicks in at the destination. You might come across a great location but the light is coming from the wrong direction, or you know it will look much better without the crowd of people, or there are no people when there should be. You may figure out that if you climb a particular hill, at a particular time of day, then the view over the city or landscape will be what you're after. Or, if you wait for another hour, or two, the weather will change and with it the light and a mundane scene will be transformed.

Previsualisation is just as much about spontaneity as it is about planning. Whenever you raise the camera to your eye, you've already previsualised a photograph and if the scene remains static you'll get the shot. The photographer fine-tunes this act to capture seemingly fleeting moments, anticipating the photo opportunity that is imminent if, for example, a person turns their head, reaches out to hand over money to a vendor or walks through an archway; or the impact the sun will have when it appears from behind the cloud. Previsualisation is a crucial tool in achieving a high percentage of good pictures in the limited time that is typical of a travel itinerary.

Passage off Fish Square, Ljubljana, Slovenia
The cobblestoned passage is architecturally interesting but I wanted to show it being used, particularly by a cyclist as I'd seen them speeding through while I was having lunch nearby. The low viewpoint and wide-angle lens created a pleasing composition (but was a bit hard on the knees); then it was just a matter of waiting (and waiting) for the right subject to come along. The selected shutter speed blurred the cyclist slightly adding a nice dynamic element to the image.
35mm SLR, 24-70mm lens at 24mm, 1/60 f4, Ektachrome E100VS

BEING THERE

So much time creating good pictures is spent not actually taking pictures but incessantly looking, either on the move or standing around; watching, waiting. If you're out and about you create the opportunity to come across fleeting moments, to add to your knowledge of the place and build your list of potential images through previsualisation. You will not get those 'lucky' pictures from your hotel room or bar stool.

Once you've got the image in mind you need to commit, whether it's a matter of seconds for an action to occur, a couple of hours for the weather to change or revisiting a location at the best time of day. Commitment to the image is a key professional trait; it keeps photographers out there way beyond the time needed to simply visit a place or individual site.

Digital camera technology is proceeding at a relentless pace but the essence of great photography and the skills required haven't changed at all. No camera will make creative decisions for you, or take you to the right place at the right time.

Devotee making offering to Kala (Black) Bhairav, Kathmandu, Nepal
Very occasionally things come together so quickly and so well I can hardly believe my eyes. As I was composing the shot a woman walked into frame to make an offering; this is what I expected, but the fact that her clothing (and hair) mirrored the colours of the statue was way more than I could have hoped for. I used to hang around this statue a lot, now I don't. It's a great feeling to have a quintessential shot of a significant place.
35mm SLR, 24-70mm lens, 1/125 f5.6, Ektachrome E100VS

131

FAMILY WALKING THROUGH ARCHES, AMBER FORT, RAJASTHAN, INDIA

35mm SLR, 24mm lens, 1/125 f8, Kodachrome 64

Taken in 1986 on my first trip to India, this image is significant in my development as a photographer because it was the first time I can really recall previsualing an image (even though I'd never heard of such a thing at the time) and then committing time to capturing it. I only had to wait around 30 minutes until I was satisfied that I'd got the shot, but that can seem like forever when you're first starting out and you've got to see the whole fort and you've got travelling companions waiting for you. I've been back to this location a number of times over the years and tried to redo this shot, but the results never compare with the colour, light and balance of this original image.

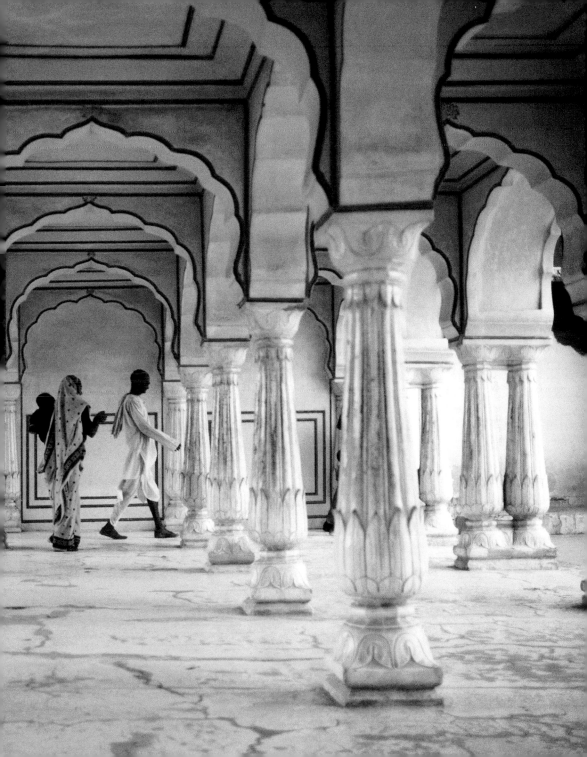

ICONIC IMAGES

One of the great challenges for the travel photographer is to capture images that in a single frame encapsulate a distinguishing feature of the country they're visiting. Every country has natural landforms, buildings and monuments on its 'must-see' list. The Pyramids, Machu Picchu, Angkor Wat, Eiffel Tower, Uluru, Great Wall, Grand Canyon, Taj Mahal…places whose image is already deeply etched in our mind's eye well before we stand before them ourselves. These places are photographed millions of times a year by visitors from all over the globe and feature in books, magazines and brochures, on websites, postcards, tea towels, cups and place mats. So even people who haven't been there or aren't known to care much about image content will have high expectations as to how pictures of these places should look.

Famous places always deserve more than one visit. On your first visit you'll probably be inclined to blaze away at the subject from all angles. A second visit can be approached more calmly and deliberately. A review of published material such as postcards and souvenir books after your first visit will make a lot more sense. You'll know where things are and where the light will be and what time you need to be there.

New and interesting pictures are possible; you'll just have to work a bit harder to acquire them. Set yourself the triple task of taking a classic view of the subject that is as good as or better than the published images, then look for a different view from those you've seen before, and, finally, get close and fill the frame with a detail view to create an abstract, but recognisable, image.

Beyond the famous sights you can achieve a similar outcome by focusing on other unique elements of a country's culture and environment: traditional dress, foods, festivals, sports, souvenirs, art and craft, and wildlife – all present opportunities for capturing iconic images.

○

Revisiting places, especially after you've seen the results from your first attempt, is one of the best ways to improve your travel photographs.

(Opposite) Big Ben seen through the London Eye, London, England

DSLR, 70-200mm lens at 153mm, 20secs f9, raw, ISO 100, tripod

Colosseum, Rome, Italy

The Colosseum, like so many other amazing Roman ruins, is situated alongside a busy road, coexisting as an iconic travel destination for every visitor to Rome and a familiar backdrop to daily life for the local population. To capture this juxtaposition I included the road and traffic but made it more photogenic by shooting at dusk with a long exposure to represent the presence of vehicles with attractive and colourful light trails.
DSLR, 24-70mm lens at 34mm, 15 secs f9, raw, ISO 100, tripod

THE CLASSIC VIEW

Spend five minutes looking at postcards or pictorial books of the country you're in and you'll soon get a feel for what are considered the classic views of its most famous places.

The classic view is absolutely worth taking, but the challenge is to do it as well as – or better than – it's been done before. In many places it's easy to get to the vantage points and replicate well-known pictures. That's no problem – it's a famous view because it's a great view – but it's better to treat it is a starting point for your own interpretation. Do this through your choice of viewpoint, lens and, of course, the light you shoot in.

○

When you're shooting well-known sights, the light has to be fantastic or your shot just won't compare.

Uluru, Uluru-Kata Tjuta National Park, Australia
6 x 7cm Rangefinder, 50mm lens, 1/8 f16, Ektachrome E100VS, tripod

A DIFFERENT VIEW

Once you've got your own take on the classic view, think about how you can photograph the subject in a different way. This is often easier said than done, particularly with really famous places, as photographers have been trying to do this for years. This includes the locals, who obviously have more opportunity to do so and the advantage of local knowledge. It's still possible, but it takes a bit more effort than following the path to the classic view.

These shots require a combination of time, clever composition and great light. Apart from those rare moments when everything comes together on your very first visit, you'll need to invest some time to achieve a different view. Walk around the area, check out various viewpoints, get up close if you can and then move further away. Compose as you go with a variety of focal lengths. Most importantly, make sure you're there when the sun is low in the sky and the colour of daylight is at its most intense, as the colour and quality of the light is the magic ingredient.

THE DETAIL VIEW

Famous buildings and natural landforms don't have to be shown in their entirety to be recognised so, for a third shot in your series of images, consider filling the frame with only a portion of the landform or structure. Apart from creating an interesting photographic challenge, the images are often of more interest to viewers than the classic shot, which they are already familiar with.

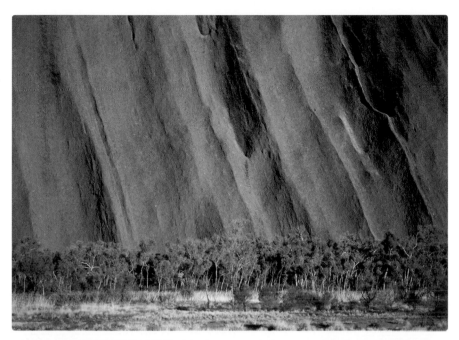

Kantju Gorge, Uluru–Kata Tjuta National Park, Australia

6 x 4.5cm SLR, 150mm lens, 1/30 f11, Ektachrome 50STX, tripod

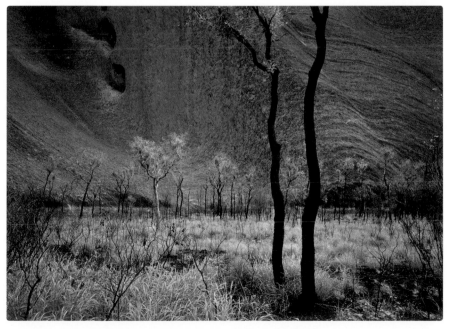

Mutitjulu, Uluru–Kata Tjuta National Park, Australia

6 x 7cm Rangefinder, 50mm lens, 1/4 f11, Ektachrome E100VS, tripod

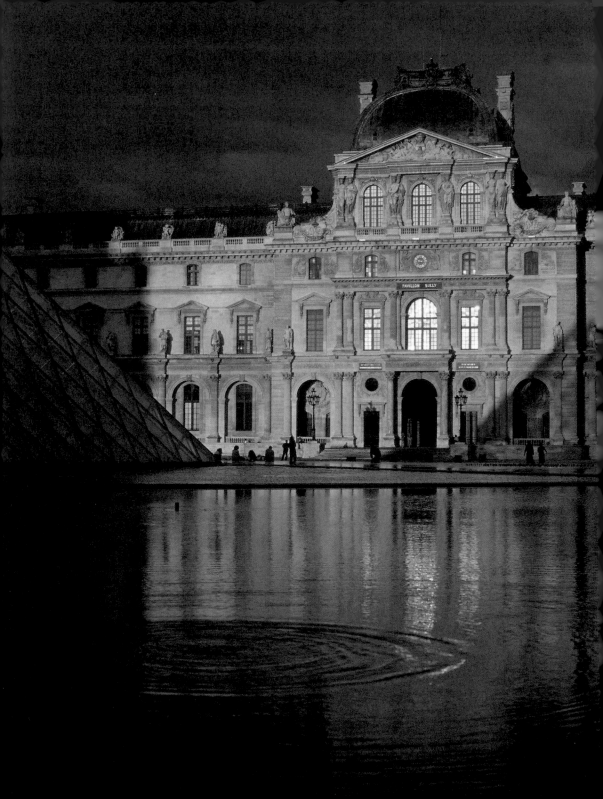

MAXIMISING THE MOMENT

You've bought the gear, learned how to use it, have developed an understanding of exposure, light and composition, travelled halfway around the world, got up before dawn, walked for 3km in the dark and the subject you've come to photograph is glowing in the warm light of a brilliant sunrise. It goes without saying that you really should maximise the moment by getting as many and as varied shots as possible while the light is at its best, so obviously you're going to be working within a very small time frame. Depending on the day you'll have anywhere from 10 seconds to 15 minutes of really fantastic light so to make the most out of it you need a plan. Ideally, you will have had time during an earlier recce, or while you were waiting for the light, to come up with a course of action. It is more difficult if you're viewing the scene for the first time but with practice you'll start doing the basics instinctively.

At its simplest you can maximise the moment by shooting a series of images of the same subject without changing camera position but by shooting at a variety of focal lengths, both vertically and horizontally. More complex is doing the above but from several predetermined camera positions. This can lead to some frantic activity – especially if it involves driving a car between shots – that gets your heart pounding and, in public places, gets heads turning.

Of course, you also need to be flexible enough to respond and reprioritise your original plan if the light throws up some surprises of its own. No matter what happens you need to balance the time you commit to getting the best shot from each location with the need to move to your next camera position. The challenge is to know when you've got 'the' photograph, so you can move on; procrastinate and you'll end up with one shot, not two, three or more.

Louvre, Paris, France

After a two-hour wait in cold and windy weather I was beginning to think the light would never eventuate. It did, for about two frantic minutes, and all the wandering around checking viewpoints and compositional possibilities paid off (there's more where these came from as well). I generally work fast and shoot prolifically on the premise that the light is not going to last and that I'll never get a second chance.

(Opposite) 35mm SLR, 50mm lens, 1/15 f11, Ektachrome E100SW, tripod

(Above, top left) 35mm SLR, 100mm lens, 1/15 f11, Ektachrome E100SW, tripod

(Above, top right) 35mm SLR, 24mm lens, 1/4 f11, Ektachrome E100SW, tripod

(Above, bottom left) 35mm SLR, 180mm lens, 1/30 f11, Ektachrome E100SW, tripod

(Above, bottom right) 35mm SLR, 24mm lens, 1/30 f11, Ektachrome E100SW, tripod

TELLING A STORY

Artist creating a painting, Bow River, Australia

When Phyllis Thomas said she was about to start painting, the opportunity to capture a photo story was obvious. Each step, from the making of the paint to the artist displaying the finished pieces, was captured from various viewpoints with varying focal lengths and compositions. The story can then be shared with as few or as many images as you think is appropriate.

35mm SLR, 24-70mm lens, 1/125 f5.6-11, Ektachrome E100VS

A variation on 'maximising the moment' is to tell a story through a series of clearly connected images. Although these are often taken in one session, they could also be accumulated over as many visits and as much time as you want to dedicate to the series. Each image should be strong in its own right and worthy of individual attention but when viewed in sequence they build on each other to reveal a story.

If the subject involves people engaged in some form of activity, you'll often have the opportunity to apply every compositional tool and people-photography technique you can remember to use in the time you've got. With any subject, work through the classic, different and detail-view strategy as well as the techniques employed to maximise the moment. You may feel like you're overdoing it by taking way too many pictures and you may not use all the images you take in the final presentation. However, it's much better to have choices than to miss a key link in the visual narrative, which you may not discover until you're actually putting the story together.

EXPOSURE

Setting the exposure is more than a technical necessity – it's a creative decision that controls the mood, quality and feel of the photograph. When you take a photograph you're translating what the eye sees, through the lens and onto the image sensor or film. The choices you make when setting the exposure play a big part in determining the success of the translation.

Correct exposure means the sensor or film is exposed to just the right amount of light to record the intensity of colour and details in the scene that attracted you to take the photo in the first place. Too much light and the image is overexposed and will appear too light. Not enough light and you have underexposure and the image is too dark.

Even though image-editing is part of the image-capture process, its primary purpose is not to rescue badly exposed pictures. Digital images can certainly be enhanced through skilful image-editing, just as a skilled craftsperson can bring a negative to life in the darkroom. However, it can only happen if all the required information is captured in the first place. It's a mistake to think that badly executed digital images can be 'rescued' in Photoshop (or other image-editing software programs) to produce stunning prints displaying the full tonal range and colour of the original scene. 'Photoshopping' to correct mistakes should be a last resort and not part of your standard practice. Having to manipulate images – even if the changes are modest – redistributes the tones in the image, affecting sharpness, colour saturation, contrast and noise, and effectively diminishes image quality. Just as importantly, getting the exposure wrong means you'll be wasting a lot of time in front of the computer correcting mistakes. And if you intend to print straight from the camera, the quality of the prints will be nowhere near as good as they could be.

A good exposure is achieved through a combination of the sensor's ISO rating, the aperture setting and shutter speed. You can let the camera make these decisions for you by selecting a fully automatic exposure mode. However, that deprives you of the ability to control key aspects of the picture-taking process that determine how your pictures look, particularly in relation to the creative use of blur and depth of field.

ISO RATING

Image sensors, like film, are light sensitive. Unlike film, which has its sensitivity predetermined and requires the entire roll to be exposed at the same ISO setting, a sensor's ISO sensitivity can be electronically varied from shot to shot. The ISO rating determines the sensitivity of the camera's sensor to light and is the

(Opposite) Path beside Main River, Frankfurt, Germany

DSLR, 24-105mm lens at 105mm, 1/60 f9, raw, ISO 100

Get into the habit of resetting the ISO to the lowest setting, known as the native setting, immediately after you've finished shooting at a higher sensitivity. It's easy to be shooting interiors at ISO 800 and forget to put it back only to find later that you spent the rest of the day shooting at ISO 800 outdoors in bright sunlight.

foundation on which the variable settings of shutter speed and aperture are based.

As the ISO setting is increased, the sensor becomes more sensitive to light. The settings are described as 'ISO equivalents', allowing the photographer to understand the sensor's sensitivity by relating it to the familiar ISO rating sequence of film: 25, 64, 100, 125, 160, 200, 320, 400, 500, 640, 800, 1000, 1250, 3200 and 6400 ISO.

Being able to vary the ISO rating from one frame to another is one of the most useful tools that digital capture has given the photographer, bringing a freedom to shoot effortlessly in dramatically different light levels and use the variable ISO as a creative tool to fine-tune exposures.

For general hand-held photography the semiautomatic Shutter-Priority Auto mode is recommended. In this mode you can't accidentally let the shutter speed drop too low and run the risk of camera shake, and it's easy to bracket in 1/3- or 1/2-stop increments.

SHUTTER SPEED

The shutter speed is the amount of time that the camera's shutter remains open to allow light onto the sensor or film. Shutter speeds are measured in seconds and fractions of seconds and progress in a sequence: typically, one second, then 1/2, 1/4, 1/8, 1/15, 1/30, 1/60, 1/125, 1/250, 1/500, 1/1000, 1/2000 and 1/4000 of a second. The higher the number, the faster the shutter speed and the less light allowed in. Digital cameras also allow intermediate settings such as a 1/90 of a second in automatic modes.

CAMERA SHAKE

A practical consideration when selecting shutter speeds is to ensure that your pictures don't suffer from camera shake as a result of the shutter speed dropping too low. This is a very common problem when cameras are used on Automatic. If hand-holding the camera, a good standard shutter speed is 1/125 or 1/250. However, be prepared to vary your shutter speed depending on the lens you're using. The general rule of thumb is to select a shutter speed the same or higher than the focal length of the lens. With a 24mm lens, a shutter speed of 1/30 is recommended; with a 200mm lens, 1/250 is the desired minimum shutter speed. With zoom lenses the minimum shutter speed should vary as you zoom in and out. The longer the lens, or at the telephoto end of zoom lenses, the higher the minimum shutter speed required.

Image stabilisation technology allows us to break this general rule to a point, but you need to understand it so that you don't drop the shutter speed below the speed at which the technology in the camera or lens can correct the movement (see p51).

APERTURE

The aperture is the lens opening that lets light into the camera body. The aperture is variable in size and is measured in f-stops. The most familiar f-stop sequence, from the widest aperture to the smallest, is f1.4, f2, f2.8, f4, f5.6, f8, f11, f16 and f22. As you progress along the scale to f22 you are 'stopping down', and with each stop you halve the amount of light that will reach the sensor. In the other direction, as you move towards f1.4, each stop doubles the amount of light that will reach the sensor, and you are 'opening up' the lens until it's 'wide open' at its maximum aperture. Digital cameras also allow intermediate settings such as f13 in automatic modes.

ISO, SHUTTER SPEED & APERTURE COMBINATIONS

The ISO setting, shutter speed and aperture are all closely interrelated. An understanding of the relationship between these variables, and the ability to quickly assess the best combination required for a particular result, is fundamental to creative photography. With the sensor's ISO setting at ISO 100, point your camera at a subject and your light meter may recommend an exposure of 1/125 at f4. But, for example, by decreasing shutter speed one stop to 1/60 and stopping down the aperture by one stop to f5.6, you could still make a correct exposure (because the smaller aperture compensates for the longer time that the lens is open). Similarly, 1/30 at f8 or 1/15 at f11 would also be correct exposures. If you chose to set the sensor to ISO 400 under exactly the same conditions, you could select 1/500 at f4, or 1/250 at f5.6, or 1/125 at f8, or 1/60 at f11. All of the above combinations will ensure the sensor is exposed to just the right amount of light. You have to decide which combination will give you

New Road, Kathmandu, Nepal

The same scene can be portrayed quite differently through choice of shutter speed and aperture. The first image captures a realistic view of the street with all the movement frozen and excellent sharpness from front to back. The second image, taken with a much longer shutter speed, has recorded the moving vehicles as a blur, adding a dynamic element to the street scene.

(Left) 35mm SLR, 24-70mm lens, 1/60 f4, Ektachrome E100VS, tripod

(Right) 35mm SLR, 24-70mm lens, 3 secs f20, Ektachrome E100VS, tripod

the effect you want by giving priority to one element over the other. A photograph of a waterfall taken at 1/250 will look quite different to one taken at 1/2. The ability to alter the combination of these three variable settings is one of the most powerful creative tools at your disposal.

PROGRAM SHIFT

A really useful, and quite powerful, feature that is available on the more advanced digital cameras is a Program Shift control. The Program Shift control offers manual control of the aperture and shutter speed combination while the camera is in the fully automatic Program mode. After depressing the shutter release halfway – in order to focus and set exposure – the Program Shift control allows you to scroll through the other shutter speed/aperture combinations that would also result in the correct exposure of the scene.

MEASURING LIGHT

All compact and DSLR cameras have built-in light meters that measure, or read, the amount of light reflected from the subject. All meters work on the principle that the subject is mid-tone; ie not too light or too dark. In practice, most subjects are a mix of tones, but when the meter averages out the reflected light a mid-tone reading results in a properly exposed image. When very light or very dark subjects dominate scenes, exposure compensation is required (see p148). Some advanced compacts and all DSLRs provide the user with a choice of three metering modes: multizone, centre-weighted and spot.

MULTIZONE METERING

The most common system used in DSLRs, multizone metering divides the scene into zones. The meter reads the light in each zone and sends the information to the camera's computer, which recognises the extreme tones and gives a reading based on what it evaluates as the most important parts of the scene. This system is also called matrix, evaluative, multisegment, multi-pattern and honeycomb-pattern metering.

CENTRE-WEIGHTED METERING

Centre-weighted metering reads the light reflected from the entire scene and provides an average exposure setting biased towards the centre section of the viewfinder. Generally, readings are accurate unless there are very large light or dark areas in the scene.

SPOT METERING

This takes a reading from a small area and is ideal for taking a reading of your main subject when it's part of an unevenly lit scene. Once the light meter has read the light, it recommends appropriate settings. Depending on your camera, you can prioritise the settings by selecting manual, semiautomatic or fully automatic exposure modes.

EXPOSURE MODES

MANUAL MODE

You set both the shutter speed and the aperture manually. Adjust either of the controls until the meter indicates correct exposure.

SHUTTER-PRIORITY AUTO MODE

You select the shutter speed and the camera automatically selects an appropriate aperture.

APERTURE-PRIORITY AUTO MODE

In this semiautomatic mode you select the aperture and the camera automatically selects an appropriate shutter speed.

PROGRAM AUTO MODE

In this fully automatic mode the camera selects both the shutter speed and the aperture.

SUBJECT OR SCENE PROGRAM EXPOSURE MODES

In these fully automatic modes you select a preset exposure mode to suit the subject, and the camera sets the appropriate shutter speed and aperture combination. The list of preset modes varies from camera to camera but will always include these five standard subject modes:

Portrait Sets a large aperture to minimise depth of field and produce an out-of-focus background.

Landscape Sets focus on infinity, a small aperture for maximum depth of field and turns off the flash.

HAND-HELD EXPOSURE METERS

Most modern cameras have inbuilt exposure meters that measure the amount of light reflected from the subject. You can do the same thing with an accessory light meter, which some photographers prefer to use. However, for the traveller there isn't really much point carrying around this extra piece of equipment.

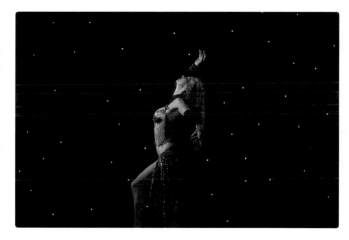

Dancer performing at Maho Casino, St Martin
This is a classic example of when to use spot metering – a spot-lit subject against a black background.
DSLR, 70-200mm lens at 200mm, 1/125 F2.5, raw, ISO 500

Sport or Action Sets the fastest shutter speed to render sharp images of moving subjects.

Night Scene Sets slow shutter and large aperture to record the low level of ambient light and fires flash to illuminate foreground subjects.

Close-up or Macro Allows the camera to focus on subjects less than 60cm or 70cm away and is useful for photographing flowers and other small objects.

OTHER EXPOSURE CONTROLS

EXPOSURE COMPENSATION

Many compact digitals and all DSLRs allow you to override the recommended meter settings via an easy-to-use exposure-compensation control, without having to make changes to the shutter speed or aperture settings. The control typically allows over- or underexposure of the sensor in third- or half-stop increments, up to two or three stops. Turn the dial to +1 and you'll increase the amount of light reaching the sensor by one stop. Turn it to −1 and you'll decrease the amount of light by one stop. After adjusting the exposure-compensation dial remember to reset it before shooting your next subject.

Get comfortable using the exposure-compensation control and you might find it does the job for you in the majority of difficult light situations.

FOCUS & EXPOSURE LOCK

Most advanced compacts have a combined focus-and-exposure lock that works like a spot meter. Check your manual to learn how to engage the lock. Usually it involves selecting a 'spot mode', positioning the auto-focus mark on the subject, depressing the shutter button halfway and holding it there while you recompose. Press the button fully when you're happy with the composition. The camera will focus and set the exposure for the subject you spot-metered.

BRACKETING

Bracketing is an important technique used to ensure that the best possible exposure is achieved. A standard bracket requires three frames of the same scene. The first is at the recommended exposure, say 1/125 at f11; the second, generally at half a stop over (1/125 at f9.5) and the third at

Customs House and marina at Telaga Harbour Park, Pantai Kok, Langkawi, Malaysia
A three-frame bracket shows the difference a full stop either side of the camera meter's recommendation makes.

(Top) The mix of dark and light areas has resulted in a good exposure.
DSLR, 24-70mm lens at 55mm, 1/80 at f11, raw, ISO 100, tripod

(Middle) One stop over and the light areas have lost the depth of colour and the image looks weak, but there is detail and colour in the shadow.
DSLR, 24-70mm lens at 55mm, 1/80 at f8, raw, ISO 100, tripod

(Bottom) One stop under and the light areas still look good with lots of detail, but the dark areas have lost their colour and detail.
DSLR, 24-70mm lens at 55mm, 1/80 at f16, raw, ISO 100, tripod

half a stop under (1/125 at f13). Bracketing with film can get expensive. Bracketing with digital cameras uses memory-card space. This can be recovered by deleting the less successful exposures. However, if you're bracketing a lot make sure you have enough memory-card capacity to cover your shooting requirements until you get a chance to review and delete, or transfer the images from the memory card. If the shot really matters, then bracketing is the best way to guarantee that the image you see is the image you get, particularly when the lighting is really difficult.

Many cameras have an auto-bracket setting that allows you to select a three-exposure bracket at third-, half- or one-stop increments. You press the shutter once and the camera captures all three images in one burst. There's a good chance one of these will be clearly wrong, so it can be deleted immediately.

SETTING EXPOSURE

If you don't want to, you don't have to get involved with setting exposure at all. Select the fully automatic Program mode, point and shoot. If, however, you are sometimes disappointed with your pictures because they are too dark or too light, a little understanding and a few techniques will give you the option of improving things, rather than putting up with unsatisfactory pictures. If you're shooting raw files then there is a bit more to understand to make sure you get the best out of your camera's sensor and produce the best quality files possible (see p150).

EXPOSING JPEG FILES

When you point your camera at a scene, the camera's light meter recommends appropriate settings (based on the exposure mode you've selected). You can accept the meter's recommendation or override it. In many cases, especially when the lighting is even, the camera's light meter does a good job. If you're shooting JPEGs and don't intend doing any image-editing on the files, you'll enjoy the simplicity of shooting with whatever exposure the camera suggests.

Difficulties arise when a scene contains large areas that are very light or dark, when shooting into the sun, when light sources are included in the frame, or when the subject is black or white.

One of the easiest and best methods of setting exposure in such situations is to expose for the subject, or the most important part of the subject, such as the face of a person, rather than their clothing, or the facade of a building rather than the bright sky behind it. Try the following techniques when the lighting is difficult:

o Use the spot meter to take a reading off the subject.

o In manual mode, fill the frame with your subject, either by moving closer or zooming in, take a reading, then recompose ignoring the meter readout.

o In automatic modes, use the above technique, but lock the exposure before you recompose or the meter will re-adjust the settings.

o If the subject is black or white, the meter will average out the scene to a mid-tone. Your black or white subject will be rendered as a mid-grey if you don't compensate or override the meter's recommended settings. For white subjects take a reading off the subject and overexpose by one or two stops. For black subjects underexpose by one or two stops.

o Use the exposure compensation control to force the camera to under- or overexpose (see p148).

o Bracket your exposure (see p148).

International flag display at Commonwealth Place, Canberra, Australia
When you're working with long shutter speeds and wind you can't totally predict the outcome. You just have to work very fast in the 10–15 minutes you have to match the shutter speed to the wind strength to get just the right amount of blur for the effect you want.
35mm SLR, 24-70mm lens, 10 secs f18, Ektachrome E100VS, tripod

A quick look at the camera's LCD display will give you an indication as to whether or not you've made an acceptable exposure although it's most useful for showing badly under- or overexposed pictures. It's actually very hard to tell if an image is really well exposed on a small LCD screen that changes in appearance with even the slightest alteration in viewing angle. Lots of practice will give you some confidence that your exposures are correct but you can get a much more accurate indicator by viewing the histogram, a feature that is now found on most cameras (see p151).

EXPOSING RAW FILES

Shooting raw files allows you to create the best possible results from your digital camera. The files contain all the data captured by the camera's sensor and their potential is only limited by the exposure and ISO setting. All other decisions regarding the look of the image are decided at the conversion stage so the original camera file can be edited in many different ways to achieve the look you want. However, shooting raw requires a commitment to time in front of the computer and an interest in mastering raw-conversion and image-editing techniques.

Before looking specifically at raw exposure techniques it's worth understanding the concepts of dynamic range, clipping and bit depth.

DYNAMIC RANGE

Dynamic range describes the ratio between the brightest part of a scene (the highlights) and the darkest part of the scene (the shadows) in which an image sensor can record detail. Larger sensors,

containing larger pixels, have a greater dynamic range than smaller sensors. The larger the range of a sensor the more detail it can capture at both ends of the range at the same time. A raw file, not processed by the camera, retains the full dynamic range capable of being captured by the sensor, whereas a JPEG file's dynamic range is reduced during in-camera processing.

CLIPPING

Image detail that is off the edge of the histogram, at both the shadow and highlight end, is outside of the sensor's dynamic range and cannot be recorded. This image data is considered clipped, or lost. Some cameras have an overexposure warning that highlights the clipped areas and alerts you to the problem by flashing.

BIT DEPTH

A bit is the smallest unit of digital data. Each bit is an electronic pulse that can either be *on* (represented by a '1') or *off* (represented by a '0'). Bit depth is a measure of the number of bits stored for each pixel in an image. The higher the bit depth the more colours used in the image. Eight bits per pixel is the minimum requirement for a photo-quality colour image. Each pixel is created through a combination of the three primary colours – red, green and blue (RGB) – also referred to as colour channels. An image captured in 8-bit uses a total of eight 0s and 1s in each colour channel, which translates to 256 discrete levels of colour information for each primary colour. When all three primary colours are combined at each pixel, the image can display up to 16.7 million different colours. JPEG image files are saved in 8-bit. Raw

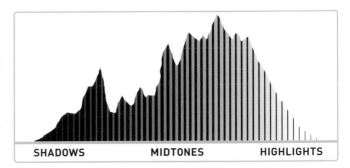

SHADOWS MIDTONES HIGHLIGHTS

HISTOGRAMS

Histograms are a graphic representation of the distribution of pixels, or tonal range, in the image, showing their relative weighting in the shadow, midtone and highlight areas. The histogram is viewed on the LCD screen after the picture has been taken and is a powerful tool for determining correct exposure when capturing JPEG files. Understanding the readout allows immediate assessment of the exposure and the opportunity to adjust settings and reshoot if necessary. For general photography the aim is to see pixels spread across the horizontal axis with most of them in the centre of the graph, indicating that detail has been recorded in the shadows, midtones and highlights. If the pixels are bunched too far to the right side of the histogram, the image will be overexposed and the image too light. If they are bunched too far to the left the image will be underexposed and the picture too dark. There is not one ideal histogram. In fact, the distribution of the pixels, or the tonal range, can vary significantly from image to image influenced not only by the exposure settings but also by the subject matter. The histogram has limited use when shooting raw as it is based on the camera processed JPEG file rather than the raw camera data.

files are typically captured in 12-bit, which means that each of the RGB colour channels can display up to 4096 levels of information per channel.

OPTIMISING RAW FILE EXPOSURE

Whether or not the sensor actually records its potential number of levels of information depends on setting the optimum exposure. Pictures that are underexposed record far fewer levels.

The ideal exposure is bright enough to record the maximum amount of tonal information without clipping the most important highlights. Therefore, you'll generally get better raw files from digital camera sensors if you slightly overexpose the image. This is because image sensors record most data at the highlight end of their range.

If you divide a histogram into five equal parts with each part representing one stop of exposure latitude, the stop on the far right receives most of the data. The adjacent stop (to the left) receives around half the amount of data again, potentially halving the number of levels that can be recorded. The same applies to each further stop decrease. Therefore, the fifth

Grand Canyon, USA

(Left) DSLR, 24-105mm lens at 28mm, 0.6 sec at f11, raw, ISO 100, tripod (+1 stop)

(Middle) DSLR, 24-105mm lens at 28mm, 0.6 sec at f22, raw, ISO 100, tripod (-1 stop)

(Right) Merged file

HIGH DYNAMIC RANGE PHOTOGRAPHY

There is another way for raw shooters to overcome really difficult situations and produce images with the greatest tonal range. High dynamic range photography involves exposing the same scene at different exposure settings, typically at the camera's recommended setting followed by −2, −1 and +1 and +2 stops. The files are then combined in image-editing software and different tones are selected from each of the original images to produce a single file displaying detail from the darkest shadows to the brightest highlights. Mount the camera on a tripod to ensure accurate registration of the original shots; use the Aperture Priority exposure mode so the depth of field doesn't vary from shot to shot; and avoid moving subjects such as people, vehicles and clouds.

stop at the shadow end of the histogram has the ability to record very few levels. If you underexpose an image the recording capacity of the sensor is being underutilised and you'll miss out on capturing highlight detail, resulting in overexposed highlights. These reproduce as featureless white areas which have a considerably more detrimental impact on composition than the more natural-looking areas of shadow.

When you open the image file in raw-conversion software you will be able to extract detail from the shadow areas; however, it's often impossible to recover detail from overexposed, or clipped, highlight areas.

This exposure technique is known as 'exposing to the right' as it results in the distribution of pixels in the histogram being weighted to the right side. In prac-

tice it means overexposing your images in relation to the camera's recommended meter reading. Of course, every scene needs to be treated individually and you'll need to experiment with your own gear, but to get started try overexposing by one-third to two-thirds of a stop and you'll start seeing the pixels move towards the right of the histogram.

SILHOUETTING SUBJECTS

Place an object in front of a much brighter background and expose for the background; the foreground subject will be recorded as a solid shape without detail, or silhouetted.

The most commonly seen silhouettes are taken against the colourful skies of sunrise and sunset. Silhouetting an interesting or familiar shape against a bright

You need to practise 'exposing to the right' as well as quickly developing your post-capture raw file processing skills to build your confidence in the technique. The images that appear on the camera's LCD screen, and when you first see them on your computer screen, often look washed out and awful. This can come as quite a shock if you've been used to working with colour slides that display brilliant saturated colours right out of the box.

'Chinese' fishing nets, Fort Cochin, India
The cantilevered 'Chinese' fishing nets are perfect subject matter for silhouetting against a coloured sky. Because the sun was partially obscured by cloud and the timber frame, the light meter wasn't tricked into underexposing the scene and turning the sky black.
DSLR, 24-70mm lens at 28mm, 1/125 f14, raw, ISO 100, tripod

EXPOSURE LATITUDE IN DIGITAL FILE FORMATS

The digital equivalent of the exposure-latitude variations between slide and negative film is the selection of file format. Shooting raw files is comparable to exposing negative film. The unprocessed file allows images that were under- or overexposed by up to two, or even three, stops to be successfully converted and printed. TIFF files also offer a fair bit of latitude, with over- or underexposure by up to 1½ stops not causing too many problems. Shooting JPEGs is more like exposing colour slide film. The processed file demands greater accuracy at the time of capture, but excellent results can still be achieved with skilful image-editing with files over- or underexposed by one stop.

and colourful background gives a point of interest and adds depth to what otherwise may be a mundane image. However, you can create silhouettes at any time of day as long as you can find an angle of view where the subject to be silhouetted is surrounded by a bright background and doesn't disappear into dark areas. Look for separation between elements; otherwise, their shape and impact will be lost. See p176 for advice on shooting directly into the sun.

or stronger, colours. Many photographers also up-rate their colour slide film slightly by setting the ISO a quarter- or third-stop above the actual film speed. Typically, a film speed of 50 is rated at 64 ISO, 64 at 80 ISO and 100 at 125 ISO.

Make sure you experiment with your own equipment and preferred film before shooting an entire trip's worth of film at an up-rated ISO.

EXPOSING COLOUR SLIDE FILM

Understanding the subtleties of exposure control is particularly important when using colour slide film. Slides can be unacceptable if they're overexposed (too light) or underexposed (too dark) by anything more than half a stop. However, as a general rule, colour slide film produces the best results when it's slightly underexposed. Slightly darker slides always look better than slides that are too light. This is easily achieved by exposing for the highlights, which ensures detail is retained in the lightest parts of the picture and produces more saturated,

EXPOSING COLOUR NEGATIVE FILM

In contrast, negative films are much more tolerant of exposure errors. It's possible for satisfactory prints to be made from negatives that are two stops over- or underexposed. In fact, mistakes often go unnoticed because they're corrected automatically by the minilab when the prints are made. Although exposure latitude is greater with negative film, best results are produced when it's slightly overexposed. Expose for the shadows and the highlights will take care of themselves.

Man floating in lake, Udaipur, India

The simple rule of exposing for the highlights when using colour slide film comes into its own in this sort of situation. If you don't override the light meter the large dark area will trick the camera into overexposing the subject, washing out the colour in the subject.

35mm SLR, 70-200mm lens, 1/250 f8, Ektachrome E100VS

COMPOSITION

Composition is a creative act that allows you to encapsulate in a single frame the subject matter that you think is worth photographing in a way that is pleasing to the eye. If you do it well, it will be pleasing to other people as well. The challenge of composition is to select and organise the various elements before you into a visually cohesive image. Experience and practice will teach you how to create striking compositions quickly. Along the way you'll develop your own preferences and style.

There is no one single or correct composition for any given subject or scene and it's often worth trying several different compositions. Photographers regularly work the subject, exploring the different possibilities, all the time taking photos.

All compositions are the direct result of a series of decisions that only you can make regarding point of interest, choice of lens (or the focal length set on a zoom lens), camera viewpoint, content and orientation. By considering these interrelated variables before you press the shutter, you can put your own interpretation on the subject.

(Opposite) Woman spinning in weaving workshop, In Phaw Khone, Inle Lake, Myanmar
DSLR, 24-70mm lens at 40mm, 1/60 F3.5, raw, ISO 1250

(Below) Stari Most over Neretva River, Mostar, Bosnia & Hercegovina

Although Mostar's famous stone bridge is not dominant in the frame it is still a strong point of interest. Being the brightest element in the composition it is the natural place for the eye to rest after following the sweep of the river past the riverside buildings.

DSLR, 24-70mm lens at 35mm, 30 secs f5.6, raw, ISO 100, tripod

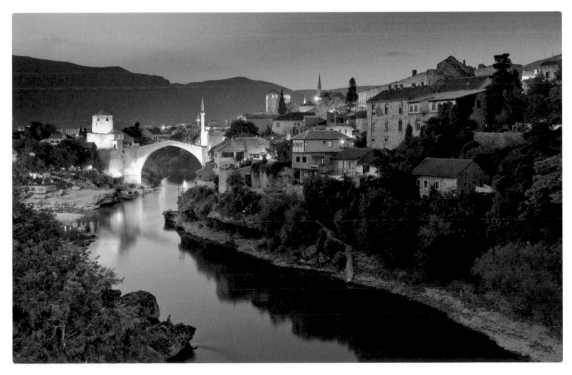

POINT OF INTEREST

The very first thing to consider is the subject – what is it and why are you taking a photo of it? Successful images have a point of interest: the key element around which the composition is based and which draws and holds the viewer's attention. It's probably the thing that caught your eye in the first place. Always focus on the point of interest. If something else is the sharpest part of the composition, the viewer's eye will rest in the wrong place. Aim to place the point of interest away from the centre of the frame because centering the subject often makes for a static composition. Avoid including other elements that conflict with the main subject. Look at the space around and behind your subject and make sure nothing overpowers it in colour, shape or size.

THE RULE OF THIRDS

As you think about where to place the point of interest, keep in mind the 'rule of thirds' that has traditionally been the starting point for successful composition. As you look through your viewfinder or study the LCD screen, imagine two vertical and two horizontal lines spaced evenly, creating a grid of nine rectangular boxes. Try placing the point of interest, or other important elements, on or near the points where the lines intersect. If you're taking a portrait, the subject is the person's face and the point of interest would be their eyes. In a landscape the point of interest may be a boat floating on a lake; place the boat on one of the intersections and also position the horizon near one of the horizontal lines.

Old Town from Parc du Chateau, Nice, France
Having a clear point of interest is particularly important in busy photos, but much harder to achieve. By following the rule of thirds and positioning the pink church tower away from the centre, the eye is forced to scan the image and is then lead naturally to the tower by the sweeping black curve of the street, which is completely in shadow.
35mm SLR, 70-200mm lens, 1/60 f11, Ektachrome E100VS, tripod

DEPTH OF FIELD

Depth of field refers to the area of a photograph, in front of and behind the point of focus, that is considered acceptably sharp. It is controlled by the aperture and is one of the most important creative controls available to the photographer. The smaller the aperture, the greater the depth of field, and vice versa. An aperture of f16 will give maximum depth of field, while f2 will give minimum depth of field. For general photography use f8 or f11 as your standard aperture setting. These apertures will generally allow you to use a shutter speed of around 1/125, give enough depth of field for most shots and even give you some latitude against inaccurate focusing.

When you look through the viewfinder of a DSLR you're seeing the scene through the lens at its widest aperture, or 'wide open'. This allows you to focus and compose through a bright viewfinder. The lens doesn't 'stop down' to the selected aperture until the shutter is released. As a result, you'll see your composition with very little depth of field. If your camera has a depth-of-field or preview button, you can get an idea of what will be in focus at any chosen aperture by manually stopping down the lens before taking the shot. Select an element of the image that appears out of focus and watch it come into focus as you stop down from f4 to f5.6 to f8. With each stop the viewfinder will get darker, but as you practise this technique the usefulness of controlling depth of field will soon become apparent.

It's commonly understood that three other variables combine with the aperture to determine depth of field: the focal length of the lens, the distance between

Prayer wheels, Tawang, India

This sequence clearly shows the dramatic effect the aperture has on the depth of field. Without changing the lens or point of focus, the prayer wheels on the left and right of the centre wheel can be in or out of focus, creating quite a different image.
(Left) DSLR, 24-70mm lens at 70mm, 1/3200 f2.8, raw, ISO 100

(Middle) DSLR, 24-70mm lens at 70mm, 1/400 f8, raw, ISO 100

(Right) DSLR, 24-70mm lens at 70mm, 1/100 f16, raw, ISO 100

the camera and the subject, and the sensor size. Well, they don't, at least technically. Their impact is more to do with magnification factors and so they are considered to affect the 'apparent' depth of field in an image. In practice you'll find that at the same f-stop, shorter focal length lenses, such as 24mm or 35mm, will have greater apparent depth of field than telephoto lenses of 135mm or 200mm. The further away your subject is, the greater the apparent depth of field. Move in close and the depth of field will appear minimal. So, maximum apparent depth of field can be achieved by focusing on a subject over 50m away and using a wide-angle lens at an aperture of f16. Apparent depth of field will be minimised by focusing on a subject under 5m away and using a telephoto lens at an aperture of f2.

Achieving shallow depth of field with compact digitals is not really possible. The small 7mm to 30mm focal length lenses typically used deliver a much greater depth of field compared with the much longer focal length lenses used on full-frame sensor cameras. A compact camera with a 1/1.8 inch sensor shooting at an aperture of f2.8 will produce an image with a depth of field equivalent of f13 if the same image was shot on a full-frame sensor.

FOCUS

The sharpest part of the image should be the point of interest, so take care when focusing. If something other than the main subject is the sharpest part of the composition the viewer's eye will rest in the wrong place.

There are five reasons why unsharp images are so common:

o The lens is not focused accurately, particularly at wide apertures (f1.4–f4).

o The lens is focused on the wrong part of the composition.

o Shutter speed is too slow for hand-holding, resulting in camera shake.

o The photographer jabs the shutter release, wobbling the camera.

o The subject moves.

One of the traps with the rule of thirds for autofocus cameras is that if the subject is not in the middle of the frame, it may not be in focus. The autofocus sensor is usually in the middle of the viewfinder, which tends to prompt people to put their subject in the middle of the frame. This isn't a recommended place for the majority of striking compositions (see p158). Unfortunately, when the main subject is not in the centre it's often out of focus. The focus sensor misses the subject and focuses on something in the background. Additionally, the meter will take a reading from the background rather than the main subject.

Most compact digital cameras have a focus-lock facility, which you should be

confident using. The focus-lock facility allows you to produce more creative and technically better pictures by locking the focus on the main subject then recomposing without the camera automatically refocusing (see p148).

DSLRs and advanced compacts offer more sophisticated options for achieving the focus you want by allowing you to select single or multiple focus points as well as offering a choice of auto focus modes.

FOCUS POINTS

The standard single focus point set-up gives you the choice of choosing a point in the centre, or a point above, below, left or right of the centre of the focusing screen. Select the multiple focus points set-up and you will activate all of them. Advanced cameras offer an even greater number and wider coverage over the focusing screen area. You really do need to experiment with these options and decide your own preference, which you'll probably find you stick with for all subjects. If you leave it to the camera, the default setting is usually a single focus point in the centre of the viewfinder. This is fine as long as you use the focus-lock technique to add variety to your compositions (see p148).

FOCUS MODES

DSLRs and advanced compacts allow you to focus the camera manually or offer two autofocus modes: one-shot and predictive, also known as servo or tracking mode.

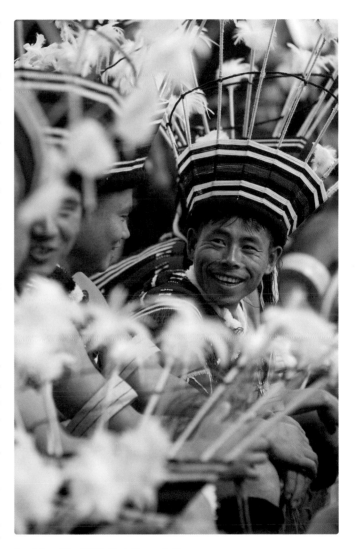

Spectator at Hornbill Festival, Kisama, India
No matter what kind of camera you use or whether you use manual or autofocus lenses, practise focusing fast and/or using the focus-lock facility until it becomes second nature. You'll get your reward when a great but challenging opportunity like this arises, where the subject gives you two seconds to take the shot, is a small part of the frame, is partially obscured and is off-centre.
DSLR, 70-200mm lens at 200mm, 1/250 f5, raw, ISO 125

MANUAL FOCUS

Photographers generally use autofocus technology for much of their work, but there are occasions where switching to manual focus is useful. Typically, manual focus will be employed when a sequence of shots are to be taken of a static subject that is composed off-centre and would require refocusing every time the shutter is released. Having mounted the camera on a tripod and taken the time to carefully compose an image, you don't want to have to go through the process again after each frame.

ONE-SHOT

With one-shot mode, you place your focus point on your subject and depress the shutter halfway; the mode locks the autofocus until you either take the photo or lift your finger. If the subject moves after you've focussed on it you need to release the shutter and repeat the procedure by depressing the shutter halfway to refocus. This mode is standard on compact cameras, which you'll recognise from the focus-lock technique (see p148), and is also the recommended mode for general photography with DSLRs.

PREDICTIVE

As long as you keep your focus point on the subject, the predictive autofocus mode (aka servo or tracking) updates the focus as your subject moves. The trick is to keep the focus point over the subject by following it with your lens. If the focus point moves off the subject the lens will focus on whatever it finds over the focus point, typically the background, or something that has come between you and your subject. This is the mode to use for moving subjects.

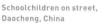

Schoolchildren on street, Daocheng, China

With a group of about 300 schoolchildren fast approaching, I took up a slightly elevated position in their path (on a piece of broken concrete) so that I could pick interesting individuals out from the middle of the group. As they approached I zoomed out to keep them in frame until their expression and my composition came together. This is a classic example of when to use your camera's autofocus servo or tracking mode to achieve accurate focus. By letting the lens do the technical work you can focus on your subjects' expression and capturing the best moment.

35mm SLR, 70-200mm lens, 1/250 f5.6, Ektachrome E100VS

CHOICE OF LENS

The focal length of your lens determines the field of view, subject size, perspective and depth-of-field potential. (See p50 for more information on the features of different types of lenses).

FIELD OF VIEW

The focal length determines the field of view and refers to the image area that the lens provides. On a DSLR with a full-frame sensor, a standard 50mm lens covers an angle of 46 degrees, which gives about the same field of view and subject size as the human eye. Wide-angle lenses provide a wider field of view and smaller subject size. Telephoto lenses have a narrower field of view and a larger image size.

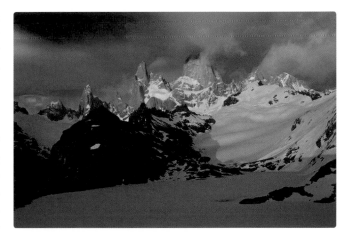

Mt Fitz Roy and range, Laguna de Los Tres, Patagonia, Argentina
This is why we use zoom lenses or carry different focal length lenses. After a one-hour predawn climb to the top of a big hill, we can take very different photos without walking any further. These examples show the difference in the field of view between two very useful focal lengths, 24mm and 200mm.
(Top) 35mm SLR, 24-70mm lens at 24mm, 1/125 f11, Ektachrome E100VS, tripod

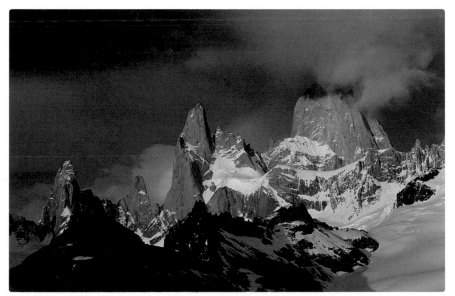

(Bottom) 35mm SLR, 70-200mm lens at 200mm, 1/125 f11, Ektachrome E100VS, tripod

DEPTH-OF-FIELD POTENTIAL

The wider the angle of the lens, the greater its apparent depth-of-field potential. The longer the focal length of the lens, the more its apparent depth-of-field potential is reduced. (See p159 for more information on depth of field).

PERSPECTIVE

Perspective refers to the relative size and depth of subjects within a picture. When the field of view is wide (with wide-angle lenses), the perspective becomes more apparent because it's stretched. Close objects appear much larger than those in the background. With a narrower field of view (with longer focal lengths), the perspective is foreshortened and becomes less apparent – far objects look like they're directly behind closer ones.

Fisherman's Wharf, San Francisco, USA
[Top] Fisherman's Wharf is packed on the fourth of July. The wide perspective of the 24mm lens gives a sense of place, and the space between the people on the street is apparent.
35mm SLR, 24mm lens, 1/250 f11, Ektachrome E100SW

[Bottom] The 180mm lens shows only a small part of the scene. The foreshortened perspective brings the people on the street closer together, making it seem more crowded than it actually is.
35mm SLR, 180mm lens, 1/250 f8, Ektachrome, E100SW

VIEWPOINT

The position of the camera is important for two reasons. Firstly, in conjunction with your choice of lens, it determines what elements you can include and how they are placed in relation to each other. Secondly, it determines how the subject is lit by its position in relation to the main light source.

Don't assume that your eye level or the first place from where you see your subject is the best viewpoint. A few steps left or right, going down on one knee or standing on a step can make a lot of difference. Varying your viewpoint will also add variety to your overall collection.

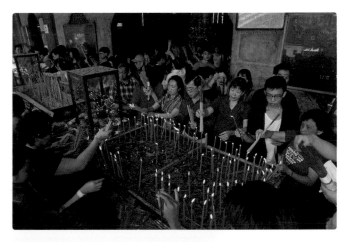

Siong Lim Temple, Singapore
These two pictures of devotees lighting incense to celebrate Chinese New Year illustrate clearly how easy it is to create two very different images of the same place, simply by altering the position of the camera and the focal length of the lens.
(Top) DSLR, 24-70mm lens at 24mm, 1/100 f7.1, raw, ISO 160

(Bottom) DSLR, 24-70mm lens at 70mm, 1/100 f4.5, raw, ISO 160

165

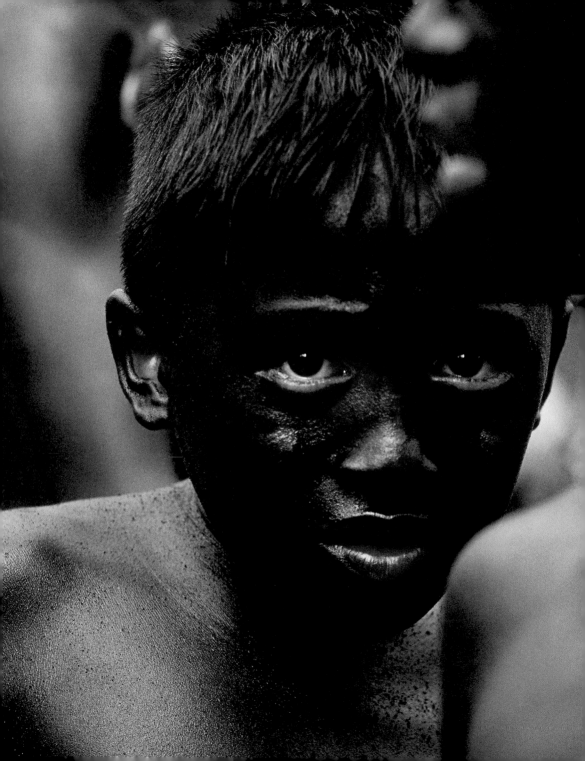

BOYS AT HARVEST FESTIVAL, LUZON, PHILIPPINES

35mm SLR, 100mm lens, 1/125 f4, Ektachrome E100VS

Their faces and bodies painted black and their lips bright red, these boys were part of a group waiting to join the procession during the small town of Lucban's harvest festival. As usual I had arrived before the stated starting time because over the years many of my best festival shots have been taken when participants are milling about before or after the actual event. My original intention was to create a portrait with a clean composition, ie with nothing distracting jutting in from the sides of the frame, but quickly changed my mind when I saw the potential of adding a sense of depth by concentrating on one of the boys partially hidden by another. This sort of image could be considered an action portrait as both the subject and the other boys around him were moving so when the elements come together there is only a split second – and only one chance – to capture the moment. The final picture is slightly cropped to eliminate distracting highlight areas on the left and right of the frame, but in these fluid situations I always concentrate on the expression and key compositional elements rather than worry about what's going on around the edges.

CONTENT SELECTION

Life Guard, Puri, India
What you leave in or out of your frame is another simple but powerful creative tool at your disposal. In a crowded situation such as Puri Beach just before sunset, a quick way to cut out distractions behind your subject is to lower your viewpoint and use the sky as a background. You have an instant, even-coloured and clean background.
(Left) DSLR, 24-70mm lens at 48mm, 1/125 f3.5, raw, ISO 200
(Right) DSLR, 24-70mm lens at 70mm, 1/125 f3.5, raw, ISO 200

Good compositions leave no doubt as to the subject of the photograph. A good way to start is to fill the frame with your subject. This helps to eliminate unnecessary or unwanted elements and overcomes the common mistake of making the subject too small and insignificant, which leaves the viewer wondering what the photo is supposed to be of. Often just taking a few steps towards your subject or zooming in slightly will make an enormous difference.

What you leave out of the frame is just as important as what you leave in. Do you really want power lines running across the facade of the most beautiful building in the city? It's fine if you do, but not if you didn't notice them in the first place. Scan the frame before pressing the shutter release, looking for distractions and unnecessary elements. If you have a depth-of-field button (see p159), use it to bring the foreground and background into focus, which will help you spot unwanted elements.

FRAMING

Framing subjects is a common practice, but if not executed well it can actually weaken a composition. This is often the case when it's just something on one or two sides of the composition, such as tree branches, whose only achievement is to draw the viewer's attention away from the main content of the shot. The framing device must have some relevance to the subject and lead the viewer's eye to the point of interest. Remember, the element being used to frame the composition is not the subject, so it shouldn't be so overpowering in colour or shape that it competes for the viewer's attention with the actual subject.

Duomo rooftop, Milan, Italy

This is the perfect situation to use framing as a compositional technique. The framing device is clearly part of the main subject and is complementary in colour, texture and style, adding a sense of depth to the photograph.
DSLR, 24-70mm lens at 24mm, 1/125 f7.1, raw, ISO 100

Market on Gunduliceva Poljana, Dubrovnik, Croatia

Although the framing device is not directly connected to the subject, framing the view from a window is something we can all relate to. In this case it offers a strong sense of the travel experience; the thrill of waking in a new place to discover that what was a deserted square the night before is the town's focal point every morning. And you're right there!
35mm SLR, 24-70mm lens at 24mm, 1/60 f8, Ektachrome E100VS

HORIZONS

Keep horizons level. This doesn't just mean that line far out at sea. It means all horizontal lines, such as the base of buildings, window frames, table tops etc, that should be parallel to the ground; they should be kept at zero degrees.

If you're going for a deliberate angled look make sure it looks deliberate by tilting the camera's axis off-centre by at least 30 degrees. Otherwise it can look more like a mistake.

ORIENTATION

Consider whether the subject would look best photographed horizontally or vertically. Camera orientation is an easy and effective compositional tool and often a quick way of filling the frame and minimising wasted space around the subject. It feels much more natural to hold the camera horizontally, so it's not surprising that people forget to frame vertically. Start by framing vertical subjects vertically.

Palazzo Vecchio and city at dusk, Florence, Italy
Some subjects look best framed vertically, others horizontally. In this case it works both ways, which is actually often the case. Photographers routinely look to create horizontal and vertical compositions of the same subject to give them and their clients flexibility in how the images can be used. The vertical is perfect for use on a cover, the horizontal perfect for a double-page spread. If you're not sure, and you've got time, take both and you can consider your preference later.
DSLR, 70-200mm lens at 155mm, 10 secs f7.1, raw, ISO 100, tripod

SCALE

To emphasise the vastness of a landscape, the bulk of a landform or the height of a building, include elements that are of a familiar size in your composition to add a sense of scale that is clearly understood. Place the element in the middle distance and use a standard to telephoto lens for best effect. If the subject is too close to the camera and you use a wide-angle lens, perspective will be exaggerated. The subject will appear far bigger than the background elements, and all sense of scale will be lost.

If you're using people to show scale, ensure that they're looking into the scene. This will lead the viewer's eye to the main subject rather than to the edges of the composition.

(Left) Mingyong Glacier, China
The inclusion of the umbrella-carrying visitors on the boardwalk alongside part of the 12km-long glacier gives a hint at just how vast it is.
35mm SLR, 24-70mm lens, 1/60 f8, Ektachrome E100VS

(Right) Mt Thamserku, Nepal
Trekkers silhouetted against Mt Thamserku add a sense of scale and human interest to the landscape. It's not hard to get your trekking friends to pose when the opportunity presents because everyone loves a hero shot like this. The trick to seeing the image is to walk some distance behind, but not so far that they can't hear you yelling for them to stop. If you're at the front of the group you just won't see the potential.
35mm SLR, 24-70mm lens, 1/125 f11, Ektachrome E100VS

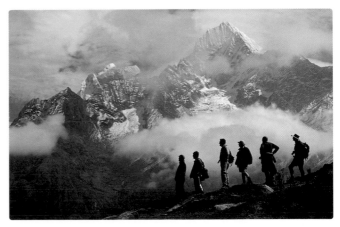

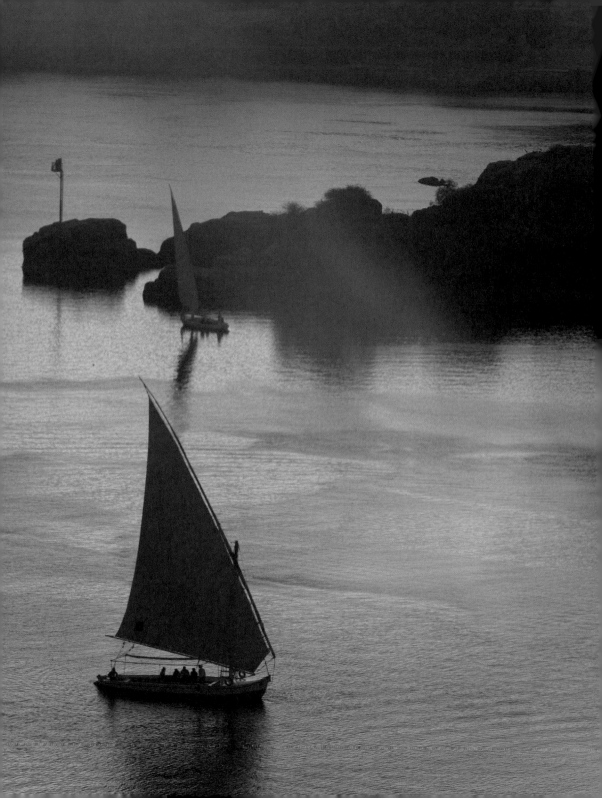

LIGHT

The ability of light to transform a subject or scene from the ordinary to the extraordinary is one of the most powerful tools at the photographer's disposal. To be able to 'see' light and to understand how it translates onto the sensor and how it impacts on your compositions is the final building block in creating striking images.

The majority of travel pictures are taken with the natural light of the sun, but you'll also use incandescent lighting indoors or at night, and flash light when the available light is too low.

There's light and there's the 'right light'. The keys to the right light are its colour, quality and direction. Once you understand these elements you can predict the effect they may have on a subject. This will help you decide what time of day to visit a place. The trick to shooting in the right light is to find a viewpoint where you turn the conditions to your advantage, rather than struggle against them.

The impact of light cannot be emphasised enough. Given all other things are equal, it is the light a photographer shoots in that sets images apart.

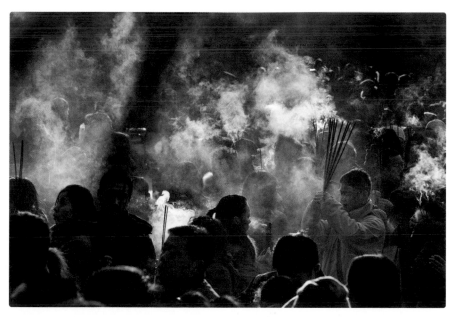

(Left) Worshippers at Lama Temple, Beijing, China

I always scan a crowd looking for an interesting person to base my composition around. In this case, I picked out the person with the most incense sticks hoping for lots of smoke and therefore maximum effect when it drifted up and into the rays of the early morning sun.
DSLR, 70-200mm lens at 155mm, 1/125 f10, raw, ISO 400

(Opposite) Feluccas on Nile at sunset, Aswan, Egypt
DSLR, 70-200mm lens at 175mm, 1/60 f7.1, raw, ISO 100

NATURAL LIGHT

The colour, quality and direction of natural light change throughout the day. As your eye settles on a potential subject, note where the light is falling and select a viewpoint that makes the most of the natural light to enhance your subject. There is an optimal time of day to photograph everything, so be prepared to wait or return at another time if you can't find a viewpoint that works. However, most subjects are enhanced by the warm light created by the low angle of the sun in the one to two hours after sunrise and before sunset. At these times shadows are long and textures and shapes accentuated. If you're serious about creating good pictures, this is the time to be shooting the key subjects on your shot list.

COLOUR

The colour of the light changes as the sun follows its course through the day. On a clear day when the sun is low in the sky (just after sunrise or just before sunset), the colour of the light is warm and subjects can be transformed by a yellow-orange glow. This light enhances many subjects and it's worth making an effort to be at a predetermined place at the beginning and end of the day. As the sun gets higher in the sky, the colour of daylight becomes cooler and more 'natural', or neutral. If heavy cloud is blocking the sun, the light will be even cooler and photographs can have a bluish cast. This will also happen on sunny days if your subject is in shade.

Harbour, St Tropez, France
Just before 3pm on a warm summer's day, head out to the sea wall overlooking the harbour at St Tropez and stand there for around 6½ hours to get a crash course in how the colour, quality and direction of the light impacts on the photos you take. These four pictures were taken at 3pm, 6pm, 9pm and 9.30pm respectively. The colour variations captured in these images are repeated every day (weather permitting) on outdoor subjects all over the world.
(Top left) 35mm SLR, 24-70mm lens, 1/250 f8, Ektachrome E100VS

(Top right) 35mm SLR, 24-70mm lens, 1/60 f11, Ektachrome E100VS, tripod

(Bottom left) 35mm SLR, 24-70mm lens, 1/8 f11, Ektachrome E100VS, tripod

(Bottom right) 35mm SLR, 24-70mm lens, 1 sec f11, Ektachrome E100VS, tripod

DIRECTION

As the colour of light changes through the day, so too does its direction. Considering where light strikes your subject will improve your pictures significantly. Although the direction from which light strikes a subject is constantly changing, there are four main directions to consider: front, side, top and back. If the light is in the wrong place your options are to move the subject, move yourself, wait or return at the appropriate time of day.

Yachts moored on the Caribbean Sea, Gustavia, Saint Barthélemy
(Top) Front lighting: this gives clear, colourful pictures. However, shadows fall directly behind the subject, and can cause some photographs to look flat and lack depth.
35mm SLR, 70-200mm lens, 1/125 f8, Ektachrome E100VS

(Middle) Top lighting: this occurs in the middle of the day and is rarely flattering, giving most subjects a flat, uninteresting look. However, skies and seas will often look their bluest.
35mm SLR, 24-70mm lens, 1/250 f16, Ektachrome E100VS

(Bottom) Back lighting: this occurs when the sun is in front of your camera. Silhouettes at sunset are a classic use of back light. Back light has to be carefully managed or your subjects will lack colour and detail.
35mm SLR, 70-200mm lens, 1/250 f11, Ektachrome E100VS

(Below) Village elder demonstrating traditional fire-lighting technique, Tanna Island, Vanuatu
Side lighting: this brings out textures and emphasises shapes, introducing a third dimension to photographs.
35mm SLR, 24-70mm lens, 1/25 f11, Ektachrome E100VS

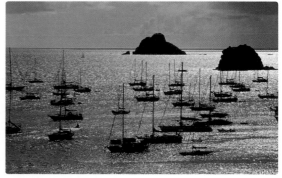

LENS FLARE

When shooting directly into the sun, watch for lens flare caused by stray light entering the lens. This reduces contrast, and records as patches of light on the sensor. With DSLRs, bridge cameras and when composing with the LCD screen on compacts, you can usually see lens flare (if you're looking for it) in the viewfinder. It can be highlighted by stopping down the lens with the depth-of-field button. A slight change in camera angle or viewpoint will usually solve the problem. Lens hoods help prevent flare but shading the lens with your hand may also be required (don't let your hand enter the field of view), or try placing the sun directly behind an element in the scene.

Bled Island, Bled, Slovenia

At first light mist was floating over the lake and the quality of the light was very soft, offering little contrast and rendering the scene in monotone. Within the hour the sun broke through, the mist cleared and the church and treed island are clearly defined by the direct light.

(Right) 35mm SLR, 24-70mm lens, 1/4 f11,Ektachrome E100VS, tripod

(Left) 35mm SLR, 24-70mm lens, 1/125 f11, Ektachrome E100VS

QUALITY

The quality of natural light is determined by the position of the sun and the weather. Light quality can vary from one moment to the next. Direct sunlight becomes indirect as a cloud blocks its rays. A small break in heavy cloud just above the horizon can transform a scene from ordinary to spectacular in a split second.

Direct sunlight produces a harsh light. This is especially noticeable in the middle of the day. Shadows are short and deep and contrast will be high. Colours are strong and accurate, but they can also be washed out by the intense, overhead sunlight.

In the two to three hours after sunrise and before sunset, direct sunlight is not quite as harsh and colours are still reproduced naturally. The lower angle of the sun gives shadows with some length, brings out textures and adds interest and depth to subjects.

At sunrise and sunset the very low angle of direct sunlight produces long shadows, and texture and shape become accentuated. Combined with the warm colour this is an attractive and often dramatic light.

Indirect sunlight produces a softer light. On overcast but bright days, or when the sun disappears behind a cloud, shadows become faint and contrast is reduced, making it possible to record details in

all parts of the composition. Colours are saturated and rich, especially in subjects close to the camera.

Rain, mist and fog produce an even softer light. Shadows disappear, contrast is very low and colours are muted. If the cloud cover is heavy, and light levels are low, the light will be dull and flat.

SUNRISE & SUNSET

The beautiful light that often accompanies the beginning and end of daylight hours deserves special mention as it's an attractive subject in its own right and also throws up a couple of issues to be aware of.

When the sun is below the horizon, behind cloud, or isn't in the frame, meter readings are usually accurate. If the sun is in the frame, override the recommended meter settings or the image will be underexposed (leaving you with a well-exposed sun in the middle of a dark background). This effect is exaggerated with telephoto lenses. To retain colour and detail in the scene take a meter reading from an area of sky adjacent to the sun and then recompose. Modern cameras with advanced metering systems handle these situations pretty well, but it's still worth using a couple of extra frames and overexposing by half a stop and one stop to be sure.

Bracketing sunrises and sunsets is recommended, particularly if the sun is in the frame. If you have a compact camera avoid including the sun in your composition, or at least take a couple of shots: one with and one without the sun.

Sunset at Korolevu Bay, Fiji
My first inclination with sunsets is to find a subject – boats or swaying palms, usually – to silhouette against the bright, coloured sky. However, the intense colours, interesting clouds and not-so-common lake-like reflections in the sea on this particular evening didn't need any support.
35mm SLR, 24-70mm lens, 1/30 f5.6, Ektachrome E100VS

Shikara on Dal Lake at sunset, Srinagar, India
You don't always get lens flare when the sun is in the frame; it depends on atmospheric conditions, the angle at which the sun strikes the lens and the quality of the lens.
DSLR, 70-200mm lens at 120mm, 1/160 f7.1, raw, ISO 100

177

Rainbow over Central, Hong Kong Island, China
The upside of a rainstorm is that when it ends there's often a period of wonderful light as the sun breaks through the clouds. When it does, the chance of rainbows is high, but the trick is to find a subject to include with the rainbow. A rainbow alone won't always make a photograph worth looking at. A polarising filter will intensify the colours of a rainbow and is often required so that the rainbow can actually be 'seen' by the lens.
35mm SLR, 24-70mm lens, 1/30 f8, Ektachrome E100VS, polariser, tripod

RAINBOWS

Fleeting and colourful, rainbows add a surprising element to a photograph, no matter what the subject. Like colourful skies, a rainbow in your composition doesn't automatically make a good photo. The content should be interesting and the composition good, and then enhanced by the inclusion and careful placement of the rainbow. Use a polarising filter to increase the contrast between the rainbow, clouds and sky. It will strengthen the colours of the rainbow and cut down distracting reflections in the landscape. In some cases rainbows will not record on the sensor without the aid of a polariser. Rainbows will really test your ability to work quickly, as they rarely last more than a few minutes. And be prepared to get wet.

FLASH

Flash provides a convenient light source that will let you take a photo even in the darkest places without having to change sensor setting or use a tripod, as long as the subject is within the power range of your unit. You'll find yourself in lots of these low-light situations, particularly after dark, at cultural and live-music shows, restaurants, bars and nightclubs.

Most compact cameras and DSLRs have built-in flash units. Otherwise a separate flash unit can be mounted on the camera via the hot-shoe or off the camera on a flash bracket with a flash lead. However, pictures taken with flash from built-in or hot-shoe mounted units are usually unexceptional. The direct, frontal light is harsh and rarely flattering. It creates hard shadows on surfaces behind the subject and backgrounds are often too dark. To improve the look of your flash photographs get to know the features of your particular unit. If you have a DSLR, much more pleasing pictures can be made by using bounce and fill-flash techniques and by combining flash with the ambient light.

TECHNICAL CONSIDERATIONS

Built-in flashes and compact accessory units have limited power output. Subjects generally need to be between 1m and 5m from the camera for the flash to be effective (check your camera or flash manual for exact capabilities). Photographing an event in a big stadium at night with flash is pointless. If your picture comes out it will be because there was plenty of available light on the subject, not because your flash fired. Your flash will only have enough power to light up the four or five rows in front of you. Selecting a higher ISO sensitivity setting will extend the effective range of your flash or let you work with smaller f-stops for greater depth of field.

SYNCHRONISATION (SYNC) SPEED

All cameras have a maximum shutter speed that can be used to synchronise the firing of the flash with the time the shutter is open. You don't need to worry about this if you are using your camera's built-in flash or a DSLR in Program mode with the camera's dedicated flash unit. However, if you shoot with a DSLR using manual exposure modes, or a nondedicated flash unit, you must select a shutter speed that synchronises with the firing of the flash. This has traditionally been a maximum of 1/60. In recent times sync speeds have increased, but check your manual. If you select a shutter speed above the sync speed, part of your sensor or film will not be exposed to the flash light and that part of your picture will come out black. It's OK to select speeds slower than the designated maximum sync speed.

Dancers, Kandy, Sri Lanka

With modern cameras, a mounted hot-shoe or built-in flash set on automatic is pretty well guaranteed to get you a sharp, well-exposed photo, as long as you stay within the output range of the flash. The subject will appear bright but the background fades to black very quickly.
35mm SLR, 24-70mm lens, 1/60 f5.6, Ektachrome, E100VS, hot-shoe mounted flash

SYNCHRONISATION TIMING

On some DSLRs and some advanced compacts you can switch the timing at which the flash fires. The default setting, known as first-curtain sync, triggers the flash to fire immediately after the shutter opens at the start of the exposure. The alternative is to select second-curtain sync, which triggers the flash just before the shutter closes. Second-curtain sync is best used in conjunction with slow shutter speeds and the flash-blur technique (see p189). It allows the camera to record the subject's movement first so that the blur follows the subject, producing a more realist and natural look than having the blur ahead of the subject.

RED-EYE

If you use direct, on-camera flash when photographing people your pictures may suffer from the dreaded red-eye which can make even the most innocent-looking person quite demonic. The flash is in line with the lens and the light reflects off the blood vessels of the retina straight back onto the sensor. To try to minimise this problem many cameras have a Red-Eye Reduction feature, which triggers a short burst of pre-flashes just before the shutter opens. This causes the pupil to close down. It's a sophisticated way of increasing the light in the room.

Alternatively, red-eye can be minimised with the following techniques:

o Ask your subject not to look directly into the lens.

o Increase the light in the room, which causes the pupil to close down.

o Bounce the flash off a reflective surface.

o Move the flash away from the camera lens.

When using bounce flash off a ceiling or wall, the surface you bounce off should ideally be white; coloured surfaces will give your picture a colour cast.

Patrons at the Juke Box Bar, Bucharest, Romania
Flash light doesn't have to be a bright, nasty atmosphere killer. By bouncing the flash off the low white ceiling, a reasonable area of the bar has been illuminated and the warm mood and light have been retained.
35mm SLR, 24-70mm lens, 1/30 f8, Ektachrome E100VS, bounced flash

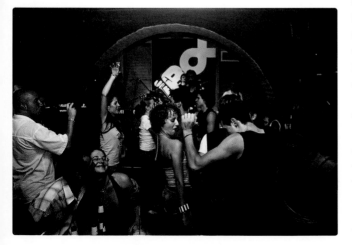

OFF-CAMERA FLASH

Off-camera flash gives more pleasing results because the light is moved to the side and above the lens so that it's angled towards the subject. Red-eye is eliminated and shadows fall below the subject (rather than directly behind). A sync lead connects the flash to the camera, and although you can hold the flash and shoot one-handed, mounting the flash on a flash bracket makes life a lot easier. This will limit the angle you can use, but you'll soon be able to anticipate how the flash will light your subject.

BOUNCE FLASH

Even more pleasing results are possible if bounce-flash techniques are employed. You need a flash unit with a tilt head or the ability to mount the flash off-camera on a flash bracket. The flash is aimed at the ceiling, wall or flash reflector, which bounces the light back at the subject. The light is indirect and soft and shadows are minimised. However, walls and ceilings come in varying heights and colours, and this can present some problems. If ceilings are too high you won't be able to bounce the flash. Dark-coloured walls and ceilings will absorb too much of the light.

To overcome these problems a bounce-flash kit is worth the small investment. By using a flash with a tilt head (on or off the camera), the flash is bounced off a reflector attached to the tilt head. The reflectors are interchangeable and available in different colours. A gold reflector will bounce warm light and a silver reflector will bounce cooler light.

FILL FLASH

Fill flash is a technique used to add light to shadow areas containing important detail that would otherwise be rendered too dark. The flash provides a secondary source of light to complement the main light source (usually the sun). If executed well, the flash light will be unnoticeable, but if it overpowers the main light source the photo will look unnatural.

Fill-flash techniques have long been the domain of professional photographers. Now most compact cameras, DSLRs with built-in flash units, and professional DSLRs with dedicated flash systems have a Fill Flash feature. Some activate automatically; others require you to decide that it is needed. Use the Fill Flash feature under the following conditions:

- The light on your subject is uneven, such as when a person's hat casts a shadow over their eyes but their nose and mouth are in full sun.

- Your subject is backlit and you don't want to record it as a silhouette.

- Your subject is in shade, but the background is bright.

If you're using a less sophisticated DSLR and accessory flash, you'll need to override the flash so that it delivers less light than it would if it were the main light source (usually one to 1½ stops less). Set your exposure for the brightest part of your composition, say 1/60 at f8, but set the flash on f5.6 or f4.5. Alternatively, you can change the ISO setting on the flash unit, from say 100 to 200. Both techniques trick the flash into thinking that the scene needs less light than it actually does. Output is reduced, which prevents it becoming the main light source while still giving enough light to fill in the dark areas.

FLASH CONTROL WITH COMPACT CAMERAS

Most advanced compacts have five flash modes: Auto, Red-Eye Reduction, Fill Flash, Night Scene and Flash Off. The Auto mode is always on and fires the flash automatically in low light and back light situations. However, you can take control of the flash so that it only fires when you want it to. Too often the flash on compact cameras fires when it doesn't need to, overriding the available light to produce flat, brightly lit pictures that lack mood and render the background dark and uninteresting.

Remember: your subject must still be within the effective range of your particular flash unit for the fill-flash technique to be successful.

Dancers, Leh, Ladakh, India
In the late afternoon the dancers arrived in the hotel garden to put on a cultural performance. The area was in heavy shade, taking the edge off the colours of the traditional clothing, and the light beyond was very bright. Fill flash made sure the dancers' faces are seen and put the snap back into the colours of their outfits.
35mm SLR, 24-70mm lens, 1/30 f5.6, Ektachrome E100VS, fill flash

Most compacts have automatic shutter speeds from 1/500 down to at least one second. By turning the flash off, you can access these slower shutter speeds and take advantage of the available light. Many cameras will warn you that you risk blurring the photo if the shutter speed to be used is slow. With or without the warning, be conscious of the risk of camera shake in low light. Experiment in different conditions to learn how low the light can be before needing a tripod or some other support. Further control can be achieved with the Fill Flash mode.

INCANDESCENT LIGHT

When taking photographs indoors or after dark we often have to rely on incandescent, or artificial, light sources such as electric light bulbs, floodlights or candles. The concepts of colour, quality and direction discussed earlier are just as relevant to incandescent light – it's just that the light source is different.

When you find yourself in dimly lit interiors, don't assume you need flash. As a rule, if you can see it you can photograph it. By using a tripod or other camera support you'll be able to shoot in low-light situations with your preferred sensor setting. Alternatively, increase the sensitivity of your camera's sensor in order to hand-hold the camera in very low light but be aware at what setting noise will become a problem with your particular sensor (see p26).

There are good reasons for being prepared to work with the available light. Most importantly, you'll be able to take pictures in many places where the use of flash is impractical (floodlit buildings, displays behind glass), prohibited (churches, museums, concerts), intrusive (religious ceremonies) or would simply draw unwanted attention (shops and shopping centres).

If your camera's white-balance control is on automatic, check that you're happy with the way it's recording the colours in the scene. Remember that the white-balance function adjusts the colours to ensure that

Nun attending candles at Stone Gate Shrine, Zagreb, Croatia

Thirty minutes before I took this picture the shrine was deserted, so I left. Fortunately, I went back to discover it alive with people offering prayers and lighting candles. With so many candles it was possible to work with the available light. Spot metering on the nun's face solved the problem that the extreme contrast between the burning candles and the dark background causes light meters.

35mm SLR, 24-70mm lens, 1/80 f6.3, Ektachrome E100VS

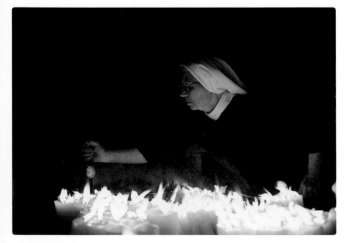

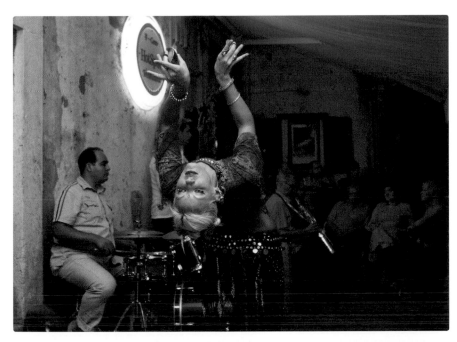

Belly dancer performing at Troubadour Café, Dubrovnik, Croatia

Although the performer didn't seem to mind the audience using flash, I much prefer the varied effects different light sources provide and only use flash as a last resort. Sometimes it means waiting for the performer to move into an area that is appropriately lit in terms of level and direction, as she has here, albeit in a way only a belly dancer could.

35mm SLR, 24-70mm lens, 1/60 f2.8, Ektachrome E100VS rated at 400 ISO (2-stop push)

Peddlar's Walk at Clarke Quay, Singapore

By day this is a short, unassuming walkway, but at night it transforms into incandescent-light heaven. Featuring a quickly changing sequence of the most garish neon colours, it's guaranteed to keep your attention way longer than first expected (or is that just me?).

DSLR, 24-70mm lens at 70mm, 1/6 f9, raw, ISO 100

Flinders Street Station, Melbourne, Australia
Without doubt the mix of natural and incandescent lights produces the most attractive urban images. The greater the number and variety of light sources the more magical the effect.
DSLR, 24-70mm lens at 43mm, 2.5 secs f10, raw, ISO 100, tripod

white is recorded as white under all lighting conditions. For more accuracy select one of the presets that typically include tungsten and fluorescent-lighting settings. If you're shooting raw files, you can also fine-tune the white balance in your image-conversion software before processing.

If you use daylight film in incandescent light, your photos will have a yellow-orange cast. The strength of the cast varies depending on the light source. The cast can be neutralised by using tungsten film balanced for incandescent light or light-balancing 82 series filters (see p64). More often than not, the warm colours are appealing and help capture the mood of the location.

MIXED LIGHT

At the beginning and end of each day, the urban environment provides the opportunity to mix daylight with incandescent light. Streetlights come on; light switches are flicked on in homes, offices and shops; monuments and statues are brought to life with floodlights; and the headlights and rear lights of city traffic are turned on. In the half-hour or so before sunrise and after sunset, cities and buildings take on a completely different look and feel, and the images you capture will add an extra dimension to your collection. The best time to photograph is around 10 to 20 minutes before sunrise or after sunset, when incandescent lighting is the dominant light source, but there's still some light and colour in the sky.

Evening traffic, Bangkok, Thailand
You can't hide the fact that the road is congested, but the warm tones of mixed lighting is the best way to make a busy city road look a little more attractive.
35mm SLR, 100mm lens, 1/4 f8, Ektachrome E100VS, tripod

If you're shooting JPEGs in mixed light, set the camera's white balance to daylight to ensure the warm colours are captured, as the auto setting will tend to neutralise the colours.

State Department Store on Red Square, Moscow, Russia
A spectacular building at any time, this building that dominates one side of Red Square takes on a completely different look once the thousands of light globes are switched on.
35mm SLR, 24-70mm lens, 1/4 f11, Ektachrome E100VS, tripod

185

MOVING SUBJECTS

Dancers in Yasur, speeding tuk tuks in Bangkok, surfers in Waikiki, wildlife, fireworks, moving cars, hot-air balloons, waterfalls… There are lots of subjects that just won't keep still. In fact the majority of subjects are moving, to different degrees. Generally, we aim to freeze movement in our shots to achieve clear, sharp images. You do have an alternative though, that when used with the right subjects allows you to suggest movement, speed and action through controlled blur of all or part of the image.

FREEZING THE ACTION

Where the activity is fast and furious, shutter speeds faster than 1/500 will freeze the action and capture the moment with great detail. Fast shutter speeds will result in wider apertures and less depth of field, but get the balance that suits you and the subject best by increasing the ISO sensitivity of your sensor.

When the subject is coming straight towards you, you don't need quite as fast a shutter speed; 1/125 will often do the job. What you do need to do is select the Predictive or Tracking autofocus mode (p162). If your camera doesn't have that feature, prefocus on a spot on the ground and release the shutter when your subject gets there.

With all moving subjects, you'll be more successful if you adopt a 'shoot first, think later' policy.

(Below) Tribal group performing at Hornbill Festival, Kisama, India
If the action is slower and more rhythmic you can still stop the movement with shutter speeds around 1/200, but you can help ensure sharpness by concentrating on one person and releasing the shutter when they are at the high point of their movement. Luckily, the other dancers were in sync with the guy I was focusing on.
DSLR, 70-200mm lens at 185mm, 1/200 f5.6, raw, ISO 400

(Opposite) Hot-air balloon, Melbourne, Australia
The degree of difficulty in photographing a moving subject increases when you're also on the move and the light is low, as was the case when the hot-air balloons took off before sunrise on an overcast morning. However, I was able to stop the action without an excessive ISO rating or high shutter speed because the balloons rose steadily side by side, almost cancelling out each other's movement from a photographic capture point of view.
DSLR, 24-70mm lens at 24mm, 1/60 f2.8, raw, ISO 800

187

PANNING & BLUR

Cyclo, Hanoi, Vietnam
When it's raining heavily and the light is low it's a good time to practise your panning skills, and the cyclo-filled streets of Hanoi offer lots of opportunities. The results of panning are unpredictable, so allow plenty of time for experimentation.
35mm SLR, 100mm lens, 1/15 f5.6, Ektachrome E100SW

Panning and blurring are techniques that allow you to suggest movement in a still photograph. Rather than freezing the subject for maximum detail, part of the image is blurred: either the background or the subject; sometimes both.

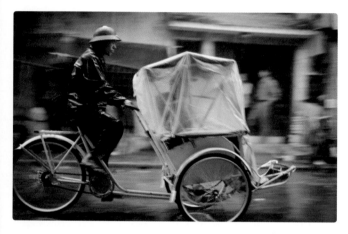

SHOOTING FROM MOVING VEHICLES

There will be times when you, the photographer, are the one moving because you're in a speeding plane, train, car, bus or boat. Success rates under these circumstances are going to be low, but if you must shoot:

- Set the fastest shutter speed possible (aim for 1/1000).
- Select a standard to short telephoto lens or zoom setting around 50mm–100mm to frame out the foreground.
- Switch to manual focus and set the focus on infinity.
- Turn off the flash if you're shooting through a closed window.
- Look ahead for a potentially clear viewing spot.
- Don't hesitate.

PANNING

Panning is generally used to keep a moving subject sharp while blurring the background, giving the impression of movement and speed. The speed the subject is moving at will determine the shutter speed. Start with 1/30 and 1/15. Train your camera on your subject and follow it as it moves. As it draws level with you press the shutter release and keep following the subject. The shutter must be fired while the camera is moving. Don't expect a high success rate but, with the right subject, panning can produce very effective pictures.

BLUR

Movement, action and activity can also be suggested by using a shutter speed that is slow enough to blur a moving element in your photograph, but still retain sharpness elsewhere. It can be as subtle or as obvious as you like. The key is not to shake the camera or record movement in the wrong part of the image. When a potter is at work a slow shutter speed will blur the spinning wheel with great effect, but if the potter also moves the image won't work. Likewise, the tumbling water of a waterfall can be made to look silky smooth, but the effect will be lost if the surrounding rocks and vegetation aren't sharp.

For pictures that don't include people the best effects are achieved with the camera on a tripod. You can then take a series of pictures at different shutter speeds until

you get the desired result. If you're photographing people the choice of shutter speeds narrows because you'll probably be hand-holding the camera and need to avoid both camera shake and movement in the wrong part of the image, typically the person's head. The simplest technique is to use a wide-angle lens as this lets you hand-hold the camera at slower shutter speeds such as 1/30 (see p144). Watch your subject's eyes and release the shutter when they appear motionless.

FLASH BLUR

If your subject is within the output range of your flash unit, you can express movement and mood in your photos and get some interesting and quite surprising results by using the flash-blur technique. Select a slow shutter speed as if exposing for ambient light and use second-curtain sync if your camera allows (see p179). Any movement by your subject or camera is captured through the blur caused by the slow shutter speed, but the action is stopped and the subject rendered sharp at the moment the flash is fired. The flash can be aimed directly at the subject or bounced using a reflector or off the ceiling (see p180). You can use this technique in daylight or indoors with incandescent light.

Compact cameras give you access to flash blur via the night-scene mode, a fun and creative tool to play around with. The level of available light determines how long the shutter stays open, so it's hard to predict how much blur will be captured. It's worth a few frames just to see.

Asan Tole, Kathmandu, Nepal
In the heart of old Kathmandu, Asan Tole is a focal point of activity day and night, and a thoroughfare for vehicular and pedestrian traffic. To portray this sense of constant activity I used a long shutter speed to blur movement around the fixed stalls and shops.
35mm SLR, 24-70mm lens, 4 secs f8, Ektachrome E100VS, tripod

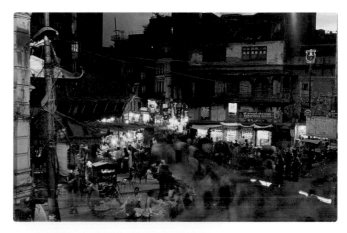

Dancer, Ulaan Baatar, Mongolia
The flash-blur technique has produced an image with subtle movement, and it reflects nicely the warm light and ambience of the stage. Until you've practised a lot, these kinds of shots have a high failure rate, so practise whenever you get the chance.
35mm SLR, 24-70mm lens, 1/30 f4, Ektachrome E100VS

Great Barrier Reef, Australia

A totally different aspect to the famed underwater imagery of the Great Barrier Reef is revealed when seen from the air. The meandering reefs and beautiful colours of the water present myriad opportunities for dramatic images but, being in the middle of the ocean, the only way to see them is to fly. The colours are most vibrant when the sun is shining brightly, so a po-larising filter is required to eliminate unwanted reflections off the water and to ensure saturated colours. Eliminating the horizon enhances the abstract nature of the photograph.
35mm SLR, 100mm lens, 1/250 f8, Ektachrome E100SW, polariser

FROM THE AIR

The main exception where you may deliberately choose to photograph your subjects from a moving platform is when you take to the air. The world certainly looks different from up there and can inspire even the most reluctant camera user to fill what seemed like an endless memory card. Opportunities for great pictures from commercial aircraft are limited, but many places offer joy flights in light planes, helicopters and hot-air balloons.

The most economical way up is to book a place on a sightseeing flight. This is a suitable option if you're happy with the proposed flight path and don't expect to get great shots of everything you fly over. However, if you want to capture particular angles or shoot at a specific height or time of day, you'll have to charter a plane or helicopter. The advantages are worth the expense, as you'll be able to remove the door for an unhindered view, work with the pilot to determine the flight path and altitude, and hover or repeat passes until you're satisfied. You'll need a minimum of 15 minutes or up to an hour depending on the distance between the airport or helipad and the destination.

Commercial Flights

Good pictures are difficult to get from commercial planes. Often the plastic windows are marked or dirty and the curve in them causes the image to go out of focus. If you're behind the wing, vapour from the engines may interfere with the view. To increase the possibility of good

aerials from a commercial aircraft:

o Find a seat forward of the wing and on the opposite side to the sun.

o Wipe marks and fingerprints off the window.

o Place the lens close to the centre of the window to minimise reflections from the cabin and blurring from the curved perspex; don't rest the lens against the window.

o Don't use a polarising filter (it doesn't work with perspex).

o Use standard focal lengths (35mm–70mm).

o Keep shutter speeds high to minimise camera shake and vibration.

o Look for photo opportunities just after take-off and during the descent.

Andes mountains, Argentina
Photographing snow-capped mountain ranges seems to be the one subject that returns the most consistently positive results for images taken from a commercial jet. Make sure you've got your camera with you for take-off and landing, because often the best opportunities come in those few minutes during ascent and descent.
35mm SLR, 24-70mm lens, 1/250 f8, Ektachrome E100VS

191

LIGHT PLANES & HELICOPTERS

Flying at low altitudes over natural attractions is a wonderful experience. To capture it is a challenge, but a little planning will help. Helicopters provide clear views, but make sure you request a window seat. High-winged planes offer a clearer view than low-winged planes. Talk to the pilot about the best place to sit to take photos and ask if a window can be opened. If you're with family or friends and are taking every seat, you could inquire about having the door of the plane or helicopter removed. It's not as radical as it sounds. Most companies work with photographers and will treat this as a standard request. When photographing from planes and helicopters:

As with all landscapes, aerials benefit from shooting early in the day. The low angle of the sun casts shadows that emphasise the texture and form of the land. The lower light levels can mean having to use slower than preferred shutter speeds, but light-plane and hot-air balloon flights are often smoother early, before the wind picks up.

(Top) Hinchinbrook Channel and Island, Australia

35mm SLR, 24-70mm lens, 1/500 f5.6, Ektachrome E100VS

(Bottom) Wilpena Pound, Flinders Ranges, Australia

6 x 7cm SLR, 45mm lens, 1/500 f8, Ektachrome 50STX

- Set the shutter speed at 1/1000, or as high as possible.
- Don't rest any part of your body against the aircraft, as vibrations will cause camera shake.
- Keep the camera within the cabin; don't let it protrude through the window or open door as it's impossible to keep it still.
- Keep horizons straight; this requires constant adjustment.
- Use a polarising filter when over water.
- Wear camera straps around your neck if the door is off (and keep your seatbelt on!).
- Start the flight with a enough space on the memory card to take at least 100 photos.
- Have spare memory cards handy.
- Most importantly, don't hesitate – shoot quickly and often.

HOT-AIR BALLOONS

Balloons are an ideal camera platform. They're steady and provide an unhindered view down to earth (if you lean out a bit) and out to the horizon. Hot-air balloons can't be manipulated with the speed of a helicopter or plane but they provide a much more peaceful and relaxed environment for taking pictures. Shutter speeds of 1/125 and 1/250 are sufficient and once at cruising height there's time to consider compositions, change lenses...and enjoy the view.

Amber Fort, Amber, India
The size, scale and geographic location of the magnificent Amber Fort, near Jaipur, is put clearly into perspective when viewed from the basket of a hot-air balloon.
DSLR, 24-70mm lens at 34mm, 1/100 f5, raw, ISO 400

LIGHT TRAILS

Tracing the patterns left by streaks of moving light add movement and colour to photographs that is only fleetingly visible to the naked eye. Combined with other incandescent lights and colour in the sky at dawn or dusk, light trails add a powerful and dynamic element and can make for quite dramatic images. Favourite subjects include fireworks, the lights of moving cars and, if you're lucky enough, close encounters with exploding volcanoes.

You'll need to mount your camera on a tripod, use a cable release and turn off the flash. There's no need to increase your sensor's ISO rating or use fast film; you can use your preferred settings and capture maximum detail and sharpness.

Some compacts have a Fireworks mode; use it when your composition includes the fireworks only.

Traffic at North Point, Hong Kong, China
The 20-second exposure has allowed plenty of vehicles to pass on both the lower and upper levels, almost completely filling in the grey road area with attractive light trails. Bus lights have added height to the effect and the f11 aperture has transformed the street lights into star bursts. A normally dull stretch of road now reflects the vibrancy of a modern urban environment.
35mm SLR, 100mm lens, 20 secs f11, Ektachrome E100VS, tripod

CAR LIGHTS

Including the trails of car lights in streetscapes or city views adds a visual element to photographs that we can't actually see as the traffic passes by. Use the technique described for fireworks (below), but set the aperture to f11 for lots of depth of field and expose the sensor for 10, 20 and 30 seconds. There are no guarantees because the intensity of the lights and length of the trails will vary from frame to frame depending on how many vehicles come into range and the speed they are going, so bracket away. Many built-in meters have automatic shutter speeds to 30 seconds. As a starting point, fire the camera on automatic and time how long the shutter is open. Then switch to manual and the B (Bulb) setting and bracket around what the camera recommended.

FIREWORKS

Avoid setting up in a brightly lit place where extraneous light can enter the lens and overexpose the image. You also need to make sure you've got some space so that your tripod isn't accidentally knocked by other spectators. The brightness levels will vary with different fireworks and different combinations of fireworks. You'll rarely have time to study the LCD screen and analyse the histogram, so vary the length of your exposures to increase success rates.

The simplest shots are those that fill the frame with the trails of light; the trick is to make sure you've got your lens focused

on the right part of the sky. It may take a few bursts to figure out exactly where that is. A wider focal length setting will cover more area of sky and pick up more bursts. Much more interesting and colourful pictures can be made if several bursts of light are recorded on the one frame. If there are lengthy delays between bursts use the B setting, which leaves the shutter open for as long as you wish.

In urban environments look for a position that allows you to include illuminated buildings or city skylines to add additional interest and a context for the pictures. Trial and error is called for, but if you're using a DSLR or compact with manual-exposure options, the following procedure should result in successful pictures:

- Mount the camera on a tripod.
- Set the shutter speed to 20 or 30 seconds or the B setting.
- Set the aperture to f16.
- Switch autofocus to manual.
- Set the focus on infinity.
- Turn off the built-in flash.
- Frame a part of the sky where you anticipate the fireworks to burst.
- Release the shutter with a cable release and allow several sets of fireworks to trace their paths on the sensor.

Note that the same technique can be used for photographing lightning.

Fireworks on the Singapore River, Singapore
The Singapore sky lights up with fireworks during Chinese New Year celebrations. You can concentrate on filling the frame with light trails but fireworks make even more spectacular photographs when incorporated into a cityscape. You've really hit the jackpot if there is a river to catch the reflections as well.
DSLR, 24-70mm lens, 13 secs
f22, raw, ISO 320, tripod

195

YASUR VOLCANO
ERUPTING,
TANNA ISLAND, VANUATU

35mm SLR, 24-70mm lens, 1 sec f11, Ektachrome E100VS, tripod

Standing around 50m from the rim of an
erupting volcano is right at the top of my
list of exhilarating picture-taking and travel
experiences. Arriving about an hour before
sunset, it was already an impressive sight
as huge clouds of grey smoke, ash and
dust rose high into the air. As the sun
set these clouds turned golden. But the
real show began after sunset. As the sky
darkened, the fiery red rocks being spewed
out became visible and able to be recorded
as light trails. It didn't feel dangerous
at the time, but if you're hit by one you
simply melt. A sobering thought, but not
one you can ponder for long as you're
grappling with much more important things
like composition and exposure. With the
camera on a tripod I exposed for the sky
between eruptions, priðritising the shutter
speed and shooting very quickly at various
speeds between one second and 1/15.
As the light and colour in the sky faded,
the eruptions couldn't come fast enough.
In the end I felt fortunate to be able to
capture two sequences when the eruptions
coincided with good colour in the sky.

CAMERA PHONE IMAGES

Taking photos with a camera phone is no different from using any other type of camera. Apply the same basic photography skills as you do when you're using a compact or DSLR camera and you'll be able to make up for some of the technical deficiencies. And there are plenty of deficiencies to make up for: inaccurate exposures, dull colours, lack of sharpness and subject detail, serious fringing and coloured halos around the edges of objects, lag time between pressing the release and the shutter firing, delay between shots as the image is processed, slow shutter speeds resulting in blurred photos, and cameras without flash that are effectively unusable at night.

But disappointing pictures are not all the fault of the technology. Poor technique by the camera-phone owner also plays a big part in the outcome. As with all cameras, the aim is to get the most out of the equipment you've got by working within its limits. If you're doing that then it all comes down to expectations. If you expect high quality files you'll mostly be disappointed, but if you're realistic about the possibilities and follow these suggestions you may be pleasantly surprised as to what can be achieved with a camera phone:

- Set the camera phone's resolution to the highest setting. Images will take longer to save and send but they will be clearer. Buy a larger flash memory card and set up an easy workflow so that transferring pictures from your camera phone is easy and doesn't force you to delete images to take new ones or switch to a lower resolution to save space.

- Don't delete images based on what you see on the small, low-resolution LCD screen; wait to see them on your computer.

- Shoot in the brightest possible light and avoid low light. When indoors, turn lights on and have subjects face the light

Venice, Italy

The Hipstamatic app records images that replicate the look and feel of plastic toy cameras.

Camera Phone, 5 MP, 4mm lens, 1/1371 f2.8, JPEG, ISO 80, Hipstamatic app with John S lens and Kodot XGrizzled film

CAMERA PHONE APPLICATIONS

The creative possibilities of capturing imagery with camera phones are being fuelled by the hundreds of photographic apps available for smartphones. Apps build on the basic functionality of the built-in camera to increase performance and add capture, enhancement and sharing capabilities. Camera replacement apps often mimic various classic cameras, lenses and film types. You can turn your camera phone into a plastic Holga (or Helga) camera with its square format, high contrast and heavy vignetting; pay tribute to Ansel Adams, the master of classic black and white landscape photography, by applying an Ansel-style filter to your image or produce a photograph that looks like it was taken with a Polaroid instant camera in the 1970s.

You can also improve your images with editing apps such as Photoshop Express for iPhone and Android smartphones. Apps like this one allow you to crop, rotate, colour correct, add titles, borders and numerous special effects.

(adjust white balance to suit if phone allows). If you have a flash use it indoors and outdoors in low light, but remember its range will be around 1m. If your subject is backlit, turn on the flash.

o Fill the frame with your subject, by moving in or using an optical zoom. You'll also avoid having to crop into the frame, which will lower the image quality. Experiment to find the minimum focusing distance. Watch for distortion that can occur when you get too close.

o Shoot both verticals and horizontals.

o If your camera has a fixed lens, its optimum focus point will be a meagre 50cm to 70cm from the lens. Subjects within this range will be as sharp and as detailed as the camera can deliver. Subjects further away will be less sharp.

o Avoid using the digital zoom, as image quality will be reduced. Better to crop in image-editing software if you

can't move closer to your subject. Also, digital zoom often only works when the resolution is set at a lower setting.

o Hold the phone steady. The shutter release button isn't always in the best place for achieving a steady hand. Concentrate on holding it steady, especially in low-light situations as the camera will select a slower shutter speed to compensate for the low light and blur is likely. If you're phone has image stabilisation leave it turned on.

o Adjust the white balance if you can, especially when shooting indoors without a flash.

o Experiment with the camera and get to know its features, strengths and weaknesses before you find yourself in an important picture-taking situation.

o Consider the basic rules of composition, especially the rule of thirds (p158) and orientation (p170).

o Keep the lens clean. This is almost impossible if it can't be covered so get into the habit of wiping away finger marks before you shoot.

o Experiment to find out how much shutter lag your phone has. Take this into account for content and camera shake.

o Keep the phone cool. As the sensor heats up, the noise increases, making for inferior quality photos.

o Transfer the images to a computer and edit them using image-editing software in exactly the same way as your camera photos. You'll be amazed at how good some of the pictures can look.

Chinese New Year Festival, Beijing, China
Even in soft, early morning winter light a 5 MP camera phone is capable of capturing an image file that is good enough to make a 20cm x 25cm (8in x 10in) print.
Camera Phone, 5 MP, 4mm lens, 1/212 f2.8, JPEG, ISO 80

MAKING MOVIES

Video is a popular way to capture imagery of the travel experience but, as people record their travels with mindnumbingly long 360-degree pans or with intermittent tilts as unexpectedly tall people come into view or their attention is grabbed by a few random birds flying overhead, one can't help but feel sorry for the people who will be made to watch. As photographers we can do better than that. If only you are going to watch your video, do what you like. If you expect other people to watch, then some basic shooting and editing techniques will give you a better chance of keeping your friends.

VIDEO CAPTURE WITH STILL CAMERAS

Nearly all compact digital cameras and a growing number of DSLRs feature a Video mode. This has given many people a first taste of recording moving images so it's worth considering and practising the following simple techniques before you find yourself in a situation where you want to record something to keep and share. At the same time you'll improve the quality and watchability of your efforts.

- Set the resolution, sometimes called video size, on the highest setting offered by your camera unless you are sure you'll only watch the video on the camera's LCD screen. If that's the case, a lesser resolution will still be watchable and you'll get a lot more footage onto your memory card.

- Consider the basic rules of composition (see p157), especially the rule of thirds.

- Frame each opening shot as though it were a still photograph.

- Study the light and be aware how changes in camera position or subject movement are affecting the scene.

- Depress the release button smoothly at the beginning and end of each clip to minimise camera shake.

- Begin recording two or three seconds before the action begins and stop recording two or three seconds after you've got what you need so that any movement caused by pressing the button on and off can be edited out later.

- Resist the temptation to zoom in and out. It may be fun while you're recording but it often ends up being annoying when played back. It's much better to stop the sequence and change to a different shooting position. You can also try walking towards or away from your subject, but watch for excessive camera movement. If there's a good reason to zoom, such as starting close and zooming out to reveal the subject, zoom slowly.

○ Resist the temptation to pan from one subject to the next or from one area to the other. When panning is appropriate, such as following your subject, pan slowly. It is easier for the viewer to watch and any exposure adjustments required will be less noticeable.

○ Turn on image stabilisation if it isn't automatic.

○ Use a tripod where possible. Even with image stabilisation it's hard to prevent all movement when hand-holding.

○ Keep clips brief, with a view to joining them using video-editing software.

See below for video shooting techniques, some of which you'll be able to use when using Video mode on your digital camera.

○

If you intend shooting a lot of video make sure you've got at least one fully charged, spare battery in your bag. Recording video drains batteries fast.

VIDEO CAPTURE WITH CAMCORDERS

If shooting video on your still camera has piqued your interest in moving images, you may want to try your hand at capturing your travels on video with dedicated movie-making equipment. What follows is a simple introductory guide for people familiar with playing with Video mode on their digital camera who are ready to have a go at making movies for the first time.

Remember that most people are visually literate when it comes to video thanks to the amount of television and movies we watch. We are accustomed to, and expect to see, well-made movies. You'll be given some leeway with your first efforts but if you apply all your technical and creative photographic skills and keep in mind the techniques outlined below, your videos will jump a grade or two quickly.

PLANNING A SHOOT

Still photographers generally see images in isolation. You need to keep in mind with video that you are creating a story with a beginning and end. Each sequence should be connected to the one on either side. You may not shoot it in sequence (but rather get the order right at the editing stage) but you need to keep the overall aim of the video in mind to ensure you capture all the things you need and that it flows.

COMPOSITION

Again, consider the basic rules of composition (see p157), especially the rule of thirds. Frame the opening shot of each sequence as though it were a still photograph.

Utilise the pivoting LCD standard on all camcorders to shoot from a variety of angles to add interest to your clips. It's also useful when you want to film discreetly to capture events that you may not otherwise be able to if people were more aware of the camera.

LIGHT

Study the light and be aware how changes in camera position or subject movement are affecting the scene.

ESTABLISHING SHOTS

An establishing shot does just that, establishes where you are and sets the scene for the video. The most famous place in a country makes an obvious establishing shot: the Tower Bridge in London, the Opera House in Sydney, the Pyramids in Cairo. These shots also make good footage over which to place titles, so record for around 10 to 15 seconds. Follow up with a series of three- to four-second shots of the subject from different angles and perspectives to confirm the content of the upcoming story.

CUTAWAYS

Cutaways are a common technique that sees the video cut away from the main subject or action to an associated shot for a brief duration, say around three seconds, before returning to the main scene. Cutaways serve to break up longer sequences, and add relevant and interesting information to keep the viewer engaged. You'll be quite familiar with the shots of an interviewer nodding their head and smiling while the interviewee keeps talking. If you're filming a parade or performance, cutaway to faces in the crowd. At markets, cutaway to close-ups of merchandise or money changing hands.

ZOOMING AND PANNING

When you first get a video camera all you want to do is zoom in and out and pan around the scene. Maybe this is a reaction to years of having to keep a still camera perfectly steady. Well, try to get over it before you start shooting video you want others to watch. Before zooming consider the alternative techniques of physically moving towards or away from your subject and cutting from a wide shot to a close-up or vice versa. There is, of course, a place for judicious zooming and panning. When that time comes practise the shot first. Determine where to start and finish the movement and don't make them too long. The movement is easier for the viewer to watch and any exposure adjustments required will be less noticeable. The shots will be improved significantly if taken using a tripod.

CLOSE-UPS

For strong close-ups move in with the camera at a wider setting rather than zooming; this will help keep most things in focus. If you go to the widest focal length be careful not to distort the image, which can be unflattering for people (albeit quite funny).

PULL FOCUS

Add a sense of depth, and professional technique, by pulling focus. In manual focus mode and with the camera on a tripod, focus on a subject close to the lens and then adjust the focus to a distant subject. This technique is used often in TV and movies.

SELECT ASPECT RATIO

Select aspect ratio based on how you intend to watch your recordings. For traditional TVs and computer monitors use 4:3, and use 16:9 for widescreen TVs and monitors.

CHECK WHITE BALANCE

The camcorder's auto white-balance feature does a good job in most situations. To

take control set the white balance manually by focusing on a white card or object (professionals carry the card with them) and press the white-balance button.

CHECK EXPOSURE

Auto exposure works fine if the light remains constant, but if strong variations occur this can cause unsightly changes in your clip. Let the camera find the optimum exposure and then lock it in manually before recording. Strong back light can be difficult for the camera's exposure meter to handle. Some cameras have a back-light feature which forces the exposure meter to read for the foreground subject. Background detail may be lost but your subject will be correctly exposed. A better option is to avoid backlit situations, unless you're after silhouettes, by moving the camera or subject to a more evenly lit location. If you can't move the camera position, zoom in to fill the frame with the subject and minimise the influence of the back light. In low light the auto-gain control increases the sensitivity of the sensor to try to achieve a viewable image. Low-light images can appear flat, unsharp and with minimal depth of field as the lens is working wide open.

FOCUS ACCURATELY

To ensure accurate focus: frame the subject, let the lens focus and then depress the record button. The autofocus function takes a few seconds to analyse the scene and determine what it should be focusing on. Slow and steady movements while recording will allow the autofocus to keep up with you. If your subject is off-centre

or there is movement around your subject that could be sensed by the autofocus, your subject could jump in and out of focus. If available switch to manual focus.

HOLD THE CAMERA STEADY

There is nothing worse than jerky, jittery video. Given that a lot of shots will be taken with a hand-held camera, it's important to develop a technique to minimise camera shake. Cameras are instinctively held with the right hand through the strap which lets the fingers rest on the zoom controls and the thumb rest on the record button. You can gain much more stability by placing your right hand under the camera body and using your left hand to add additional balance. The result will be steadier hand-held shots, you won't be able to zoom and you'll be able to make manual adjustments while recording. More tips to improve steadiness:

- Depress the record button gently, rather than stabbing at it, at the beginning and end of each clip.

- Start your recording two or three seconds before the action begins and stop the recording two or three seconds after you've got what you need so that any movement caused by pressing the button on and off can be edited out later without affecting the clip.

- Use a tripod with a fluid head to support the camera. Not only will it eliminate camera shake and create a much more pleasant viewing experience for your audience it will make you consider a bit more carefully what you're about to record.

203

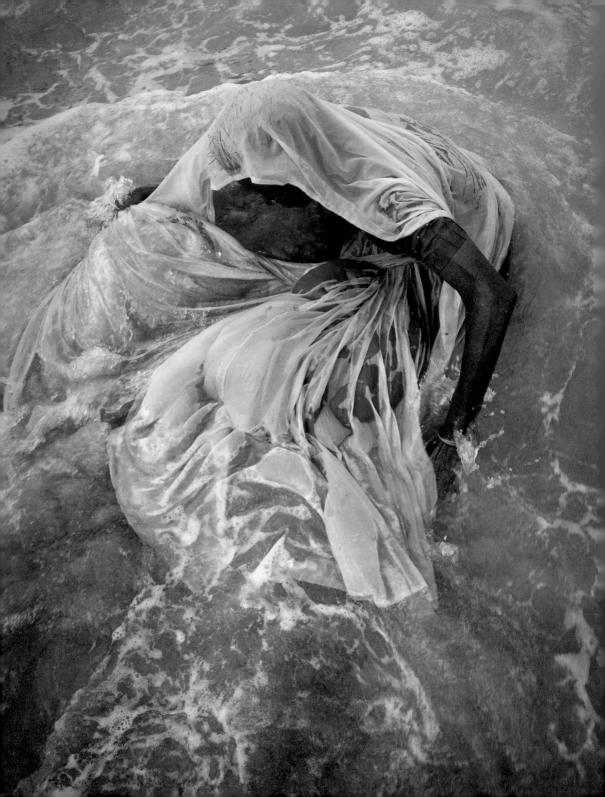

03: THE SUBJECTS

There are countless subjects to photograph once you hit the road, whether you're travelling locally or far from home. This section illustrates and considers the issues related to successfully photographing just about everything, in just about every situation, that you're likely to encounter. The big themes of people, landscapes, the urban environment, festivals, entertainment, food and drink and wildlife are introduced and then delved into by looking at specific subjects and situations. Use the subject headings as a shot list for your own photographic journey and you'll be taking a big step towards capturing the character and diversity of the places you visit.

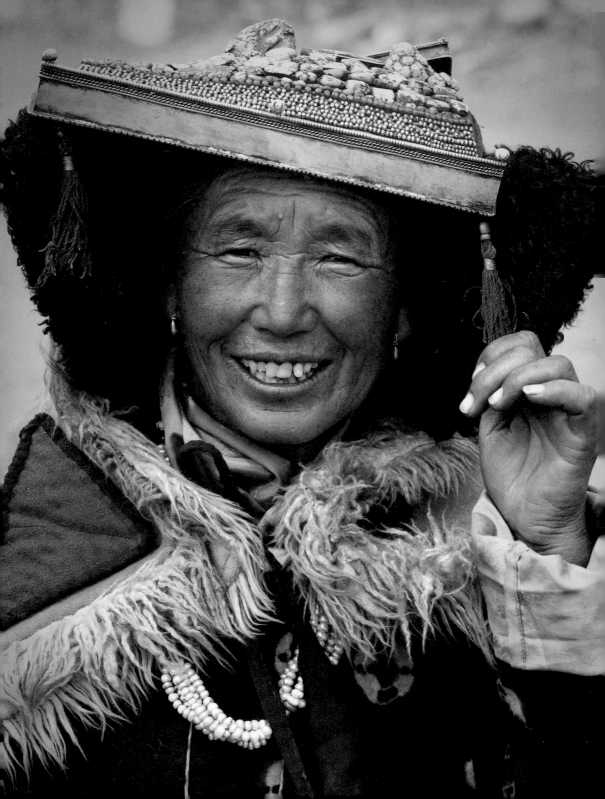

PEOPLE

Famous skylines, buildings, monuments and natural landmarks may get all the glory as the signature images of a country, but people are a country's heart and soul. Your photographic collection and memories of the journey will have a considerably more personal feel if you include a variety of people shots to complement the familiar sights. You'll certainly have lots of opportunities. Hundreds of potential subjects surround you daily, yet the step from seeing a potential photograph to actually capturing it doesn't come easily to many people. Photographing people well is commonly cited as the most difficult of all subjects faced by any traveller.

Often travellers are reluctant to photograph people because they're too shy or self-conscious to ask permission. They may fear they won't be understood or will have their request turned down, or they may feel that they're invading people's privacy. They sometimes feel guilty, especially when the people being photographed are living in poverty. These are all valid issues, but are easily countered by the fact that experience proves that way more people are happy to be photographed than the few who prefer you point your camera at someone else. There are, of course, plenty of techniques to smooth the way for both you and your subject.

To shoot people pictures you'll need to employ both direct and candid techniques. Either way, for really good images, you've got to be prepared to get close to your subjects. Except for crowd shots, standing at a distance with a long lens will rarely result in pleasing images, as you generally won't be able to fill the frame with your subject, and these kinds of shots usually look as though you've tried to sneak them, which you have.

People pictures can be categorised into two groups: portraits, which are close-up studies of a subject's face; and environmental portraits, which include the subject's surroundings as an integral part of the image, providing a context for the portrait.

There are two ways to go about photographing people. One is to get to know the people by spending time with them, or at least spending time in the locality. In theory, this should lead to better access and more relaxed, natural photos. The other is to jump straight in, get the pictures, and get out. Travellers will find themselves in the second category most of the time, whether they like it or not.

Ensure you're completely comfortable with your equipment. A good way to miss people photos is to start messing around with gear and settings in front of them. People quickly become self-conscious and often stop what they're doing and go into their 'camera pose'. It's important to develop techniques that make photographing people easier and minimise the intrusion into your subject's day.

Plan the shot before you approach your subject. Think about your composition and make sure you've got the right lens on the camera. Should it be horizontal or vertical,

The ideal focal length for portraits is between 80mm and 105mm, allowing you to fill the frame with a head-and-shoulder composition while working at a comfortable distance from your subject. For environmental portraits, use focal lengths in the 24–35mm range.

(Opposite) Portrait of woman at festival, Changthang, Ladakh, India

You'll see lots of interesting characters on your travels but there is often something not quite right about the light, location or background. However, when the light is perfect you must act then and there, because the chance of the person being there later, or you remembering to go back, is slim. Most people are happy to be photographed if you approach them in a friendly and polite manner.

DSLR, 70-200mm lens at 90mm, 1/320 f5.6, raw, ISO 100

portrait or environmental? Have an idea of the viewpoint you intend to use. Study the light on the person's face and check where it's coming from; this will allow you to position yourself correctly in the first instance. Once you have permission to take a photo the person will follow you with their eyes if you move. The slightest change of camera angle can make all the difference. Set your exposure settings. Select a wide aperture if you want the background out of focus, or a small aperture if you want your subject and their environment to be rendered sharply.

Being organised and efficient, you'll minimise drawing attention to yourself, which will help your subject remain relaxed and result in more natural-looking photos.

Lots of things can go wrong with people pictures, including unsharp photos due to inaccurate focusing or subject movement; closed eyes if your subject blinks; an unflattering expression, especially if the person is talking; and loss of eye contact if your subject is distracted or shy. People often relax a little after they hear the click of the camera, thinking you've finished; a second frame may capture a more natural pose.

COMMUNICATION WITH STRANGERS

Photographing strangers can be daunting, but it needn't be. Most people are happy to be photographed. Some photographers ask before shooting, others don't. It's a personal decision, often decided on a case-by-case basis. Asking permission allows you to use the ideal lens, get close enough to fill the frame, and provides the opportunity to take several shots, as well as to communicate with your subject if necessary. It also means you know you're not photographing someone against their wishes.

Asking for permission may lead to a refusal, which can be disappointing but should be accepted with good grace. If you are refused do not assume that everyone else in the vicinity will also refuse. Of course, you should make sure there aren't any religious or cultural reasons that discourage or prohibit photography. If in doubt ask a local

How you approach people will affect the outcome of your request for a photo. Simply smiling and holding your camera up is usually sufficient to get your intention across. You may choose to learn the phrase for asking permission in the local language, but it can be less effective than sign language (when you have to repeat the sentence 10 times to make yourself understood).

Approach the person with confidence and a smile. When you get the go ahead, shoot quickly. You'll increase the possibility of capturing more spontaneous and natural images. There's nothing more frustrating than seeing someone you think would make a great photograph, only for them to change position when they realise you want to photograph them. Don't be afraid to take control of the situation and ask the person to look at you, or away, or at what they're doing. Demonstrate the pose you want by doing

PAYING FOR PHOTOS

In popular destinations you could be asked for money in return for taking a photo. This may be considered a fair and reasonable exchange by some or a tiresome annoyance by others, or it may simply discourage you from photographing people. Ultimately you'll have to come up with a personal response. Certainly, don't hand out money (or sweets, pens or anything else for that matter) if it's not requested, but if it is be prepared to pay or walk away. From a photographer's point of view it really comes down to how important or unique the potential image is.

Agree on the price beforehand to avoid problems afterwards and make sure you're working in the local economy, not yours. It goes without saying that bargaining is compulsory at this point. Always have coins and small denomination notes with you in an easily accessible pocket (a different pocket from where you carry the rest of your money) so that you don't have to pull out great wads of money, confirming not only that you are relatively rich (as if the camera hadn't already done that) but more importantly, where you actually keep your money, making it much easier for someone who may want to relieve you of it.

it yourself. If your subject is wearing a hat in a sunny location half of their face will be in heavy shadow; ask them to look up slightly or to push the hat back a bit. If people stiffen up in front of the camera it's up to you to get them to relax. Take one frame however they have posed themselves, then wait or talk to them before trying again. Remember, you're aiming to take a beautiful shot of someone and they'll not only understand but be delighted when they see how good they look on the LCD screen.

The direct approach of asking permission results in more satisfactory images than trying to sneak them from a distance. People will be more suspicious of your intentions and less cooperative if they spot you pointing a long lens from the shadows. You still have to be fairly close, even with a 200mm lens, to get a frame-filling portrait. It's best to be open about what you're doing.

If you're hesitant, a good way to get started with portraits is to photograph people who provide goods or services to you. After a rickshaw ride, or buying something from a market stall, ask the person if you can take their photo. Very rarely will they refuse.

Finally, showing your subject the results on the camera's LCD screen is a great way to say thank you and, assuming you've taken a flattering photo, leave them with a positive memory of their encounter with you.

Woman sewing, Ludiya, India

In some places payment is simply expected if you take photos – either that or you buy something that your subject has made. There are only so many pieces of 'very old' embroidered fabric that I need, so sometimes handing over a few rupees seems like the better option. I see paying someone to take their photo as a fair and reasonable exchange. I generally don't offer money unless asked, and I don't give money to children, based on the advice that this helps create a dependence on begging.

DSLR, 24-70mm lens at 45mm, 1/100 f3.5, raw, ISO 160

PORTRAITS

Monk, Bodhgaya, India
The monk was sitting like this as I approached him but changed his pose to speak to me. He happily obliged when I asked him to put his chin back in his hands. If you're clear how you want your subject to look you'll be much more confident in asking and directing when necessary.
35mm SLR, 24–70mm lens, 1/125 f5.6, Ektachrome E100VS

Capturing strong, well lit, well composed close-ups of people in the brief encounter that typifies travel photography is a challenging proposition. It's a challenge well worth taking as there is no doubt that if done successfully, a series of frame-filling head-and-shoulder portraits of a variety of individuals will add a great deal of depth, interest and personal satisfaction to your travel pictures.

Avoid backgrounds that are too busy or have very light or very dark patches of colour. Your eyes should not be distracted from the subject's face. Always focus on the eyes. It doesn't matter if other features are out of focus: if the eyes aren't sharp the image will fail.

Expose for your subject's face: it's the most important part of the composition. The ideal focal-length lens for shooting portraits is between 80mm and 105mm. Lenses in this range are often called portrait lenses because of the flattering perspective they give to the face. They also allow you to fill the frame with a head-and-shoulder composition while working at a comfortable distance from your subject. If using a zoom lens on a DSLR or compact camera, preset it to 100mm, then position yourself to suit – this will guarantee a pleasing perspective. Set your shutter speed to at least 1/125 to prevent movement resulting in a blurry photo. A wide aperture (f2–f5.6) will ensure that the background is out of focus and minimise distracting elements. Compose the photo vertically to minimise empty, distracting space around your subject. In low-light situations increase the sensor's ISO rating rather than use the flash.

If you're using a compact camera remember not to get closer than the minimum focusing distance (usually around 1m).

Overcast weather is ideal for portraits. It provides even, soft light that eliminates heavy shadows and is usually flattering to the subject. It allows you to take pictures of people in all locations and use automatic metering modes to shoot quickly.

SHOOTING WITH RESPECT

I don't see why people with cameras think they can side-step the basic rules of courtesy when photographing people. It's particularly prevalent in developing countries and tribal areas. Lack of language is not an excuse. Sticking cameras in people's faces without first getting permission is rude and offensive. Would you do this to people in your own neighbourhood? And just because the person doesn't object doesn't make it right. They are probably just being considerably more polite than the person with the camera. I know this sounds like I'm taking the moral high ground, but I see it all the time. Treat people how you expect to be treated and photographing them can be a mutually enjoyable experience.

(Top left) Herero woman, Maun, Botswana

This is my least preferred light for photographing portraits. Harsh front lighting makes it hard for people to look straight into my lens. Shadows under the nose and chin are too strong. However, you can't assume that the person will still be standing there when you come back later, and for travellers there very often isn't a later. To reduce the impact of the harsh light I composed a mid-length portrait to place as much emphasis on the woman's clothing as on her face.

35mm SLR, 50mm lens, 1/250 f11, Ektachrome E100VS

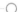

For frame-filling portraits you'll need to approach individuals and seek their permission, as you will if you want to take a series of images, say of a street performer or someone at work. You don't need to speak their language – simply holding the camera up usually makes it obvious what your intentions are.

(Bottom left) Village elder, Iunier, Tanna Island, Vanuatu

Generally I like my portrait subjects to make eye contact with the viewer by looking straight into the lens. However, this man kept glancing at his friend with a mischievous glint in his eyes, enlivening his face compared to the straight serious look he was adopting for me.

35mm SLR, 70-200mm, 1/320 f5.6, Ektachrome E100VS

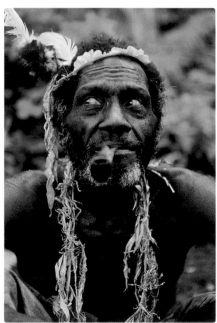

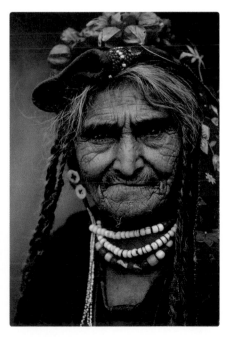

(Bottom right) Brokpa woman, Dha, Ladakh, India

The soft and even but bright light illuminating this woman's face is perfect portrait light, bringing out the texture in her face and hair without causing unsightly shadows. When I first asked to take her photo she refused, instead beckoning me to follow her into the monastery which is where she assumed I wanted to go. I was more interested in taking some photos around the village before the sun set. However, it turned out that the time spent attentively looking at various things she pointed out in the monastery was well spent as she didn't hesitate to be photographed the second time I asked. Sometimes you have to invest time to create a photo opportunity.

35mm SLR, 70-200mm lens, 1/60 f2.8, Ektachrome E100VS

ENVIRONMENTAL PORTRAITS

Environmental portraits add context and allow the viewer to learn something about the person. This kind of portrait lends itself to the use of wide-angle lenses. The wider field of view offered by 24mm, 28mm or 35mm lenses allows you to get close but still include plenty of information about where the subject is. Getting close also ensures nothing comes between the camera and the subject at the vital moment and is an essential technique in crowded situations such as markets and busy streets. The use of wide-angle lenses also allows slower shutter speeds to be employed to maximise depth of field. This is important because the location is an integral part of the picture.

Look to add variety to your environmental portraits by capturing both formal shots, where your subject is looking into the camera, and informal shots where people are busying themselves with something and interacting with others. People at work make excellent subjects for achieving this combination of shots. They're often less self-conscious in front of the camera because they're occupied with familiar activity, and you'll be able to capture them looking into the lens and at what they're doing. Markets and workshops are great locations to capture images of people in an interesting environment.

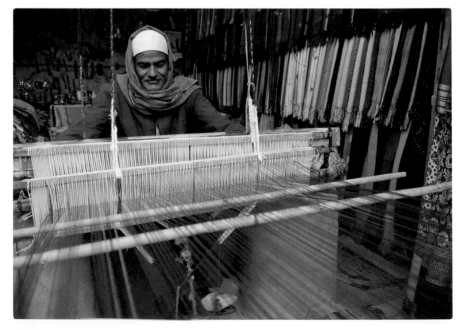

Weaver, Aswan, Egypt
People at work or occupied with an activity make excellent subjects for environmental portraits. They're often less self-conscious in front of the camera because they're engrossed in what they're doing, as was this weaver at a village shop. The 24mm wide-angle lens has allowed me to get close enough to fill the frame with the craftsman and his work but still include plenty of the interesting location in which he is working.
DSLR, 24-105mm lens at 24mm, 1/50 f4, raw, ISO 400

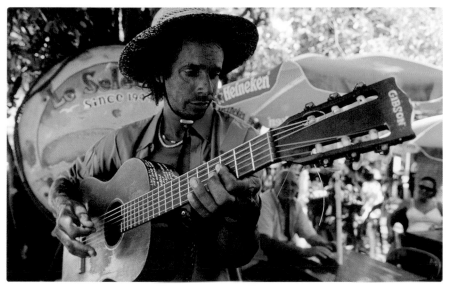

**Musician, Gustavia,
Saint Barthélemy**
After taking a few initial
shots of the two musicians
entertaining the lunch-
time crowd at Le Select
Café, they invited me to
join them at their table.
This gave me the opportu-
nity to be more directive,
which I needed to be
because I knew the first
shots hadn't worked. Get-
ting the musician to turn
his back on his audience,
just briefly, solved the
light problem and also let
me include the café sign
and some of the setting,
placing the musician in
context. Working close to
the subject with a 24mm
wide-angle lens has
slightly distorted the head
of the guitar but works
well to draw the viewer's
eyes to the musician.
35mm SLR, 24-70mm lens,
1/125 f8, Ektachrome E100VS

If you've got a zoom lens with a focal range around 24–105mm and you position yourself well,
you can often take an environmental portrait and a frame-filling, head-and-shoulder portrait
without changing position. Add variety by shooting the wide shot horizontally with the person
looking away and the close-up vertically with the subject looking into the lens.

**Skateboarder,
Melbourne, Australia**
You can't see a lot of the
skateboard, but there's
enough to indicate that
this is what the subject is
into. The background is
just as subtle but the co-
lours and graffiti connect
to the subject's clothes
and skateboard to create
a contemporary urban
environmental portrait.
35mm SLR, 24-70mm lens,
1/125 f4, Ektachrome E100VS

GROUPS

Crowd at Indra Jatra Festival, Kathmandu, Nepal
The multiple levels of the temples dotted around Durbar Square make the perfect location for people to gather to watch festival action. It's also a great place to be to take very informal group shots, picking out various combinations of people.
35mm SLR, 24-70mm lens, 1/125 f11, Ektachrome E100VS

Add one or more people to a portrait or environmental portrait and you've not only got a group, you've got an incredibly diverse range of people pictures to work with. Photographing groups of people is really an extension of the environmental portrait and covers just about every other situation involving people. From a travel photography perspective, the formal, posed group shot will be a rarity. Rather, groups encountered on the road are self-forming and fluid so be ready to photograph them how you find them. Groups form waiting to catch a bus or cross the road, to watch a street performance, to purchase things at market stalls, to watch the world go by on a park bench, to make offerings at temples, to eat, drink and even just to stand around and watch the foreigner take photos.

The larger the group the less chance you have of getting a shot where everyone looks good. It's impossible to check everyone's expression and make sure their eyes are open before you hit the shutter, so taking extra frames is really all you can do. Even groups can have a point, or person, of interest so place them carefully in the composition and concentrate on releasing the shutter when they are looking where you want them to look, or just looking good. When you've taken the group shot consider

moving or zooming in on, subgroups of two or three people and then pick out individuals for portrait shots.

If you're photographing a group that is actually posing for you, you'll need all your assertiveness to demand everyone's attention, to get them to look at the camera and stop talking. If it's a large group be ready to keep shooting as they break up, when they think you've finished. Often you'll get some great expressions as people interact and relax.

Family at Lantern Festival, Shanghai, China
A young family stops to admire the lanterns decorating Yuyuan Bazaar. With their attention directed away from the camera the result is a relaxed, informal family group photo. Very different from the stiff, posing-for-the-camera shots that most families were taking of themselves in front of the lanterns.
DSLR, 24-70mm lens at 35mm, 1/60 f2.8, raw, ISO 200

School children, Thimphu, Bhutan
When a group is as chaotic and noisy as a bunch of excited school children, you have to expect a variety of expressions. It's impossible to watch multiple faces, so I always pick out one person of interest and compose the shot around them.
35mm SLR, 24mm lens, 1/125 f8, Kodachrome 64

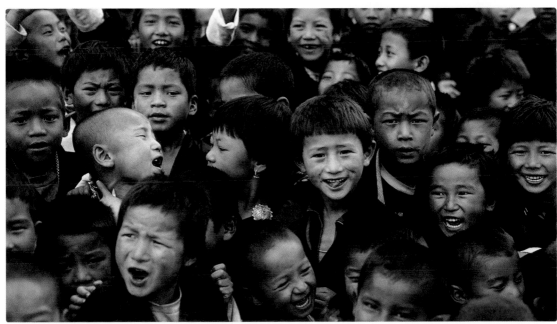

CHILDREN

Aim your lens at a child and you can never be quite sure what kind of reaction and expression you'll get. Some will simply stare unflinchingly, others will act coy but maintain eye contact, the cheeky ones will strike an amusing pose, pull a face, stick out their tongue, or all of the above. Some just ignore you and keep on doing what they were doing. Mostly though children are very enthusiastic about being photographed and will often give you time to take several frames and come away with an endearing photo. Consequently, many people feel more comfortable taking pictures of children than adults. Make sure to look around to see if a parent is about and seek permission to photograph their child before shooting.

If you're trying to take a child's portrait and there are other children present, they'll be easily distracted. You'll have to take control by moving their friends out of view and reminding them where you'd like them to look. Get down to the child's eye level, or just above. Getting them to look up slightly often works well, but avoid looking down on them.

Take a moment to let the kids look through the viewfinder to get a sense of what you're seeing. This is especially exciting for them if you have a telephoto or zoom lens on. You can even let them take a photo and show them the result on the LCD screen alongside the pictures you take. These are easy and fun ways of giving something back to the kids for cooperating with you. Hang on to the camera though; you don't want it being passed around or accidentally dropped.

Seeing themselves on the screen often encourages them to pose for more shots, so if you're not getting the shot you want, break it up by sharing what you've done so far and then trying again.

Children playing or engaged in other activities offer the best chance to get the most natural shots. If they're running around select a fast shutter speed, say 1/250 or higher, to prevent unacceptable subject movement.

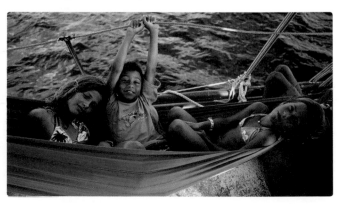

Children in hammock on yacht, St Barthélemy
At the end of an active day the three children were happy to settle into the hammock for the sail back to the harbour. They didn't need posing; I just had to be quick so the shot captured the mood of the moment.
35mm SLR, 24-70mm lens, 1/250 f8, Ektachrome E100VS

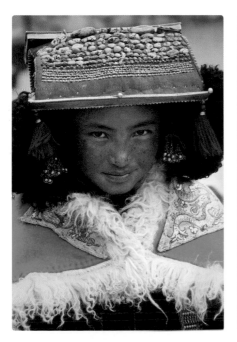

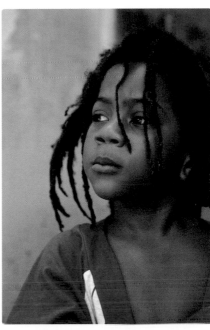

(Top left) Girl at festival, Changthang, Ladakh, India

DSLR, 70-200mm lens at 110mm, 1/250 f6.3, raw, ISO 100

(Top right) Boy on city street, St George, Grenada

35mm SLR, 70-200mm, 1/250 f4, Ektachrome E100VS

(Bottom left) Boy on village street, Siou Nubian, Egypt

DSLR, 24-105mm lens at 105mm, 1/125 f4, raw, ISO 100

(Bottom right) Girl at market, Inthein, Inle Lake, Myanmar

DSLR, 70-200mm lens at 160mm, 1/160 f4, raw, ISO 200

TRAVEL COMPANIONS

Steering yacht on Caribbean Sea, St Barthélemy
Taking control of the yacht ensured that my fellow traveller would be concentrating on the task rather than worrying about me taking photos. Even with friends, never assume you'll get a second chance. Once we changed directions, and as the day progressed, the elements never combined as nicely as they did in the first half-hour of the trip.
35mm SLR, 24-70mm lens, 1/250 f11, Ektachrome E100VS

Treat taking pictures of your friends and family as seriously as the other people pictures you take. A great way to get good shots of your companions on the road is to look out for situations where they are interacting with the locals or are occupied with something of interest. This will create much more rewarding shots than by getting them to look at the camera. Look for instances where your friends are browsing street stalls, bargaining for a souvenir, loading packs on the bus roof or looking at temple statues. Your photos will capture the travel experience in an active rather than passive way.

Photographing your travel companions is also good practice for photographing strangers, the techniques are the same, only the rapport is different.

You can also use your friends as a stepping stone to photographing someone you don't know, whom you'd like to photograph. By taking pictures near them or asking to include them with a shot of your friend may encourage them to then let you take their portrait. That is, if your friend is cooperative and doesn't treat being photographed as an ordeal. If they do, perhaps you should get a new friend (only joking!).

Floating in rubber rings, Gold Coast, Australia
Natural-looking shots of your travel companions should be easy. If you don't manage to catch them in the right place at the right time, organise the elements yourself. The girls didn't need too much encouragement to go around the lagoon again and again, but they did have to be instructed to stick together as they passed under the bridge.
35mm SLR, 24-70mm lens, 1/500 f11, Ektachrome E100VS

DAILY LIFE

INSPIRATIONAL BOOK:
MAGNUM STORIES,
CHRIS BOOT

(Opposite, top) Men playing chess at Szechenyi Baths, Budapest, Hungary

DSLR, 24-70mm lens at 24mm, 1/125 f11, raw, ISO 100

(Opposite, bottom) Man and shadows at Circular Quay, Sydney, Australia

DSLR, 70-200mm lens at 70mm, 1/160 f5, raw, ISO 160

(Below) Couple carrying frame and painting, Venice, Italy

DSLR, 24-105mm lens at 70mm, 1/60 f4.5, raw, ISO 100

In many countries life is lived on the street. Meals are cooked and eaten; clothes, bodies and teeth are washed; games are played and business is transacted; all in full view of the passing public. As with all people photography you'll have to develop your own approach to taking pictures of people on the street, but you will require a quick eye and shutter finger, as the aim is to capture fleeting moments that you often can't anticipate.

Street photography is one of the cornerstones of traditional photographic genres, where the everyday and happenstance take centre stage as subject matter over the more sensational public events like annual festivals and familiar iconic structures. Walking the streets looking to capture unique moments is a fun, interesting and challenging goal to set yourself, and the shots make a nice counterpoint to the more exotic imagery typical of travel photography.

Although the magic of the moment should take precedent over technical perfection, you can influence the outcome by finding an interesting location where there is a fair bit of activity and good light and then wait for things to happen around you. Good places to get started are the

You'll become more comfortable photographing people, and enjoy better results, if you're able to compose and make technical decisions quickly.

obvious centres of human activity, such as city squares, marketplaces, restaurant precincts, shopping centres, places of worship and transport hubs. However, for a general introduction to daily life no matter where you are, set off in any direction and you'll witness people from all walks of life going about their daily activities. Look to photograph them up close, at work, individually and in groups, posed and unposed. Each picture will add more depth to the impression of the destination you're able to communicate through your photographs.

Street photography requires enormous patience, but if you're prepared to pound the streets in equal parts to standing around watching and waiting, you'll be rewarded with distinctive pictures as long as you remember rule number-one – don't hesitate. Fleeting moments are just that: fleeting. Hesitate in releasing the shutter and the image is gone forever.

LANDSCAPES

For the professional photographer, landscape photography demands a very different way of working to that employed when photographing people. People are usually photographed with a hand-held camera, often you only get one chance and expression is more important than perfect composition and perfect exposure. Wide apertures are preferred to render the background out of focus. By carefully selecting locations, pictures of people can be taken at any time of day. Landscapes, on the other hand, are typically photographed with the camera mounted on a tripod. The aperture is given priority to ensure the image is sharp from front to back. As for light, the window of opportunity is small, limited to the beginning and end of the day. Simply by putting the camera on a tripod, the technical and compositional process becomes more considered, so there really is no excuse (except for not having the appropriate lens) for not using every pixel available to capture the subject and getting the exposure right.

Don't be fooled into thinking that just because landscapes don't walk off like people do, it's any less demanding. As with all subjects, the high point, when all the elements come together perfectly, is usually fleeting. You need to be ready and waiting for that moment. While you're waiting, experiment with various compositions and settle on the best one so you're not decision-making when you should be making exposures.

(Opposite) Grand Canyon from Grandeur Point, Grand Canyon National Park, USA

DSLR, 24-105mm lens at 50mm, 1/50 f16, raw, ISO 100, tripod

(Left) Karst mountains and fishermen on Yulong River, Yangshuo, China

Landscapes don't have to exclusively feature the natural environment. They can include manmade structures, such as rice terraces, pagodas, farm houses and fishermen on bamboo rafts, which, when included as part of the broader landscape, add a point of focus or interest or a sense of scale.

DSLR, 24-70mm lens at 38mm, 1/160 f7.1, raw, ISO 100

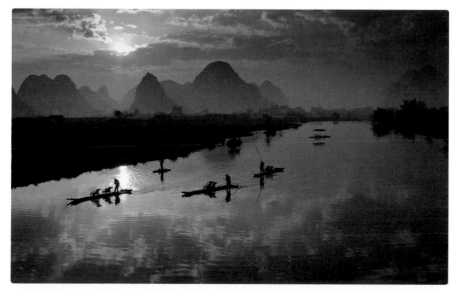

Twelve Apostles, Port Campbell National Park, Australia

The intriguing shapes and bulk of two of the Twelve Apostles are emphasised when silhouetted against a dramatic sky at sunset.

6 x 7cm Rangefinder, 50mm lens, 1/2 f16, Ektachrome E100VS, tripod

When we look at a scene we scan a wide area, noting the colour, beauty, scale and main features – we see straight through power lines and rubbish bins and create in our mind's eye a perfect impression of the scene. The camera sees everything; it doesn't know you didn't mean to include the toilet block on the left or the 'Keep Out' sign on the right.

When you are confronted with a beautiful scene it's very tempting to put on the widest lens to try and get everything into your composition. Remember that landscapes don't have to always take in the big scene. Isolate elements that say something about the environment and complement the panoramic views. As with all good compositions, there needs to be a point of interest in the landscape, a main feature that can hold the viewer's attention. Choice of an appropriate lens plays a major part in achieving this.

Wide-angle lenses increase the foreground and sky content, exaggerate sweeping lines and make the subjects in a landscape smaller. Make sure that the

Professional landscape photographers habitually rise early for first light and return two or three hours before sunset to make the most of the warm, low-angle light. This light is available to everyone. You don't need expensive equipment to get up early...just a good alarm clock and a lot of will power.

foreground and sky are interesting and relevant to the composition. Telephoto lenses allow you to select a part of a scene and to flatten the perspective, making the foreground and background elements appear closer to each other. What you focus on will become larger.

Generally, the aperture is given priority when shooting landscapes, to ensure sharpness from front to back. For maximum depth of field, focus on a point one-third into the scene, just beyond the foreground subject, and stop down to f16. Use the depth-of-field button to confirm visually

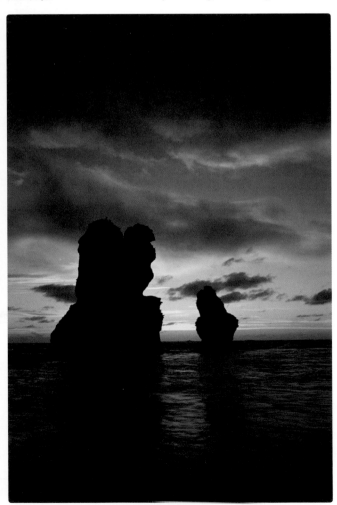

INSPIRATIONAL BOOK:
EDGE OF THE EARTH, CORNER OF THE SKY,
ART WOLFE & ART DAVIDSON

what you're hoping to achieve. At this aperture, with a sensor setting of ISO 100, shutter speeds will drop below 1/15. A tripod and cable release are essential equipment for the serious landscape photographer. On windy days slow shutter speeds will record movement in the landscape. Swaying branches will blur at 1/15 or slower, depending on how strong the wind is. This can be very effective if desired. Clouds may also blur if exposures are longer than half a second, which isn't so effective.

As you compose landscapes pay particular attention to the horizon and check the elements in the frame.

○ Place horizons carefully. Start with the rule of thirds to ensure the horizon is placed away from the middle of the frame. If the sky is dull and lacking detail it will look flat. Place the horizon in the top third of the frame. If the foreground is uninteresting place the horizon on the bottom third. If both do nothing for the photograph, eliminate them by moving closer or zooming in.

○ Horizons should be straight.

○ Scan your viewfinder before you release the shutter to check for unwanted elements, particularly at the edges of the frame.

○ Don't accidentally photograph your shadow in the landscape. You have to be especially careful when shooting very early or very late in the day with wide-angle lenses. Shoot from a low angle or position your shadow in a natural shadow area of the composition.

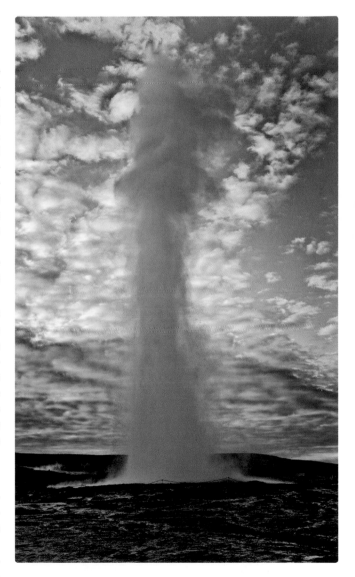

Strokkur Geyser, Geysir, Iceland

Strokkur Geyser is the world's most reliable hot-water spout, erupting approximately every six minutes. Eruptions vary considerably in volume and height and the soaring water spout doesn't last long, but at least you don't have to wait long to have another go if you're not happy with the geyser's performance, or your shot. However, you still only get a couple of chances to capture the water rising in front of colourful clouds at sunrise.
DSLR, 24-70mm lens at 34mm, 1/125 f7.1, raw, ISO 100, tripod

MOUNTAINS

There's nothing quite like being in the right place to photograph the first and last rays of warm light on snowcapped mountains.

Big mountains always look impressive, but when they're lit by the early morning or late afternoon sun and they glow pink or gold, you'll be glad you bought that extra-large memory card. These colours don't last long and frequently occur at the same time as a build up of clouds, particularly in the evening. Rapidly changing and unpredictable weather is standard issue in the mountains and demands that photographers are patient, organised and fully prepared before the light show begins.

o Be in position at least half an hour before sunrise and an hour before sunset.

o Mount your camera on a tripod and attach a cable release or remote switch.

o Spend time, while you're waiting, experimenting with different compositions and lenses and decide which composition you'll start with. You may only get one chance, so make the first shot count.

o If cloud is threatening to engulf the mountain take a photograph every couple of minutes in case it disappears completely before the light peaks.

o Ensure you have plenty of frames left. The mountain can disappear in cloud in the time it takes to switch memory cards or change film.

If you don't have a cable release or remote switch use the self-timer. By giving the camera eight to 10 seconds to steady itself after the shutter release is pressed, sharper pictures will result. Don't forget though, in eight to 10 seconds you could have recomposed a different shot by changing lenses, zooming in or out, changing orientation from horizontal to vertical or, worse still, the sun could have dipped below the horizon or the mountain could be engulfed by cloud.

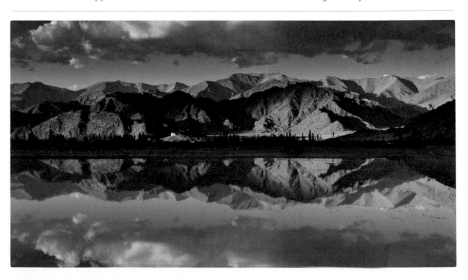

Ladakh Range, Stakna, Ladakh, India
Barren and monochromatic by day, the mountains come to life as the setting sun adds colour and highlights the textures in the rock. The interplay of sun and cloud results in the shadows being a dynamic element as they move from one part of the range to another. To achieve the maximum reflection the camera was positioned about 30 centimeters from the water's surface.
DSLR, 24-70mm lens at 35mm, 1/15 f11, raw, ISO 100, tripod

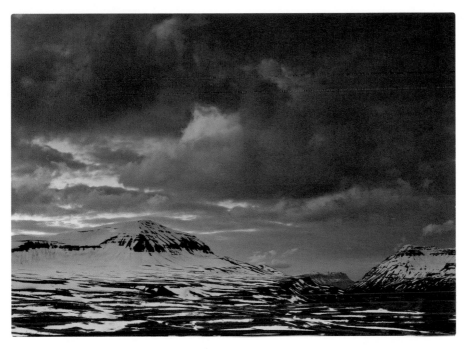

Mt Bjolfur at sunset, Seydisfjordur, Iceland

Each frame brings something different when photographing mountains; shadows, light and cloud come and go. Patience will be rewarded with a photograph that captures just the right mix of mountain, cloud, shadows and highlights. Even if the mountain is in cloud, set up and wait – sudden changes in the weather are common.

DSLR, 24-70mm lens at 34mm, 1/20 f9, raw, ISO 100, tripod

INSPIRATIONAL BOOK:
THE HIGH HIMALAYA,
ART WOLFE

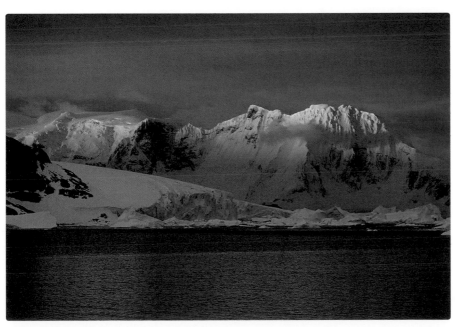

Mountains at sunset, Paradise Bay, Antarctica

For most of the day the Antarctic mountains gleam pure white, but at the very beginning and end of the day there's always the chance that they'll turn orange, red or yellow. The main difference between photographing these and other mountains is that you're on a ship, so a tripod is ineffective and you don't go to bed between sunset around 11pm (when I was there) and sunrise, around 1am.

35mm SLR, 24-70mm lens, 1/60 f5.6, Ektachrome E100VS

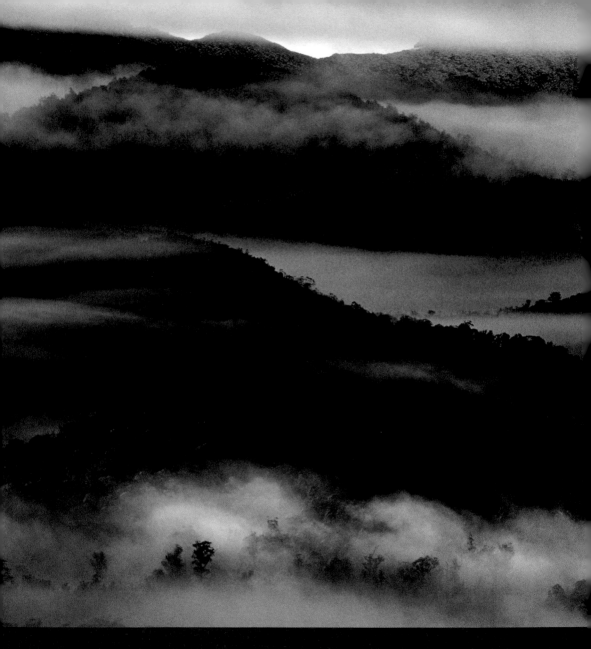

CLOUD RISING ON KING WILLIAM RANGE, TASMANIA, AUSTRALIA

35mm SLR, 70-200mm lens, 1/60 f8, Ektachrome E100VS, tripod

So many photographs give no hint as to what was required to capture them, and this is a classic example. I needed just one image from Donaghys Hill in Tasmania's southwest to fill the last empty page of my 368-page pictorial book of Australian land-scapes. With one week left before the book went to print the pressure was really on. This is the image I

imagined (or previsualised) was possible if I travelled to Tasmania's southwest in winter, which obviously proved correct but didn't come easily. It took three visits on consecutive days, rising at 5am to drive and walk to the lookout, and a total of seven hours standing in a freezing cold mist with zero visibility

in the most perfect morning light. Persistence and patience regularly reveal themselves as essential prerequisites for successful travel photography. When I find myself in these situations, which is far too often, I keep myself going by recalling past successes born from infuriating waits and miserable

SNOW, ICE & GLACIERS

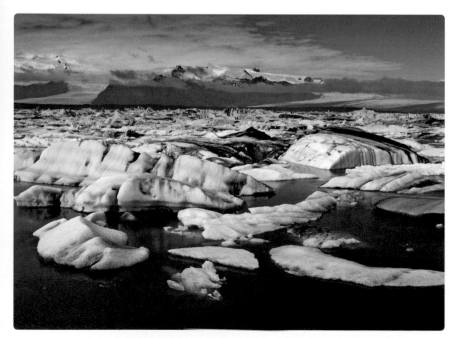

INSPIRATIONAL BOOK:
*ANTARCTICA: THE
GLOBAL WARNING*,
SEBASTIAN COPELAND

Snow and ice cause a high level of reflection when they're the dominant element of a composition, and the camera's light meter will underexpose the scene, particularly on sunny days. To compensate, override the meter. Older cameras may require you to overexpose by one or two stops. Modern cameras with advanced metering systems cope much better, but it's still worth overexposing by a half-stop and one stop until you learn how your camera's meter performs in different situations. Bracketing in half-stop increments is recommended to guarantee an accurate exposure, as is shooting early or late in the day. The lower angle of the sun brings out detail and texture in the snow and ice, and the contrast levels are more manageable.

In overcast conditions snow will record with a bluish cast so check the white balance setting. If you're shooting film, an 81B warming filter eliminates this colour shift and helps keep the colour white. Be careful using polariser filters for scenes featuring snow and ice. Often blue skies are already very dark and can go almost black.

When shooting landscapes in snow be aware of where you're walking – you could leave your own footprints in an area you want to photograph. (See p123 for information on photography in the cold.)

**Jokulsarlon glacial
lagoon, Jokulsarlon.
Iceland**
With the sun shining brightly the contrast between the deep blue of the sky and water and the intense white of the icebergs was very high. Exposing for the ice was important otherwise all detail would be lost and I would have ended up with large featureless areas. A polarising filter also helped retain detail by cutting down some of the reflection off the ice. The fast shutter speed was required because I was shooting from a briskly moving boat (not my normal choice of platform for shooting landscapes!).
**DSLR, 24-70mm lens at 42mm,
1/400 f9, raw, ISO 100, polariser**

**Perito Moreno Glacier,
Los Glaciares National
Park, Argentina**

The light on the landscape
fluctuated rapidly as
clouds passed in front
of the sun, highlighting
one part of the glacier
and then another. It took
some time but eventually
I got the combination I
was after: the face of the
glacier and mountains in
sun and the rest in shade.
Lots of other combina-
tions worked as well, but
this was the most graphic
of the series.

**35mm SLR, 24-70mm lens,
1/125 f8, Ektachrome E100VS**

DESERTS

Photographing deserts is a little like photographing snow and ice, except you'll probably be too hot instead of too cold. If conditions are really bright, bracket exposures, favouring overexposure up to one stop. As usual, early morning and late afternoon sun will make desert landscapes much more interesting. The low angle of the sun's rays will emphasise the contours of the dunes and hills, and bring out the details and textures in the sand and rock. Remember to watch where your own shadow is falling and not to leave footprints in areas you want to portray as pristine. Look for a vantage point to survey the area and walk around the edges of potential picture subjects. Climb dunes on the shadow side, as you're less likely to make it a feature of the landscape. Extra attention must be paid to camera care when taking pictures in sandy environments (see p125).

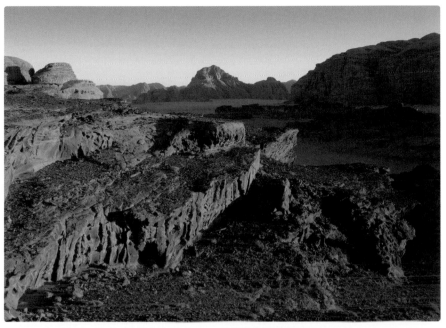

Escarpment and mountains, Wadi Rum, Jordan

The colours, textures and landforms of Wadi Rum's dramatic desert landscape are accentuated by the low angle and warm colour of the sun as the last rays of the day skim across the landscape. Pictures taken a couple of hours earlier just don't do justice to such remarkable places.

DSLR, 24-105mm lens at 32mm, 1/13 f14, raw, ISO 100, tripod

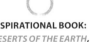

INSPIRATIONAL BOOK:
DESERTS OF THE EARTH,
MICHAEL MARTIN

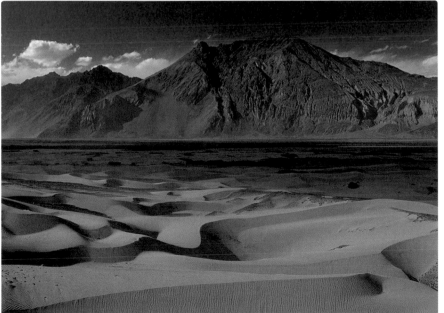

Dunes in Nubra Valley, Ladakh, India

Unfortunately, when the light was at its best in the dune region of the Nubra Valley, the wind was at its strongest. It can be hard work shooting in desert environments when it's windy. Only expose your camera to the elements when you're ready to shoot and make sure your bag is properly sealed. A single grain of sand once made one of my autofocus lenses unworkable.

35mm SLR, 24-70mm lens, 1/4 f16, Ektachrome E100VS, tripod

THE COAST

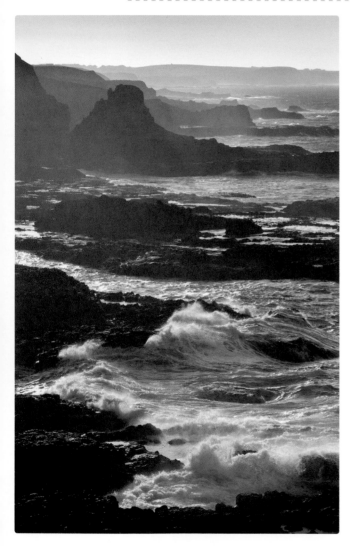

High cliffs, rugged coastlines, eroded landforms, pounding seas, still rock pools, beaches…the coast has enough photographic possibilities to give you no time to lie around on the beach all day. The sea adds an intriguing new element to landscapes. Unlike the rock-solid landforms it meets at the shoreline, the sea is in a constant state of change. Not only does the light change throughout the day, so does the subject. Fast shutter speeds (higher than 1/250) will stop the motion of the waves and freeze sea spray. Slow shutter speeds (less than half a second) will blur the waves and soften the seascape.

Although mostly associated with recreational activities, some beaches make great landscape subjects. Rise early and you'll have beaches that are crowded by day all to yourself, except perhaps for a few early morning walkers. They can be useful too, for adding a human element and sense of scale. Head for piers and rocky promontories to include the sea in the foreground. If the fall-off isn't steep you can also walk into the water for a similar effect.

A polarising filter will often improve the colour and contrast in photographs taken around water by reducing the glare of the light reflecting off the water. (See p125 for information about protecting your equipment around salt water.)

Coastline, Phillip Island, Australia
Shooting into the sun has emphasised the shape of the rocks and headlands and separated one from the next. By exposing for the highlights, the detail in the water and the colour in the sky are retained.
DSLR, 70-200mm lens at 120mm, 1/160 f11, raw, ISO 100, tripod

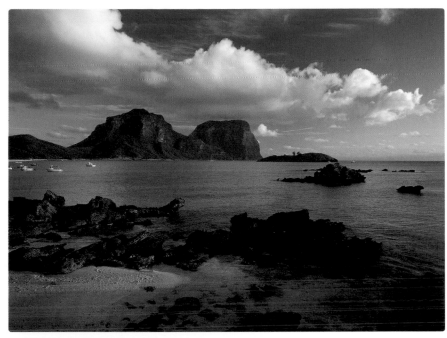

Mt Lidgbird and Mt Gower, Lord Howe Island, Australia
Coastal weather is almost as notoriously changeable as mountain weather, and that's why you always have to head to your predetermined spot in the late afternoon. The weather during the day had been clear and fine, not inspirational. As the evening approached beautiful clouds rolled in and positioned themselves perfectly above the island's two most prominent mountains, and a good day ended perfectly.
6 x 7cm Rangefinder, 50mm lens, 1/2 f16, Ektachrome E100VS, tripod

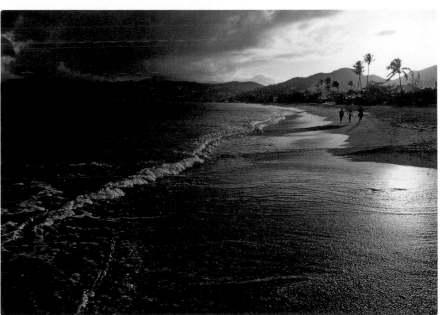

Grand Anse Beach, St George, Grenada
Busy with sun lovers during the day, the long stretch of beach at Grand Anse takes on a completely different look under a stormy sunrise. Get out early and even beaches in urban environments can offer interesting land-scape opportunities.
35mm SLR, 24-70mm lens, 1/4 f16, Ektachrome E100VS, tripod

RAINFORESTS

Rainforests are one of the most difficult landscapes to photograph well. Often the light is too low to hand-hold the camera and causes automatic flashes to fire. If the sun is shining strongly enough to break through the canopy, the trees become speckled with uneven light and pictures will look colourless and messy. The best time to take pictures in a rainforest is after it has rained, or in light drizzle. The cloudy skies guarantee an even light and the water on the leaves adds life and emphasises the colour. With lower ISO sensor settings, a polariser and low light, shutter speeds will be too low to hand-hold. A tripod is essential and you'll be able to precisely control depth of field. The polariser will cut down the reflection off the wet leaves, increasing the intensity of the colours.

Without a tripod, look for brighter areas of the rainforest where hand-held photography may be possible. You'll find these around the edges of the forest or in clearings near streams, rivers and waterfalls.

(Top) Palm leaf, Daintree, Australia
If the lighting is patchy or you can't find a suitable viewpoint for a scenic shot, look for details that are evenly lit.
6 x 7cm SLR, 105mm lens, 1/30 f11, Ektachrome 50STX, tripod

(Bottom) Old-growth forest, Annapurna, Nepal
The old-growth forests in the valleys below the Annapurna mountain range are beautiful to walk through and difficult to photograph. Having tried unsuccessfully before, I knew the answer lay in carrying my tripod. This would allow me to shoot in the densest part of the forest during periods of even, but very low, light when the sun disappeared behind a cloud. Use a polarising filter to ensure maximum saturation of the greens and select a small aperture for maximum depth of field. The weight of the tripod paled into insignificance when I got the shot I had envisioned.
35mm SLR, 24-70mm lens, 1 sec f16, Ektachrome E100VS, polariser, tripod

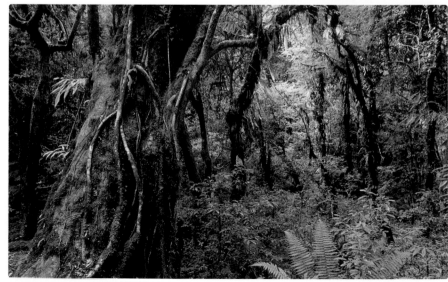

Myrtle Beech tree, Great Otway National Park, Australia

The ancient Myrtle Beech tree and surrounding ferns at Maits Rest receive a lot of patchy sunlight. If the sun is shining I wouldn't even bother going in. However, when it's bright but overcast, all the textures and colours record perfectly.

6 x 7cm Rangefinder, 50mm lens, 1 sec f11, Ektachrome E100VS, polariser, tripod

RIVERS & WATERFALLS

The flowing water of rivers and waterfalls can be interpreted in different ways through shutter-speed selection. To give the impression of running water, experiment with shutter speeds from 1/30 to one second. If the flow is fast 1/30 will do and you may be able to hand-hold the camera using a wide-angle lens. For best results and maximum depth of field, use a tripod. Start at 1/15 and go down to one second depending on the rate the water is flowing and the amount of blur you're after. Quite a different effect is achieved with fast shutter speeds (1/250 and higher), which 'freeze' the water in mid-flow, bringing out colour and detail. Like rainforests, waterfalls photograph best in the even light of a bright overcast day. Contrast between the water and the surroundings is often naturally high, and the soft, indirect light allows detail to be recorded in the highlights and the shadows. A polarising filter can improve the image by cutting out reflections from the wet rock and surrounding vegetation.

(Right) Victoria Falls, Zimbabwe

Rainbows appear on waterfalls if the sun strikes the rising spray at just the right angle. Around mid-afternoon is a good time to see the dramatic rainbows that form on Victoria Falls. A polarising filter is essential to ensure the colours of the rainbow look their best.

35mm SLR, 24mm lens, 1/250 f8, Ektachrome E100VS, polarising filter

(Above) American Falls section of Niagara Falls, Niagara Falls, Canada

In winter part of the American Falls had frozen mid-flow. To emphasise that the water was frozen literally and not frozen with a fast shutter speed, I used a slow shutter speed to blur the water that was still flowing to create a distinct contrast between the different drops. The shutter speed and the speed the water is flowing determine the amount of blur. Longer exposures provide a softer, milkier effect than short exposures.

DSLR, 70-200mm lens at 95mm, 1/6 f22, raw, ISO 100, tripod

Skogafoss waterfall, Skogar, Iceland

Spectacular waterfalls abound in Iceland but expecting to simply turn up and achieve great pictures would be a mistake. On a cloudy day the sun was making only an occasional appearance, but the difference it made when it struck the falling water, adding life, texture and a rainbow was substantial and had to be patiently waited for. The birds that nest on the cliffs over which the water pours added another dynamic element to the scene, as well as 50 minutes to the photography session. It was a challenging exercise to capture one of them in flight, in the right place at the same time as the sun hit the falls

DSLR, 24-70mm lens at 24mm, 1/640 f5, raw, ISO 100, tripod, polarising filter

LAKES & REFLECTIONS

Lakes add a dynamic element to a land-scape. Be aware that a gust of wind can change the look of a lake significantly – a mirrored landscape can quickly become an abstract interpretation of the same scene. Reflections can't be guaranteed, but are more likely early in the day. See what effect a polarising filter has on the reflection as you rotate it. You can some-times get two different-looking photos by changing the position of the filter. The reflected part of the landscape is often darker than the actual subject. Take your meter reading from, and focus on, the landform rather than the reflection so that the landform is sharp and correctly ex-posed. If there are more than two stops difference between the two parts of the composition a graduated neutral density filter will even out the lighting.

Inle Lake, Myanmar

A tranquil scene by day is transformed into a dynamic landscape at sunset, truly reflecting the immensity of Inle Lake. A massive cloud stack, lit by the warm rays of the setting sun, fills the frame, thanks to the reflection in the water. You know you're having a good day when a leg rower, the icon of Inle Lake, glides gracefully into the composition at just the right time.

DSLR, 24-70mm lens at 45mm, 1/125 f5, raw, ISO 100

(Opposite)
Dal Lake, Srinagar, India

On a perfectly still morning, rising before dawn was rewarded with a perfectly still lake and ideal conditions for capturing a mirror image of the mountains and village in Dal Lake. As I was shooting from the water in a shikara I had to ask the boatman to stop paddling to not only allow me to compose carefully, but also to ensure we didn't create ripples and spoil the effect. Placing the horizon in the centre of the frame is generally not recommended but in situations like this it serves to highlight the symmetry of the mirror-like reflection.

DSLR, 24-70mm lens at 43mm, 1/250 f7.1, raw, ISO 100

FLOWERS

The colour and natural beauty of flowers make them a favourite travel subject, whether they're growing in pots and decorating the exterior of a building, flowing down fences or growing wild as solitary specimens or dominating the landscape in dramatic fields of colour. Flower studies require macro equipment if you want to fill the frame with a single flower and achieve maximum impact. If you're using the macro facility on a zoom lens and can't fill the frame, treat the flower as one element of the picture. In a sense you're looking to create an environmental flower portrait. Alternatively, look for groups of flowers to fill the frame with a repetitive pattern of colour and shapes. Unless the flowers are all parallel to your camera or you're able to work with an aperture of at least f8, you'll find that typically only one or two flowers will be in focus. Select the best specimen and make it the focal point, preferably away from the centre of the frame. The other flowers will form a soft and very pleasing background.

If there is the slightest breeze, flowers move and blur, which can look great if it's what you want. Shutter speeds over 1/125 will stop most movement except on very windy days, but if using speeds slower than 1/60, wait for a still moment. Light-coloured flowers against dark backgrounds can fool light meters, so meter for the flower to maintain detail and colour.

NATURAL DETAILS

It's easy to get carried away with the big picture when out shoot-ing landscapes. Lower your eyes for a minute and you'll find the natural world is equally impressive in miniature. Colour, texture, patterns and intricate detail can be found in the bark of a tree, the surface of a rock, in the leaf litter on a forest floor or just about any-where you take the time to look. Searching for and photographing nature's detail is a great way to pass the time while you're waiting for the light to perform its magic on the larger landscape. You'll know you've succeeded in capturing interesting images when viewers squint and peer closely trying to work out what the sub-ject is, or are simply amazed at the beauty of the detail.

Tree canopy, Fort Cochin, India

DSLR, 24-70mm lens at 32mm, 6 secs f4.5, raw, ISO 100, tripod

(Top left) Autumn leaves, Melbourne, Australia

DSLR, 24-70mm lens at 70mm, 1/3 f20, raw, ISO 100, tripod

(Top right) Glacial ice in Jokulsarlon glacial lagoon, Jokulsarlon, Iceland

DSLR, 70-200mm lens at 200mm, 1/160 f5.6, raw, ISO 200

(Bottom left) Shells on beach, Langkawi, Malaysia

DSLR, 24-70mm lens at 52mm, 1/125 f7.1, raw, ISO 200

(Bottom right) Cherry blossom tree, Beijing, China

DSLR, 70-200mm lens at 200mm, 1/125 f6.3, raw, ISO 200

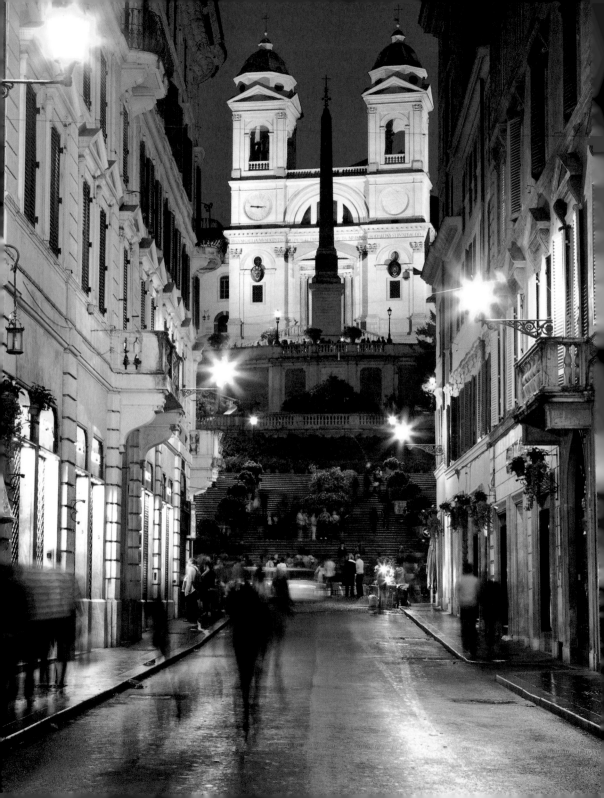

THE URBAN ENVIRONMENT

There's no shortage of subjects to photograph in the urban environment, even in the smallest of towns. For the photographer who likes to shoot a wide range of subjects this is great news. The urban environment of the world's towns and cities provides easy access to the greatest variety of subject matter and photographic possibilities per square kilometre than any other photographic category in any other location. In the time it takes to walk a block or two, you can photograph panoramic skylines; people up close, at work or at play; abstract architectural details; frenetic street activity and peaceful park scenes. You can capture elements of the past and the present through the city's architecture in one carefully composed street scene; focus in on torn wall posters in a dimly lit alleyway and within minutes you're framing up the most recognisable landmark in the city.

For the majority of us, this environment is on our doorstep, as most of us live in or close to cities and towns. In fact, you could photograph your own doorstep in pursuit of an urban image. This means you can get out there and shoot urban pictures every day, even if you don't have a trip planned to an exciting megalopolis.

If you do have a trip planned, be warned. Arrive in a new city intent on covering the full range of subjects the urban environment has to offer and you'll find you won't have much time between shots and little time to rest. Cities and towns are rich in subject matter and offer round-the-clock photo opportunities. A typical day will look like this:

o up before dawn to get to a predetermined location before the sun rises to capture the classic skyline or city view at first light

o over to the waterfront for early-morning activity

o into the city centre for people- and traffic-free architectural pictures of key buildings and quiet streetscapes as the city wakes up

o head to the morning produce markets for an hour or so

o back to the main thoroughfares and city squares as peak-hour crowds and traf-

The key to photographing a city is to walk, walk and walk.

(Opposite) Via dei Condotti, Spanish Steps and Trinita dei Monti Church, Rome, Italy
The usually crowded road leading to the Spanish Steps was not only much quieter thanks to a heavy rain shower, but was also transformed by a golden glow as the warm colours of the incandescent lights and stone buildings reflected more intensely off the wet road.
DSLR, 24-70mm lens at 62mm, 4 secs f10, raw, ISO 100, tripod

(Above) Amman, Jordan
DSLR, 24-105mm lens at 105mm, 1/125 f13, raw, ISO 100

○

City tours are offered everywhere and are useful to get a quick over-
view of a new city and its main sights. However, they have limited use
for good photography as they're usually run in the middle of the day
and give very little time at each destination. If your budget isn't too
tight forget the bus and do the same thing in a taxi.

fic build up for busy streetscapes

o breakfast and note taking

o walk the streets searching out new
views, urban details, interesting shops
and people engaged in daily activities

o a late-morning visit to the city's muse-
ums and art galleries

o get to an outdoor-eating precinct in
the middle of the day as cafés fill with
lunchtime crowds

o lunch and note taking

o an early-afternoon walk around shop-
ping precincts before visiting places
further from the city centre, including
parklands and beaches

o mid-afternoon check out the craft mar-
kets and city squares to photograph
souvenir stalls, street performers and
people shopping

o then take a quick walk around the food-
market precinct as the cafés and bars get
busy

o late afternoon head to a vantage point
for another (and different) city skyline
or view

o stay on at the viewpoint to photograph
the skyline at dusk as the lights take ef-
fect or dash to another location to pho-
tograph a key building or streetscape in
the half-hour after sunset

o dinner and note taking

o spend the evening in the night markets,
photographing bands playing in bars
and people dancing in nightclubs – by
now it's gone midnight and you've got
to get up and do it all again in around
five hours.

Although this schedule suggests a frenetic
pace to see and photograph everything,
the aim is to create a series of images that
capture the character and diversity of a
place and to photograph all subjects in the
best possible light. When time is limited
there will clearly be a tension between see-
ing everything and taking quality images.
This tension is increased when you realise
that cities are dynamic and that things can
change dramatically within minutes. To
really get to know a city you have to be
prepared to retrace your steps at different
times of the day on different days of the
week. A quiet Sunday market can become
a busy throng as people pour out of a near-
by church. Crowds gather and disperse as
street entertainers come and go. Restau-
rant and bar precincts humming at midnight
are deserted at nine in the morning. Parks
that are empty on weekdays become the
focus of activity on weekends, while busy
business districts are abandoned.

While all urban environments have
much in common, the challenge for the
photographer is to reveal the unique spir-
it of each city. Many cities are famous for
certain buildings, skylines or activities
and until people visit, that is often all they
know about the place. As a photographer
you should aim to delve much deeper to
reveal a more realistic and comprehen-
sive impression of each city.

AFTER DARK

Cities and buildings take on a completely different look and feel after dark, and night images will add an extra dimension to your collection. The best time to photograph is around 10 to 20 minutes after sunset. By then the incandescent lighting provided by interior, spot and streetlights will be the dominant light source, but there'll still be some light and colour in the sky.

Shooting at this time of day offers guaranteed results regardless of the weather (unless you're talking heavy fog) and ensures you get the shot even if your schedule doesn't allow you to get back to photograph the building at the right time of day in natural light. If, in order to avoid converging verticals, you've chosen a viewpoint that offers an interesting foreground to fill the bottom half of the frame, be aware that the foreground must also be illuminated; otherwise you'll have an unacceptably large area of the composition in shadow.

When it's completely dark, concentrate on filling the frame with well-lit subjects and avoid large areas of unlit space, including the sky. Night photography requires a tripod and cable-release, as exposures are generally long. To record detail, overexpose by one and two stops – otherwise the only thing that will come out will be the lights themselves. As with all difficult lighting situations, bracketing is recommended.

Palace of Parliament and fountains at dusk, Unirii Square, Bucharest, Romania
35mm SLR, 24-70mm lens, 1/2 f11, Ektachrome E100VS, tripod

INTERIORS

Photographing interiors requires the ability to switch from one technique to another, depending on the amount of available light. Individual displays are sometimes lit with spotlights intense enough to allow the camera to be hand-held. Generally, though, light levels are too low to photograph interiors hand-held without increasing the sensor's ISO rating or switching to a faster film, using flash or mounting your camera on a tripod. Be prepared for all three situations. In many places flash and tripods are prohibited, so there's no choice but to increase the ISO rating or put away your camera. If flash is permitted remember to keep your subject within the range of your unit. The main advantage of a tripod is that you can shoot at your preferred sensor setting or continue using fine-grain film, and

achieve the exact amount of depth of field that you require.

Most interiors are lit with incandescent light. Digital photographers can let the camera's auto white balance (p38) correct the colour to record the subject as the eye sees it. Standard film however is balanced for daylight and records incandescent light as a yellow-orange colour cast. The actual colour and strength of the cast depends on the type and mix of artificial lights (see p182 for more information). This caste can be quite acceptable, and even pleasing, as it creates ambience and shows that it was taken indoors. If you want to record the colours more faithfully use an 82 series colour-conversion filter or tungsten film, which is balanced for such conditions. Unless you plan to take a lot of pictures with tungsten film it's impractical to carry on your travels.

Carrousel du Louvre
shopping centre, Paris,
France

DSLR, 24-70mm lens at 48mm,
1/125 f14, raw, ISO 200

CITY VIEWS

Not all cities have impressive skylines, but an overview from a high vantage point or a panoramic view of a particularly interesting part of town provide great photo opportunities and the same scene-setting effect for a series of images.

The vantage point for city views is usually in the city itself and easily accessible. Apart from official observation decks that are often in centrally located skyscrapers, keep an eye out for other vantage points that will give you the chance to create more unique images. Hotels sometimes have rooftop bars and restaurants that are easy to access, cafés with balconies are often situated around town squares, cathedrals sometimes have viewing platforms high in their spires and domes, and high-rise car parks are common in big cities. In hilly cities there are endless opportunities to find interesting views – it's just a matter of perseverance and stamina as to how many you discover. Check out a few during the day, noting where the sun will set and rise, and return later to the best-placed viewpoint.

If the city is on a river or by the sea (or both) you'll find bridges and harbours that often offer brilliant vantage points. They create an open space that lets you get back from the city buildings and at the same time provide an interesting foreground. When conditions are right, usually early morning or late afternoon, you have the added bonus of reflections in the water. Use your map and compass to make sure you're on the right side of the river or harbour at the right time of day.

City at sunrise, Ushuaia, Argentina
It's always important to know where you want to be for sunrise, but it's especially important if you've got to start walking at 4am. An afternoon recce the day before established just how long it would take to get to the perfect vantage point and more importantly exactly what time I had to get out of bed.
35mm SLR, 24-70mm lens, 1/4 f11, Ektachrome E100VS, tripod

SKYLINES

Every large city has a unique skyline and getting to a vantage point in the first or last hour of the day should be a top priority in every city you visit. The classic skyline – a panoramic view of the skyscrapers and buildings in the city's central business district – is a great opening image for albums or slide shows and provides a context for the photos that follow.

Many cities have well-known vantage points on nearby hills or in public spaces along rivers or around harbours. Often there will be several viewpoints with different perspectives on the city. These will feature in local postcards, souvenir books and tourist brochures, giving you a good idea as to which location will offer the shot you're after. Vantage points are sometimes on city outskirts, so find out how to get there and how long it will take. If the viewpoint is on the remote side or in a park, it's more practical and often wiser to pay a taxi to wait for you.

Use a map to determine the direction of the sun in the morning and evening and thereby establish the best time to visit and capture the city in great light. No matter where the sun sets, you'll be rewarded with great pictures in the half-hour after sunset as the sky darkens and city lights begin to take effect. Even if the weather isn't good, make your way to the vantage point at this time. The combination of illuminated buildings, a darkening sky and long exposures creates dramatic and colourful images even on the worst of days. See p249 for advice on night photography.

It's also worth taking your full complement of lenses to the viewpoint because they are never one-shot spots. You'll have the opportunity to capture all sorts of images, from entire city panoramas to the city's signature skyscraper, in various vertical and horizontal compositions. Just as importantly, until you've been there, you can't be sure just how far the lookout is from the city and you might end up requiring a 200mm lens to shoot the panoramic view.

Pudong skyline & Huangpu River, Shanghai, China
The Pudong skyline is changing so fast this shot will have to be retaken at every available opportunity. Fortunately, if you're in Shanghai, it's about as straightforward as it comes. Walk to the end of Nanjing Rd (the city's most famous street), cross the road and there's the view. Then it's just a matter of waiting until the colour in the sky and the cloud formations are perfect.
DSLR, 24-70mm lens at 24mm, 2.5 secs f11, raw, ISO 100, tripod

Skyscrapers dominate the skyline and central business district of most large cities. They are often difficult to photograph as it's hard to get far enough away to get a clear view of an entire building from within the city. Take the opportunity when you're photographing the skyline to pick out groups of or individual skyscrapers, as it may be the best view you get.

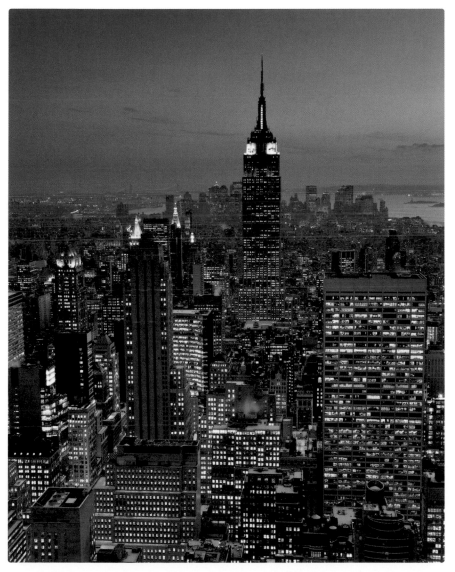

Manhattan high-rise buildings and Empire State Building, New York, USA

I always take the opportunity to photograph cities from their designated lookouts. The view can be guaranteed and it's often the signature image of the city so it's important to have in my collection. After that I'll look for a view that's more unique.

DSLR, 24–105mm lens at 45mm, 8 secs f10, raw, ISO 100, tripod

253

ARCHITECTURE

Cities are defined by their architecture. Their histories and aspirations are clearly manifest in the buildings that line the streets, overlook the squares and house institutions. Photographing architecture is an integral step in creating a collection of images that capture the soul of a city.

The most famous buildings are major drawcards and deservedly high on everyone's shot list. They should be given priority in terms of time and commitment to photographing them well, because it's easy to take boring pictures of buildings. Simply walking up to a building and grabbing a shot will rarely do the job. Don't forget you're photographing someone else's creativity, so try to do it justice.

One of the main difficulties faced is getting far enough away to capture an entire building without causing converging verticals in the image. Tilt your camera up to photograph a building and it will appear to be falling backwards.

Look down on a building and it will appear to lean towards you. The wider the lens and the closer you are to a building, the more pronounced the effect. Converging verticals or linear distortion can be effective, however, when the composition exaggerates the distortion. Looking up at skyscrapers is a good example of this technique. To record buildings faithfully, the camera's sensor plane must be parallel to the vertical surface of the building. Unless you're carrying a perspective-correction (PC) lens (p55), this is most easily achieved by:

○ Finding a viewpoint that is half the height of the building that you're intending to photograph.

○ Finding an interesting foreground to fill the bottom half of the frame.

○ Moving away from the building and using a telephoto lens.

If you're really serious about keeping your horizontal and vertical lines straight, a spirit-level accessory is most useful. Some tripod heads have them built in, or you can buy an accessory that fits into the camera hot shoe. The best of these have two spirit levels, one for horizontal accuracy and another for vertical accuracy.

Once you've established a viewpoint and lens combination that doesn't bend the building (too much), you have two or three opportunities each day when the light is right. This is either early in the morning or late in the afternoon, depending on which way the building faces, and,

Shanghai fashion store, Shanghai, China
DSLR, 24-70mm lens at 24mm, 1/4 f5, raw, ISO 100, tripod

when it's illuminated, in the half-hour after sunset. There's no point taking the picture at all if the main facade is in shade.

Look for opportunities to include people in architectural pictures. They add scale, colour, movement and interest. If you don't want to include people or other elements such as parked cars or traffic, and don't want to put your patience to a severe test, photographing early in the morning is usually the best opportunity you'll have.

────────○────────

You can also correct converging verticals using perspective correction controls in image-editing software. It's a very handy tool to learn how to use as carrying a PC lens is an extravagance for most of us and no matter how hard you try you often just can't avoid converging verticals.

As you can see, I think dusk is the time to photograph buildings of all sorts, from humble department stores to landmark mosques. The combination of incandescent light and the magical and unpredictable colours of the sky at sunset rarely fail to do justice to the magnificent buildings that have been created around the world.

(Top) Hassanal Bolkiah Mosque, Banda Seri Begawan, Brunei
DSLR, 24-105mm lens at 98mm, 1/8 secs f14, raw, ISO 100, tripod

(Bottom) Duomo and bell tower, Florence, Italy
DSLR, 24-70mm lens at 35mm, 8 secs f7.1, raw, ISO 100, tripod

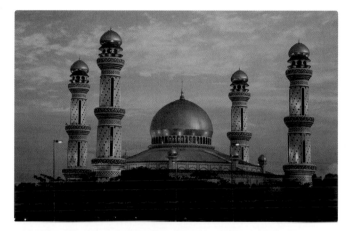

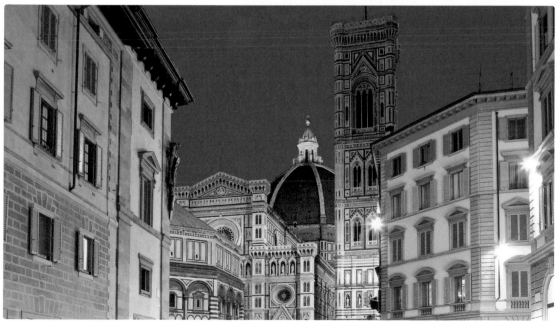

ARCHITECTURAL DETAILS

It is impossible to appreciate the fine architectural and artistic details that adorn many buildings in a photograph of the entire structure. Therefore, look to complement your architectural shot with close-ups of the most symbolic and graphic of these details. You can often do this from the same position by zooming in or changing lenses for the most obvious and grander details. Then walk in and around the building to ensure you see the more intricate work. Look for texture, shape, colour and pattern in the design and structure of the building. Textures and details are much easier to see and appreciate when early morning or late afternoon side light is skimming the surfaces of the building.

Face of Luna Park, Melbourne, Australia
Yes, it's a big detail, but it's still a detail. I drive past this spectacular entrance to a theme park two or three times a week and it's always impressive. Only occasionally, though, does the light fall in a way that does justice to the scale, detail and colour, and reveal the facade in all its glory.
35mm SLR, 24-70mm lens, 1/125 f18, Ektachrome E100VS

(Top) Dome interior, Bucharest, Romania

This grand glass dome sits above an unassuming passageway that reveals nothing of its grandeur when you first peer in from the main street that passes its entrance. Once inside though, the unusual colour of the light created by the coloured glass draws your eye upwards.

35mm SLR, 24-70mm lens, 1/20 f8, Ektachrome E100VS

(Bottom) County Hall, London, England

DSLR, 24-70mm lens at 46mm, 2 secs f7.1, raw, ISO 100, tripod

STREETSCAPES

Shanghai's Bund, New York's Fifth Ave, Memphis' Beale St, Dubrovnik's Placa and Paris' Champs Élysées are streets that demand to be photographed. Their very names conjure up images of the heart of the city. Every city has such streets (even if they aren't household names) – streets that are the city's commercial, cultural, tourist and transport focus for locals and visitors alike.

The most consistently effective streetscapes can be made with a medium telephoto or zoom lens setting around 100–150mm. These focal lengths

Street corner at Burra Bazaar, Kolkata, India
Don't just concentrate on the famous streets. Scenes like this in one of Kolkata's busy commercial districts offer a glimpse of life around the city and pack in plenty of information about architecture, transport, people and local government policy on the use of advertising signs! An elevated vantage point overlooking a corner is also a great opportunity to use a wide-angle lens to capture the view down two streets in the one frame.
35mm SLR, 24mm lens, 1/125 f8, Kodachrome 64

allow you to pick a point of interest at least 100m away from your camera position and provide just the right amount of subject compression to give a realistic perspective between the foreground and distant elements in the street. This will create a dynamic and busy feel, and will keep the buildings parallel with the sensor plane so the verticals remain straight.

An elevated viewpoint works best, as it gives you the clear space you need in front of the lens to prevent foreground elements such as people and traffic from unbalancing the composition and blocking the view. Keep an eye out for 1st-floor windows and balconies, rooftops, bridges and pedestrian overpasses, as they all make ideal vantage points. At street level find a viewpoint with some space in front of it. Even a slight rise in the road or standing on a couple of steps will let you shoot over the immediate foreground. Otherwise, standing on the kerb or in road intersections (once the traffic has cleared on your side of the road) will do. However, you need much more patience when shooting at street level.

When you're planning your shot and searching for a viewpoint, remember that when the light is at its best (early morning or late afternoon) one side of the street will usually be in shadow. Once the sun has set and the lights come on, you'll have your best opportunity to include both sides of the street in a single photograph.

Lloyd's of London, London, England

This distinctive building deserved a more unusual treatment but it wasn't until I walked a block away that I found a point of view that delivered. This is the kind of photo opportunity that's easily missed as it isn't what you see as you walk by the building with the reflective surface. To achieve the (almost) perfect reflection the lens, and therefore my head, had to be placed hard up against the mirrored glass.

DSLR, 24-70mm lens at 24mm, 1/125 f5.6, raw, ISO 100

URBAN DETAILS

Change your focus from the grander subject matter of skylines and architecture and you'll discover a whole new world of less obvious but equally interesting subjects. The subjects are the kinds of things that most people take for granted and walk by without a second look, but for the sharp-eyed photographer they're important in creating an overall impression of the city. Frame-filling close-ups of walls, signs, decorated bus shelters and lamp posts, shop-front decorations,

cafe menu boards and posters add colour, texture and personality to your collection. Look out for urban details that are unique and recognisable as belonging to the city.

The other great thing about these subjects is that many can be photographed at most times of the day in any weather, so they're great for filling in the time when the circumstances aren't right for shooting other subjects. You can also continue your search for urban details well into the night with well-lit subjects such as neon signs and street lights. You'll need your tripod and cable release, as exposures are generally long. To record detail, overexpose by one and two stops. As with all difficult lighting situations, bracketing is recommended.

The ideal lens for capturing many urban details is a medium telephoto or zoom lens set to a focal length around 70–135mm. You'll be able to fill the frame with your subject without having to get too close or without getting down on your knees.

Spire, Dublin , Ireland
In the middle of O'Connell Street is a very tall, shiny, pointy spire. It's quite a challenge to photograph. While I was contemplating my options the sun came out, bringing to life the pattern and fine texture in the spire's surface and strengthening the colours of the reflected buildings.
DSLR, 70-200mm lens at 155mm, 1/160 f6.3, raw, ISO 100

(Opposite, top) Cafe wall, Cairo, Egypt
DSLR, 24-105mm lens at 24mm, 1/25 f4, raw, ISO 400

(Opposite, bottom left) Cathedral tower reflected in puddle, Siena, Italy
DSLR, 24-70mm lens at 38mm, 25 secs f3.2, raw, ISO 100, tripod

(Opposite, bottom middle) Harbour Bridge reflection, Sydney, Australia
DSLR, 70-200mm lens at 160mm, 1/100 f2.8, raw, ISO 160

(Opposite, bottom right) Snow on train track, Frankfurt, Germany
DSLR, 24-105mm lens at 70mm, 1/50 f10, raw, ISO 100, tripod

261

STREET ART

Cities are full of street art, including high-profile sculpture installations in key locations, colourful murals on walls of all sizes, illicit graffiti scrawled across derelict buildings and statues of all shapes, sizes and significance.

You can photograph the artwork in its entirety or focus on a detail to create an abstract image emphasising shape, colour or texture. Walk around, under and between large sculptures and installation art. Then check it out from a more distant position, observing how the light is falling and what the background options are. It can be portrayed in very different ways: as a static piece of art, a prominent or insignificant element in the streetscape or a backdrop to the hustle and bustle of city life.

Walls covered with murals or graffiti also make excellent backgrounds, so if the light is right, take up a position, compose your image and wait for interesting people to pass by. In bright sunlight watch out for shadows and reflections that create uneven light. Our eyes and brain compensate for the difference in brightness, so they can be easy to miss, but images don't work if there is an unsightly shadow or a bright area blocking out detail in part of the composition. A polarising filter is

Nelson Mandela mural, Soweto, South Africa
Murals make great photographic subjects, either in their entirety or by selecting the most graphic or colourful elements to create your own piece of art. They're even better from a travel photography perspective if they reveal their location in their subject matter.
35mm SLR, 50mm lens, 1/125 f8, Ektachrome E100VS

often useful for this subject to cut down reflections and ensure saturated colours.

Statues often result in some of the most boring pictures imaginable, as people feel obliged to photograph them but rarely give much thought to the image. They are often made of very dark materials so the details are hard to see and they end up looking like silhouettes. That's fine if it's deliberate, but not so good if you intended to see the detail. Early morning or late afternoon side light will bring out the detail and texture and add a touch of colour, bringing even the dullest of statues to life.

(Top) Sculpture in Brisbane Square, Brisbane, Australia
The sculpture is impressive enough, but at certain times of the day the shiny metal surface reflected the colours of the surrounding buildings. Each time I passed I checked to see if the reflections were stronger than what I'd already captured.
Rangefinder, 21mm lens, 1/125 f8, raw, ISO 160

(Bottom) Artist at Circular Quay, Sydney, Australia
A very high vantage point offered a unique perspective of this street artist at work. The inclusion of the children make this a very different take on a familiar subject, which is usually captured from eye level looking down with a wide angle lens.
DSLR, 70-200mm lens at 200mm, 1/160 f6.3, raw, ISO 160

GALLERIES & MUSEUMS

Entry to Rock & Roll Hall of Fame, Cleveland, USA
Sometimes you're only allowed to take photos in the entrance of museums, which is fine when they feature an impressive display. Lots of available light also made it quick and easy to take a series of shots.
35mm SLR, 24mm lens, 1/60 f8, Ektachrome E100VS

Galleries and museums are often significant places in the city's psyche and their collections are housed in buildings as diverse as centuries-old, dark, musty mansions and purpose-built futuristic spaces. The exhibition areas vary enormously from place to place and even from room to room, presenting the photographer with various challenges.

Be clear what it is that you want to achieve. Unless you have set yourself the goal of cataloguing every item in the building, you don't need to photograph every room, exhibit or piece of art. Two or three images from each place will do; ideally, this will include an overview of the most impressive public space and a close-up of the most attractive exhibits. This will free you up to concentrate on finding exhibits that you can photograph well with the gear you have, rather than struggling to photograph a particular thing with the wrong gear.

Photographing the interiors of galleries and museums requires the ability to switch from one technique to another depending on the amount of available light and the restrictions placed on photo-taking by the establishment.

In many galleries and museums flash and tripods are prohibited, so in dimly lit spaces there's no choice but to increase sensor sensitivity or use fast film. Even if flash is permitted, a single flash unit will rarely be powerful enough to light up a room and, when used within its range on individual exhibits, the results will be pretty ordinary, giving you a record shot at best. Also, many displays are behind glass, so you'll have to turn the flash off to avoid an image-ruining highlight as the flashlight bounces straight back into your lens. A tripod is the best solution and will give the most consistent results in any situation, no matter how low the light, you can use your standard sensor setting or fine-grain film and achieve good depth

of field. However, as already noted, tripods are not welcome in most places so increasing sensor speed or switching to fast film is usually the go.

Before you change your sensor settings or film, spend the first half-hour or so (depending on the size of the place) looking around and establishing which exhibits or rooms you want to capture and how best to do it. If you shoot as you go along, especially in a large, many-roomed building, you could spend your time in difficult-to-photograph rooms when there is a much easier situation next door or on the next floor. Using ambient light will better capture the atmosphere of the exhibition spaces, so look for rooms that have a mix of daylight and incandescent light; are flooded with daylight (from windows or skylights); or individual exhibits placed near windows or lit with spotlights intense enough to allow the camera to be hand-held.

National Gallery of Victoria, Melbourne, Australia
Photographing a gallery goer taking a close look at a sculpture by Ron Mueck without a flash or tripod is no problem for the digital photographer who can crank up the ISO sensitivity of the camera's sensor. Just make sure you know its limits in terms of acceptable noise; just because the numbers go up to 6400 doesn't mean the image files will be acceptable. Alternatively, look around for displays that are near windows or get close to individual displays that are lit with intense spotlights.
DSLR, 24-70mm lens at 24mm, 1/50 f2.8, raw, ISO 800

Museum of Old and New Art (MONA), Hobart, Australia
Although increasing the ISO sensitivity of the camera's sensor is one way of getting images in places where you're not allowed to use a tripod or flash I always aim to shoot at 100 ISO. At MONA I was able to achieve this by placing my camera on a wide balcony rail overlooking the space containing Sidney Nolan's 'Snake'. The inclusion of the people, who were asked not to move, provide important scale to emphasis just how big this work, made up of 1620 individual paintings, is.
DSLR, 24-70mm lens at 24mm, 15 secs f7.1, raw, ISO 100

PLACES OF WORSHIP

INSPIRATIONAL BOOK:
WHERE EVERY BREATH IS A PRAYER, **JOHN ORTNER**

Monasteries, temples, churches, mosques, shrines and synagogues are a focus of day-to-day activity in many places, from the smallest village to the biggest city, and are rich in subject matter. The buildings are often architecturally impressive, inside and out, and many contain fabulous works of art or at least ornate altars, painted ceilings and walls, statues of all sizes and stained-glass windows. There are also plenty of interesting details to discover, such as burning candles, incense coils, religious texts and motifs on walls. Because they're the focus of daily life, there is activity in and around the place much of the time, including a steady stream of pilgrims and devotees, stalls selling religious paraphernalia, souvenirs and flowers. This activity, of course, culminates at times of worship and special events.

Visitors are generally welcome to enter and observe and, in return, sensitivity and respect are expected. Find out if certain days or times of day are busier than others because you'll be far less conspicuous in a crowd. Always ask before shooting if there's any doubt as to whether photography is allowed. Religious ceremonies are not put on for the benefit of tourists and you really should take a step back and consider the situation before jumping in with all flashes blazing. It's possible to be respectful and still come away with a rewarding experience and images to match.

In the most famous or interesting places it's ideal if you have time for two visits. Firstly, go when the place is quiet so you have the time and space to photograph the interior architecture and artworks. The interiors are usually dimly lit so a

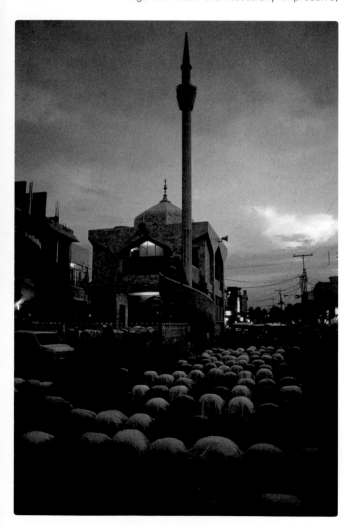

Evening prayer, Peshawar, Pakistan
It certainly makes access easier when there are too many people to fit inside the mosque and a hundred or so men had to perform their evening prayers on the road.
35mm SLR, 35mm lens, 1/30 f2, Kodachrome 200

tripod is needed for best results, and it's considerably more practical to take these pictures when there is no formal activity. Secondly, go at a time of worship, to capture the real spirit of the place, when it's functioning as a focal point for people's faith. During ceremonies, especially those indoors, turn off the camera's flash and if your camera allows, switch to the silent operating mode. Take up a position where you can come and go without disturbing others and that makes the most of any available natural or incandescent light.

(Bottom) Lama Temple, Beijing, China
When it's really busy at Chinese temples it gets noisy and very crowded around the altars. Take advantage of these circumstances to get in close to the action and your pictures will have an appreciable intimacy about them. At Lama Temple, the only barrier to getting close was the intensity of the heat coming from the burning incense.
DSLR, 24-70mm lens at 34mm, 1/125 f4, raw, ISO 100

(Top) Cathedral of the Immaculate Conception, Castries, St Lucia
When I enter places of worship I always have my cameras out so I can shoot quickly and don't give the impression I'm trying to sneak pictures. If taking photos is a problem someone will soon tell you. On Easter Sunday the cathedral was packed and I'd gone prepared for the big interior shot by taking my tripod along.
35mm SLR, 24-70mm lens, 1/60 f8, Ektachrome E100VS, tripod

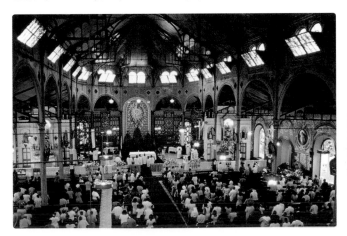

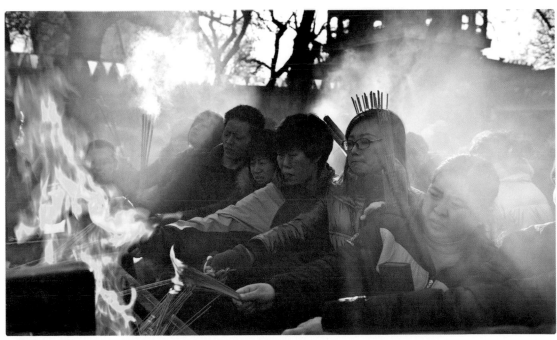

TRAFFIC & TRANSPORT

No pictorial coverage of the urban environment would be complete without images of vehicles plying the roads, waterways and tracks in and around town. Vehicles that are typical of a city, such as man-pulled rickshaws in Kolkata, three-wheeled tuk tuks in Bangkok, harbour ferries in Sydney and cable cars in San Francisco, are all symbolic of their urban location.

Many big cities are infamous for their road-traffic congestion and the pollution it causes. It might be annoying as a pedestrian or passenger, but it's good value for the photographer. The only way to really show congestion is from a high vantage point. Bridges and pedestrian overpasses are dotted across most major roads and are perfect for photography. Shooting in harsh light in the middle of the day will heighten the impression of an unattractive environment and clearly show the pollution. Shooting in the warm light of early evening, when the rear lights of vehicles are on, can make crowded roads seem much more attractive than they really are.

From your vantage point, focus on a point some distance up the road with a 100–200mm telephoto lens or zoom and you'll compress the traffic, giving a much stronger impression of a busy road. Shooting with a tripod also allows you to use slower shutter speeds to blur moving vehicles.

Back down at road level, you can illustrate the frenetic pace of the traffic by picking out individual vehicles and using the panning technique to keep the moving subject sharp while blurring the background, creating a sense of movement and speed.

Becak leaving Bennghan Market, Yjogjakarta, Indonesia

Rather than running around trying to get in front of moving vehicles, find a location that is obviously a popular route and wait for them to come to you. With a zoom lens you can reframe as they get closer and take a series of shots of each vehicle. Fixed lens users will have to wait and fire off one or two frames when the vehicle reaches the place that fills the frame.

35mm SLR, 180mm lens, 1/125 f8, Kodachrome 64

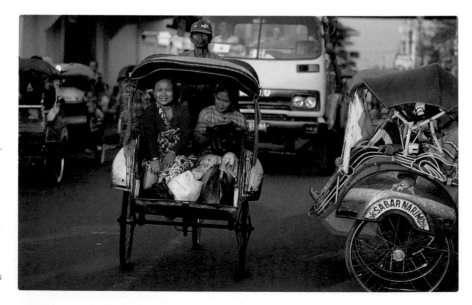

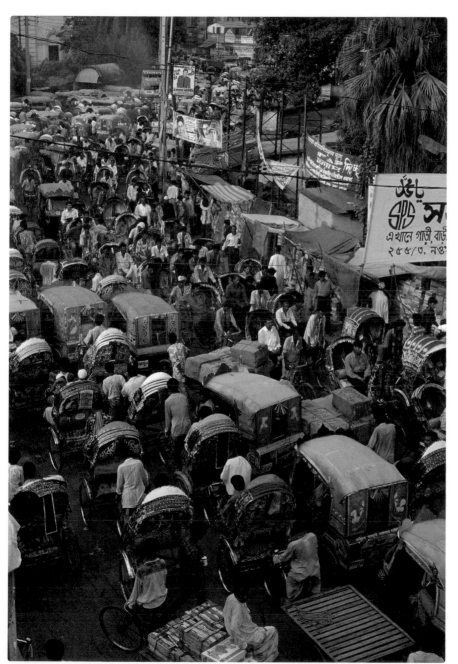

Auto & bicycle rickshaws, Dhaka, Bangladesh

With over 300,000 bicycle rickshaws plying the streets, Dhaka is clearly the rickshaw capital of the world. They have to fight for space with their motorised baby taxi cousins, and sitting in a rickshaw jam is a classic Dhaka experience. A vantage point on a bridge gives some sense of the wait in store for the people at the bottom of the frame.
35mm SLR, 35mm lens, 1/125 f5.6, Ektachrome E100VS

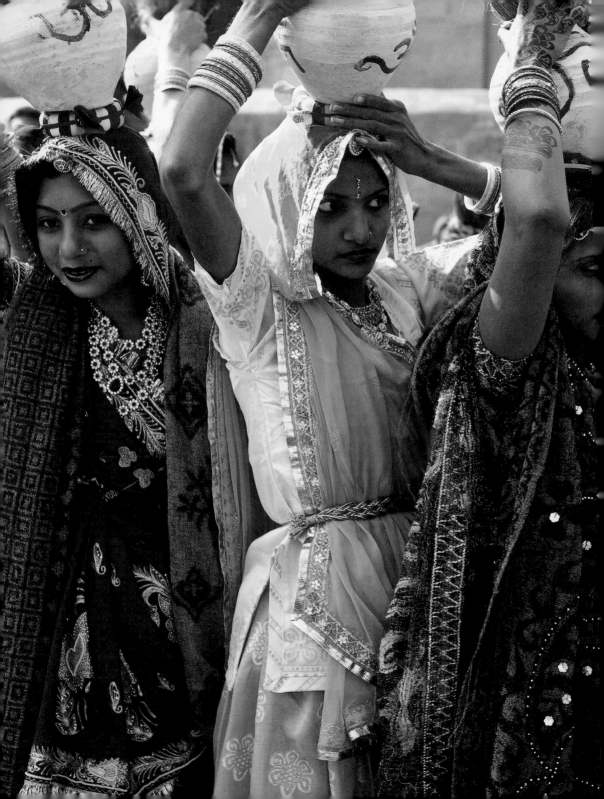

FESTIVALS

The spectacle, colour and crowds that are the hallmarks of festivals around the world make them a great subject for travel photography. They offer the chance to see a completely different side to the people of the place you're visiting. Many people dress up for the event, either in their best clothes, traditional dress or just for fun in whacky gear and you'll find they're relaxed, in high spirits and very happy to be photographed. Take advantage of the crowds and festive atmosphere to mingle with the locals and get in close to the action.

At seated events, getting close to the action can be difficult and a telephoto or long zoom lens is essential. If you're stuck in one place or the participants are moving around a stage, wait for the action to come to you. Infuse variety into your shots by varying focal lengths and framing horizontally and vertically. Remember to turn your lens on the spectators who also make great subjects as they watch and react to the proceedings.

Fancy costumes and traditional dress is a feature of most festivals. Interesting images can be made by getting in close and filling the frame with the colours, patterns and unique features of the participants' clothing. These shots can be done quite unobtrusively and successfully with lenses in the 150–200mm focal length range. If you're going to use a shorter lens and get close, you'd better get permission before you start focusing in on parts of someone's anatomy, even if it is clothed.

Regardless of how much information you acquire, patience and flexibility will help you enjoy the day. There's often a lot going on, so be prepared for long days and lots of walking.

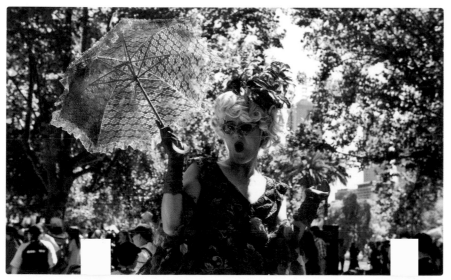

Festivals provide great opportunities to photograph people as they are often dressed up and in party mode and it doesn't take much to encourage them to stop for a picture. Be on your toes because the atmosphere is conducive for people to spontaneously play up for your camera.

(Opposite) Women in procession at Camel Festival, Bikaner, India

DSLR, 24-70mm lens at 45mm, 1/200 f5, raw, ISO 200

(Left) Participant in Moomba Festival Parade, Melbourne, Australia

DSLR, 24-70mm lens at 38mm, 1/160 f5, raw, ISO 100

DEALING WITH CROWDS

The bigger festivals can be particularly intense as they attract large crowds into finite spaces, hemmed in by buildings, roads, barricades and ropes. Crowd control is obviously an issue for the organisers and getting close to the action can't be guaranteed. Arrive in the vicinity early for the chance to get your bearings of the area, check out possible vantage points and confirm basic facts with organisers or knowledgeable locals, such as start and finish times and the timing of scheduled events, and secure a seat if necessary. Remember also that festivals in urban areas can cause traffic chaos and that crowd-control measures may close roads around the focus of activity. It's better to be in position a little early than too late, so allow extra time to get to the event.

You really do need to step up your level of vigilance to ensure your gear is safe when you're in crowded situations. When you're caught up in a large throng, wear your day pack in front or your shoulder bag across your body and swing it in front of you. Make sure it's properly closed. Assuming you're wanting to take photos you'll need your camera around your neck as well, but this is probably safer than continually having to open and close your bag to get it out and put it away.

Ganesh Chathuri, Mumbai, India
The annual celebration for India's favourite idol, the elephant-headed Ganesh lasts for 10 days and culminates in the mother of all processions. Thousands of idols are carried from homes, businesses and temples and carried in procession to the sea for immersion. The largest of all the statues takes around 12 hours to make the journey, so if you can't get a decent shot in that time something is terribly wrong. The challenge, as always with big crowds, is to find suitable vantage points and maintain the energy to complete an extended coverage of the day's events. This is the only festival I've been to where I've gone back to my hotel while it was in full swing. It just goes on and on and on.
DSLR, 70-200mm lens at 150mm, 1/160 f4, raw, ISO 200

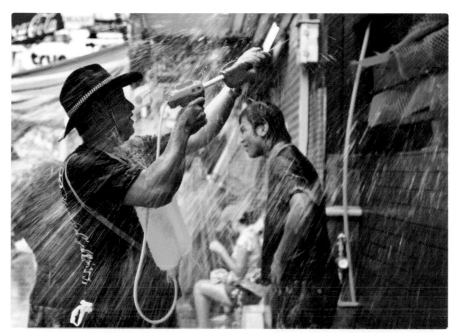

Songkran Festival, Bangkok, Thailand

During the Songkran Festival the streets of Bangkok are crowded with water-pistol-carrying people intent on giving anyone within range a good soaking. It's a lot of fun but be sure to protect your camera as carrying one does not protect you from being on the receiving end. To capture the action I selected a shutter speed fast enough to prevent my subject from blurring as he did battle with people in a bar, but slow enough to allow the bucket of water thrown at him to record as streaks on the sensor.
DSLR, 24-70mm lens at 38mm, 1/50 f2, raw, ISO 200

Spectators watching dance performance at Changthang Festival, Ladakh, India

Don't forget to pay some attention to the crowd at special events. Often they're so engrossed in proceedings that you'll capture great expressions as they react to what they're witnessing.
DSLR, 70-200mm lens at 200mm, 1/400 f8, raw, ISO 400

PARADES & PROCESSIONS

Parades and processions are often a feature of festivals and are particularly demanding subjects in their own right. By their very nature (they're moving) you don't get a lot of time to think, compose and shoot. Big, organised parades attract big crowds and routes are often roped off, making it difficult to move around quickly. You may also prefer to remain in one place if you're with family or friends. If so, choose the position carefully. Consider the direction of the sun and the background possibilities in relation to the direction of light. You don't want to find yourself looking into the sun or at a jumble of power lines, unable to move. If you do have the freedom to move, try walking with the parade. This will give you the opportunity to concentrate on the elements you find most interesting and to try various viewpoints.

For more informal shots and great opportunities to get really close, seek out meeting places where the participants gather before and after the parade. This is a great time to take portraits of people in costume, which is difficult while the parade is moving.

When you head out to a festival, take every memory card you've got. You'll be amazed how many photos you take and you don't want to spend half your time deleting images to make way for new ones while the action passes you by.

Phaung Daw Oo Pagoda Festival, Inle Lake, Myanmar
A procession of hundreds of boats is a serious challenge to photograph. To start with, you definitely need your own boat and a boatman who understands exactly what it is you are trying to do. I hired the same boatman to get around Inle Lake for several days preceding the festival. This gave me a chance to learn about what to expect, the procession route, timings and potential vantage points. It also gave my boatman a chance to learn how serious I was about my photography. On the day of the procession we were in sync and he successfully got me to the best spots ahead of the action.
DSLR, 24-70mm lens at 24mm, 1/30 f9, raw, ISO 400

Dussehra Festival, Kullu, India

The Procession of the Gods through the small town of Kullu is a chaotic affair. Hindu idols are paraded around the town on palanquins accompanied by devotees, soldiers and musicians, some with really long horns that are extremely loud when you're standing this close. Mingling with the participants before a procession sets off provides the opportunity to shoot up close to something that isn't quite so easy when people are on the move.

DSLR, 24-70mm lens at 24mm, 1/100 f5.6, raw, ISO 200

Independence Day Parade, Washington DC, USA

The guns were fired several times during the colonial military demonstration, which gave me the chance to improve my point of view as I was able to predict the sequence of events that led to the discharge. The aim was to get a decent amount of smoke and suitable expressions on the faces of the men.

35mm SLR, 100mm lens, 1/25 f8, Ektachrome E100VS

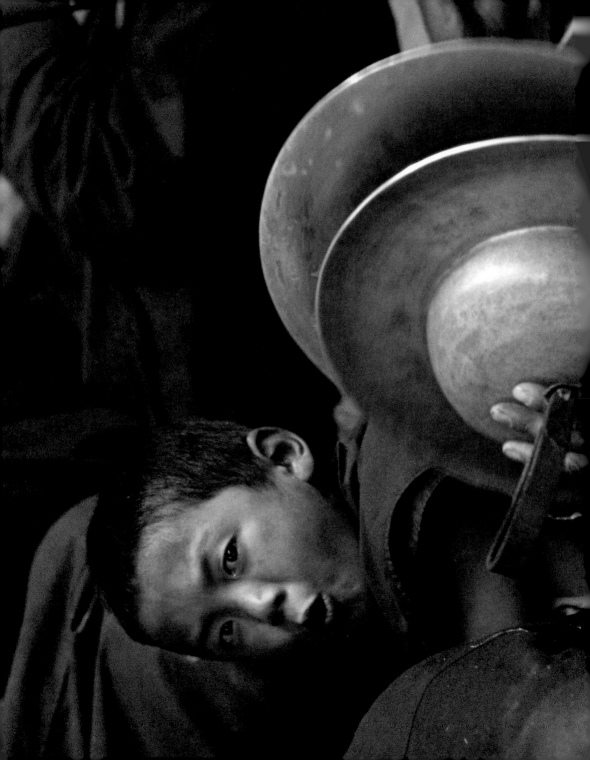

NOVICE MONK AT
TENGBOCHE MONASTERY,
KHUMBU, NEPAL

35mm SLR, 100mm lens, 1/125 f4, Ektachrome E100SW

The three-day festival at Tengboche Mon-
astery, situated in the Sagamartha National
Park within sight of Mt Everest, is one of
the most important events for the local
Sherpa people. The second time I attended
the event I stayed for all three days but this
shot, taken during preparations a couple
of days before the opening ceremony on
my first visit, remains unique. Following
the sound of horns and cymbals, I came
across the orchestra practising in one of the
monastery's side courtyards. This novice
monk was quite happy to play peek-a-boo
with the tourist, disappearing between his
friends every time the camera went to my
eye. Fortunately, he peeked once too often
and lost, just before a senior monk told him
to concentrate on the job at hand.

ENTERTAINMENT

Shopping, live music, cultural shows, sporting events, the bar scene and crowded nightclub dance floors – there are plenty of activities to choose from to keep us entertained, and still photographing, when we've finished seeing the main sights.

Many of the subjects are found indoors and the combination of very low ambient light with bright spotlights, crowded venues and moving subjects make these subjects as challenging as it gets.

Experimentation is the key in all these situations, so be prepared to take plenty of frames. Digital users will really appreciate the instant feedback on the LCD screen.

(Opposite) **Band performing at Tropicana Club, Miami, USA**
The large venue provided an excellent vantage point from the mezzanine level to photograph the band and dancing patrons. The colour of the stage lighting can be tweaked when the raw file is processed but I still generally prefer that stage lighting is rendered warm in the same way it was when using daylight film with artificial light.
DSLR, 24-70mm lens at 42mm, 1/30 f2.8, raw, ISO 1000

(Above) **Suzuki Night Market, Melbourne, Australia**
Low key, free, outdoor community events in your home town are great places to practice photographing musicians and bands. Getting to the front of the stage and shooting from various viewpoints is easy and you don't need a massive telephoto lens to fill the frame with a musician and her instruments.
DSLR, 24-70mm lens at 48mm, 1/100 f2.8, raw, ISO 1600

PERFORMANCE

You'll come across theatrical performances and cultural shows featuring music and dance indoors and out, day and night, in venues large and small, on the street in impromptu shows and in hotels, resorts and restaurants accompanied by dinner. At many of these shows you may be restricted to your seat, so take along your full set of lenses. Avoid using direct flash as it will kill the ambience of the venue and performance. Instead use the available incandescent light or combine it with flashlight if permitted. Using the flash-blur technique (see p189) and mixing incandescent and flash light works well at shows where there is movement on stage and you're able to get within the range of your flash unit.

If you choose to work with the available light, fast 400 or 800 ISO sensor settings or film will allow you to hand-hold your camera at shutter speeds of 1/30 or 1/60 of a second, particularly if your camera or lenses have image-stabilising technology. Study the lighting carefully. Stages and performers are rarely lit evenly. Performers are often lit by a spotlight and are brighter than the background. Unless the performer fills the frame, automatic meters will overexpose the subject. This is the ideal situation to use your camera's spot-metering system. Or, zoom in and fill the frame with the spot-lit performers, lock the exposure and recompose, or underexpose the meter's recommendation by one or two stops.

With or without the aid of flash, time your exposures for the moments when the lights are at their brightest to minimise large areas of shadow behind your subject.

If you have to sit in a seat, select one at the end of a row, that way you'll be able to get up and move around if the opportunity arises without disturbing other audience members.

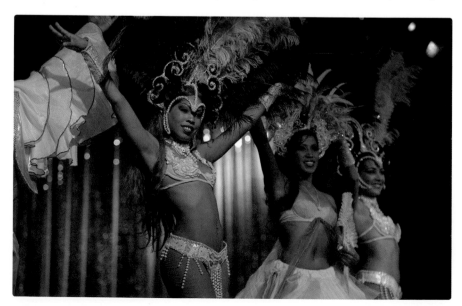

Dancers at Maho Casino, Grand Case, St Martin
At most performances where you can't move around, or would rather not, a front-row seat and a telephoto zoom lens will usually give you the opportunity to capture a variety of compositions including the whole stage and close-ups of individual performers.
DSLR, 70-200mm lens at 135mm, 1/60 f2.8, raw, ISO 500

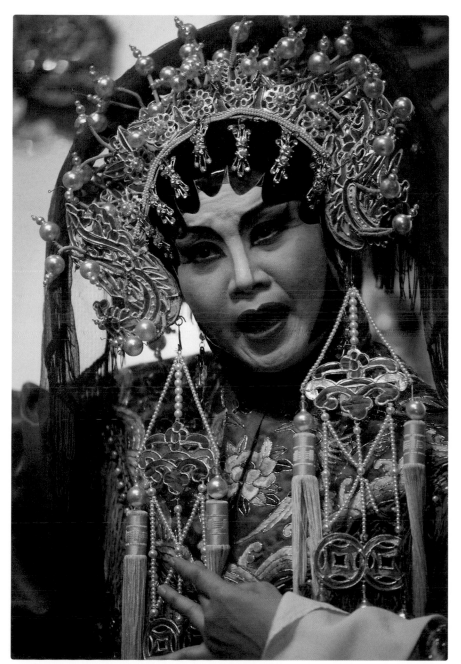

**Chinese opera per-
former, Singapore**
The small venue for
this performance
allowed frame-filling
portraits to be made from
the seating area.
**DSLR, 70-200mm lens at
200mm, 1/80 f2.8, raw, ISO 400**

SHOPPING

(Top left) Venetian glass for sale in shop window, Venice, Italy
DSLR, 24-70mm lens at 32mm, 1/30 f6.3, raw, ISO 200

(Top right) Shopping at antique market, Kotor, Montenegro
DSLR, 24-70mm lens at 24mm, 1/125 f2.8, raw, ISO 100

(Bottom left) Shopping at Bur Dubai Souq, Dubai, United Arab Emirates
DSLR, 24-105mm lens at 24mm, 1/20 f6.3, raw, ISO 320

(Bottom right) Shop at Dihua market, Taipei, Taiwan
DSLR, 24-70mm lens at 24mm, 1/30 f3.5, raw, ISO 400

Shopping probably doesn't leap to the top of most people's minds as riveting subject matter. However, shopping is a significant travel experience and shops and markets take up a lot of space. Plus, if you're a guy who doesn't like to shop, with a girl who does, (or vice versa of course!), you'll find plenty to do. In fact, the shopper will probably end up having to drag *you* away.

In large modern complexes, central public spaces are often architecturally interesting and good vantage points are numerous. Window displays and shop interiors are created to be eye-catching, some are almost works of art, and they certainly make good subjects, especially when the product for sale is photogenic. Unless you place your lens directly against the glass of a shop window, you'll usually require a polarising filter to cut down the distracting reflections.

Shop window displays are good subjects to photograph at night, assuming they are lit up. You won't have to explain yourself, but you will need a tripod, unless the lighting is bright enough to let you use an acceptable ISO sensor setting.

Be aware that in most modern shopping complexes you'll be approached very quickly by security people if you set up a tripod or spend too long with a professional-looking camera in one spot. They will not have the authority to give you permission to continue, so if you want to pursue the issue you'll end up in an office making an appointment to see the appropriate person. This is to be avoided at all costs and is another good reason to have your technical skills well sorted.

Shop interiors are often lit by a mix of light sources and using the available light often gives a pleasing result. If the light is too low to use your preferred sensor setting or film, you'll need to use a tripod, although they can be awkward in busy shops. Refrain from using a single flash as it destroys the ambience. To avoid these problems altogether, which is the recommended course of action, look for shops and displays that are well lit, especially those that have large windows, as the even light will allow you to capture the entire space while getting more detailed product shots quickly and easily.

It's common courtesy to seek permission to take pictures of window displays or shop interiors and it's certainly much easier to get the go-ahead in smaller, privately run businesses than it is in major-brand shops in modern shopping complexes. You can increase your chances of getting on-the-spot permission by buying something first, complimenting the staff on how fantastic the display is and making your request when the shop is quiet. Don't forget the possibility of creating an environmental portrait by asking the salesperson or owner if you can photograph them in their shop.

Art and craft for local and tourist consumption is usually available at the general market, but products aimed at tourists are hard to miss in popular destinations. Artisan markets have the added bonus that often you can photograph the craftspeople at work. Although pictures of the products themselves are relatively easy to take (they're stationary, in the same place every day and there's lots of choice), careful composition making the most of the graphic elements in the displays, and good lighting, will always set pictures, even simple ones, apart.

Waterfront market, Listvyanka, Russia

I always look to capture images of the souvenirs that are representative of the country. Matryoshka dolls are everywhere in Russia and the traders spend all day demonstrating just how many dolls can be made to fit inside the big doll. At the souvenir market on Lake Baikal's waterfront, I finally got the shot that I think captures the essence of the souvenir as a trader reveals one doll after the other.
35mm SLR, 24-70mm lens, 1/125 f5.6, Ektachrome E100VS

SPORTING EVENTS

Australian Rules football match, Melbourne, Australia

Taken from the second level of the stadium with a long telephoto lens, the high angle was put to good effect to create a more graphic sports image thanks to the uncluttered background and position of the players. Patience is a key factor as very little of the play will occur exactly where you want it to.

35mm SLR, 300mm lens, 1/400 f8, Ektachrome E100VS

Boxing in Thailand, sumo wrestling in Japan, baseball in the USA, cricket in India and football the world over, sport is an important part of the culture in many countries. Without accreditation, photographing big professional events is usually confined to the grandstands, so if you only have one opportunity to go to a game you'll have to make the most of the general access areas and the view from the seat you're given.

This will often give you plenty of variety anyway, particularly if you view the photo opportunities as going beyond the field of play. Going to the biggest game in town is a cultural as well as sporting experience, so you'll have plenty to do even if you can't get as close to the on-field action as you'd like. Look to capture crowd shots, spectator activity, traders selling sports paraphernalia and the stadium itself.

For more opportunities to shoot close-up action, go to less important or lower-grade games where access to the fence or boundary is much easier. You'll also get access to the boundary line, or even the playing arena, at cultural sporting events that are part of a festival program.

No matter what venue, to photograph the players in action you'll need a long telephoto lens, ideally around 300mm. Even so, on large fields you won't be able to photograph a lot of the play so wait until the action comes within range and shoot quickly – you'll only get a few chances during the course of the game. Select a sensor setting that allows a minimum shutter speed of 1/250 but ideally 1/500 to freeze the action.

(Right) Beach cricket, Anse La Raye, St Lucia
Local sport is just as much fun to watch and photograph as professional sport. A vantage point on the pier gave me the perfect view over the stumps for this beach cricket game; keeping me out of the way of the kids and my feet dry. The ball was bowled each time the sea retreated from the pitch (I think this is what you might call a truly sticky wicket). The action was fast and furious so a fast shutter speed was selected to freeze the ball the moment it was caught.
35mm SLR, 24-70mm lens, 1/250 f8, Ektachrome E100VS

(Opposite, right) Sumo wrestling, Nagoya, Japan
Flash would not have been appropriate at this event, even if I could get close enough to the ring for it to be effective. If events are broadcast on television, as the Sumo wrestling is, there's often sufficient light for still photography. Sports that are unique to the country you're in are well worth the effort to get to and photograph as the images offer just as strong an association with the country as the most famous architecture or landscape.
35mm SLR, 180mm lens, 1/250 f2.8, Kodachrome 200 rated at 400 ISO (one stop push)

NIGHTLIFE

There really is no peace for the travel photographer. Just as the sun has gone down and everyone else is going out to play you're preparing to take more pictures. From around 8pm every night you can try your hand at capturing the evening's entertainment.

Achieving good pictures in bars and nightclubs is hard work. Most venues are crowded and have low light levels. If you intend to take any more than one or two quick shots of your friends, you're best advised to seek permission from the manager. Venues with marketing departments generally need to be contacted in advance and will often refuse unless you've got a specific purpose that they approve of. Privately owned places very rarely say no and usually go out of their way to help, introducing you to the security guys and bar staff.

For the traveller, the easiest subject matter in these places is your friends. Don't just blast them with direct flash. Impress them with images that capture the unique aspect of the venue and the mood of the night. You'll best achieve this using the flash-blur technique (p189). If you're using a compact camera now is the time to switch to Night mode.

If you're hoping to photograph a live band you'll need to seek their permission. In smaller venues this is usually easily done about half an hour before they go on stage. Find out how long the set is so you can plan your shoot. Aim to get wide shots of the entire band, tight shots of individual singers and musicians and a general venue shot that captures the crowd and atmosphere.

Fast sensor speeds will let you use the ambient light – and the flash-blur technique or Night mode will create pictures with movement and individuality.

Keep your equipment simple. A small shoulder bag with one camera and your fastest wide-angle zoom or fixed wide-angle lens and flash unit is all you'll need. It makes working in crowded spaces more comfortable for you and the other patrons.

(Top) Patrons at Smoke House Grill, Delhi, India
DSLR, 24-70mm lens at 24mm, 1/8 f2.8, raw, ISO 200, flash

(Bottom) Pawn Shop Nightclub, Miami, USA
DSLR, 24-70mm lens at 43mm, 1/50 f2.8, raw, ISO 1250

Even in dimly lit nightclubs and bars there is usually enough light to take pictures without flash, but you'll find yourself setting the sensor between ISO 500 and 1000. I always seek permission from the manager to take pictures, either during the day or early in the evening before they get too busy. Otherwise I run the risk of being refused and having to spend my time looking for other venues when I should be taking pictures. In bars, the best opportunities are around the bar itself which is usually illuminated and often a distinctive feature of the establishment. Stages where the bands perform are usually brighter than the rest of the venue and getting up close to the musicians will let you take advantage of the spotlights and general stage lighting, allowing good results to be achieved even with compact and phone cameras.

(Top) Barman at Alhambra Lounge, Brisbane, Australia

DRangefinder, 21mm lens,1/2 f4, raw, ISO 640

(Bottom) Mark Hunter and band at Trak Nightclub, Melbourne, Australia

Camera Phone, 5 MP, 4mm lens, 1/17 f2.8, JPEG, ISO 320

FOOD & DRINK

Food and drink is high on the priority list of many a traveller. Given many of us spend a fair amount of time wondering and talking about where, when and what to eat and drink, why not take the time to photograph well what is dished up?

We tend to photograph our best and worst meals, or the ones served in the dodgiest or fanciest places. As for drinks, the larger or more unusually shaped glasses and the most colourful concoctions set shutters going, with extra frames dedicated to anything that's got a little umbrella stuck in it. What we eat and drink often rate right up there with our best (and worst) travel memories. That's because food and drink are an inherent cultural feature and trying the local cuisine is a must-do travel experience in many places.

Whether it's a Singapore Sling in the Long Bar at the Raffles Hotel in Singapore, a pint of Guinness in a traditional Irish pub, a margherita in Mexico, sushi in Japan, butter tea in Tibet, a plate of calamari accompanied by a glass, or two, of ouzo in Greece, a lamb on a spit served up in a yurt in Inner Mongolia or Peking duck in China (the list goes on and on), the national dish or drink is something worth seeking out to eat, drink and photograph.

Your coverage of food can be reserved to what is served up at your table or you can take the wide view and track its progress from the field, to the market, to the kitchen and to its presentation at your table in the restaurant or street stall.

(Opposite) Dessert buffet, Kuala Lumpur, Malaysia

Floor to ceiling windows provided perfect soft, even light to capture the detail and texture of the dessert table at a hotel's buffet lunch. The displays don't remain untouched for long in a buffet restaurant so you should check out the photographic possibilities at opening time and shoot before you eat.
DSLR, 24-70mm lens at 27mm, 1/30 f3.2, raw, ISO 400

○

INSPIRATIONAL BOOK:
TASTING INDIA,
CHRISTINE MANFIELD

(Left) Bottles displayed at bar, Bangkok, Thailand
DSLR, 24-70mm lens at 70mm, 1/50 f4, raw, ISO 1600

IN THE FIELD

Some crops are particularly attractive. Emerald green or golden yellow rice paddies, fields of yellow mustard, impressively tall sunflowers, orderly rows of grapes in vineyards, red and green chillies drying in the sun and the blanket of green of tea gardens, just to name a few. Travelling through rural areas at any time of year will give you plenty of access to the crop cycle. Photograph crops as you would any landscape, starting with the panoramic view, then moving in to highlight details, textures and colours. Unlike natural landscapes, the agricultural landscape is often alive with people, and opportunities are many to capture people at work. It's advisable, and courteous, to seek permission before entering someone's field, but often if you just hang around the periphery you'll be invited in.

Planting rice, picking tea and sorting potatoes are just some of the subjects you can photograph when you turn your attention to photographing food in the field. Getting close to the action is rarely a problem, but if the area is fenced it's best to seek permission before jumping over.

(Top) Planting rice, Banaue, Philippines
35mm SLR, 100mm lens, 1/125 f4, Ektachrome E100VS

(Middle) Picking tea leaves, Nuwara Eliya, Sri Lanka
35mm SLR, 24-70mm lens, 1/125 f4, Ektachrome E100VS

(Bottom) Sorting potatoes, Chinchero, Peru
35mm SLR, 24mm lens, 1/125 f8, Kodachrome 64

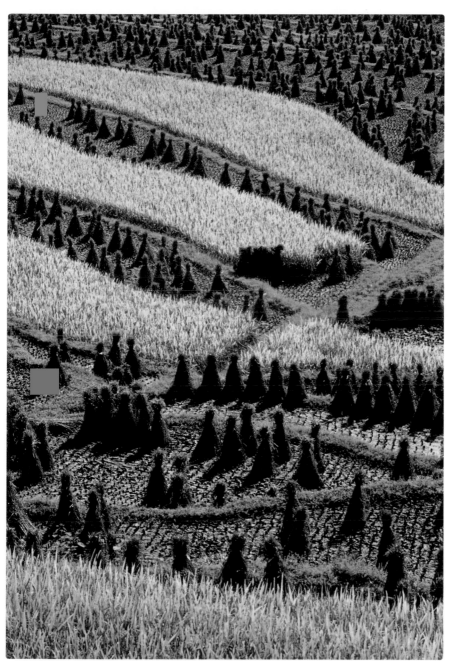

Bundles of rice straw, Nan Mu, China

Rice is probably the most photogenic crop. At harvest time in the fields between Guilin and Longshen the fields are dotted with bundles of rice straw standing amid ripened and ready to harvest rice. A telephoto lens and tight framing has created a graphic take on the scene.

35mm SLR, 100mm lens, 1/125 f8, Ektachrome E100VS

AT THE MARKET

INSPIRATIONAL BOOK:
BAZAAR, **DINESH KHANNA**

(Opposite, top left) Vegetables displayed on a stall at Rialto Market, Venice, Italy

DSLR, 24-70mm lens at 46mm, 1/125 f7.1, raw, ISO 400

(Opposite, top middle) Starfish displayed on a stall at Donghuamen Night Market. Beijing, China

DSLR, 24-70mm lens at 59mm, 1/125 f8, raw, ISO 400

(Opposite, top right) Ice-cream cones displayed on a market stall, Inthein, Myanmar

DSLR, 24-70mm lens at 46mm, 1/125 f7.1, raw, ISO 400

(Opposite, bottom) Men producing Kashmiri puris at market, India

DSLR 24-70mm lens at 24mm, 1/125 f4.5, raw, ISO 400

(Right) Vendors calling to customers at Dong-huamen Night Market, Beijing, China

Unless you're taking frame-filling portraits, photographs of the traders at markets work best if you capture them at work. When you're this close to the action it's best to gain permission to shoot and then wait until your subject's attention returns to serving the customer.

DSLR, 24-70mm lens at 70mm, 1/160 f3.5, raw, ISO 500

The way food is displayed at markets is close to being an art form. Fill the frame with a display of fruit, vegetables or grains to emphasise their colour and texture and the artistry of the stall owner. Try including several different items to show variety and add interest through contrasting shapes and colours. Whether the produce is displayed flat or stacked high try to keep the camera parallel with the produce to ensure sharp focus across the entire frame. You'll often have to lean right over the display, so watch for your own shadow.

Lighting can be difficult in markets. Careful observation of where the light is falling will prevent wasting time. Umbrellas or sheets of plastic cast heavy shadows so make sure the light is even across the entire composition. Concentrate on finding subjects that are either in full shade or full sun. Covered markets pose a particular problem. The light is low and often comes from fluorescent tubes. If you're using film your pictures will be a horrible blue-green unless you compensate with a colour correction filter. Digital photographers will again benefit from the white-balance function that corrects colour casts automatically or, for more accuracy, select the white-balance setting for the actual lighting you encounter. For film photographers, flash is one option or use fast film and search out areas where there is a mix of lighting. Better still, no matter how you're capturing your images; concentrate your efforts on the stalls near the entrances and around the edges of the market. These areas are usually the brightest and the quality of light is better.

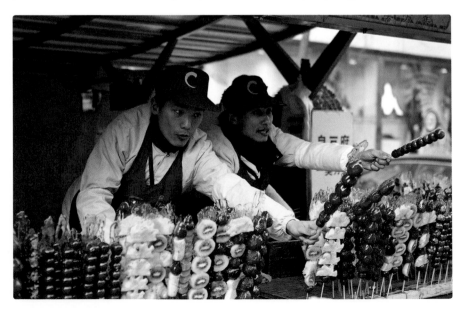

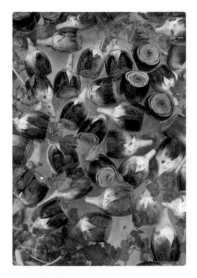
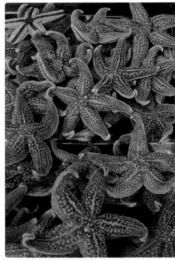

Markets are vibrant, colourful places offering a wealth of photo opportunities. Search out the most interesting stalls, especially those displaying food that is unique to the city or country. Wait nearby for the customers to come and go; you'll be less obvious and better placed to capture candid moments than if you dash from one stall to another as you see things happening. Photographing vegetables close up probably confirms the local people's suspicion that tourists are mad, but that's a small price to pay for the colour and interest food pictures add to the overall coverage of a destination.

IN THE KITCHEN

Seeing food being prepared and cooked is actually a lot easier than it sounds. Markets and street stalls are probably the most easily accessible of kitchens, but plenty of restaurants and small eating establishments have open kitchens facing the street. Resorts and hotels often cook themed buffets and BBQs in the open air. In all of these situations, you obviously need to keep out of the way, but a quick word with the chef should give you the freedom to photograph a wide shot of the kitchen with the cooks at work, an environmental portrait of the cook at work and tight shots of the food in the pans, on the hot plates or being served onto plates.

The most effective shots see everyone in the kitchen busy with their work, so if everything stops for you either indicate that they should go back to work, or wait a moment and their attention will soon return to the task at hand.

(Above) Making kibbeh and falafel, Amman, Jordan

The kitchen of this small family restaurant was facing the street behind a sliding glass window which when opened provided the ideal shooting position (very close but not in the way) and bathed the area in great light. It's much easier to get permission to open windows and spend time taking photos of the cook in action once you've taken a seat and placed an order.
DSLR, 24-105mm lens at 24mm, 1/80 f4, raw, ISO 400

(Opposite, top) Kitchen at Shilin Night Market, Taipei, Taiwan

Hundreds of small restaurants with open kitchens fill the expansive halls of the Shilin Night Market. Apart from the low light the main difficulty is being able to take up a position to shoot from, as the narrow aisles throng with customers. You just have to be prepared to get in the way for a few moments.
DSLR 24-70mm lens at 24mm, 1/60 f5.6, raw, ISO 500

(Opposite, bottom) Making dumplings, Shanghai, China

The glass-fronted kitchen facing a street in Yuyuan Bazaar provides the perfect opportunity to see and photograph an incredibly busy dumpling kitchen in action. With my lens right up against the glass I felt I was actually in the kitchen, but with a better view.
DSLR, 24-70mm lens at 24mm, 1/80 f2.8, raw, ISO 320

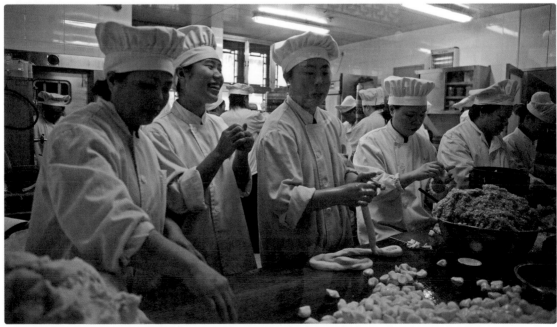

ON THE TABLE

Whenever you sit down to eat or drink at a street stall, café, bar or restaurant and place an order, a photo opportunity will soon be delivered to your table. To make the most of it look for an area of soft, even light. Choose a table by a window, or outdoors in open shade or under an umbrella if it's sunny. The best, on location, food and drink shots are taken with natural light. A camera flash will rarely make the food look appetising, so is best avoided. Glasses of liquid come alive with side or back lighting, which emphasises the colour and the little bubbles of a freshly poured fizzy drink. Use this technique when you're filling the frame with a full glass of your favourite tipple. Therefore, it's best to concentrate your photography efforts to daylight hours and capture the ambience of the restaurant or bar after dark.

Plan the shot before the food or drinks arrive. Is it to be a close-up of the plate of food or will it include cutlery and a glass of wine? Will you use the table itself as the background for the cocktails by looking down or shoot from a lower angle that will take in some background. Either way, clear the table of potentially distracting bits and pieces such as ashtrays, sunglasses, guidebook, map etc, unless they are to be deliberately included. If you intend to include some background or your dining companion you'll also have to consider the wider environment.

By now your order will be on its way and when hot food arrives sizzling or steaming you'll only have a few seconds to capture it and you're preplanning will pay off. The same goes for cakes and desserts. Take

too long and that perfect stack of ice cream or dollop of cream will melt away in front of your lens. The perfect head on a beer or the effervescing bubbles of sparkling wine don't give you long either. Plus, you'll want to consume your order while it's hot or cold, and even if you don't, your dining companions certainly will.

Outdoor restaurants and food markets offer the best opportunities to photograph people enjoying the dining experience. People rarely look dignified with mouth wide open about to consume a fork full of food, so shoot when they are selecting the food on their plate.

Restaurants and bars are often very attractive places so a wide shot is a good scene-setter for your frame-filling food and drink shots. The easiest way is to take a seat in the corner or at the end of a row of tables. A seat at the bar will let you photograph the staff pouring and making drinks, as well as the often attractive displays of bottles behind the bar. Taking pictures as a paying customer is generally a

lot easier than just walking in taking photos. There aren't that many opportunities to drink while you're taking pictures so take advantage of them when you can.

Food centre, Shanghai, China
Food courts or food centres like this one at Hui Jin department store are always worth checking out as they are far less formal than cafés and restaurants. The large ones are usually so busy at meal times that no one takes any notice of you hanging over 2nd-floor railings or wandering around looking for the best take on the scene.
DSLR, 24-70mm lens at 55mm, 1/60 f2.8, raw, ISO 400

I don't just check the menu when deciding where to eat; I check the ambience and decor, the availability of a table or seat in the right position, the quality and level of the light and the other customers. If everything is satisfactory then I'll order. It can sometimes take ages to get something to eat!

(Opposite, left) Burmese lunch, Inle Lake, Myanmar
DSLR 24-70mm lens at 45mm, 1/125 f5.6, raw, ISO 400

(Opposite, middle) Seafood display at restaurant, Paris, France
DSLR, 24-70mm lens at 42mm, 1/80 f4, raw, ISO 400

(Opposite, right) Italian lunch, Rome, Italy
DSLR, 24-70mm lens at 32mm, 1/125 f4.5, raw, ISO 200

WILDLIFE

Even though wildlife photography really is a specialist area, to which some photographers dedicate their lives, it is a subject matter that is often encountered by the traveller. It's also a subject that is renowned for low rates of success and high rates of disappointment.

Photographing animals requires an abundance of patience, time and, for the traveller, luck. Animals aren't renowned for their cooperation and you'll have to work hard to build a collection of recognisable, interesting and varied photos. Wildlife photographers increase their chances of success, and thereby increase their 'luck', through meticulous research and

planning, and a deep knowledge of wildlife behaviour and habitat. For the rest of us we need to accept that we are not going to see every animal and certainly not going to see it in action or in the best light on our occasional forays into wildlife photography. However, good results are possible by bringing our general photographic skills and technique to the subject, by understanding the limitations of our equipment and of course, by practicing. Wildlife encounters are often very short, and they are a good test of how well you're going in bringing your technical and creative skills together.

Seeing animals in the wild is pretty special, but it's no excuse for forgetting

(Opposite) Orang-utan at Semenggoh Wildlife Rehabilitation Centre, Kuching, Malaysia

Twice a day the orang-utans at the Semenggoh Wildlife Rehabilitation Centre appear at the feeding site where they're greeted by enough cameras to open a small shop. Even though they appear close and can hang around for an hour or so, the only chance of getting decent shots is with powerful telephoto lenses or zooms. It might be a sanctuary but they are still wild animals so quick and accurate focusing, metering and composition is required. The low light also means high sensor settings to keep the shutter speed up to prevent blur from subject movement and camera shake.
DSLR, 300mm lens, 1/400 f4, raw, ISO 2000

(Left) Indian Peafowl, Ranthambore National Park, India

DSLR, 300mm lens with 1.4x teleconvertor, 1/200 f5.6, raw, ISO 640

299

Gharial crocodile, Kasara, Nepal

Watching the crocodiles appearing from under the water in their breeding tanks I was taken with the concentric circles of water they created. I searched out the largest area of water and followed individuals as they swam until one eventually surfaced in the right spot.

35mm SLR, 70-200mm lens, 1/250 f5.6, Ektachrome E100VS

everything you've learned about good photography. The first challenge is to get close enough. You might know it's an elephant, but if you have to tell the person looking at the photo what it is, consider the image a failure. It's also important to select a viewpoint that considers the direction of the light and the background, just as with any subject, although this may not always be possible without missing the moment. Shoot first, and if you've got time improve your position for a second attempt. Always focus on the eyes; everything else can be out of focus but if the eyes are not sharp the photograph will fail. Because the focusing screen is in the centre of the frame, consider recomposing after focusing on the eyes to avoid the central, and often static, placement of the subject in all your pictures.

Some wildlife photography is possible with compact cameras with typical zoom lenses such as 38–90mm or DSLRs with standard zooms such as 28–105mm. In many national parks, particularly around camp grounds, some animals are quite used to human presence and will allow you to get close enough. In the wild the limitations

INSPIRATIONAL BOOK: *MIGRATIONS*, **ART WOLFE**

of such equipment can make for a frustrating experience, except in one or two special places such as the Galápagos (see p312) and Antarctica (see p314). The eye will zoom in on distant animals and exaggerate their size, but they will be insignificant on the sensor. To avoid disappointment concentrate your efforts on animals that you can get close to and compositions that show the animal in its habitat.

For wild animals a focal-length lens of 300mm is generally considered essential. The magnification is strong enough to satisfactorily photograph the majority of animals and will allow frame-filling portraits of those you can get close to. If wildlife photography is a part of your travel plans and your longest lens (fixed or zoom) is less than 300mm, consider purchasing a teleconverter, which will give you many more opportunities without the expense and weight of another lens. If you have a 300mm already, a teleconverter will open up a whole new range of opportunities (see p56).

Even if you're travelling independently, joining a tour to see the local wildlife is an option worth considering, and often it's mandatory. You'll benefit from having a knowledgeable guide or naturalist who will point out the animals and direct the vehicle, boat or elephant to areas of recent sightings.

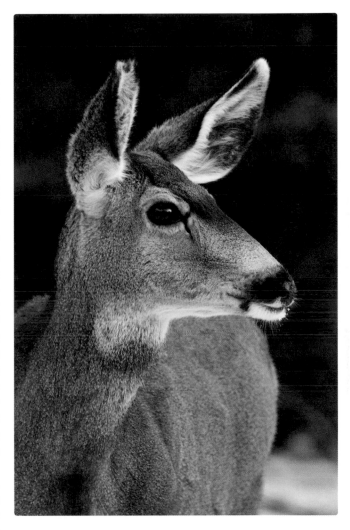

Deer, Grand Canyon National Park, USA

This image has all the elements I aim for in a portrait. An interesting face, a natural pose, a natural expression, eye contact, no distracting elements and a background that complements the colours of the subject. Even if you haven't had much experience photographing wildlife, you can use all your people-portrait skills to successfully photograph our friends in the animal kingdom.

DSLR 70-200mm lens at 200mm, 1/250 f3.5, raw, ISO 500

ZOOS & SANCTUARIES

Zoos and wildlife sanctuaries give you access to wildlife that you may never see or get close to in the wild. They are also great places to practice and prepare for photographing animals in the wild. Spend a day at your local zoo or wildlife park before heading off on safari and you'll soon discover the limitations of your equipment, how close you need to get to animals large and small and just how much patience and speed of technique you'll need to make strong pictures. Just as in the wild, captive animals are not generally active in the middle of the day. You'll find them most active in the mornings and 30 minutes before feeding times.

When the animals are in cages it's still possible to eliminate signs of captivity by eliminating cage wire from your shot.

Place your lens against the cage, if you can get that close, and select the widest aperture available (f2.8 or f4). This technique works best with a telephoto lens and if the animal is at least 2m from the cage. Chances of success are increased if the cage wire is in shade, not in direct sun. With compact cameras remember that what you see through the viewfinder is not what the lens sees so compose with the LCD screen and position the lens in an opening in the cage wire.

Some zoos have glass enclosures which are great for photography. Place your lens, or better still the lens hood, against the glass to cut down reflections and you'd never know you weren't in the wild. Compact camera users should also turn off their flash.

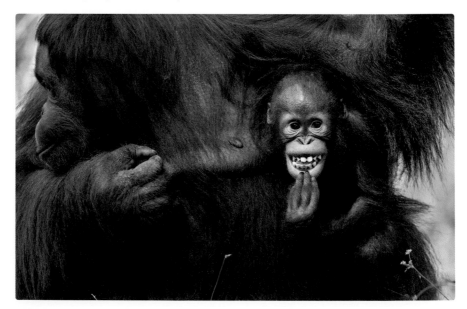

(Right) Orang-utan at
Semenggoh Wildlife
Rehabilitation Centre,
Kuching, Malaysia
DSLR, 300mm lens, 1/400 f4,
raw, ISO 2000

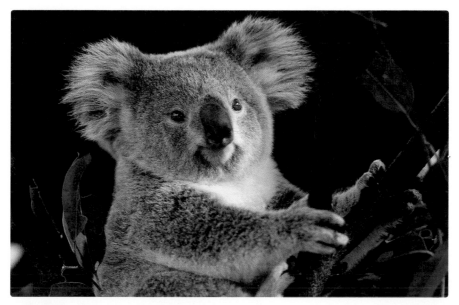

(Below) Elephants at Pinnewala Elephant Orphanage, Sri Lanka

When the herd of elephants from the Pinnewala Orphanage is bathing, there is plenty of action, especially in the first 30 minutes after they arrive at the river. Look for action that is repeated by individuals and the herd generally, like the affection shown when two of them get together, which gives you the opportunity to fine-tune your composition and predict the perfect moment to hit the shutter.

35mm SLR, 70-200mm lens, 1/250 f5.6, Ektachrome E100VS

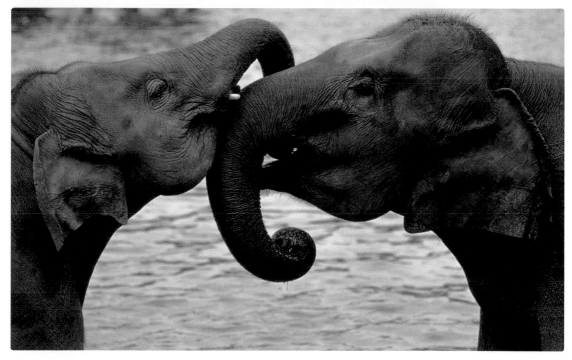

UP CLOSE

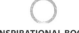

INSPIRATIONAL BOOK:
EYE TO EYE: INTIMATE
ENCOUNTERS WITH
THE ANIMAL WORLD,
FRANS LANTING

(Opposite, top left)
Marsh mugger crocodile,
Kasara, Nepal
35mm SLR, 70-200mm lens,
1/250 f11, Ektachrome E100VS

(Opposite, top right)
Brown pelican feathers,
South Plaza Island,
Galápagos, Ecuador
35mm SLR, 180mm lens,
1/1250 f8, Ektachrome E100VS

(Opposite, middle right)
Peacock feathers,
Melbourne, Australia
35mm SLR, 180mm lens,
1/1250 f5.6, Ektachrome
E100VS

(Opposite, bottom right)
Zebra skin detail,
Durban, South Africa
35mm SLR, 100mm lens, 1/125
f11, Ektachrome E100VS

(Opposite, bottom left)
Detail of turtle shell at
Crocodylus Park,
Darwin, Australia
35mm SLR, 70-200mm lens,
1/160 f8, Ektachrome E100VS

(Right) Pelican, Monkey
Mia National Park,
Australia
The pelican's eyes were
closed when I composed
the shot so I was able to
catch the brief moment
she opened them to check
on proceedings.
35mm SLR, 70-200mm lens,
1/250 f7.1, Ektachrome E100VS

Use all your people photography skills to capture frame filling portraits of the animals you can get close to. As with taking portraits of people, short telephoto lenses from 85mm to 135mm give the most pleasing perspective, although you'll probably find you need your longest lenses for many subjects, particularly if they are in the wild.

If you can get really, really close, try filling the frame with the beautiful fur, skin or feathers of your subject to create striking, abstract type images. The patterns, textures and colours will give diversity to your wildlife collection.

Unlike natural and urban details you'll need to compose and shoot quickly as it's unlikely your subject will remain still for long. For the same reason, select faster shutter speeds (1/125 or higher to prevent unwanted blur from subject movement).

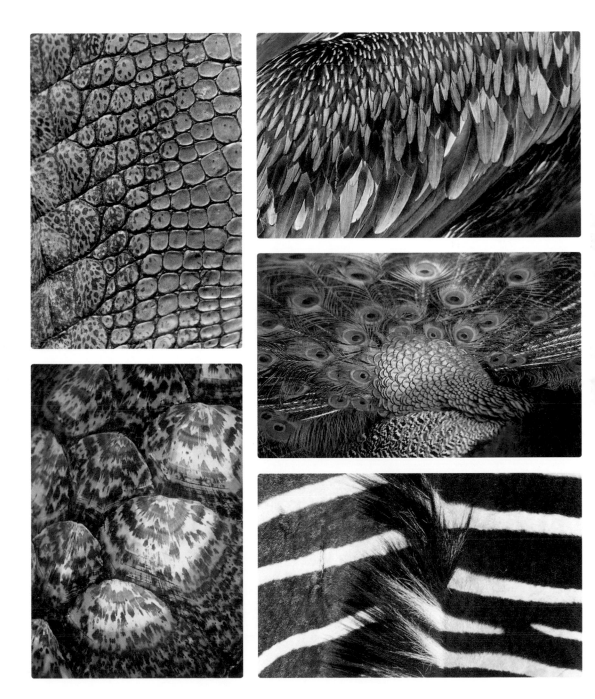

HABITAT

Your search for animals in the wild will often take you to some extraordinary environments, so use a combination of your environmental portrait and landscape photography techniques to create images that show wildlife in its natural habitat. You'll add to the impression of wilderness if the animal is not looking at the camera. Compose the shot so that the subject is looking or walking into the frame rather than out of it. Check the background to ensure the subject is not lost by blending in and that it does not contain distracting patches of colour or bright spots.

If you don't have long lenses, look for situations that show the animals in their habitat. These pictures will be particularly pleasing when the animal hasn't been alerted to your presence.

(Top) Spotted deer drinking from Padam Lake, Ranthambhore National Park, India

35mm SLR, 300mm lens, 1/250 f8, Ektachrome E100VS

(Bottom) Asiatic one-horned rhinoceros, Kaziranga National Park, India

DSLR 70-200mm lens at 200mm, 1/125 f5, raw, ISO 400

(Opposite) Tiger, Ranthamhore National Park, India

DSLR 70-200mm lens at 200mm, 1/250 f5, raw, ISO 400

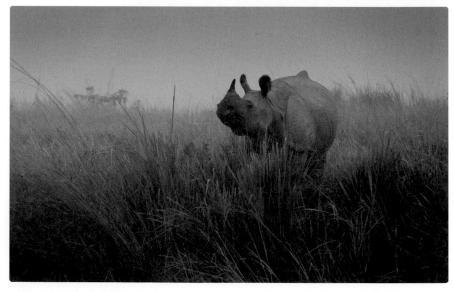

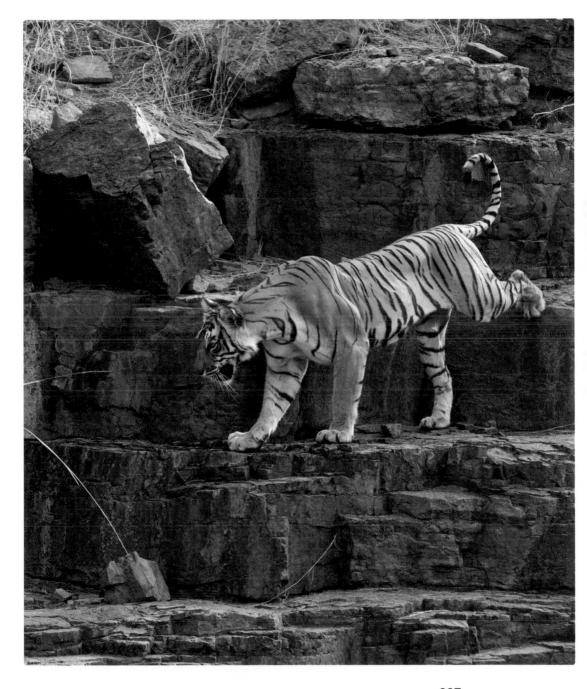

ON SAFARI

The game parks of Africa are quite rightly the best known destinations for wildlife safaris. The access they provide to an incredibly diverse range of creatures justifiably gives them legitimate 'photographer's paradise' status. No matter where you are, a trip in search of wildlife is a safari, and they are always exciting and challenging for the photographer. You'll find yourself shooting through the open window of a car, from the back of open-top jeeps and trucks, from boats, rubber dinghies, hot-air balloons and atop elephants, sharing the experience with one, two or 20 people. You'll also find yourself holding the camera to your eye for much longer periods than normal as you observe the animals and wait for the perfect moment. This can be very tiring.

Animals are at their most active early in the morning and late in the day so you'll be up and about before sunrise. At both ends of the day the low light will require high sensor settings or film speeds to ensure you are working with appropriate

Cheetah, Mokolodi Nature Reserve, Botswana
35mm SLR, 350mm lens, 1/1000 f8, Ektachrome E100VS

shutter speeds to prevent both camera shake and blurring if the animal moves. If you're using zoom lenses at their maximum focal length, say 210mm or 300mm, you'll need to use shutter speeds of at least 1/250 and 1/300 respectively. Adjust your sensor's ISO setting with the changing conditions, decreasing the speed as the day brightens up. Film users may find it's best to select 400 ISO film first thing in the morning, then switch to your standard film as soon as it's bright enough.

Most wildlife viewing is experienced in national parks from motor vehicles, which you're prohibited to leave. The vehicle window makes an excellent support in conjunction with a small bean bag and can be moved up and down to suit your height. In vehicles with pop-up tops, rest your camera on the roof while following the action. Use a piece of clothing or a camera bag to rest the camera on. If you've got particularly large, heavy lenses consider supporting your camera on a monopod, which is quite easy to use even if sharing a vehicle with others. Turn the engine off to stop unnecessary vibrations

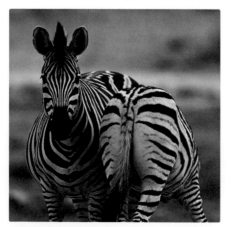

Pair of Zebra, Moremi Wildlife Reserve, Botswana

35mm SLR, 350mm lens, 1/500 f4, Ektachrome E100VS

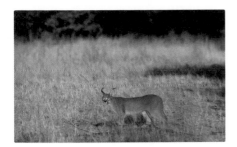

Caracal, Moremi Wildlife Reserve, Botswana
35mm SLR, 350mm lens, 1/500 f5.6, Ektachrome E100VS

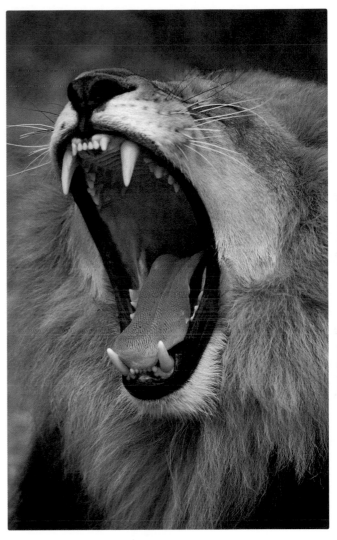

and noise. Be constantly aware of the direction of the light so that you can position the vehicle quickly or give directions as to where you want to shoot from. This is much easier to achieve if you're driving your own vehicle. As already suggested it's better to get some shots in before finessing your point of view, just in case the animal departs the scene. You'll soon learn how close you can get to a particular animal before it moves off and this will allow you to select the right lens, or set your zoom at the appropriate focal length, before you approach the animal.

The degree of difficulty steps up a notch when your safari involves shooting from small boats or the back of a lumbering elephant. Not only is the wildlife moving but so are you. Getting into position and stopping on demand takes longer than in a motor vehicle, so you'll have no choice but to shoot while on the move. The fast shutter speeds you usually employ when using long lenses may not be quite enough in these situations depending on how much movement you're experiencing. Ideally, aim for 1/500 and try and shoot at the apex of the movement.

Lion, Moremi Wildlife Reserve, Botswana
After six weeks and 16 wildlife parks in southern Africa, it became clear that just seeing the animals could be a challenge. It wasn't until the twelfth park that I finally got to photograph lions, and then they were everywhere – well, all within 500m of where I had to get out of my vehicle to dig it out of the deep sand it had got stuck in.
35mm SLR, 350mm lens, 1/1000 f5.6, Ektachrome E100VS

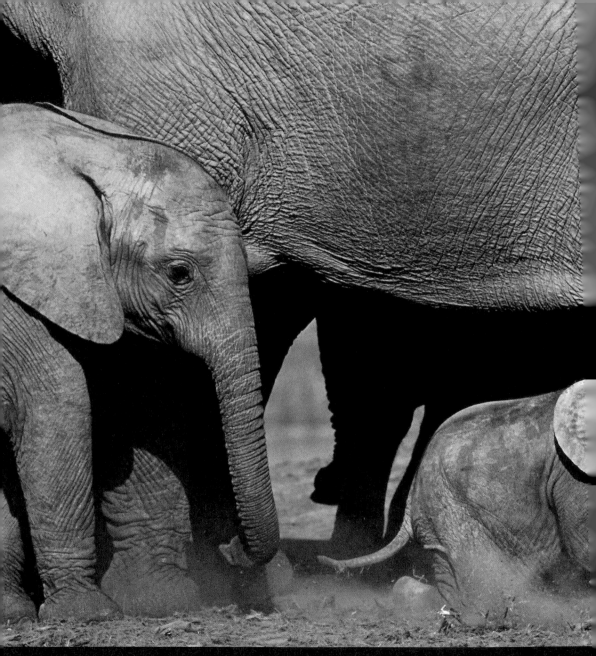

ELEPHANTS AT WATERHOLE,
ADDO ELEPHANT NATIONAL PARK,
SOUTH AFRICA

When I pulled up at the waterhole there were half a dozen elephants drinking, and I thought that was pretty good. Then out of the bush came herd after herd, until I counted 160 elephants. (That's right, I actually had time to get my shots *and* count the elephants.) Sometimes things just fall into place. It's hard to imagine coming

35mm SLR, 350mm lens with 1.4x teleconvertor, 1/500 f8, Ektachrome100VS

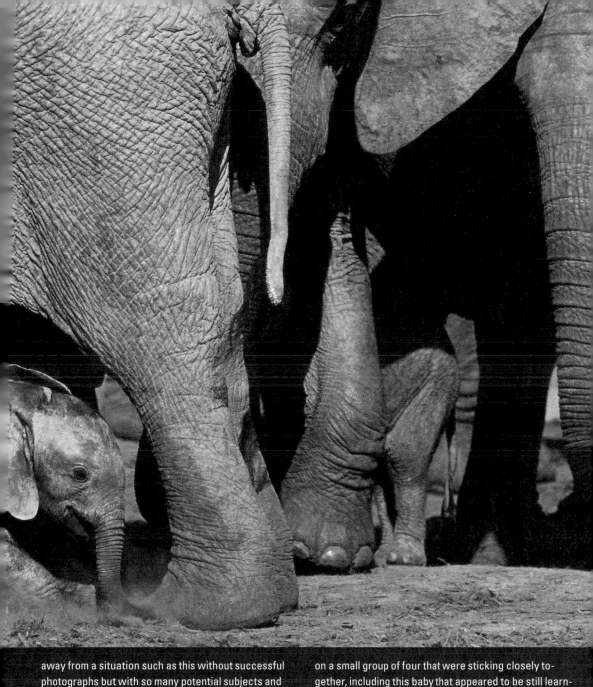

away from a situation such as this without successful photographs but with so many potential subjects and compositional options it's easy to fall into the trap of thinking the subject will do the work for you. I took plenty of wide shots to capture as many elephants as possible in the one frame, but I concentrated most of my efforts on a small group of four that were sticking closely together, including this baby that appeared to be still learning to walk. There was enough time to check that other, better options weren't developing among the herd, but in the end the smaller group provided a series of images with a stronger point of interest than the wide shots.

THE GALÁPAGOS

The Galápagos Islands, straddling the equator, 1000km off the coast of Ecuador, offer unique wildlife photography opportunities. It's true that in some places you have to be careful not to step on the animals.

There are 16 islands in the Galápagos archipelago and only three have human settlements. To see the wildlife you must join a tour group and sail from island to island. You sleep and eat on the boat and use small boats or rubber Zodiacs to access the visitor sites on each island. Typically, you'll go ashore at two different visitor sites a day (one in the morning and one in the afternoon). Snorkelling is also a daily activity. The ship sails between sites and islands in the middle of the day and during the night. This program means a lot of visitor sites are covered in a week and you see a great variety of wildlife. There is also plenty to challenge the photographer.

The Galápagos is a harsh environment for camera equipment. It's always hot, often humid and the heat from the sun can be intense when on land. You'll be on or near the sea all the time and spend a lot of time on beaches. There is little or no shelter at most visitor sites. Keeping your gear cool, dry and sand free is a real challenge. Once you leave the ship for a visitor site you can't go back and forth, so everything you anticipate needing has to be carried. A large, strong rubbish bag is useful for placing your

Great blue heron, Isla Santa Cruz, Galápagos, Ecuador

The Galápagos really is an exception to the rule that states long lenses are needed to photograph birds. You won't capture close-ups like this of all the birds if you don't have a 400mm or 500mm lens, but you'll still find plenty to photograph within the range of a 200mm lens.
35mm SLR, 70-200mm lens, 1/250 f4, Ektachrome E100VS

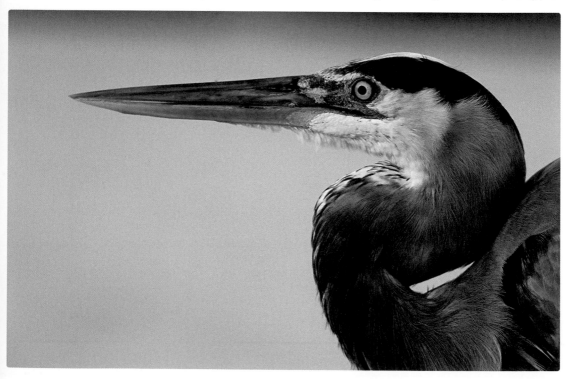

entire camera bag in while you're swimming and snorkelling from the beach. For compact camera users this is the perfect environment to take a weatherproof camera. Flash isn't allowed, so make sure you can turn yours off.

Most wildlife viewing is on foot (as opposed to vehicle-based viewing in most wildlife parks), which is great for finding the perfect viewpoint. But also be prepared for viewing wildlife from the small landing boats (on sometimes rocky seas), which is a real test of technical and creative techniques. Either way, you'll find you have to work quite fast. One to two hours is allowed at each site but the tour leaders keep the groups moving to stay on schedule for meals or sailing times and you're not allowed to wander off on your own. Consequently, you'll rarely have more than a few minutes to spend on any one subject. A dedicated photo tour may be worth investigating if photography is

the reason you're going to the Galápagos.

Because you can get close to a lot of wildlife, lenses that cover the 100mm to 200mm focal-length range will allow you to capture good close-ups of many of the

Galápagos land iguana, South Plaza Island, Galápagos, Ecuador
After the thrill of first encounters, don't forget that good composition and lighting are as important for wildlife as for other subjects. Iguanas are just about everywhere, but it took a concerted effort to find one as well situated as this, with the light coming from the right direction and a nondistractive background.
35mm SLR, 180mm lens, 1/250 f8, Ektachrome E100VS

INSPIRATIONAL BOOK:
GALÁPAGOS: ISLANDS BORN OF FIRE, **TUI DE ROY**

Galápagos sea lion, Isla Espanola, Galápagos, Ecuador
Animals in the Galápagos will allow close human presence, so take the opportunity to try different compositions that complement the more traditional choice of showing the whole animal.
35mm SLR, 180mm lens, 1/250 f5.6, Ektachrome E100VS

animals. However, you'll still find plenty of situations where the animals are too far off the track (and you can't leave the track), too high in a tree, too small, or all of the above, to take satisfactory images. The 300mm-plus lenses recommended for wildlife and the 500mm-plus lenses recommended for birds are just as necessary in the Galápagos. Additionally, because snorkelling is a daily activity, an underwater camera or housing is worth considering.

ANTARCTICA

Antarctica is another brilliant wildlife hotspot for those of us who aren't specialist wildlife photographers. Like the Galápagos, most wildlife viewing is on foot and you can get very close to the locals. The routine is also similar. Ship-based cruising with two daily shore excursions to controlled visitor sites using rubber Zodiacs. Apart from the dramatic difference in landscapes, the main variation is you'll be very cold, instead of too hot. Plus, you won't go snorkelling.

The most common subject is penguins, followed by seals, sea birds and if you're lucky, whales. Exposures are made tricky by the expansive white background you'll have in nearly every composition. The fact that many of the birds are also white makes life really interesting. In these white-on-white situations overexpose by up to one stop (see p230 for more information on shooting in snow).

Believe it or not, you'll soon get tired of penguins standing around perfectly posed for their photo. That's when you need to start looking for them on the move, jumping into the sea and squabbling over stones for building their nests. At the rookeries, which are very busy places, take the time to find a nest with a neutral background to highlight the individual or pair of penguins.

Gentoo chicks, Wiencke Island, Antarctica
Even though you can get close to the wildlife there are, of course, restrictions. Which is why a 300mm lens is still required to capture the chicks trying to make themselves heard.
35mm SLR, 300mm lens, 1/250 f5.6, Ektachrome E100VS

Gentoo penguin, Danco Island, Antarctica

After the busyness of the rookeries, I searched out a position where I could create a very simple composition with the sky as a background focusing on just one penguin demonstrating the classic penguin walk.

35mm SLR, 300mm lens, 1/500 f11, Ektachrome E100VS

Elephant seal pup, Greenwich Island, Antarctica

Elephant seals don't give you a lot to work with after they haul themselves onto the beach, so when the pup finally decided to express himself I was glad I'd waited for just such a moment.

35mm SLR, 70-200mm lens, 1/250 f5.6, Ektachrome E100VS

315

BIRDS

--

Birds make fascinating and very, very challenging photographic subjects. They are even harder to photograph than other animals. They're mostly small, rest high up in trees, fly off at the slightest disturbance and rarely sit still for very long. They will put your patience and technique through the most rigorous test. A 300mm lens is adequate for larger birds, but, except for some rare exceptions, to have any hope of filling the frame you really need a focal length of 500mm or 600mm. On the up side, you'll find birds anywhere in the world. A quick introduction to the trials and tribulations of bird photography is available in your own garden or at local parks. Some time practicing locally will give you a realist sense of what you'll be able to achieve in the wild.

To emphasise the shape of the bird and the colour of its feathers pay careful attention to the background so that it doesn't get lost in a jumble of branches, twigs and foliage.

BIRDS TAKING OFF

Again you have a couple of creative choices to make as to how you want to capture birds taking off. You can either take a series of shots as it flies across the frame or follow it by panning. Either way set the autofocus to Servo mode and compose your shot so that the bird is on one side of the frame, so that it has space to fly into. You probably can't be 100% sure of the speed and direction of the bird as it takes off, so don't compose too tightly or you may cut off its wings.

Indian Pi, Ranthambhore National Park, India
Unless you're very well equipped and dedicated, photographing birds can be very frustrating. There are a few exceptions including the Indian Pi which you can easily photograph with a typical zoom on a compact camera.
35mm SLR, 70-200mm lens, 1/250 f8, Ektachrome E100VS

BIRDS LANDING

According to the experts capturing birds landing is the easiest of all flight shots. With the autofocus set to Servo (Predictive, p162) and a fast shutter speed selected, follow the bird as it comes in to land. Start shooting when you see its feet fully outstretched as it is about to touch down. You should be able to record a sequence of two or three frames, and one should give you the perfect combination of body and wing position.

(Top) Blue-footed booby, Isla Baltra, Galápagos, Ecuador
35mm SLR, 300mm lens, 1/500 f8, Ektachrome E100VS

(Bottom) Kelp gull at Andvord Bay, Neko Harbour, Antarctica
35mm SLR, 300mm lens, 1/500 f5.6, Ektachrome E100VS

BIRDS IN FLIGHT

It's one thing to capture a bird resting on a branch, quite another to capture it in flight. But flying is what birds do best, it's what distinguishes them from ground-dwelling species and so capturing birds in flight is fundamental to bird photography.

Swallow-tailed gull, South Plaza Island, Galápagos, Ecuador

35mm SLR, 300mm lens, 1/500 f8, Ektachrome E100VS

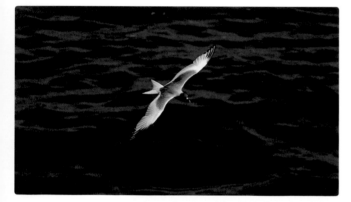

Take up a position and follow your chosen bird as it flies in your vicinity, waiting for it to come into the range of your chosen focal length. Use your camera's Servo or Predictive focus mode (p162) to keep the subject sharp. You will mostly find yourself panning, as opposed to having the bird flying directly towards you. You have the choice of selecting a fast shutter speed (1/500 or higher) to stop the movement for a crisp image or use slower shutter speeds, such as 1/15 or 1/30, to blur the background and the motion of the bird's wings. The sky makes a perfect backdrop, but only if it's blue, as does the sea, both offering large areas of solid colour (without distracting elements) against which the bird will stand out.

Kelp gull at Andvord Bay, Neko Harbour, Antarctica

35mm SLR, 300mm lens, 1/500 f8, Ektachrome E100VS

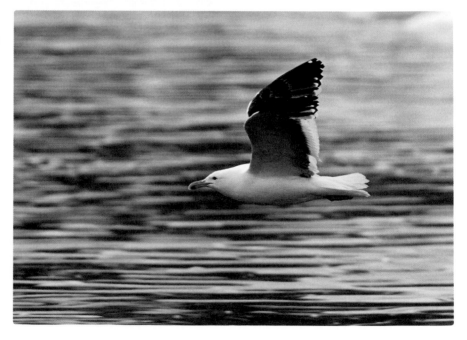

Magnificent frigatebird,
Isla San Salvador, Galá-
pagos, Ecuador

35mm SLR, 70-200mm lens,
1/500 f8, Ektachrome E100VS

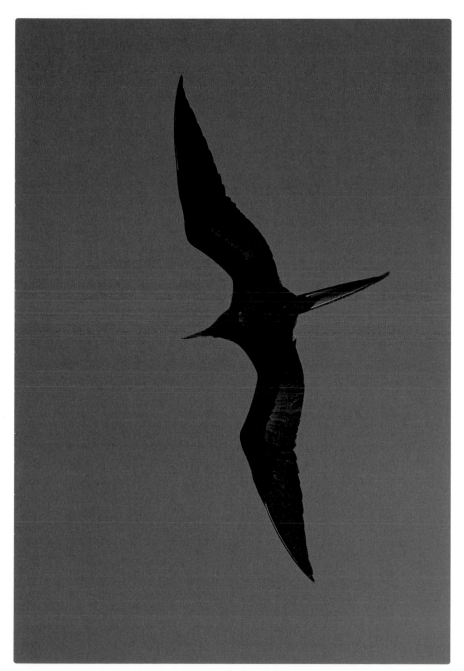

MARINE LIFE

Whale off Hervey Bay, Australia
The whale-watching boats get you pretty close but your longest focal lengths will usually be required to capture any action the whales provide.
35mm SLR, 300mm lens, 1/500 f8, Ektachrome E100VS

You can photograph some marine life from land or boat, such as whales breaching, dolphins surfing a boat's bow or leaping out of the water, but really, you're going to have to get wet at some point. Like wildlife photography, underwater photography is a specialist area that requires the photographer to add dedicated equipment, such as Nikonos cameras or underwater housings for conventional cameras, macro lenses, sports finders, bulky flash equipment, a deep knowledge of marine life and environments and diving skills to their repertoire. However, we can all get our feet wet, so to speak, and experience the colour and beauty of the underwater world by starting off with snorkelling and the simplest of underwater equipment options.

Underwater housings are available for all DSLRs and many compact digital cameras. You can expect to get excellent to acceptable results on sunny, calm days at depths of 2m to 3m, using the natural light. Water acts as a filter on sunlight, reducing its intensity and changing its colour. The deeper you go the more light is absorbed and the bluer your pictures will become. Colours should record naturally down to 2m or 3m. The auto white balance will usually do a good job compensating for the changes, but many cameras have an Underwater Scene mode; if yours does, use it.

In deeper water a flash is essential not only to capture accurate colours but to actually provide the light to record the marine life. To increase the number of successful shots without diving and underwater photography experience, aim to:

○ Shoot in the middle of the day, between 10am and 2pm, when the sun is at its brightest and the maximum amount of sunlight penetrates the water.

○ Look for subjects in shallow areas.

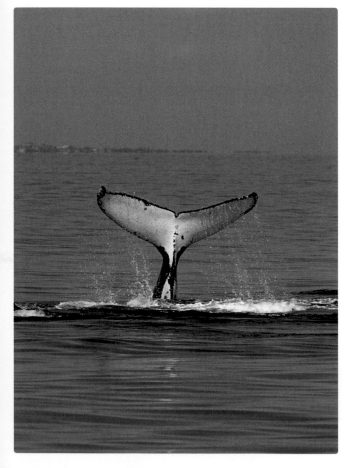

- Get as close as you can to your subjects. Colours will be stronger, contrast higher and pictures sharper if you keep subjects within 3m or 4m.
- Adjust the sensor's ISO rating to allow shutter speeds of 1/250 or higher to prevent subject movement.
- Rinse your underwater housing or camera in fresh water as soon as possible when back on the boat or dry land.

At some dive destinations, gear shops and dive-boat operators hire out underwater camera equipment and offer photography advice and lessons. If you're keen to progress your underwater photography skills these are great options to get your hands on professional gear without the expense of buying it.

 INSPIRATIONAL BOOK: *WATER LIGHT TIME*, **DAVID DOUBILET**

Snorkelling provides the traveller with an accessible window into the world of underwater photography. I don't shoot underwater regularly, but when you're somewhere such as the Great Barrier Reef or Galápagos, it's hard to resist. Be patient – let the seals, turtles and fish come to you and you'll get much better results than chasing them around.

(Top) Galápagos sea lion, Isla San Salvador, Galápagos, Ecuador

35mm underwater rangefinder, 35mm lens, 1/250 f11, Ektachrome E100VS rated at 200 ISO (one-stop push)

(Middle) Turtle at Moore Reef, Great Barrier Reef, Australia

35mm underwater rangefinder, 35mm lens, 1/250 f11, Ektachrome E100VS

(Bottom) Fish at Moore Reef, Great Barrier Reef, Australia

35mm underwater rangefinder, 35mm lens, 1/125 f5.6, Ektachrome E100VS

04: BACK AT HOME

The trip is over, you're back at home and the proud owner of lots of new photos. How you captured your photos and what you intend to do with them determines how you'll manage your pictures to ensure they are safe, easy to find and look their best. You'll then be ready to share them with others. If you think your photographs are good enough and could earn you some money, you can delve into the world of professional photography and image licensing.

POST-CAPTURE WORKFLOW

Digital photography is brilliant and everyone agrees that being able to shoot to your heart's content, unrestricted by film and processing costs, is one of its greatest attractions. But, there is a cost. Unless you've followed the computer-free workflow (see p93) and are content with the digital files straight from the camera and the prints produced by the photo lab, then you need to come to grips with the world of digital asset management, or DAM, and you need to do it sooner rather than later. Put simply, you must have an easy, systematic, efficient and fast way of moving your image files from your camera to the computer, reviewing and assessing them, editing, storing and keeping track of them. Get this right and you'll enjoy some of the other benefits of the digital workflow, including having complete control over how your pictures look, and easily sharing your images with the world. It will also save you lots of time.

Remember, there is more than one way to manage and work with images. Your choice of software and degree of interest in the process are key factors in the system you develop. For everyone, the aim is to develop a routine to manage your images in a way that works for you so that you do it, rather than putting it off. To get started you can follow the workflow outlined here or just perform the tasks that suit you. Refer to the section on Computers, p93, for information on hardware, software and technical jargon.

CRITIQUING YOUR IMAGES

The assessing and selection process is also an excellent time for reflection and self-teaching. Your best pictures and worst failures will stand out clearly. Study them to see what you did wrong and what you did right. Before you discard an image file, check the EXIF data and see if you can learn anything as to why the image didn't work out as you'd expected. If you haven't got time at this point, save them in a folder for review at a later date. Look for patterns. Are all your best pictures taken on a tripod? Are all the out-of-focus frames taken with the zoom at its maximum focal length? Next time you can eliminate the cause of your failures and concentrate on the things that worked. Your percentage of acceptable pictures will start to rise. Self-critique is an important and neverending process in the life of a photographer.

(Opposite) Effigy burning at Dusshera Festival, Kota, India
DSLR 24-70mm lens at 32mm, 1/2 f11, raw, ISO 100, tripod

TRANSFER

The first step is to transfer your images from the camera's memory card to your computer. This process is also called importing, copying, acquiring, ingesting or downloading. All digital cameras have a socket for connecting, or interfacing, the camera directly into a computer or portable storage device. If you own a computer, ensure that it has ports compatible with the camera's cable. Most use fast Universal Serial Bus (USB2.0) cables. Some professional DSLRs and a few advanced compacts use fast FireWire (IEEE 1394) connection cables.

Images can be transferred to a computer by connecting the camera directly to the computer with a USB or FireWire cable that is supplied with the camera. Alternatively, images can be transferred via a card reader or camera dock (see p67). If you transfer the images directly from the camera,

○

Image files are at their most vulnerable during the transfer process, so never delete files from the memory card until you have verified that they are safely at their destination.

make sure the battery is sufficiently charged, as power failure during transfer could result in the loss of images.

Image transfer to the computer's hard drive is easy and no special software is required. Modern computer operating systems recognise the camera, reader or dock as soon as they are connected as an external disk drive and display a dialogue box with options allowing users to decide what they want to do with the files. Typically, you have the choice of copying or moving files. 'Copying' duplicates the image files on the computer's hard drive and does not delete the original files from the memory card. 'Moving' transfers the image files to the computer, emptying the card of images. 'Copying' is recommended.

If you do connect your camera directly to the computer, the bundled software that came with your camera will open automatically. You'll be given the choice of transferring all images or selecting only the ones you want to transfer into a folder or album that can be instantly browsed.

Be aware that some of these software programs have options to enhance images automatically as the files are being transferred from the camera. If you like the sound of these time-saving applications, do some tests to make sure you're happy with the results. To get the best result, this option is best turned off.

Alternatively, you can transfer images manually by creating folders on your desktop and dragging the files to the

This is the grid view in the Library Module of Adobe Lightroom, with the image folders on the left, the histogram and EXIF data on the right. You can see I've selected images to process marked with five stars, and the ones I'm going to delete with a red label.

folder and then browsing the folders in your program of choice.

If you are really conscientious about protecting your valued images or just don't trust computer hardware (probably because you've experienced a hard-drive crash) you should now copy the images to an external hard drive. You now have two sets of images on two different hard drives and can confidently format the memory card and reuse it. The copy on the external hard drive is your archival copy. If you don't do this now, you can create an archive copy later (see p328).

VIEW, SELECT & DELETE

Now you can really sit back and enjoy your photos, as this is probably the first time you've seen them at a decent size and hopefully you're viewing them on a colour calibrated screen. Out of the many pictures you've taken you need to select the best for processing, if you've captured raw files, and enhancing in image editing software, decide which ones you won't work on but still want to keep, and delete the ones you never want to see again.

It's much easier using a browser or workflow application that allows you to compare images by viewing two or more side by side (this is one of those jobs where you just can't have too big a monitor) and to magnify parts of the image to 100% to check for sharpness.

Most imaging applications let you rate or label the images on a scale of 1–3 or 1 5 using a star system or different colour tags. Even the simplest bundled software will usually let you tag an image as a favourite. You can then sort your images based on their rating to quickly review the ones to keep or delete.

Remember to regularly empty the computer's recycle bin to free up space on your hard drive and maintain good computer performance.

ADD METADATA

Metadata is information about the image that is attached to the image file and typically includes your name, contact details, copyright assertion, location data such as country, state and city, a brief descriptive caption and relevant key words. As your digital image collection grows, so does the importance of a system that allows you to find the images you want quickly and easily and to know where, what and who they are of. It might be clear now, but look ahead five years and several thousand images and you may not be so sure. A consistent metadata and key wording regime is the best thing you can do for your image collection.

Cameras generate hard-to-use names for each file. If you intend to identify or

It's advisable to add metadata as soon as possible and this is one job that can be done on the road if you're travelling with a laptop.

search for images via a number you'll want to change this number to your own easier to understand numbering sequence. If you're going to add metadata and keywords, the file names generated by the camera are irrelevant.

ARCHIVE

You've now got a set of images you intend to keep with appropriate metadata for easy searching. Now is the time to archive them for safe keeping by copying them to a separate folder on your computer's hard drive, or better still, to an external hard drive dedicated to your archived images. This is the digital equivalent of storing negatives in archival filing sheets and putting them away for safe keeping, knowing you can always go back to them if required. It's a particularly important step if you've captured raw files so that you have a copy of the raw data before converting the file to a usable format such as TIFF or JPEG.

Some photographers create an archive copy at the same time as they transfer the files from the memory card to their computer, whether at home or on the road. Using Adobe Lightroom you can add generic metadata such as your name, copyright assertion and location data to the images as they are being transferred so that the archived images have this vital information attached.

CONVERT & EDIT

Apart from the security reasons for archiving raw files, another great benefit is that you can return to the original when you acquire new image-editing skills or new software.

Not to be confused with selecting images, editing refers to the enhancing of images in image-editing software and typically involves adjusting the white balance and exposure, cropping and straightening horizons, adjusting colour, contrast and brightness, removing red-eye and sensor dust. The editing process can be very simple using the automatic options in the most basic software, or very complicated where every possible option is considered and changes from the most minute to the drastic are applied using the most sophisticated software.

It's worth noting though that all digital images can be improved in image-editing software. It is the most time-consuming stage of the post-capture workflow and is much quicker if your images are correctly exposed in the first place.

JPEG FILES

If you've captured your files as JPEGs and intend to do any image-editing on them, you should convert the file to a suitable working format, typically a TIFF file. You should not save and resave JPEG files as you will throw away image data each time

ARCHIVING IN ADOBE DNG

Images are usually archived in the format in which they were captured – raw, TIFF, JPEG. If you're shooting raw you could also consider the option of converting the raw file, which is specific to the camera manufacturer, to Adobe's 'open' DNG (Digital Negative format). Conversion is straightforward via the Adobe DNG convertor, downloadable for free from www.adobe.co.uk. To ensure complete flexibility of your archived files, you can also select an option that allows the original raw file to be embedded with the DNG conversion. See p29 for more information on Adobe's DNG format.

you do, creating a more and more inferior file each time.

RAW FILES

Raw files must be converted to a working format, typically a TIFF file, using a raw conversion program before they can be opened in image-editing programs. Depending on the raw conversion program and your own workflow regime, you can convert the images without applying any changes or perform all of the image-editing adjustments in the raw file–conversion program before converting the file.

The point of shooting raw is to make the most of every ounce of data captured by the sensor to produce the best possible digital files. Typically, photographers will at the very least adjust the white balance, exposure, contrast, saturation and sharpness before converting the raw file to a TIFF file and completing their image-editing in a program such as Adobe Photoshop.

EDITING TOOLS

There is a lot to learn to really get the most out of your files in image-editing software and several excellent books with many more pages than this one have been written to help come to grips with the process. There are lots of programs available to perform image-editing tasks (see p97) all offering a range of image-enhancement tools. By way of introduction to the options, language and procedure involved in image editing, you'll find following a summary of the tools available in Adobe Lightroom. I'll then take you step by step through a typical image-edit of a raw file in Lightroom's Develop module. Although you may choose to work with another program, this will help you become familiar with many of the features you'll find in most image-editing software packages, in varying degrees of sophistication, and give you an idea of what's possible in the world of post-capture processing. With a little practice, these tools and techniques are easy to come to grips with and your pictures will really come to life.

In Adobe Lightroom the tools are grouped into panels and are called controls. They are presented here in the order in which it is recommended that the adjustments and corrections are applied. You don't apply every control to every

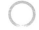

HOW TO BOOK:
THE ADOBE PHOTOSHOP LIGHTROOM 4 BOOK: THE COMPLETE GUIDE FOR PHOTOGRAPHERS, **MARTIN EVENING**

329

photograph, just the ones that will make a difference to the particular image file to get the effect you desire.

BASIC PANEL CONTROLS

These tools allow you to adjust the camera file to optimise the colour and tone of the image.

- o White Balance: adjusts the colour temperature, affecting the warmth or coolness of lighting conditions
- o Exposure Slider: sets the point where the highlights just begin to clip and adjusts the overall brightness of the image to compensate for over- and underexposed images. If you've 'exposed to the right' (see p153) this is where you will apply a negative exposure setting to reveal all the pixels captured in the highlights.
- o Blacks Slider: sets the point where the darkest black tone is just clipped. (Note that in most image-editing software these adjustments can be made using a tool called Levels that lets you set the point where the shadows and highlights are clipped and adjusts the brightness and contrast in the image. In higher-end programs you can do the same thing but more precisely with Curve controls (see Tone Curve Panel Controls, right).
- o Recovery Slider: brings out detail in the highlights
- o Fill Light Slider: brings out detail in the shadows
- o Brightness Slider: adjusts image brightness, but not as accurately as the slider controls in the Tone Curve panel

- o Contrast Slider: adjusts image contrast, but again not as accurately as the slider controls in the Tone Curve panel
- o Clarity Slider: adjusts the contrast in the midtones without affecting the overall contrast of the image
- o Vibrance Slider: boosts saturation in the less saturated colours without affecting the already saturated colours. On most images this is the better of the two sliders to use.
- o Saturation Slider: used to make significant changes in saturation to boost or subdue colour

TONE CURVE PANEL CONTROLS

These tools allow you to fine-tune the image's brightness and contrast.

- o Highlight Slider: adjusts the brightness and contrast in the highlights
- o Lights Slider: adjusts the brightness and contrast in the light tones
- o Darks Slider: adjusts the brightness and contrast in the dark tones
- o Shadow Slider: adjusts the brightness and contrast in the shadows

HSL / COLOUR / GRAYSCALE PANEL CONTROLS

This group of controls is for fine-tuning colour by individually affecting the colours in eight colour band ranges (red, orange, yellow, green, aqua, blue, purple and magenta) and also making grayscale conversions.

- o Hue (H) Slider: adjusts the hue colour balance in the selected colour band range

○ Saturation (S) Slider: adjusts the saturation to boost or subdue colours in the selected colour band range

○ Luminance (L) Slider: darkens or lightens the colours in the selected colour band range

○ Colour: offers an alternative and simpler way of adjusting the hue, saturation and luminance

○ Grayscale: used to convert colour images to black and white

SPLIT TONING PANEL CONTROLS

The split toning controls are primarily used as a creative tool to add colour to monochrome tones after a colour image has been converted to black and white.

○ Hue Slider: adjusts the hue colour in the shadows or highlights

○ Saturation Slider: adjusts the strength of the colour

○ Balance Slider: fine-tunes the balance between the colour tones in the shadows and highlights

DETAIL PANEL CONTROLS

These tools allow you to sharpen, adjust noise levels and correct chromatic aberrations. Adjustments using these controls should be made with the image magnified to 100% to accurately gauge the change.

○ Sharpening Sliders: correct for the inherent lack of sharpness that is typical of a raw camera file. This sharpening step is not to be confused with the sharpening of a file in TIFF or JPEG format when it is being prepared for a des-

ignated output such as reproduction in a book or as a print for the wall.

○ Noise Reduction Sliders: there are two noise reduction sliders to deal with – luminance and colour noise. The Luminance slider smooths out the speckled pattern of electronic grain. The Colour slider removes colour noise by blurring the colour channels, so use it judiciously to avoid softening the image.

○ Chromatic Aberration Sliders: correct any deficiencies in lens optics not being able to resolve fine levels of detail captured by the sensor, resulting in colour fringing around edges of high contrast that appears as red/cyan or blue/yellow borders.

○ Vignettes Sliders: there are two sets of vignette sliders, lens correction and post-crop. The Lens Correction sliders correct for any light fall off, typically seen in images containing large areas of even tone, such as a sky, shot with a wide angle lens. The Post-Crop sliders are a creative tool used to darken or lighten the corners of a photograph.

EDITING AN IMAGE

Following is an example of the steps involved in processing a raw file before exporting it as TIFF file. You can edit a JPEG file in the same way. Not every step is performed on every image, and other steps are required on some images that weren't required in this example. But, this should give you an idea of what needs to be done and it is achievable quite quickly (around one minute) on files that are properly exposed.

1. Open Raw File. This is the original raw file, overexposed by 1/3 stop with only Lightroom default settings applied. As you can see, it's flat, lacking colour – this is how raw files look out of the camera and before they are processed. I failed to keep the horizon straight (obviously the road I was standing on must have been wonky) so the first thing to do is straighten it up.

2. Crop and Straighten. Using the ruler tool, I marked a line along a vertical edge, the red building, and the image is rotated. When you straighten an image, you then have to crop out the blank space that is created around the image. When you crop, you are removing pixels from the image file making it smaller, so ensure you crop accurately to maintain the maximum size file.

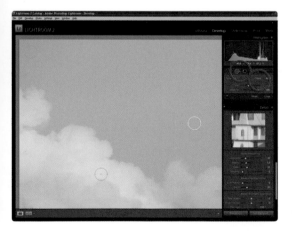

3. Check for Sensor Dust Spots. Next, I zoomed in to magnify the image to 100%. Unfortunately, there were a few dust spots in the sky, even though the camera has an integrated cleaning system, so I removed them using the clone brush.

4. Adjust White Balance. The image looked a bit too cool with a colour temperature of 5250, so I selected the white-balance tool and placed the cursor over an area in the scene that should be neutral in colour.

5. Set the White Balance. Clicking the white-balance tool, I increased the colour temperature to 5400, giving the image a slightly warmer and more accurate look.

6. Adjust the Tonal Range. Next I used the basic tone adjustment sliders – in this case Exposure, Recovery and Blacks – to improve the overall contrast and brightness.

7. Fine-Tune the Tonal Range. Further improvement was made using the Tone Curve tool to fine-tune the tonal balance and bring out more detail in the highlights and shadows.

8. Adjust the Clarity, Vibrance and Saturation. The image still lacked the saturated colours that I used to achieve when shooting colour transparency film by using a film stock that was biased to capture vivid and saturated colours. To address this, I tweaked the image using the Clarity and Vibrance controls.

 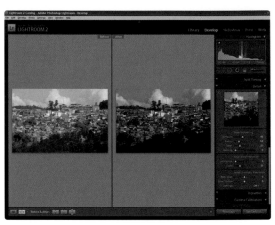

9. Sharpen. Finally, I added some sharpening to correct for the inherent lack of sharpness that is typical of a raw camera file. As already stated but worth emphasising, this sharpening step is not to be confused with the sharpening of a file in TIFF or JPEG format when it is being prepared for a designated output such as reproduction in a book or as a print for the wall.

10. Sit Back and Admire. The image is now displaying accurate, nicely saturated colour and good tonal range with detail in the shadows and highlights, and everywhere in between. The next step is to convert, or export, the edited file to a usable file format, which for me is a TIFF. These steps took around a minute to complete. If you've got a series of shots of a similar scene, you can copy the adjustments and paste them onto the other image files, which adjusts the photos in about a second.

ONLINE PHOTO EDITING

If you're on the move without a computer and image-editing software, or you don't want to invest in software and the inevitable updates, you could consider the image-editing options provided by online services such as Splashup (www.splashup.com). You upload your pictures to their site, edit them online in real time, then distribute the images to your social networking or photo sharing account or bring them back to your own computer for printing and archiving. You can edit and distribute your images from anywhere you can get an internet connection.

OUTPUT

You now have a set of great-looking images ready to output as prints, email, post on the web, burn to disc or just archive (again). You should be able to prepare the files for the different types of output in your image-editing or workflow program. Typically, TIFFs are required for most professional uses including printing in publications, producing large prints for display or exhibition and supplying to clients and photo libraries. JPEGs are the preferred format for web, email and making prints via home printers, photo labs and online print services.

BACKUP

At this point you've got an archive of your original images. Now you need to create a backup copy of your edited image files to a separate folder on an external hard drive or burn them to disc or upload to an online storage provider.

If you're doing this properly, you should also make a second copy of both your archived original files and your edited files and store them at a separate location. You are then well protected against accidental loss by writing over your images, the inevitability of hard drive failures and the worst case scenarios of theft, fire and natural disaster.

It's important to occasionally check your archives and backups to make sure they are still readable, so that you can make a new second copy if you discover a problem.

The need to back-up your pictures immediately cannot be emphasised enough. Storing the only version of your digital images on a computer hard drive is asking for trouble. It's a very different proposition to throwing negatives or prints in a shoebox or drawer. Fewer things can go wrong with a shoebox or drawer!

ONLINE BACKUP AND STORAGE

Online backup and storage facilities provide an easy way to add a high level of security to protecting your precious image and video collection, and other important data as well. There are plenty of options including Dropbox (www.dropbox.com), SugarSync (www.sugarsync.com), Mozy (www.mozy.com), Apple iCloud (www.apple.com/icloud) and photo-dedicated sites such as PhotoShelter (www.photoshelter.com), Zenfolio (www.zenfolio.com) and Mosaic (wwwmosaicarchive.com). If you're shooting video as well, have a look at Phanfare (www.phanfare.com). These systems offer solutions for everyone, from those who want to save the family photo collection, to professional photographers. The services compete on price, storage amounts, features and sharing options, so check out a few, find one that suits you and start backing up those photos before it's too late.

All you need is a computer, a broadband connection and most importantly, the discipline to do it.

REMOVE FILES FROM HARD DRIVE

With your two archives of original images and two backups of edited images in two separate locations you can now remove the image files from your computer hard drive to free up space if you wish. You'll access your images by connecting the external hard drive to your computer, which you'll probably want to leave permanently connected.

AT HOME WITH FILM

If you're shooting film, your initial workflow process will seem remarkably simple, compared to that of digital photographers. That's primarily because the lab has processed your film. However, once you've assessed and stored your film, if you want to email, display on the internet or reproduce an image on the printed page, you've got to digitise the film by scanning it and then follow the same image-processing steps as outlined for a digitally captured file.

ASSESSING SLIDES

Assessing colour slides requires additional equipment, unless you want to hold them up to the sky or room lamp. You need a light source to shine through the slide and a magnifier to enlarge it. The cheapest and simplest option is a slide viewer. Slides are viewed one at a time by placing them into the unit between a small light globe and a magnifying lens. Apply slight pressure to the slide mount and the light comes on. The unit is handy because it enlarges the image slightly, but it makes comparing slides difficult and involves a lot of handling of the slides. You could also use a slide projector to view your slides, but that's time consuming and impractical if you have anything more than a few rolls.

The only way to assess slides properly is on a colour-corrected light box (or light table). The fluorescent tubes provided produce the same colour as daylight, so that the colours in your slides are faithful to the film. Slide viewing will be much more enjoyable and practical if your light box is large enough to see at least an entire slide-filing sheet of 24 mounted slides (see p337). If you're going to prepare slide shows, you'll appreciate a light box that is large enough to lay out 100 slides at once. Slides on a light box are viewed with a loupe, an optical accessory that magnifies the slide. Loupe prices range from US$15 to US$300. Buy the best you can afford. A good-quality loupe is an essential piece of equipment for anyone using slide film. Viewing slides with the naked eye, or a cheap loupe, is not practical or fun. If you don't use a loupe, you will not only miss much of the detail and colour saturation in the slides, you'll mislead yourself as to their sharpness: slides nearly always look deceptively sharp when viewed with the naked eye.

STORING FILM

Colour slide film and negative film should be stored in a cool, dry, dark place for protection. The most popular way to store negatives and slides is to leave them in the packets and boxes they're returned from the lab in. But there are better ways. Photographic materials fade over time, and that can be a very long time, if they're stored properly. The things to avoid are heat, humidity and storage materials such as vinyls and wood that can emit harmful chemicals that react with photographic materials. Use archival-quality products that are chemical and acid free.

NEGATIVES

Negatives generally come back from photo-finishers in clear negative holders in strips of four, which satisfy most people. If you're taking lots of film and would like to get really organised, you can buy negative filing sheets. (Archival sheets are made from polyethylene or polypropylene.) Generally, they take seven strips of six exposures and are made for ring binders and hanging in filing cabinets. They have room for writing relevant information at the top. Ask your lab not to cut the film so you can cut it yourself into strips of six exposures for most efficient use of the negative files.

SLIDES

Slides are generally stored in boxes or slide-filing sheets. Boxes are not recommended if you intend to access your slides regularly. They require excessive handling and don't allow easy viewing. The recommended option is to use archival slide-filing sheets that hold 20 or 24 mounted slides. These are then stored in ring binders or in filing cabinets. They allow easy viewing on a light box or can be held up to any light source. There's a wide range to choose from and some are better than others. Ensure that the slides fit snugly into the pockets so that they're easy to put in and remove but don't fall out if the sheet is held upside down. Also, make sure that they are truly clear. There are some on the market that make it almost impossible to see what the slide is of, let alone judge exposure and sharpness. If you're handling a lot of slides you'll also find the top-loading sheets are best for quick access.

Calligraphy artist painting with water, Beijing, China

35mm SLR, 24-70mm lens, 1/125 f5.6, Ektachrome E100VS

SHARING

Not that long ago, sharing meant showing others loose sets of prints, putting framed pictures on the mantle piece or desk or framing a print for the wall. Organised people put together albums of pictures. Those who shot colour slides could project their images in a darkened room and if you were really serious you could hold an exhibition of your work. These outlets still exist but have been joined by a host of new options thanks to the wonders of digital technology and the distribution power of the internet. You can now share your creativity with the world via the World Wide Web through general social networking sites like Facebook (www.facebook.com) or dedicated photography sites like Flickr (www.flickr). You can also send your images to friends via email or upload them to photoblogs, moblogs and vlogs or set up your own website. Slide shows can now be made with numerous effects and adding a soundtrack is easy. Even though they are still best shown in a darkened room, the projector screen has been joined by the much more accessible television and computer screens. Photo albums have taken on a whole new life and look as online services turn image sets into hard covered books. Even the humble photo frame has gone digital, so you can enjoy a different one of your favourite pictures every time you glace at the mantelpiece.

CHOOSING PHOTOGRAPHS TO SHARE

It doesn't matter who you're showing your photos to (except perhaps people who were there), you should edit your photos tightly. Heavy sighs and excuses are not what you want to hear when you invite friends and family around to see your latest travel pictures. That's what you'll get if you bore everyone with several images of the same thing and a long-winded story about every photograph. When you send people the link to your online albums or send them a CD of pictures, they can at least skip through the pictures at their own pace. But, the idea is to provide some viewing pleasure and leave them wanting more.

We all take bad pictures – the trick is not to show them to anyone. Edit the technically poor and creatively weak pictures out and you'll be left with a much stronger and more interesting set of photos. This takes a fair bit of discipline, as emotion too often interferes with this process and poor pictures are frequently shared. If you can bring an objective view to image selection you'll not only please your audience, you'll leave them thinking you are a great photographer.

PRINTING DIGITAL IMAGES

Printing digital images is easy. You can print them yourself or order them from a digital print service. Either way, one of the most significant cost savings gained by digital capture is the opportunity to review images before they're printed, allowing you to select only the images you want to print, instead of having to print an entire roll of film. Prints can be made from a digital camera's memory card in various ways:

- Transfer the images to a computer and then print on a desktop printer or via an internet print-service.
- Connect the camera directly to a desktop printer or insert the memory card directly into a printer.
- Take the memory card to a photo shop for printing.
- Visit a self-serve printing kiosk.

PRINT QUALITY

The maximum size print you can make is determined by the number of pixels captured. The more pixels you have, the bigger the print you can make. The size of the image is determined by the number of pixels on the horizontal and vertical axis; an 8 MP camera produces an image file that is approximately 3264 pixels wide by 2448 pixels high. If you divide each dimension by 300, you will have the size of the image at 300 pixels per inch (ppi). It is generally accepted that a minimum of 200 pixels per inch (200ppi) is required for a good quality print, and 300ppi is needed for high quality prints. If you don't have enough pixels

the print will lack detail and sharpness. It's always recommended to capture images at the highest quality setting the camera offers so that you are not restricted later by your choice of file size, only the physical dimension of the sensor, which is a decision you make when you buy the camera.

PRINTING AT HOME

Printing your own photos has never been easier, with a wide and ever-expanding range of ink jet, desktop printers that produce photo-quality prints. You'll find a wide range of models to suit every budget and application. Some printers are so compact, they're being promoted as an accessory to be carried around so you can print on location. Epson, HP and Canon are the big players and all produce excellent devices.

Standard models use four colour-ink sets (cyan, magenta, yellow and black) and offer reasonable quality prints. Dedicated photo printers add additional inks, such as light cyan and light magenta and other black inks. The best printers have seven or eight colour ink-sets and offer improved fade resistance, a wider colour gamut, vibrant colours, invisible printer dots which create a continuous tone so colour transitions are smooth, the ability to reproduce neutral grey tones, increased detail in the highlight and shadow areas and sharper-looking prints. They also accommodate the widest range of print media so you can print on interesting surfaces such as watercolour paper or canvas. Of course, the more inks in the printer the higher the running costs.

MEDIA

There is a wide choice of print media to choose from. Always check that the paper is compatible with your printer, especially if you want to use some of the fancier papers. Prints can look completely different from one paper to the next. Glossy paper reproduces deeper blacks and vibrant colour but is more contrasty and loses some detail in the highlights and shadows. Matte papers are not as contrasty so produce a greater range of colours, but they can be dull in comparison to a glossy print.

There is also an interesting range of artistic papers to consider, many coming from traditional fine art paper manufacturers rather than the photographic companies. You'll find different shades and weights with varying degrees of textured finishes such as smooth pearl, linen, watercolour, silk and canvas as well as the classic 100% cotton, museum standard acid free art papers.

Some of these papers are quite expensive so it's particularly important to make sure they are compatible with your printer. Check your printer specifications and the paper manufacturer's website. See if you can buy a sample pack to test before handing over your money. Get started by visiting www.hahnemuehle.com, www.crane.com and www.kentmere.co.uk.

PRINTER PROFILES

To ensure the best results it's important to tell the printer what paper you're using by selecting the paper profile. The software that came with the printer will probably include profiles for all the papers the printer company makes that are compatible with your particular printer. If you use paper from a different manufacturer, you can access the profiles free from their websites.

Camera Megapixel Rating	Camera Pixel Resolution*	Maximum Print Size in Centimetres	Maximum Print Size in Inches
5	2750 x 1900	23.1 x 16	9.1 x 6.3
6	3000 x 2000	25.4 x 17	10 x 6.7
8	3260 x 2450	27.6 x 20.8	10.9 x 8.2
10	3900 x 2600	33 x 21.8	13 x 8.6
12	4272 x 2848	36 x 24.1	14.2 x 9.5
21	5616 x 3744	47.4 x 31.7	18.7 x 12.5
25	6048 x 4032	51.3 x 34.2	20.2 x 13.5

*Actual pixel dimensions vary from camera to camera

This table shows the maximum print size recommended for high-quality photo prints from 5 MP to 25 MP cameras set on the highest JPEG image quality setting. The table assumes the full frame of the image is used and printed at 300ppi. If you crop the image the maximum print size will be reduced unless you're willing to sacrifice print quality. Opinion varies as to the maximum-size photo-quality print that can be achieved from each MP value. Camera manufacturers are generally more liberal in their recommendations, and their claims vary considerably from camera to camera. Treat this table as a starting point for your own research and tests.

INK

Printer inks generally come in easy-to-install cartridges. Standard printers use one cartridge to contain the ink-set; the higher and photo-quality printers accept individual cartridges for each colour. There are two kinds of ink used in ink-jet printers: dye-based and pigment. Dye-based inks are the most common and generally considered the best because they produce the most vibrant colour. Pigmented inks don't produce such good colours but are considered to offer greater print longevity. Many of the better ink sets with good archival quality ratings use a combination of dye and pigment inks.

The printer manufacturers insist that their own inks should be used in their printers to ensure accurate colour reproduction, maximum longevity of the print and to prevent damage to the printer head. Third-party ink suppliers tempt us to stray by producing ink at considerably better prices. If you're doing massive amounts of printing you may want to investigate the third-party option further; otherwise, it's probably better to use the printer's recommended inks.

STAND-ALONE INK-JET PRINTERS

If the 'no computer' option interests you but you still want to make your own prints, there are several choices. Some printers have cable ports that connect directly to the camera. Another range of printers has built-in slots that accept single- or multi-format memory cards for direct printing from the card. For future flexibility consider buying a camera and printer that are PictBridge compatible. PictBridge

technology is an industry standard that allows devices made by different manufacturers to be connected. The main benefit is that you have a greater choice of camera and printer combinations, and one component can be upgraded without having to replace the other. Features vary with price but it's very handy if the printer has an LCD screen to make image selection easier. You should be able to print a contact sheet of thumbnails, and some have checkboxes for various print sizes – you feed that order form into the printer and it prints accordingly.

PRINT LIFE

The longevity of a print is determined by the combination of ink and paper, how the print is stored, framed and displayed and environmental conditions such as humidity. The outcome can vary wildly, from six months to 100 years. You can learn more from Wilhelm Imaging Research, a lab that specialises in evaluating and predicting the archival qualities of printed output, at www.wilhelm-research.com.

KIOSKS

Another variation on developing and printing is self-serve printing kiosks. Often located in photo shops (but expect to see them in more and more places), the kiosks are set up to receive digital files from most storage media. No computer knowledge is required and after inserting your memory card the software takes over and prompts you step by step. You select the images you want to print and the size required. You can also generally perform many of the standard image-editing functions found in

basic image-editing software such as colour correction, cropping, red-eye removal and alterations to brightness, contrast and sharpness. When you've completed your order it's sent via the internet to a mini-lab, which outputs the prints on standard photographic paper.

If you're going to print using direct-to-computer, online print services or kiosks you must shoot JPEGs or convert and save your raw files to JPEG.

PHOTO LABS

If you want to keep it really simple, take the memory card to a photo retailer for printing. This is just like taking a roll of film to a photo shop for developing and printing. However, if you want to reuse the memory card and want the option of making reprints or enlargements later, you also need to order a copy of the files before deleting them from the memory card. The photo shop will do this at the time of printing by transferring

PRINT IT OR RISK LOSING IT

Even though manufacturers are doing everything they can to make printing as easy as possible it appears many people are storing digital images on hard drives and CDs with the idea of printing at a later date. This resulted in the photographic industry launching a media campaign in 2003 that carried the message 'print it or risk losing it'. The aim was to get people to make prints sooner rather than later. The concern is that delay in printing may mean that images are lost forever due to damaged CDs or DVDs, hardware failures and obsolete software. This warning is just as valid nine years later.

the files to CD. You'll then have the digital equivalent of negatives.

Unfortunately, the standard of prints that photo labs produce varies wildly. If you get a set of prints that are really disappointing it's well worth explaining the problem to your photo-finisher and requesting a reprint. If they refuse or suggest that they've supplied the best prints possible, get a second opinion from another minilab.

ONLINE PRINTING

Internet print services allow you to select the images in your image-editing software, enhance them if you want (for example remove red-eye or crop), choose from various print sizes and finishes and send your order via email. You then pick up your prints at a nominated local retailer or they're posted to your address.

Some digital print retailers are tailoring services specifically to travellers allowing you to share your pictures with family and friends back at home long before you return yourself. A complete service includes printing directly from your memory card, copying the files to CD so you can reuse the card, and posting the images to a password-protected website. Family and friends are told the website address and password. They go online and view your photos in the comfort of their own home. Of course, if someone got hold of your camera and reeled off a few indiscreet shots at that great party that you really don't want your mum to see, you simply don't select them for posting to the website. Yes, they've thought of everything. Finally, the people who care about you can then order prints

themselves, which are sent to their address within a couple of days.

Online printing is just one service offered by many companies; see p348 for the details of the wider offering and list of services providers.

○

Don't forget to consider the aspect ratio of your image when choosing a paper size to print on. See p85 for details.

PHOTO ALBUMS

Prints are traditionally stored in photo albums. The main album styles have self-adhesive pages, plain pages or slip-in pockets. Many of the self-adhesive pages are cheap, but over time the contact can wear off and the prints fall out. Even if they don't fall out they're probably in contact with harmful chemicals. Albums of plain paper allow you to write directly below the photographs but require you to supply adhesive or photo corners. Most of us don't expect to remove pictures once they're in an album, but, if you do, photo corners might suit you, although they're fiddly. If you're sticking the pictures in, ask your photo retailer what they recommend rather than using normal glue. The slip-in, clear-pocket albums don't allow for various size pictures and you can't be creative with how you lay out the pictures. Captions are important: you can remember where you've been, and they allow the photos to be enjoyed by people who weren't there.

Before you quickly put every photo in the album why not pick out your favourites for enlarging? This will highlight your best photos and make sure they get the extra attention they deserve. You could also use enlargements to introduce each new country or theme. One big advantage of prints is that you can crop them at the printing stage. Cropping allows you to enlarge the main subject or eliminate unwanted elements around the edges of the print.

DIGITAL PHOTO BOOKS

Having your name on the front of a hardcover book featuring your own images is the dream of most photographers. It's still as difficult as ever to get published if you want to see the logo of publishers such as Aperture, Phaidon, Thames and Hudson, Tashen or Lonely Planet on the spine. However, it's now possible to produce single or short-run editions of your own book using custom digital bookmaking services provided by online companies such as Blurb (www.blurb.com), Lulu (www.lulu.com), Momento (www .momento.com.au), Asuka (www.asuka book.com) and Digital da Vinci (www .digitaldavinci.com.au). They provide the software, design templates and tools and you provide the images and text. Next thing you know you've got your own book being delivered to your door.

WALL PRINTS

Framing your favourite prints for wall display is very satisfying. Most photo labs can print or organise enlargements from digital files, colour negatives or slide film up to poster size (50cm x 76cm; 20in x 30in). If you want the best possible print and are prepared to spend a bit more money, seek out a professional lab to

Wall prints decorating family room

Get everything right when you take the photo and you'll be able to fill whole walls with your images.
DSLR, 24-70mm lens at 47mm, 1/30 f4, raw, ISO 640

glass. Nonreflective glass takes the edge off the sharpness and dulls the colours. Careful positioning of the print on the wall helps minimise reflections…as does a little step to the left or right by the viewer.

Prints should not be placed in direct contact with the glass. Traditionally, a border called a window mount, or matt, goes around the print and separates the print from the glass. If that look doesn't suit you, a good picture framer will advise on the options. You'll also have a number of choices of mount board and mounting adhesives. Ask for the archival products which prevent discolouration of both the matt and the photograph. Place the framed print in an area that doesn't receive direct sunlight.

handle the enlargements. A good lab will advise which images will and won't print well, rather than just taking your order. If you decide to frame your print behind glass, use plain glass, not nonreflective

SLIDE SHOWS

Slide shows, with original slides or digital files are a great way to present a lot of photos in a short time and the images themselves will never look better. You'll need a slide projector to show original slides or you can scan the images and access the options available for producing slide shows with digital technology. Digital files can be shown via various output devices including digital projectors, computer monitors or television screens. The simplest path is to insert the media card into a dedicated slot in a computer or TV and the pictures will appear in the order you took them. It's just as simple if you've transferred your images to a CD or DVD.

However, if you've got a computer, you can do much better than that and really do justice to the time and effort you put in capturing the images by presenting them in a creative and entertaining way. With the right software, you can turn your photos and videos into slide shows complete with soundtrack, transitions, captions, narration and special effects. You only have to do the work once. When you're happy with the show, you can save it and output it to all sorts of formats including DVD, Blu-ray and CD as well as devices like iPads, mobile phones and share it on YouTube. Software programs cater to all levels. For those who want to keep it simple,

check out Ulead CD & DVD PictureShow (www.ulead.com). For more sophisticated productions take a look at ProShow Gold (www.photodex.com), a favourite of professional photographers.

Whatever you do, don't turn a great set of pictures into a dry slide show instead of the entertaining and informative experience it should be. You have a captive audience and it's your duty not to bore them. Following are suggestions that will have your family and friends calling out for more:

○ Always view the show first to ensure the photos are in the right order and the right way up.

○ Don't leave images on the screen for more than six seconds; four seconds is fine. At four seconds each you can show 225 images in 15 minutes.

○ Don't show similar pictures of the same subject. Just select the best one.

○ Be ruthless in your image selection and only show the best.

○ Grouping destinations or themes reduces the commentary because you can introduce a sequence of shots with the first image.

○ Have some order to the images. The chronological order of the trip is most logical. If you're coming and going from a home base or a country more than once, group the slides into countries rather than jumping back and forth.

○ Keep the length of the show to around 15 minutes.

○ Add a soundtrack, or at least play some appropriate music, to set the atmosphere and to help prevent you feeling the need to talk about every image. Let some of the photos speak for themselves.

○ Project or play the show in the darkest room possible. Too much stray light will reduce the impact of your images.

○ Project or play the show earlier in the evening rather than later. After dinner and a couple of drinks, it's easy for people to fall asleep in a dark room with music playing.

EMAILING PHOTOS

If you've ever sat in front of your computer waiting for a photo to download and then when it arrives it's far too big for your screen and you have to scroll left and right, up and down to see it, then you'll know the problem of sending inappropriately sized photos as email attachments. If images are being sent via email for viewing on a computer screen, then they must be resized for that purpose by lowering the resolution and sending a physically smaller version. Most of the software that is bundled with digital cameras, as well as the popular image-editing programs, has dedicated email functions that automatically resize images for emailing. Windows users can also resize images easily by following these steps:

- Go to My Pictures, select the image.
- In the File and Folders Tasks menu, select E-mail.
- Select Picture size from drop-down menu.

- Select Smaller 640 x 480.
- Press Attach and your email program will place the image in the attachment bar.

If the files are being sent so they can be printed, select 'Original Size' from the Picture size menu. Before you hit 'Send', check the file size and be aware that many internet providers limit the size of attachments, often to around 1 MB. If you have several images to email, send them one at a time. If you have lots to send or the files are large, you're better off burning a CD and posting that.

For those not using email resizing functions, save a copy of your image file and resize it to 300–400 pixels wide and set the resolution to 72dpi. The best format to use is JPEG.

If you need to resize lots of images for email or website posting and want more control over the process check out the specialist, but free, applications such as Easy Thumbnails (www.fookes.com), PIX resizer (www.bluefive.pair.com), Graphic Convertor (www.lemkesoft.com) or EasyCrop (www.yellowmug.com).

If you want to send an image via email, your camera will have captured far more pixels than you actually need. Resizing is important to ensure the image can be downloaded quickly and viewed easily by the recipient. This is the simple image resizing interface offered in Microsoft Office Home User software.

SHARING PHOTOS & VIDEOS ONLINE

There is no question that we can get a serious amount of personal satisfaction from admiring our own photos, but if the mind-boggling numbers being touted around image activity on the online social networking sites are anywhere near accurate, it's obvious we get far more pleasure sharing them with others. Around 100 million photos are uploaded to Facebook every day. Flickr has over five billion photos in its database and 3000 images are uploaded every minute. Snapfish has more than 95 million members and one billion unique photos stored online. And this is still a relatively new phenomenon. The numbers will continue to sky-

rocket as broadband internet connections become the norm and the applications are made more and more simple to use and more people understand exactly what's being offered.

Online social networking and photo sharing sites are the modern version of the photo album, the whole point being to organise and then share your photos with others. There are numerous online businesses offering a range of services that help you organise, store, edit, share and print your images. The sites are often run by companies providing print services, so people can see and then order prints. You upload high-resolution image files, which they copy to produce a web-optimised file for quick display. The services are generally free and offer a generous amount of storage space. Some charge for storage above the free quota and for additional premium services.

These sites offer much more than just being places to store digital files and order prints. They give everyone the chance to display their work, engage with a community of fellow picture takers from all over the world, give and receive feedback, find inspiration and join groups, or pools, of people with similar interests. Flickr's travel category, for example, has over 10,000 groups. You'll also find lots of tips and techniques, including video tutorials, equipment reviews and discussion forums.

Check out a few, ask friends about their experiences or go online and read what people have to say in the online forums. Check particularly what their policy is on deleting files, some may delete if an ac-

count is left dormant for a long time. You'll soon find one that suits you. They all work along these lines:

UPLOAD & STORE

Install free software on your computer and follow the instructions to upload, or post, photos and video from your computer, via email or from your phone or tablet. The amount of free storage offered varies, but 1 GB is enough for storing around 4,000 standard-resolution photos.

EDIT

Many of the services have an image-editing application that lets you perform simple enhancements such as removing red eye and cropping as well as adding creative fonts and effects to your pictures.

ORGANISE

Create albums, collections or sets of images based on destinations, events or themes. You can add keywords and location information to help viewers find them using a search engine.

SHARE

Anyone with a computer and internet access can be invited to look at your photos. You decide who gets to see them through privacy controls. Keep them private, share with family and friends or make them public and let the whole world see what you're up to. Visitors can leave comments and you can interact with the other site members by browsing their public galleries, commenting, critiquing and inviting comments on your own work.

347

ONLINE SERVICE PROVIDERS

Numerous online services can help you organise, store, edit, share and print your images, including the following:

- www.flickr.com
- www.picasa.google.com
- www.shutterfly.com
- www.snapfish.com.au
- www.kodakgallery.com
- www.smugmug.com
- www.photo.net
- www.fokti.com
- www.mypicturetown.com
- www.photobucket.com

PRINT

You and your visitors can order prints from your collection and they will be posted out with a couple of days. But prints are just the start. You can buy all sorts of products featuring your images such as cards, photo books, DVDs, calendars, mugs, mouse pads, puzzles and framed prints.

Before signing up to a site, consider where it's located. If you order prints outside the USA from a North American service provider, the prices will be in US dollars and you'll be up for international postage charges. However, if you've got friends and family living overseas, by joining a provider local to them, the postage costs will be minimal.

BLOGS

Set up a blog, website or account with a social networking site before you hit the road and you can keep everyone up to date.

The digital space allows anyone with internet access to share their thoughts, photographs, videos, music and anything else that can be digitised without interference from the moderation of traditional media publishing via a website called a Web Log, but better known as a blog. Blogs can be as simple as a daily diary through to sophisticated multimedia programs, but generally are owned by individuals and updated regularly.

The blog quickly became specialised as one form of content became the focus of the blog so photoblogs, also known as fotologs or fotoblogs, feature photographs; video logs, or vlogs, feature video footage. If you're capturing still or video images on your camera phone you can upload to blog sites from wherever you are and you'll be blogging on the go, or mobile blogging, better known as moblogging. See more on mobile blogging and video blogging on p349.

Blog owners can include as much or as little information about their photos, such as captions and technical notes, as they wish. Most invite comment from and between viewers, and provide links to other blogs of similar interest.

PHOTOBLOGS

Anyone can create a photoblog and setting up one has been made easy by specialist photo-sharing sites such as fotolog (www.fotolog.com) and flickr (www.flickr.com). They provide all the tips, techniques and tools you need to get

your blog up and running. Check them out just to see what others are doing. To ensure more people than just your family and friends get to see your efforts, get your blog listed on a directory such as photoblog (www.photoblogs.org).

MOBLOGS

One of the great things about capturing images on your mobile phone is that you can share them from wherever you are within seconds of taking them. Sending photos to another phone as a Multimedia Service (MMS) message is just the start of what's possible.

Get yourself a blog or an account with a social networking site and you can go mobile blogging, or moblogging. Upload text, photos and video via email, MMS or SMS to any number of cyberdestinations. The major mobile-phone companies have established working relationships with the popular networking sites including Flickr, Facebook and MySpace, or they allow access to a personal page on their company blog. Alternatively, you can use a third party site which converts and uploads your content to any of the popular sites or any platform that has mobile posting compatibility. There are also

Protect your images. Make sure you fill in the Copyright IPTC metadata field in your image editor before emailing or posting images to the web using the correct format: © 2012 Richard I'Anson. The info stays with the image file if a copy is downloaded. It can be changed in an image editor, but this is a violation of copyright laws.

specialist moblog sites that will archive your text, images and videos as well as convert and upload the content to your social networking profiles, blog or website. Some of these sites will send your content directly to the mobiles of your family and friends. When you're travelling, this is a great way to send off quick updates letting everyone know what you're doing and where you are, in real time. No computer or internet connection required. You only need to send it once and the service sends it to everyone in your phone network.

VLOGS

If you've shot some footage on your camcorder, digital camera or mobile phone and you reckon it's worth sharing with the world, then go vlog. Video blogging, or vlogging, are blogs that feature video clips and are broadcast on the internet. The most popular site for sharing videos is YouTube (www.youtube.com), and it's seriously popular, with millions (and millions) of videos online. There are more than 50 other video sharing sites on the internet, including Metacafe (www.metacafe .com), Break (www.break.com) and Stickam (www.stickam.com). These sites are a good place to start to access information and opinion on vlogging. They also offer the editing tools and other resources to help you create and upload your videos.

If you really think you've shot a winning vlog, enter the Weblog Awards and compete for the best video blog prize (www.weblog awards.org).

349

SELLING TRAVEL IMAGES

There is nothing more satisfying than seeing your images reproduced on the printed page of a high quality brochure or respected publication or flashing up on a beautifully designed website. It's even sweeter when you've been paid. There are plenty of outlets for travel images, so if you feel your photographs are good enough and might be of interest to others, you may want to investigate ways of licensing your work.

The good news is that there is as big a demand for travel pictures as ever, the list is long: magazines, newspapers, books, greeting cards, calendars, CD covers, jigsaw puzzles, stamps, billboards, websites, posters – you get the idea, anywhere images are published. The bad news is that travel imagery, including outdoor/nature photography is probably the most competitive category when it comes to commercialisation of pictures and the one hit hardest by the flood of images now available thanks to the ease at which people can upload images to the web and get them seen via blogs, websites and social networking sites. This simply means there is a greater imperative than ever before to produce great pictures of more places.

If your aim is to make money from your pictures in any shape or form, shoot raw and convert the images to TIFF files. You can then send a copy of the TIFF or create JPEGs from the TIFF to any specification requested by a client.

THE BUSINESS OF TRAVEL PHOTOGRAPHY

Yes, it's hard to believe, but travel photography is, in fact, a business. It can look pretty glamorous from the outside (and sometimes it actually is), heading off on one trip after the other to places that everyone else saves their hard-earned money and time to get to. The reality is slightly different – it's a competitive, challenging business and if you want to be successful at it you work hard and you do it full time. Edward Weston summed it up nicely:

> PHOTOGRAPHY TO THE AMATEUR IS RECREATION, TO THE PROFESSIONAL IT IS WORK, AND HARD WORK TOO, NO MATTER HOW PLEASURABLE IT MAY BE.

Travel photography is certainly one of the most interesting branches of the photographic profession. It's a specialist area in terms of the business of taking, marketing and licensing images, but it's very general in terms of the kind of pictures that you need to take to be able to make a living from it. The range of subjects covered in this book should have made that clear already. The travel photographer has to be able to cover all of them well. Personally, I have several goals – no matter where I go – that, when achieved, give me the depth and breadth of coverage I need to ensure that my pictures fulfil the needs of picture buyers more often than not:

- Shoot broadly, aiming to cover as many of the key subjects as possible at every destination – whether it's a country, city or village.

- Aim to photograph every subject in the best possible light – there is a best time to photograph everything.

- Always maximise the photo opportunities. Often a lot of the hard work is in just getting there, so, once there, always look for the second, third and fourth shot of the same subject to add variety to the collection.

- Aim to be the most informed foreigner in town.

- Look to create visual narratives of all subjects.

- Apply the same work ethic and regime to stock shoots as to assignment photography, ie approach each shoot as though it's going to be delivered to a fee-paying client.

- Aim to take better pictures than anyone else.

- If a subject appeals, never assume that you'll see it again later. Shoot first, and reshoot later if a second or better opportunity presents.

- Plan and shoot as though the trip is a once-in-a-lifetime opportunity.

- Always know where you are going to be shooting first thing in the morning and in the last couple of hours of the day.

- Try to be ruthless when assessing the quality of your pictures, never sending out anything that isn't of the highest standard.

'COPYRIGHTED' IMAGES

If you use Adobe Photoshop, Lightroom or Elements you'll see a Copyright Status field in the metadata panel that lets you indicate that the image is 'Copyrighted'. This is a term that only applies in the US and explicitly means that the image has been registered with the US Library of Congress. If you operate in the US then only make this claim if you have actually registered the photo. The standard copyright notice is understood throughout the world and affords adequate protection to enforce your right of ownership over an image.

COPYRIGHT

You automatically own the copyright on an image as soon as it's created, and it remains yours for the rest of your lifetime plus 70 years. Given you won't be around for the 70 years after your lifetime the copyright is transferred to your heirs or anyone else you choose to will it to.

You need to protect your copyright. Always include a copyright notice with any image you send out in whatever format – digital file, slide or print. The correct format for the notice is the copyright symbol, the year the image was taken and your name: © 2012 Richard I'Anson. You can add another level of protection by adding the notation 'All rights reserved'.

Both assignment and stock image users will sometimes ask to buy out the copyright in an image or in all images created on assignment. This means you'll never be able to relicense those images and probably won't even be able to use them in your own portfolio or website. Read all contracts that you are offered very carefully paying particular attention to the Grant of Rights clauses, to ensure

that you're not unwittingly transferring copyright to the company commissioning or licensing your work.

RIGHTS

When a client wants to publish an image, they license the rights to use that image in a particular way (brochure), for a particular time period (12 months) in a particular territory (North America). The usage can be as narrow or as broad as is required, but you are licensing the rights to publish the image, not selling the image or selling the copyright on the image. The most common rights you'll encounter are one-time, exclusive, electronic and all rights.

ONE-TIME RIGHTS

Images are licensed for a single use for a fee.

EXCLUSIVE RIGHTS

Exclusive rights guarantee the user that you will not make the image available to other image buyers. Typically, this means the image will not be made available to competitors of the user for an agreed time.

ELECTRONIC RIGHTS

Images licensed for web, portable mobile devices and digital media such as CD-ROMs. Always check if electronic rights are required because many users mistakingly assume they are automatically included with one-time or exclusive rights.

ALL RIGHTS

This all-encompassing license allows images to be used for all purposes for a specified period of time.

> Value your images, value your time and never give up the copyright in your images unless you are very, very well compensated.

SUBMITTING PREVIEW IMAGES

Very few people will even accept original slides or prints these days and as a photographer, the last thing you really want to be doing is sending out originals. Both clients and photographers don't want the drama and potential costs that arise when images go missing. One of the best things about the digital world is that we can send multiple copies of the same image without compromising the quality. Ensure you send the files in exactly as requested. If specifics aren't mentioned, then files should be no larger than 5in x 7in at 72dpi. This is quite sufficient for your images to look good on a computer screen and equally importantly for them to load quickly. Emailing large images can clog up inboxes, take too long to download and then too long to open. This is the recommended way to quickly get on the wrong side of photo editors and buyers, and even worse they may not even look at the pictures at all.

PAPERWORK

Whenever you send out images, include professional-looking paperwork, hard copy or electronic, that specifies what you've sent, how they can be used, rights being offered and fees. Make sure your business name and contact details are clear. If you're sending a CD, DVD or USB drive and expect it to be returned, include a self-addressed and stamped envelope.

RELEASE FORMS

If you intend to make commercial use (submit to an image library, or otherwise

license or sell) of photographs of people, private property, artworks or trademarks, you need to know about releases. Model and property releases are used by photographers to obtain permission from a person or rights holder to use their image or property in a photograph. Getting written permission makes it difficult for a person to later claim that the use of the photograph has breached their rights.

Practically, it's difficult and time consuming to ask everyone you photograph to sign a form (and that's if you speak their language). Generally, editorial uses, such as books, magazines and newspapers, don't require releases, unless the use of the image might be defamatory. But in the advertising world, which pays the highest fees for licensing stock images, images will usually not be accepted without signed releases.

As every situation is different, you may want to seek out information about what you need for your particular subject and use. For example, if you're going to use images for noneditorial purposes, bear in mind you may need to provide some compensation (even nominal) for the release to be enforceable.

Release forms have now been digitised. Easy Release is an app available for Apple and Android phone and tablet users that replaces paper model and property releases by letting you collect information and signatures on your mobile device. All sorts of customisation is possible to suit your own needs and it includes releases in multiple languages.

BEING A TRAVEL PHOTOGRAPHER

Travelling to take photographs is very different from taking photos while travelling. Professional travel photography is about commitment to the image. Nothing gets higher priority than being in the right place, at the right time, all of the time; not food, not sleep, not comfort, not family, not friends, nothing! Consequently, it's quite a selfish profession, at least while you're on the road. The only way to achieve the most consistent levels of originality, quality and consistency, and eke out the maximum photographic possibilities from the time allocated for capturing images, is to travel solo – anything else compromises your ability to be 100% focused (literally) on the task at hand (you also don't feel quite so selfish).

Apart from an egocentric streak, the successful travel photographer requires several key characteristics and skills, some of which are quite contrary:

o The ability to plan every detail to make the most of whatever time you have, but be totally flexible to respond quickly to new and/or unforseen events.

o A restlessness that keeps you on your feet for hours searching out the next photo opportunity must be countered with the patience to be still and wait once you have found what you are looking for, for however long it takes for the right light or the right subject, or both, to come together – minutes, hours, days...

- Lightning reflexes so that you don't miss what you've been searching or waiting for, or to react to anything you happen to stumble upon.

- Strong social skills to make quick connections with people whether you have a common language or not, as well as needing to be comfortable with your own company – it's essentially a solitary occupation.

- The confidence to quickly and comfortably step into new places and cultures. There is absolutely no time for jet lag or culture shock.

- An open mind and respect for what you see.

- A supremely optimistic nature.

- The ability to see something that isn't there (see p130).

- And finally, the ability to leap tall buildings in a single bound and move around invisibly through milling crowds (only joking, just!).

GETTING STARTED

There are essentially three ways to make money as a travel photographer: shoot assignments where you're paid to take specific pictures for a specific purpose; supply stock images that you've already taken for a license fee; or create products to sell, such as books and fine art prints. Before you can do any of these things you need images.

BUILD A COLLECTION

There is only one way to get started in this business and that's to go travelling with the purpose of taking images for commercial purposes. That is, plan a shoot, not a trip. You don't have to go far, at least to start with, but you do need to produce a collection of images that show potential clients and photo editors that you're capable of shooting good pictures across a range of subject matter in a variety of locations and conditions. No one is going to send you off overseas, or even up the road, unless they have the utmost confidence that you can deliver. This is the key difference between taking photos for fun, and shooting for a living. The professional photographer has to deliver – no matter what.

Give serious thought to the destinations you're going to visit as you build your collection. There's not a lot of point in shooting in places that are clearly well and truly covered, although in practice this is difficult to do. The catch is that places that aren't well covered are probably not for good reason – war, famine and political unrest come to mind – and demand for travel images of these places will be minimal anyway. Ideally, your travels will take you to a range of destinations, from the iconic to those that are off the beaten path.

Better still, use you clairvoyant skills to predict where the next hot destination will be and get ahead of the game. Either that or read travel magazines, both retail and trade. Many of them devote articles in the second half of the year to predicting the following year's 'hottest' destinations.

ASSESS YOUR WORK

You need to be ruthlessly honest about the quality of your images. Yes, you may

have had to overcome all sorts of financial, mental and physical difficulties to be in just the right place to capture a stunning subject in the most remarkable light, but the photo editor and picture buyer really don't care about that. What they care about is how well you captured the scene and whether it suits the specific purpose they require an image for.

Assess your images against those that are already out there, in books, magazines and on websites. Seek a second opinion, and not your mother's! It's great if you get encouragement from friends and family, but their opinion should not be the basis for mortgaging your home to become a travel photographer; they will always love your pictures. By signing up for a short course, or even a long one, you'll get access to photography teachers and other students who will be much more objective. Some courses facilitate contact with working photographers in your field of interest. Camera clubs are great places to meet likeminded people and they run regular themed competitions with critique sessions by experienced photo enthusiast and industry experts. Professional photography organisations also run a variety of lectures, seminars and workshops that you can attend as a nonmember and are a great way to discover the latest trends in photography.

BUILD YOUR PROFILE

When you're starting out you may have lots of images but not much in the way of actual evidence that they've been used. It takes time and effort to build a profile but there are some things you can do even before you've got a single client.

Web Presence

The first thing you can do is create your own website and/or blog, or at least place images with an online photo-sharing community such as Flickr, so that you can point potential clients to an online folio. Websites are brilliant promotional tools and professional photographers are expected to have one. You can present your photos in themes to match your prospective clients and you don't have to be constantly producing and posting discs. Include the URL in an email and potential clients can easily find out about you and your work. You can pay a web designer to make you look really good or do it yourself. Some image-editing programs have web creation tools which arrange and re-size your photos for web display. You then upload the files onto the web space that is usually part of the package when you sign up with an internet service provider.

My website (www.richardianson.com), like many photographers' sites, features biographical information, image galleries and provides information about other activities such as events, workshops and publications.

355

Online Magazines

There are various online magazines that you can contribute to that may not pay in the first instance, but will expose your work to a global audience and may lead to future sales. They count photo editors and gallery owners among their viewers so you never know who may enjoy your efforts. The magazines may not be directly related to travel photography, but they can provide you with an extra degree of credibility with certain prospective clients who appreciate seeing your work being used beyond your own website. It also suggests that you're an active photographer. It's the old, reflected glory trick. Check out JPG Magazine (www.jpgmag.com), Blueeyes Magazine (www.blueeyesmagazine.com), Foto8 (www.foto8.com) and MediaStorm (www.mediastorm.com). Even if they're not suitable for your work you may find some inspiration.

Photo Competitions

There are lots of photo competitions you can enter that have the potential to offer you exposure and better still, prizes. In fact, photography competitions seem to be a growth industry in their own right. Always read the terms and conditions of entry carefully, particularly in regard to how the competition organisers can use your entry. Some competitions are simply a vehicle for companies to acquire images without paying for them. You should definitely not enter competitions that seek to transfer copyright ownership from you to them. Make sure you're comfortable with the fact that even if you aren't required to transfer copyright, you may be permitting a company to use your images in brochures, advertising and websites without payment. Two of the biggest and best-known international photo competitions are the Travel Photographer of the Year (www.tpoty.com) and the International Photography Awards (www.photoawards.com).

SELLING YOUR IMAGES

Once you've got a solid collection of images, getting them represented by a stock photo library is a good way to start earning money from your photography. At the same time, you can pursue selling images directly to clients through third-party online service providers and simply knocking on the doors and inboxes of publishers. If you happen to catch something newsworthy on your travels, the photos or video may be of interest to media agencies.

STOCK PHOTOGRAPHY

'Stock' refers to images that are shot speculatively at the photographer's expense and then either marketed directly by the photographer, usually via their own or a third-party website, or placed with an image library or photo agency ready to meet the needs of picture buyers who require existing images, instead of commissioning new ones. There are specialist libraries that hold extensive collections of one subject, such as travel, wildlife or sport, but the majority of stock libraries cover all subjects, including travel. Libraries represent the work of many photographers with the aim of always having an appropriate image on file to meet their clients' requests.

One of the best things about having images represented by a stock library is that

you don't have to worry about the business of marketing and pricing images, instead leaving it to the professionals. They, of course, take a percentage of the license fee for this which ranges anywhere from 30% to 70%, but your pictures will be seen by far more potential clients than you could ever attract to your own website.

Most libraries have a team of photo editors who assess every image that is submitted for its relevance to their collection and customers, creativity and technical quality. These are known as moderated collections. There are other businesses that work on an unmoderated model that only requires each submission to pass a technical specification check. This is the easiest way to get your images into an online collection. However, these collections are consequently massive, and travel is one of the most popular categories of submissions, so your images face stiff competition purely in terms of numbers even before content and creativity enter the equation.

Images are typically licensed using rights-managed or royalty-free models:

Rights Managed

Rights-managed (RM) images are controlled so that customers are protected against the same image being used by their competitors in a similar way at the same time. Images are licensed to a client for a particular use, for example, a travel brochure for reproduction at a specific size (quarter page, full page etc), and placement (front cover, inside etc), for a certain time (three months, one year etc), in a particular industry (travel, banking etc) in the territories it will appear (UK, Middle East etc), in designated languages (English, all languages etc) and for a designated print run (1000, 50,000 etc).

If you place images with a rights-managed collection, you can't place the same or similar image with another library or license the image directly yourself.

Royalty Free

Royalty-free (RF) images are licensed at a set fee, usually based on file size, and the client is free to use the image how, where and when they want, as can anyone else who licenses the image, so no level of exclusivity is afforded the user. There are dedicated royalty-free libraries and most of the bigger libraries offer collections of royalty-free images alongside their rights-managed collections. Images made available through royalty-free collections can usually be placed with more than one

Published stock imagery
Travel brochures, calendars, greeting cards, postcards, book covers, stamps and newspaper articles are just some of the places where you'll see travel imagery published.
DSLR, 24-70mm lens at 35mm, 1/50 f5, raw, ISO 400

library as client protection and conflicting use are not an issue.

Microstock

Microstock is a variation on the royalty-free model that aims to license lots of photos and make money from lots of small, or micro, payments rather than licensing fewer images at higher paying licenses.

Microstock also distinguishes itself from the traditional model by accepting images from anyone, including one-off submissions. However, they are moderated and so every image is reviewed by photo editors for technical and creative quality before being uploaded to the site.

Travel stock is very competitive. To get pictures into a library can be tough, and the terms and conditions may not suit you. Libraries are businesses and they're there to represent the work of photographers, many of whom rely on stock sales for their living. Your pictures will not only be judged on their own merits, but against the images that are already in the library. Then, when they go before a customer, they'll have to compete against the best pictures from other libraries for the buyer's attention. The more common subjects and the most popular destinations face the greatest competition. You only get paid for a stock image when it's used.

Once you're represented by a traditional library, you'll be expected to make regular submissions. The way to make money from stock is to be continually adding to your own collection and to have as wide a coverage as possible, both in subject matter and geographic coverage. The more pictures you have of a variety of subjects from a variety of places in a variety of light and conditions, the more times they'll go in front of picture buyers; and the greater the chance you'll have of meeting their needs.

Professional stock photographers plan their travels carefully and shoot stock in a very organised way. While researching a destination a shot list is developed of subjects that need to be covered, based on what's already in the library, requests already received from the library, and on anticipated requests.

SUBMITTING TO STOCK LIBRARIES

Stock libraries all have their own requirements and guidelines on how they prefer to receive submissions. Generally, to establish whether or not your images are of suitable quality and content, a traditional library will want to see an initial submission of around 200 to 500 images, presented as low-resolution digital files delivered on disc. When preparing your submission, remember that the people assessing your work will not have the same emotional attachment to the pictures that you have. The following are suggestions to ensure that you make the best impression with your first submission:

- Study the library's website carefully, paying particular attention to the coverage of the places and subjects you intend to submit. The images you submit have to be at least as good as what is already on its site. Look for areas where its coverage is lacking and bias your submission to those destinations (if you've been there, that is). When judging your images against what is already online,

compare them against the best images, not the worst. There are reasons why less than perfect pictures are in collections, but that doesn't mean that is the standard the library is looking for from new work. Your pictures must be as good or better than the best images in the library, not the median.

o Read the submission guidelines and follow them exactly. Image libraries receive thousands of new images every week. Don't stand out by making it hard for them to deal with your submission.

o Edit your submission. Don't send in technically poor images. Out of focus, over- or underexposed pictures will detract from your overall submission and indicate that you don't have enough quality images to meet the library's requirements. This is your first contact with the photo editors at the library and you need to impress them. Every image should be strong. The biggest single reason image submissions are unsuccessful is that they look like holiday photos, ie the pictures have been taken to record memories of a personal trip. Submissions are also weakened by too many images of one travel partner, close-ups of flowers, insects and architectural details, and iconic places shot in ordinary light.

o Present your disc, covering letter and any other material requested professionally. Good presentation will not disguise inferior work, but it does indicate you're taking the process seriously; photography is a visual business, present like you know that too.

PHOTO LIBRARIES & MICROSTOCK WEBSITES

Check out the following photo libraries and microstock sites to see where you think your images might be best placed:

Photo Libraries
o www.gettyimages.com
o www.corbis.com
o www.robertharding.com
o www.nationalgeographicstock.com
o www.masterfile.com

Microstock Sites
o www.shutterstock.com
o www.istockphoto.com
o www.fotolia.com
o www.dreamstime.com
o www.veer.com

Unmoderated Agency
o www.alamy.com

SELLING IMAGES ONLINE

An alternative option to seeking representation with a photo library is to join an online service provider that facilitates independent photographers to sell images directly to clients. Providers such as PhotoSource (www.photosource.com), AGPix (www.agpix.com) and Photoshelter (www.photoshelter.com) are worth looking up.

You can also create an online portfolio with businesses that use images to create and sell products such as posters, framed prints, greeting cards and t-shirts. Check out RedBubble (www.redbubble.com).

SELLING IMAGES TO PUBLISHERS

Travel pictures are most commonly published in books, magazines, newspapers, travel company brochures, calendars,

greeting cards, posters and websites. It's critically important that you take the kinds of pictures that people are going to want to buy. Educate yourself by browsing magazines, books, newspapers and websites and all other printed matter you can lay your eyes on. After a while you'll get a feel for the kind of pictures that get used and the sort of publications that use them. Check the picture credits. Often the photographer and photo library are both named and you can look them up on the internet to see more of their work. Create a list of titles and publishers whose products match your images. This will let you concentrate on contacting only relevant publications.

When you're ready to go, you can contact potential users directly to find out what their needs are and how they go about buying pictures. Most magazines, newspapers and book publishers have a submission-guideline document available on request or on their website. Careful study of these will save you a lot of time.

You'll put yourself at a significant advantage with the editors of magazines and newspaper travel sections if you can deliver a word and picture package. If you're going to deliver a finished article on spec, make sure to check back issues of the publication for the past year, often held at your local library or on the net. You don't want to be sending in a story on a destination that has recently been covered.

Many publishers have set rates for the use of images and photo-text packages.

Make sure you know what these are before you submit any work so you can negotiate if you feel inclined. It's no use complaining about what's offered after publication.

It should be obvious, but deliver work professionally and exactly to the stated guidelines. Quality business cards and letterheads are well worth the cost. If you're submitting on disc then produce a printed label that identifies you and the contents. This presents so much better than scrawled handwriting using a marker pen.

MEDIA AGENCIES

If you're in the right place at the right time, or more importantly the wrong place at the right time, you can join the ranks of the citizen journalist and send your pictures and videos to Demotix (www.demotix.com), a media agency that accepts images from anyone with a camera phone, digital camera or camcorder. The images must be newsworthy and of interest to the wider public. If they are, Demotix will set about licensing the image to media outlets such as newspapers, magazines and TV stations around the world. Many of the pictures of interest to a media agency are also time sensitive. Images shot on a camera phone, or a camera if you have a portable computer and wireless access so you can send from location, will put you at an advantage, rather than having to get back to a computer to send.

GLOSSARY OF PHOTOGRAPHIC TERMS

A

angle of view – image area that a lens covers, measured in degrees and determined by the focal length; the shorter the focal length, the greater the coverage

aperture – opening in the lens that allows light into the camera body; variable in size and expressed in f-numbers

auto-exposure lock – control that locks and holds exposure on the subject while recomposing (also known as AE Lock)

autofocus – system that allows focus to be set automatically (also known as AF)

autofocus lock – control that locks and holds focus on the subject while recomposing (also known as AF Lock)

B

bit – smallest unit of digital data

bit depth – a measure of the number of bits stored for each pixel in an image

bounce flash – technique of reflecting the flash-unit light from a ceiling, wall or other reflective surfaces to diffuse and soften the light

bracketing – technique used to ensure that the best possible exposure is achieved by taking additional frames and adjusting the exposure for each, usually by a half-stop either side of the recommended exposure

bridge camera – camera type between compact and DSLRs in terms of style and size

C

cable release – accessory allowing the shutter to be released without the photographer touching the camera, to prevent camera shake

calibrate – adjust digital devices (scanner, monitor, printer) so they display neutral colours, without colour bias

camera dock – accessory for transferring images from a digital camera to a computer and recharging the camera battery; also known as a cradle or power base

card reader – device for transferring images from a memory card to a computer via a USB port

centre-weighted metering – reads the light reflected from the entire scene and provides an average exposure reading biased towards the centre section of the viewfinder

charge-coupled device (CCD) – common light-sensitive image sensor used in digital cameras that converts light into data

chimping – reviewing every photo taken on the LCD screen immediately after capture

colour space – spectrum of colours available from which a digital image can be created

colour temperature – a measure, in degrees Kelvin, of the colour of light

compact disc (CD) – common storage medium that can hold up to 650 MB of data; discs can be read-only memory (CR-ROM), recordable (CD-R) or rewritable (CD-RW)

compact system camera (CSC) – camera type between compact and DSLR in terms of style and size

complementary metal oxide semiconductor (CMOS) – light-sensitive image sensor used in digital cameras that converts light into data

compression – process for reducing digital image file size by discarding some of the data

contrast – the difference between the lightest and darkest parts of a scene

conversion lenses – accessories that clip or screw onto the front of the prime lens of a compact digital camera to alter the angle of view; also called auxiliary lenses

D

dedicated flash – flash unit that connects to the camera's metering system and controls the power of the flash to produce a correct exposure

depth of field – the area of a photograph, in front of and behind the point of focus, that is considered acceptably sharp

depth-of-field preview – control that allows the aperture to be stopped down manually and provides a visual check of the depth of field at any given aperture

digital versatile disc (DVD) – common storage medium that can hold up to 17 GB of data

digital zoom – uses the (digital) camera's image processor to enlarge a portion of the image by creating and adding pixels through interpolation, giving the illusion of zooming in; image sharpness and contrast are compromised

diopter correction lens – optical accessory mounted on camera viewfinder to enable photographers who wear

glasses to compose and focus without glasses

DSLR – digital single lens reflex (camera)

DX coding – system that automatically sets the ISO by reading the film speed from a barcode printed on the cassette

dynamic range – the ratio between the brightest part of a scene (the highlights) and the darkest part of the scene (the shadows) in which an image sensor can record detail

E

effective pixels – the pixels on a sensor that are used to create an image

electronic viewfinder – advanced compact digital camera feature that displays what the lens sees

emulsion – light-sensitive material in film

EXIF (exchangeable image format) – file format that embeds image-capture information within a file

exposure – the amount of light allowed to reach the camera sensor or film

exposure compensation – allows over- or underexposure of the film by third - or half-stops up to two or three stops, when using automatic exposure modes

exposure lock – technique to lock the exposure so the scene

can be recomposed without changing the exposure setting

exposure modes – controls for exposing the sensor or film by prioritising one setting (shutter speed or aperture) over the other – can be manual, semiautomatic and fully automatic modes

exposure value – method of quantifying the light level of a scene based on the relationship between the ISO setting, shutter speed and aperture

F

fast film – very light-sensitive film

fast lens – lens with a very wide maximum aperture

field of view – image area that the lens provides

file format – manner in which the data captured by a camera to create a digital image is stored so that it can be retrieved and processed using photo-editing software

fill flash – technique used to add light to shadow areas containing important detail

filter – optical accessory attached to the front of the lens, altering the light reaching the film; used for a range of technical and creative applications

FireWire (IEEE 1394) – connector or port designed for high-speed data transfer

between peripherals such as digital cameras

flare – stray light that degrades picture quality by reducing contrast; records as patches of light

focal length – distance from the centre of the lens when it is focused at infinity to the focal plane

focal length conversion factor – the number the focal length of a lens is multiplied by to determine new focal length when used with a digital camera; determined by the sensor's size relative to a 35mm film frame

focal plane – the flat surface on which a sharp image of the subject is formed; film is stretched across the focal plane; in digital photography, the sensor lies on the focal plane

focus lock – technique to lock the focus of an autofocus lens on a point so the scene can be recomposed without changing the point of focus

focus mode – method of focusing the lens; either manual, one-shot autofocus or servo/tracking autofocus

focus point – point on the focus screen that determines what the lens focuses on

f-stop – measurements that indicate the size of the lens aperture

full-frame sensor – digital camera sensor equal in size to a 35mm film frame (24mm x 36mm)

G

gigabyte (GB) – 1024 megabytes (MB) of digital data

grain – silver halide crystals of a film emulsion visible in a photographic image; the faster the film, the coarser the grain

guide number (GN) – indicates the power output of a flash unit with 100 ISO film

H

highlight – the brightest area of the subject

histogram – graphic representation of the distribution of pixels in a digital image

hot-shoe – place on camera body for mounting an accessory flash unit

I

image-editing software – computer application for enhancing and manipulating images

incandescent lighting – artificial light source

interpolation – creation of new pixels to fill in data gaps between existing pixels, typically used when images are enlarged

ISO – International Organization for Standardization, which sets the standards for film-speed rating

ISO equivalent – the sensitivity of digital camera sensors to light, based on the sensitivity of film to light

ISO rating – the sensitivity of the film to light; the higher the ISO, the more light sensitive the film

J

JPEG (joint photographic experts group) – industry-standard file format and compression routine that uses the *lossy* process

L

light meter – device for measuring light

Lightroom – specialist image-workflow software by Adobe

liquid crystal display (LCD) – screen in digital camera body for image review and access to control menus and camera settings; can be an alternative to the viewfinder for composing images

lossless compression – compression process that results in smaller digital file size without compromising image quality

lossy compression – compression process used to reduce image files, discarding

more and more data as compression is increased

M

macro lens – lens designed to give a life-size image of a subject

megabyte (MB) – 1024 kilobytes (KB) of digital data

megapixel (MP) – one million pixels

memory card – removable and reusable storage medium used by digital cameras

metadata – information about an image, attached to the digital file

model release form – legal document giving the photographer permission to use the image for commercial purposes

multizone metering – measures the light from several areas of the scene and gives a reading (also called matrix, evaluative, multisegment, multipattern and honeycomb-pattern metering)

N

noise – error or stuck pixels in a digital image file generated during the conversion of data to pixels (colour noise); electronic grain that appears as a speckled pattern (luminance noise)

O

optical zoom – lens with variable focal lengths; zoom effect is achieved by physically moving the lens in and out of the camera body

P

perspective correction – allows control of the angle of the plane of focus through tilt and shift movements on special lenses to prevent distortion of perspective

photodiode – light-sensitive cell on the surface of a sensor that converts light into numerical data

Photoshop – professional image-editing software product by Adobe

PictBridge – industry-standard technology that allows devices made by different manufacturers to be connected

pixel – abbreviation for picture (pix) element (el); the smallest amounts of information that combine to form a digital image

pixel count – total number of pixels on a sensor; calculated by multiplying the number of pixels on the vertical and horizontal axes

predictive autofocus – sophisticated focusing system that continuously tracks a moving subject (also known as tracking focus)

prime lens – lens with fixed focal length

program mode – fully automatic exposure setting in which the camera's metering system sets both the aperture and shutter speed

property release form – legal document signed by property owner giving photographer permission to use the images of their property for commercial purposes

push processing – increased development time to compensate for underexposure when film is pushed

pushing film – intentional underexposure of colour slide or B&W film by exposing it at a higher ISO setting than its actual film speed

R

random access memory (RAM) – computer memory that holds data while being worked with

rangefinder – focusing system that measures the distance from camera to subject by viewing it from two positions

raw – file format where images are compressed using a *lossless* process, thereby retaining all data originally captured

red-eye – red artefacts visible in the subject's eye as a result of direct flash light reflecting

off the blood vessels of the retina straight back onto the sensor or film

resolution – degree to which digitally captured information displays detail, sharpness and colour accuracy

S

saturation – measure of the intensity of colour in an image

sensor – semiconductor chip made up of photodiodes that convert light into numerical data so it can be processed, stored and retrieved using computer software

short lens – wide-angle lens

shutter – mechanism built into the lens or camera that controls the time that light is allowed to reach the sensor or film

shutter speed – the amount of time that the camera's shutter remains open to allow light onto the sensor or film

SLR (single lens reflex) – a camera design that allows lenses to be interchanged and for the user to view subjects

through the lens being used to take the picture

spot-metering – light meter reading from a very small area of the total scene

standard lens – lens with a focal length of 50mm or 55mm, and an angle of view close to what the eye sees

sync speed – fastest shutter speed that can be used to synchronise the firing of the flash with the time the shutter is open

T

teleconverter – optical accessory that fits between the camera body and the lens to increase the focal length of the lens

telephoto lens – lens with a focal length longer than a standard 50mm lens

TIFF (tagged image file format) – industry-standard file format commonly used for storing images intended for print publishing

tonal range – range of tonal values in an image

tonal value – relative densities

of tones, from light to dark, in an image

TTL – abbreviation for Through the Lens metering; light-sensitive cells in the camera body measure light passing through the lens

tungsten lighting – artificial light source

U

USB (universal serial bus) – connector or port for connecting a computer to devices such as digital cameras, camera docks or card readers

V

viewfinder – camera's optical system used to view a subject

W

white balance – digital camera function that adjusts colour to ensure that white is recorded as white under all light conditions

wide-angle lens – lens with a focal length shorter than a standard 50mm lens

INDEX

GEOGRAPHIC PHOTO INDEX